# ART

## & Other
## Serious
## Matters

# ART
## & Other Serious Matters

## Harold Rosenberg

The University of Chicago Press
Chicago and London

For many years Harold Rosenberg was art critic for *The New Yorker* and professor in the Committee on Social Thought and in the Department of Art at the University of Chicago. His imaginative grasp of the contemporary artist's aesthetic and cultural situation influenced not only the field of art criticism but also the practice of art and the process of selection that proclaimed the importance of such major postwar figures as Barnett Newman, Arshile Gorky, Jackson Pollock, Franz Kline, Mark Rothko, and Willem de Kooning. Other titles by Harold Rosenberg available from the University of Chicago Press are *The Tradition of the New, Discovering the Present, The Anxious Object, Artworks and Packages, Act and the Actor, The De-definition of Art*, and *Art on the Edge.*

The University of Chicago Press, Chicago 60637
The University of Chicago Press, Ltd., London
© 1985 by The University of Chicago
© 1967, 1972, 1973, 1975, 1976, 1978 by Harold Rosenberg
© 1985 by The University of Chicago
© 1974, 1975, 1976, 1977, 1978 by May Natalie Tabak Rosenberg
Printed in the United States of America

94 93 92 91 90 89 88 87 86 85    5432

*Library of Congress Cataloging in Publication Data*

Rosenberg, Harold.
    Art & other serious matters.

    Includes index.
    1. Art—Addresses, essays, lectures.   2. Art, Modern—
20th century—Addresses, essays, lectures.   3. Artists—
United States—Addresses, essays, lectures.   4. Art and
society—Addresses, essays, lectures.   I. Title.
II. Title: Art and other serious matters.
N7445.2.R66   1985      709'.04      84-8781
ISBN 0-226-72694-0

# Contents

# Publisher's Note

This volume is a selection of previously uncollected essays by Harold Rosenberg, four of them unpublished, which were written in the 1960s and 1970s and compiled by the author shortly before his death in 1978. The arrangement was made by Harold Rosenberg with future publication in mind and has been faithfully preserved in this edition.

# Then & Now

# 1

# The *Mona Lisa* without a Mustache Art in the Media Age

Of the images that have descended into popular culture (or ascended, if you prefer) from what used to be called the fine arts, the most celebrated is, without doubt, the *Mona Lisa* of Leonardo. It has been "popularized" by reappearing in different forms for almost 500 years—I have been told that a study is being made of these adaptations. In our century, the Mona Lisa has reached a huge public; it has been reproduced in art books and for framing, has been made into illustrations for record albums and jackets of novels, and has been printed in Sunday magazine sections, in movie ads, on crockery, on sweat shirts. I have even seen a Mona Lisa belt buckle in color.

The popularity of these formerly esoteric images (one could include such inescapable fixtures of the Western mind as Michelangelo's *Moses*, Rodin's *Thinker*, Van Gogh's *Sunflowers*) depends on a factor that was not present when the earliest of them was created—the factor of reproduction through mechanical copying. Art images could not have attained their present degree of popularity if they were still part of a painting or sculpture confined to a single location. Each

Based on a talk given at a conference of the Lilly Program for Faculty Renewal, Stanford University. Originally published in *ARTnews*, May 1976.

year great crowds visit the Louvre and pause for La Giaconda to smile at them; but large as they are, these crowds are but a minute fraction of the vast masses of humanity who have never been to Paris but to whom Mona Lisa's face is familiar.

Reproduction is a kind of dismemberment. It splits the image from the physical reality of the original and allows it to manifest itself in a thousand places at once. The work undergoes an attack of schizophrenia—it is itself, but it is also those countless emanations that resemble it but bring forth alien effects upon the spectator. Reproductions carry the ghost of the work into realms where art itself rarely enters, for example, the supermarket. A reproduction of the Mona Lisa has more in common with Aunt Jemima than it has with any painting, good or bad.

As the technology of reproduction is perfected, the distinction between original and copy is progressively reduced. All art, past and present, thus becomes available for utilization in entertainment, education (propaganda) and the marketplace, and is drawn irresistibly into the media system. The concept "system" must be stressed, since in the media works are brought into conformity with the total mechanism of production and distribution—in contrast to the individual peculiarities that are typical of the creation and dissemination of art. Media characteristics now dominant in the visual arts include:

*Globalism:* The same styles in art are current everywhere—except in totalitarian countries, where they are prevented from becoming popular through measures taken by the police. Artists give the impression of being employees of the same multinational corporations. It is no more possible to restrict a mode in art—say, minimalism or photorealism—to its place of origin than to restrict the taste for Coca Cola. Indeed, the "place" of origin often can no longer be determined. A new look (or "image," in the broader sense) is picked up in many cultural centers at the same instant, and is shot back and forth from continent to continent as an item of the total cultural communications package—which includes, in addi-

tion to art, such esthetic commodities as human interest stories about political, scientific and entertainment personages and new fashions in clothing, food and resorts.

*Mass output and sales:* Situated in the global system, art is compelled to meet global requirements of quantity. To qualify for representation by major art galleries with branches in several countries, an artist must be capable of supplying an expanding market. The turn to printmaking in the last few years by such artists as Johns, Rauschenberg, Lichtenstein, Warhol and Lindner, who have penetrated the world art market, is a reflex to a new sales potential that strives to attain the magnitude of the media.

*Programmed response:* In the media world popularity is attained in gradations that reach their peak in stardom. In art, glorification of individual artists in a degree equivalent to stardom has been prevalent since the Renaissance; it is only recently, however, that eminence in art has been measured as it is in Hollywood or on Madison Avenue, by the responses of crowds rather than by critical approval. Andy Warhol signaled the change in the '60s when he observed that everyone ought to be famous for 15 minutes, a concept in which accomplishment plays no part. Warhol's democratic distribution of fame matches—in caricature, of course—the rapid turnover of "greats" in the media. The resulting demand for new "masters" brings the promotion and marketing techniques of the media into operation. Artists become famous overnight through exhibition "sellouts," before a single critical word has been uttered, or even on the sole basis of having been signed up by a successful dealer.

Art and popular culture thus overlap both in their mode of production and in their method of reaching and affecting the public. Marshal McLuhan's insight was to recognize that today the arts *are* media. The work of art in its public existence, as distinguished from what it may convey to individuals, can be nothing else than an apparatus for communicating information of a specialized sort, and in this function there is no difference between an original work and a reproduction of it.

The most recent international exhibition at Kassel, Germany, entitled Documenta 5, described itself as presenting "Today's Imagery." Under this rubric, the notion of "art" was dissolved and Documenta 5 was able to include anything available to the eye, from minimal paintings to railway-station ads for soft drinks, from pornographic films to religious objects for the illiterate, from Happenings to creations made and exhibited in a lunatic asylum, from flickering videotape outlines to simulated caves.

Art in its old form—an objective classification of objects— has come to an end, swallowed up in a sea of image-making without boundaries. The most precise way of distinguishing art from other forms of image-making media is to describe it as an art-historical medium, that is, as a mode of communication for persons familiar with and responsive to images of the past. Duchamp's Mona Lisa with a mustache and goatee is a model work of art in this context since it exists in relation to, and in visual dialogue with, the Mona Lisa of Leonardo. It encompasses both the Mona Lisa of popular culture in its manifold reproductions and the Mona Lisa of the past transformed into a comment on the present.

The relation between Mona Lisa with a mustache and Leonardo's original image attests to the fact that the adulteration of art by the media cannot be arrested. Leonardo's painting had been reduced to a cliché of the advertising industry until Duchamp defaced it, like an urchin applying his talent to a billboard on a station platform. As a Dada masterpiece, Mona Lisa with mustache transcended the decline of Mona without and restored La Giaconda to high art. Both Mona Lisas thus entered into art history and are prominent in art books and surveys.

In contemporary civilization, all images, those of art and popular media alike, are in a constant state of qualitative (that is, meaning-conveying) transformation. As art descends into incorporation by the media, popular imagery ascends into art. A painting conceived as an absolute statement of belief or view of reality, for example by Mondrian, is converted into a

design for fabrics or floor covering. In return, the design decorating a soup label is elevated into art by ingenious timing within changing forms and moods.

The borrowing by art of images from popular sources has a respected history, particularly in avant-garde art. Malevich included shop signs in his earlier compositions, Stuart Davis played with the design of Lucky Strike packages, and T. S. Eliot quoted lines about Mrs. Porter and her daughter. These appropriations, however, underlined the esthetic difference between the material appropriated and the forms into which they were introduced. What is at issue today is not adaptation but the disappearance of the very notion of high and low, of any distinction between images that represent culture and images of popular culture.

To speak of "popular" culture implies that there is a culture that is not popular and that despite this deficiency or advantage, it is a viable social and spiritual reality. I suggest that no such culture exists any longer, that all images are mingled together in one indefinable agglomeration, and that for us, who live in this time, there are only one-person cultures, which each of us pieces together as best we can.

If I objected to Documenta 5, it was not because it substituted the concept of "today's imagery" for the concept of "today's art." It was simply that I did not approve the images which the directors of the exhibition chose to present. They gave me their culture and my culture rejected it. We became the equivalent of two hostile, or at least unfriendly, tribes. And I believe that each person is a separate cultural conglomerate in the same sense as Documenta 5 and Harold Rosenberg.

In this age of reproductions, interpretation takes precedence over direct response. The nature of the image itself— for example, its complexity, awesomeness, evocativeness— becomes less and less important. It was, of course, Freud who provided the suggestion that the banalities of everyday life conceal countless layers of metaphors which, if their possible connections were traced, would reveal depths of mean-

ing exceeding those of the supreme creations of art.
Thenceforth, the meaning of an image was limited only by
the ingenuity of its interpreter.

In inscribing his mustache on the Mona Lisa, Duchamp as-
serted that instead of interpreting an image the artist prefers
to do something to it. Perhaps changing the image is the art-
ist's way of disrupting the talk about it by people who are not
artists.

If for the psychiatrist, the sociologist, the cultural an-
thropologist or the literary analyst, an image's interest lies in
its potential for interpretation, for the artist the major interest
is in the possibilities of renewal. Art that consists in remaking
art is a central theme of our time. The sources of inspiration,
however, can be the art of the museum, or its echo, the art of
the streets—either Manet's revision of Correggio and
Rauschenberg's *Erased de Kooning Drawing* or the Pop artist's
adaptations of comic strips and Coca Cola bottles. In a culture
that has dissolved distinctions between high and low, one's
point of departure and even destination count for less than
the transforming activity. In the last analysis, the prime prod-
uct of this activity, as in the instance of Duchamp, is the artist
himself. *He* is the ultimate image that the images he has cre-
ated bring before the public; it is his (or her) unique mode of
life which subsists in the history of the times.

But the artist's image, whatever the artist's attitude to-
wards art, thought or politics, is a popular-culture image. The
"artist as public personage" is transmitted through the media
as a communication package in the "human interest" catego-
ry, and is amalgamated with celebrities from—to use a favor-
ite media phrase—"all walks of life": Nixon, Sukharov,
Gloria Steinem, Bob Hope.

In the Mona Lisa with a mustache, created more than half a
century ago, previously separate currents—high culture and
art for the people—converge into a single stream. But this
unity, in which the old division between high and popular
culture is still reflected, gives rise to a web of paradoxes. The

desecrated masterpiece, actually a reproduction which is original only in the changes penciled on it by the artist, enters the museum as a response of the modernist esthetic consciousness to one of the grandest achievements of the past. But the museum itself in this phase of its development is, increasingly, a mechanism of mass communication—a popular medium like the weekly magazine, the adult-education course or the one-volume survey of world art. Formerly the quiet depository of the treasured monuments of human history, that is, of the unchanging, the museum has emerged since the war as an educational institution, a distribution center and a public relations bureau for art and artists. What is left of its orientation towards the past exists under the spell of ideologies regarding the future. The primary interest of the museum is directed toward trends that show promise of capturing the interest of the public, thus serving the function of audience building. If no such trends are apparent in art, the museum endeavors to create them. The museum has become the competitor of arts in the popular-culture competition for the box office.

Mona Lisa with a mustache effects the transition from the old static museum dedicated to conservation to the new active museum whose aim is making culture. The museum today is one of the organs by which all places and times are turned into aspects of the here and now. Pre-Columbian ceramics are contemporary with Romanesque tomb paintings in being made accessible to the media-trained masses. The *Mona Lisa* of the Louvre belongs to "our art heritage," while the Mona Lisa of the mustache is an outstanding contribution of 20th-century avantgardism, which is equally past and contemporary.

At the center of the paradoxes inherent in a two-level culture reduced to one, Mona Lisa with a mustache sparkles with meanings that contradict one another. With its obscene title, *L.H.O.O.Q.*, it is an irreverent comment on a revered icon of Western culture. As such, it represents the anti-art

aspect of Dada and Surrealism, with their tradition of attacking eminent personages, from Dante (called the "comedy writer") and Goethe to Anatole France.

But while the Duchamp tour de force is an attack on "art," it has the opposite effect—*creating* a work of art out of a worthless mechanical reproduction. It subjects a media product to an act that reflects the situation of art in our time. Duchamp's act attacks technological civilization for its leveling effects on man's endeavors, past and present. Technology makes Leonardo's masterpiece available to all, but in doing so it habituates individuals to substitutes, barring them from genuine experience. What is called cultural education is actually an indoctrination in responding to information in which the actual products of artists play little or no part. Even the most trivial intervention of an artist's hand—such as the scrawl of a mustache—is sufficient to call attention to the essentially manual nature of art. Once individuality has been totally eliminated, as it is in mass reproductions, the character of the image no longer matters. The mustache on the Mona Lisa emphasizes the distance between the commodity provided by the printing press and the conception of the artist; in drawing it, Duchamp expressed his solidarity with Leonardo against the estrangement of his painting by the factory.

The meaning given to images today depends on the professional and personal leanings of those who interpret them. It is the ghosts of art that become popular through reproductions. To return to reality we need constantly to be confronted with original creations. Ironically, after five decades of fame, Mona Lisa with a mustache has been overwhelmed, like its predecessor, by its reproductions—last year, a French artist felt induced to pay homage to Duchamp by painting a *Mona Lisa Without a Mustache,* following the example of Duchamp's own *L.H.O.O.Q. rasée* of 1965.

# 2
# Movement in Art

H̵alf a dozen years ago it still seemed odd to speak of a painting as an event occurring on a canvas rather than as an object made to be contemplated. "You can not hang an event on the wall," wrote Mary McCarthy, objecting to the concept of Action painting, "only a picture."

The introduction of movement into painting and sculpture, thus making them "happen" for the spectator, had been taking place more and more since the Cubists began shifting positions before the model and composing out of "angle shots." The Futurists tried to seize the vibrating outlines of objects in motion; the Dadaists and Surrealists extended painting into motion pictures and street demonstrations. The reaching of artists toward action made "art is a weapon" a popular slogan, and painters of the 1930's volunteered to fight in the Spanish Civil War.

Regardless of their aesthetics or their social philosophy, artists of this century have agreed in conceiving their works as vehicles of energy. Yet with a few rare exceptions, like Calder's wafting metal leaves, paintings and sculptures continued to remain fixed in their accustomed places and were active only in the metaphorical sense.

Originally published in *Vogue*, 1 February 1967.

Recently, however, as if in response to Miss McCarthy's challenge, paintings have been refusing increasingly to be mere "pictures" and have begun coming off the wall physically. Instead of waiting patiently to be perused, canvases and constructions have been projecting themselves into the living space of the spectator in order to engage him in their doings with varying degrees of aggressiveness.

A plaster man by Segal declines to be sequestered in a niche or corner; he sits in the collector's living room, and a guest who turns his back on him has the feeling of being rude. Optical paintings, although they, too, do not actually move, ensnare the spectator's eye into their quiverings and drifts; while Optical reliefs take advantage of his movements to seem to move themselves.

Kinetic art reaches the final stage of actually animating the work by means of wind, water, motor, transistors, or explosives. Works of this order owe to motion their form and their life: When the power is turned off, they are dead as a closed amusement park. One hears a kinetic collector explaining, "I am waiting for the electrician to come to fix my sculpture." As in an amusement park, too, the spectator is often solicited to start the work by pressing a button or turning a knob or switch, thus making him an accomplice of its whirling, noisemaking, or blinking on and off.

Depicting motion and action is, of course, nothing new in art—for examples one has only to think of Poussin's "The Rape of the Sabine Women" or Rubens's "The Consequences of War." The point of twentieth-century active art, however, is not to depict action (except perhaps with the Futurists) but to be itself an act of the artist, whether as Cubist composing in the midst of the limitless visual possibilities of a pitcher on a tablecloth or as Action painter evoking a potentiality of self through gestures on the canvas.

The artist of mobility is no longer content to make a thing or even to show forth a vision of his mind. He wishes his work to constitute a living situation through which he may

affect his own nature and that of his environment. The fabricator of a propelled work demonstrates that he has mastered the technological methods that dominate the modern world and that he is thus a man of the times. Through his knowledge of mechanics and electronics he is equipped to compete with the popular media, in which animation, if not violence (e.g., as in slapstick comedy), has always been a prime means for capturing the senses.

Movement in art is thus an aspect of the trend that has been converting the art object into the art event. In becoming active, whether psychically or mechanically, art takes on the dynamism of the contemporary world and accommodates itself to radical characteristics of the modern sensibility. "We love the road much more than we do places," wrote Vincent Scully recently, which is equivalent to saying that we love motion more than we do things and people. Engrossment in this abstract state marks the end of contemplation, which had survived chiefly in our attitudes toward the spatial and "static" arts of painting and sculpture. In compelling the participation of the spectator the new art asserts that no still spot exists from which one can merely look. Audience and art work are immersed in a sea of occurrences. In the modern world (if we may correct Jimmy Durante), everybody *is* in the act.

Our leading form of entertainment, television, brings motion into the house, at the same time that it engages the viewer with history in the making. This inexhaustible source of events (events that, to recall Mary McCarthy's observation, not only hang on the wall but often actually occur visually on it) provides a mental context that challenges art to do things, or at least to keep pace with what is being done. Wesselmann's painting with a television set inserted in it may be interpreted as an ironic comment on the capacity of this instrument to outdo art the moment it is switched on. In addition to television, other electronic media—hi-fi sets, tape recorders, home movies—collaborate with electrified gadgets, from elevators to oven timers, and with mechanized

appliances and toys to turn the house into a revel of anima-
tion in which art can find a place only if it runs, flies, scoots,
climbs, wiggles, shakes, or twinkles.

The apogee of our kinetic landscape is the industrial plant
and laboratory. For much of the educated public these are
alien places, mysterious groves rather than spots belonging
to daily life. All the more pervasive is the effect on the imag-
ination of their spare, abstract structures where rhythms of
sound, light, and movement are synchronized with the meta-
morphosis of substances. Most directly, kinetic art is the in-
tellectual projection of the automated processing plant with
its beat upon the eye and ear of machine tools and signalling
devices. When, a few years ago, the Volkswagenwerk, A. G.,
assembled at its home city of Wolfsburg in Germany a huge
exhibition of post-Impressionist art, the works seemed to one
who had toured the vast automated plant to belong to a by-
gone era and made him wonder whether the organizers of
the exhibition were insensible to the aesthetics of the factory
itself.

If the essence of painting and sculpture is their immobility,
these arts, in becoming active, would seem to be bringing
about their own dissolution. Logically, art in our era should
disappear into Happenings. However, it is not logical for art
to be logical. Art goes against the grain of the times as readily
as it goes with it and at the very same moment. Instead of
seeking the nearest exit, art responds to a new situation by
uncovering a labyrinth of problems.

The domination of art and the environment by motion has
given rise to an issue concerning the future of man. Walt
Whitman in "Song of the Open Road" saw in perpetual
movement the promise of health, solidarity, and human
greatness ("I think heroic deeds were all conceiv'd in the
open air"), while staying in one's place brought sickness and
self-love ("the dark confinement"). In contrast, Professor
Scully fears that the impulse to be "always on the go" will
result in an all-destroying nihilism ("One feels the tribal stir-
ring in the blood: tear it down, smash it, get away. The road,

man") that will end "in making everything one horrid uniformity. . . ."

Among artists, attitudes toward the mobile world are no more uniform than among poets and historians. Contemporaries to whom the automobile and the airplane are primary images of the new outdoors are likely to regard them with mixed feelings. Rosenquist's "environmental" airplanes takes the hostile shape of a bomber; Chamberlain's and César's junked-car sculpture may be read as a gloating over the machine's wreckage. Oldenburg's celebration of the "Airflow" Chrysler of the 1930's thrusts the automobile back into the past in an expression of nostalgia consistent with the effort of his "soft sculpture" to recapture from industry articles of daily use by giving them a homemade look. In contrast, mechanical art, from Léger's "Le Ballet Mécanique" to current Op, fights the uneasiness of this nonstop era by generating an atmosphere of glamour around modern inventions akin to that of the Wonders of Science Pavilion at an international fair.

Bringing the spectator "into the picture" transfers the issue of the moral effects of mobility into the centre of contemporary art values. What is the active element in active and environmental art? The work? Or the spectator? Looking at a painting is an intellectual transaction to which the spectator must contribute. Being enveloped by art in motion or by a Happening substitutes for this transaction the need for the spectator to recover his equilibrium. His effort to do so may renew his entire personality. Or he may renounce this effort and lose himself in the work, thus heading deeper into the conformism noted by Professor Scully.

The more extreme forms of multiple-media art deliberately set out to swamp the mind in the environmental deluge. The spectator can "appreciate" the work only by consenting completely to surrender himself. In the recent "mixed media" exhibition at the Riverside Museum in New York, the combination of paintings, films, constructions, hypnotic lighting, and primitive liturgical music supplied an "environ-

ment" conducive to catatonia, and the audience, largely of
teenagers, reclined on the floor in various stages of trance.

Confronted by the assault of hyperactive art, some artists
have adopted a strategy of monastic withdrawal. As against
paintings that "perform" they stress the moral rightness of
static and non-communicative forms. The hard, shifting col-
ours of Op painting are countered by canvases of sunken black
or of greys as unseductive as a painted fence. Contemporary
sculptures pursue stillness as contemporary music pursues
silence—indeed a relief by Kemény is entitled "Optical
Silence."

As an alternative to motion, however, stillness is largely
unreal. Today, the painting or relief that still hangs on the
wall becomes, whether or not it was intended to, an element
in a complex of audio-visual mechanisms of presentation and
reproduction that destroy any quietness it may have. Master-
pieces of the past are caught up in the motion of crowds
moved before them as if they were exhibits at a fair—the spi-
ralling ramp of the Guggenheim Museum is an outstanding
symbol of the directional push exerted on the art-audience
relationship by today's active museums.

The state of quiet is increasingly unattainable in contempo-
rary experience, be it the most meditative. As Valéry said in
*An Evening with Mr. Teste,* "No one meditates." Every mind is
aware that, consciously or unconsciously, it is in constant in-
teraction with the past, the present, and the dream. Even an
artist of "ratios" like Josef Albers is moved to declare that for
him colour is an "actor."

The opposite of motion, then, is not stillness but another
kind of motion. "All sculptures move," said Giacometti once
to me. "What a silly notion to produce a work that actually
moves."

When motion is made literal, the artist's act is converted
into mechanics. Far from increasing his powers, technology
supplants them. I admire the wacky machines of Tinguely,
but I find more energy in his drawings of plans for them.
Compared to an automobile, paint is an inert medium. Yet,

like words, it communicates more directly the energy of a mind than does an amalgam of lights and sounds controlled by an instrument panel. Giacometti's walking men are fixed, stationary. Still, they move—as do the angled profiles of his portraits. They move from within, and it is thus that the spectator is moved by them. Moved from within he expands, is empowered. Subjected to mechanical motion, he shrinks—at the Riverside Museum exhibition the stillest thing was man.

The trend toward motion in art reveals the qualitative difference between human and mechanical energy. The supreme kinetic sculpture is, of course, the hydrogen bomb, by which all humanity has been made smaller. This masterpiece of our culture can never be exhibited in its working state, if for no other reason than that if it is, the audience-participants will be in no condition to appreciate it. The great hidden art object of this era, the Bomb is comparable to the Ship of Cheops, which upon completion was buried "forever" in a mountainside. Power-driven art thus reaches its apotheosis in becoming invisible, a presence of pure energy that can not be endured. The art act, however, begins and ends in a particular person.

# 3
# Bull by the Horns

O ne gets sick of "radical" artists who produce innocuous collages of silkscreened newspaper clippings—scare headlines, electric chairs, corpses—and imagine they are striking a blow at society. All that they are saying is that they read the papers, tabloids by preference, and have found ways of making use of them for art. It's not really very radical to be aware that two Kennedys were assassinated and that Marilyn Monroe had an appealing mouth. Perhaps this art feels heroic because it has subjected itself to such low-grade information instead of meditating on the continuity of the picture plane and the plangent discovery that paint comes in colors.

Genuine perception of social reality and accompanying grim feelings don't go down well with critics, curators, and collectors, who seek, above all, peaceful enjoyment of art treasures—and thus the "unbroken continuity" not only of the picture plane but of the art market and of works of today with the masterpieces of the past. What is the contemporary art world but the collusion among its parts to turn art into a Sunday Section of life untroubled by the news of the week?

The measure of vanguard art is (1) the degree of heat it registers in its criticism of society and culture; (2) the centrality of the target to which this criticism is applied. I think

Not previously published.

No-art does well with (1), less well with (2). (Incidentally, I think "No-art" is a bad title, because it gives the impression of meaning "without art," whereas its better meaning is nay-saying or negative art.) In the temperature of their reaction against contemporary America, the No-artists were the legitimate heirs of Dada, though without the old boys' slapstick ferocity. At any rate, they showed a natural enmity to cool, slick Pop and post-Dada—Rauschenberg, Lichtenstein and other house-trained kittens.

It is not easy for an artist to be consistently negative. After all, one becomes an artist through a burst of admiration for a work of art. To say no to art through art requires, first of all, that one say no to that transforming experience. I am talking about slaying a god—or an angel, god's messenger. If anything less is involved in No-art, it is simply non-art, and modern society is full of that.

On the other hand, unless the "no" is absolute—principled and noncompromising as a religious or political oath—it becomes automatically a device for smuggling in a style of painting through propaganda about social attitudes.

Lurie, Goodman, Fisher et al. smothered their aesthetic angel under a garbage heap of media images belonging to the categories of violence and sex fantasy. They anticipated Documenta 5 by ten years—it is no wonder No-art is doing well in the land of an international exhibition conducted under the slogan Art is Superfluous and of Joseph Beuys. Lurie said in one of his statements that he couldn't get mass-distributed pictures of big tits and behinds of bent-over girls out of his head until he emptied them into his collages. The organic goodies that happen to be packaged in the human female kept at fever heat his hostility to a society that has learned to satisfy mass-market demands for anything but genuine ass—it can, on a national basis, supply only ersatz (the pinups), leaving actual toplessness and price-fixed fondling to be controlled by local ordinances. You don't have to be tit hungry to like Levy's, and to appreciate why Goodman and Lurie were sore.

The No-artists had the advantage of a self-fueled loathing.

The next question is, how good was their choice of targets? Primarily, I think, their target turns out to be not society but the art world. And the art world can only go down the drain when society does. No-art features pinups, a kind of art, according to Lurie's testimony, capable of becoming an obsession. From pinups, No-art advances to excrement, exhibited in anticipation of anti-form sculpture.

Where's the radical criticism? In the exhibits themselves, I mean, not in the accompanying manifestos? Naked girls are at home on the walls of art galleries, and to exhibit them as scandalous, with or without garter belts, in cutouts from porno magazines is to imply that they ought to be denied to the poor and uneducated.

Shit is not a radical phenomenon either—Rabelais wrote a poem in praise of it as a factor in the humanist revolution. So the "no" message boils down to the assertion that while pornography and shit are facts of life they have not hitherto been found in art galleries. But a lot worse things are prevalent in galleries and are considered highly respectable. To deal in masterpieces as if they were diamond-studded shit is more culturally destructive than to exhibit shit as if it were a diamond-studded masterpiece.

No-art reflects the mixture of crap and crime with which the mass media floods the mind of our time. It attacks this mixture through reproducing it in concentrated images. It is Pop with venom added. I think its greatest value is to remind the art world that there are things to be uncomfortable about, whereas Pop gladhanded Madison Avenue as if it were looking for campaign funds. Granted that people flee unpleasant reminders, especially when there's nothing they can do to change the situation, art can only answer, let them. It's not the business of art to get things done but to keep reality on the agenda. Art has been apoliticized since the war not because artists chose to shun politics but because they found out that a genuine artist can only do what he can do, not what he thinks ought to be done.

Besides, politics itself has abandoned all hope for a better

world. Individuals can shriek, but no one knows what to do. Art by itself can do nothing to change the general conditions of life. And if art merely shrieks it is accused of abandoning art for bad politics. Did No-art do that? Did it ask, What is *good* art for in the world today? A Swiss investment group? A Japanese-American group—highest prices paid?

No-art fixed itself in the reality defined by the self-destructive New Left of the early sixties. It accepted the latter's package of things to attack: tyranny, filth, and aesthetic hypocrisy, but it could not offer any contributions toward a new political consciousness or a rebellious sensibility. All the Marek Gallery could do was to make noise to drive away evil spirits. And to take the bull by the horns, at the risk of getting dragged in the dirt.

## Some Questions as Appendix

1. Will No-art be coopted by art history?
2. Does it seek cooption?
3. Will shit multiples be produced by Marlborough, Pace, and Castelli to commemorate this episode of art history?
4. Will a retrospective shit show be sponsored by the National Endowment for the Arts and the New York State Council for the Arts?
5. If not, is the omission a falsification of art history?
6. What about other artists who have existed but have been omitted from art history?

# 4
## History at the Met

The mammoth exhibition at the Metropolitan entitled "French Painting 1774–1830: The Age of Revolution" is based on the challenging premise that the researches of art history can result in a display of paintings attractive to the general public. Put together by a team of specialists, the show is essentially didactic—to appreciate it, visitors must come endowed with an eagerness to be educated. Though it contains some paintings often seen or reproduced—Fragonard's "The Lock," David's "Death of Socrates," Géricault's "Wounded Cuirassier," Ingres's "Roger and Angelica," Delacroix's "Liberty Leading the People"—it consists for the main part of canvases by painters whose reputation has dimmed, which are dated stylistically and, admittedly, are second-rate. The spectator is offered the opportunity—not often given deliberately—to familiarize himself with bad paintings.

To the art historian, the absence of distinction of most of the items shown makes them no less interesting. "We wanted to bring out of obscurity many artists, some famous during their lifetimes but who today are only names in specialized dictionaries," writes Pierre Rosenberg, Curator of Paintings at the Louvre, and one of the organizers of the exhibition.

Originally published in *The New Yorker*, 8 September 1975.

Rosenberg reflects ruefully on paintings of the period that could not be included because they have vanished, and on others, "many of them extremely large," that were inaccessible because they lie rolled up and neglected in museum "reserves"—in sum, paintings that no one wants to preserve or has had the courage to throw away. Had time, space, and resources been available, the exhibition could have been expanded to twice or thrice its size, if not indefinitely. In fact, however, sixty paintings, among them some from the top level of quality, have been omitted from the original group shown at the Louvre. There have been complaints about these omissions, presumably by persons with a limitless appetite for seeing paintings merely because they exist. But neither expansion nor contraction could alter the essential character of the show as primarily, in the words of the Louvre curator, an "exploration of an unknown and inadequately studied period." Matter has been dredged up from the mulch of forgotten art that underlies civilization, and has been blended with creations by masters who have managed to survive on the surface. Such a display appeals to the passion for cultural education—the accumulation of information about art: names, dates, and identifiable images—which is sufficient to insure an adequate museum attendance.

But the show at the Metropolitan promises more than pictorial data about a given period in art. When the exhibition was originally shown in Paris, it bore the title "From David to Delacroix: French Painting from 1774 to 1830"—a strictly art-history billing. In the United States, however, the survey has been given a coating of glamour through a new title: "French Painting 1774 to 1830: The Age of Revolution." In a word, political history has been invoked to add meaning to art history. Obviously, pictures that represent an epoch of revolution reach levels of intellectual and emotional interest unattainable by works that merely fill in gaps in our knowledge of art. Renaming the show might be taken as an admission that, whatever art may be for art historians, it becomes more meaningful and moving for the public through its connection

with living events. We, too, live in an "age of revolution"—
actually, the same revolutionary age that is the subject of the
Metropolitan show—and throughout this epoch artists as
well as political ideologists and philosophers of culture have
been endeavoring to determine what sort of art is appropriate
to our period of social and political upheaval. The concept of
an avant-garde and the ideal of art for art's sake are antitheti-
cal—or, if one prefers, complementary, or even inter-
woven—responses to this unending and apparently
intensifying process of overthrow. Thus, an exhibition repre-
senting "The Age of Revolution," even if admittedly uneven
in aesthetic value, might provide significant hints for art in
our time.

Unfortunately, the Metropolitan show fails to convey any
coherent impression. The expectations aroused by the link-
age of art with political history result merely in a state of be-
wilderment. A model for paintings expressive of revolution
would be "Liberty Leading the People," a detail of which ap-
pears in color on the cover of the exhibition catalogue, and
which provides a mighty finale on the back wall of the last
gallery. Portraits of Louis XVI, Napoleon, Mirabeau,
Robespierre, and of soldiers of the period are also evocative
of the struggles for the remaking of Europe, as are such histo-
ry paintings (shown in the catalogue) as "Marshal Ney and
the Soldiers of the 76th Regiment" and "Entry of the Imperial
Guard Into Paris."

Canvases related to events and personages of the Revolu-
tion constitute, however, only a small fraction of "French
Painting 1774–1830." From the first gallery on, the spectator
is overwhelmed by huge theatrical tableaux depicting epi-
sodes from myth and from the history of antiquity, and with
these appear symbolic compositions (e.g., "Love Fleeing
Slavery"), Biblical subjects, family portraits, and landscapes.
What the exhibition reflects is not the reality of the time but
its taste. That is to say, the taste of its socially dominant
groups. We are reminded that fashion accounts for a large
portion of the art of any period, and that it is a quality beyond

fashion which makes some works last. In resuscitating artists whose fame has perished, the accumulation at the Metropolitan in effect restores the rule of fashion. According to Antoine Schnapper, a contributor to the catalogue, during the Revolution, "while all the official voices (including the critics) were extolling the virtues of large-scale paintings drawn from antiquity in order to influence public morality, the artists were in fact painting what they could sell," which consisted mostly of portraits, landscapes, and genre pictures—that is, pictures without Revolutionary motifs. "The Age of Revolution" is a recapitulation of what was fashionable in French painting between 1774 and 1830, and other things were fashionable besides the Revolution. What, for example, does the "Eruption of Mount Vesuvius," by Pierre-Jacques Volaire, who settled in Naples in the seventeen-sixties, have to do with the overthrow of the Old Regime in France? From the catalogue we learn that in the eighteenth century there was "an enormous vogue" for paintings of Vesuvius, and particularly for Volaire's. The inclusion of "Eruption" is thus consistent with the aim of the show "to represent this period in its most diverse aspects," and with the effort of Robert Rosenblum, another of its organizers, to trace the "widening diversity of styles" resulting from the shattering of traditions by the Napoleonic era, but it is not relevant to an exhibition representing the French Revolution.

Whatever the logic behind the way in which the exhibition was selected, it is not apparent in the show itself. The paintings exemplify the variety of moods prevailing in the period, but the spectator has no way of knowing what the relation of this variety is to the Revolution, or whether variety and Revolution are to be regarded as synonymous. To judge by this exhibition, the impact on painting of France's tremendous Revolution was surprisingly spotty. Napoleon provided a rousing theme, but of the popular uprising and the Reign of Terror there are very few signs in the show. Very likely, one ought to accept Schnapper's view that "the swift pace of Revolutionary events . . . explains why many canvases were un-

finished." Stripped of the solemnity of research, many of the
paintings are simply ridiculous—and even more ridiculous as
elements of a show entitled "Age of Revolution." After all,
the sensibility of our time has been trained by a century of
modern art, which forcefully swept aside many modes of aes-
thetic appeal taken for granted in the art that preceded it.
Whatever scholars may choose to do in their books, it is pre-
sumptuous of them to initiate an exhibition that disregards
their contemporaries' more enlightened responses to works
of art. Jeanne-Élisabeth Chaudet's "Young Girl Mourning the
Death of Her Pigeon" was also fashionable in its day, though
probably not as popular as volcanoes, but it is as sentimental
and insipid as a Victorian chromo. To come upon it in "Age
of Revolution" is enough to dissipate any serious feeling as-
sociated with the historical theme. Unlike "Young Girl,"
Girodet's "Ossian Receiving Napoleonic Officers" does have
to do with the Revolution, but this allegorical canvas, over-
crowded with contending warriors, a bearded sage, a gigantic
eagle, a cock, a flying goddess, lute-plucking nymphs, and
fishlike nudes with classic profiles swarming up from the bot-
tom of the composition, is utterly incomprehensible, both
aesthetically and iconographically—it was not entirely under-
stood when it was first shown, in 1802. Exhuming works of
this sort can mean only that to the art historian pictures that
were once fashionable are forever guaranteed against
absurdity.

One aspect of the Revolution does come through visually
in the exhibition: the interpenetration of myth and history—a
theme of profound importance. In "The Eighteenth Brumaire
of Louis Bonaparte," Karl Marx observed that the leaders of
the Revolution played their parts in the costumes and with
the gestures of Roman heroes. "Age of Revolution" is rich in
instances of the present disguised as the past or the fabulous.
Ingres passes easily between enthroned Napoleon and en-
throned Jupiter, and Taunay's crowds serve equally for "En-
try of the Imperial Guard Into Paris" and "Sermon of Saint
John the Baptist." One sees that Now cannot shake itself

loose from Then, and this fusion is furthered by art. In pre-Revolutionary France, writes Frederick J. Cummings in his catalogue entry, painters preferred "dramatic subjects from antiquity and medieval history—worlds quite removed from current events." Later, however, "the same artists would paint in heroic guise with equally compelling implications such contemporary events as the oath of the Tennis Court or the death of Marat. In this way, the heroic aspects of contemporary life became so closely identified with the achievements of antiquity that the two were at times interchangeable." Since the past was visualized primarily through art, events were actually copying art when they duplicated the past. In the late eighteenth and early nineteenth centuries, the impact of style was at least equal to the impact of ideology in our time. Such dashing portraits as Gros's Second-Lieutenant Legrand, Géricault's carabinier, and Guérin's Henri de La Rochejaquelein are a call to arms, regardless of political party, which culminates in Delacroix's half-naked "Liberty" holding aloft the tricolor.

Given its tenuous connection with the Revolution, the Metropolitan show makes sense only through its catalogue, a seven-hundred-page treasury of reproductions (including those of the sixty omitted paintings) and text. Here the spectator may inform himself about the careers of artists he never heard of before, what each picture was intended to depict, what it derived from earlier paintings, who commissioned it and for how much, how it was received by critics of the time, its provenance from the date of execution to the present—and with this he is given essays describing the formal transformations that marked each of the four sub-periods into which 1774–1830 divides itself politically. "Age of Revolution" is an exhibition to read about, preferably before seeing it, particularly by a public that is no longer intimate with the classics and the Scriptures. Indeed, we learn that the show is based on two books: a work in German by Walter Friedlaender, from which its original title was derived, and one by Robert Rosenblum. To this extent, the exhibition itself

amounts to illustrations for a text that few spectators have read.

To put it another way, the exhibition is a pitchman's performance designed to lure crowds into the catalogue. Given the current fuss about the dependence of modern abstract art on words, it is pertinent to note the still greater dependence on words of Neoclassical and Romantic paintings. At our stage of civilization, silent pictures are no more to be found in art galleries than in movie houses. The majority of the paintings in "Age of Revolution" are like stills from a film of which one has yet to learn the plot—they can be grasped only by being fitted into the scenario. Resorting to the catalogue, the spectator is showered with bits of fact that would be as difficult to arrive at through unassisted scrutiny of the painting as would the aesthetics of a Mondrian. The difference between the footnotes to today's art and those to the art of two centuries ago arises, of course, from the "literary" character of the earlier creations—their reference to histories (Peyron's "Death of General Valhubert") and their symbolic pantomimes (the same artist's "Time and Minerva"). The new art needs theoretical explanations of what qualifies the work as art; the old art requires information. To approach David's "Apelles and Campaspe" (in the Louvre show) with any degree of comprehension—apart from the formalist ruse of responding to it as if it were an abstraction—one needs to know who these personae are and what the painting recalls in their story. Even on being informed that the male standing at the left dressed only in a helmet is Alexander the Great, that the nude with long curls and downcast eyes poised on the edge of an unmade bed is his mistress, and that the slumped figure in the center with a paintbrush in his hand is the artist Apelles, who is painting the girl's portrait and is going to be given her as a gift, one is left with plenty of questions—but without the identifications mystification is complete. And what is the spectator to do about paintings that depict even more esoteric situations—for instance, "Young and His Daughter," by the soon forgotten Pierre-Auguste Vafflard, in

which a mad-looking fellow with his eyes closed staggers through the moonlight carrying a shovel and a wrapped-up female as large as he is?

In regard to "literary" paintings, the problem arises of the changed relation between the public and the writings to which the paintings refer. Ought not exhibitors hesitate to present episodes from tales with which the public no longer has any acquaintance and emotional associations? If what counts in art is response, and not acquiring data, it is one thing to show Delacroix's Hamlet and the gravediggers, another to hang a painting of a scene from some forgotten drama. In the present revival of interest in the art of the past, the danger arises of crushing art under art education. It is not irrelevant that in the rapidly changing culture of the West artists since the mid-nineteenth century have sought immediacy of effect in their own paintings and qualities in the older art that transcend storytelling. By this measure, despite the hyper-extended roll call of "French Painting 1774–1830," the artists most worth looking at remain David, Ingres, Géricault, and Delacroix.

# 5

# The Hirshhorn

The art world today has an accumulated social energy distinct from the energy of art—a reservoir that maintains itself by means of public occasions and spectacular events; for example, new record-breaking prices. The prime art event of all time, according to the press, was the formal opening(s) on October 1st, 2nd, and 3rd of the Hirshhorn Museum and Sculpture Garden, on the Mall, in Washington. By official count, the collection Joseph H. Hirshhorn has given to the nation includes six thousand paintings and sculptures (Hirshhorn himself says sixty-five hundred); the Museum of Modern Art owns only three thousand. The inaugural exhibition, which consists of eight hundred and fifty "highlights" of the collection, will continue through September 15th of next year. On the first night, dedicated to official Washington, two thousand invited guests crowded the massive circular concrete building, like an illuminated babka, whose ponderous effect was dissolved for the evening by champagne and cookies, theatrical lighting, and the play of fountains and high winds. Next came the Night of the Art World, a gala even greater than the political opening; the attendance, no longer primarily Washingtonian but drawn by a myste-

Originally published in *The New Yorker*, 4 November 1974.

rious collective impulse of artists, dealers, and "friends of the arts" from all corners of the nation, was estimated to be four thousand. The festivities closed the following day with two receptions by "Smithsonian Associates."

The Grand Opening of the museum made possible by Uncle Joe (the press passed on to the Latvian-born millionaire its old nickname for Joseph Stalin) marked a new phase in the public status of modern art in the United States. Canvases by Dove, Diller, de Kooning, Ernst, Brandt—to pick names at random—became art "of all the people" (the phrase Presidential candidates like to apply to themselves), not only of the aesthetic élite of New York, Chicago, and Los Angeles. Works ranging from Mel Ramos's "Kar Kween," a painting of a provocative *Playboy* sort of nude nuzzling a giant sparkplug, to Ad Reinhardt's tiresome twenty-foot-long red canvas are now the property of the federal government, like the White House and the B-52s, and officially featured in the city where not so long ago Congressman Dondero was declaiming that modern art is part of the Communist Conspiracy, proved by the strategic role in it of Wassily Kandinsky, a Russian! It must have been this radical transformation of status that prompted Caryl P. Haskins, of the Smithsonian Board of Regents, to characterize the opening of the Hirshhorn Museum as "a quantum leap for the Capital."

Congressman Dondero, wherever he now is, might take comfort in the fact that there are no Kandinskys in the Hirshhorn exhibition, and no Lissitzkys, Larionovs, or Goncharovas, either, though Gabo and Pevsner are on hand. For that matter, however, there are other omissions: no Juan Gris, no Metzinger, no Lhote, no James Brooks, no Ibram Lassaw, and—one could go on—no paintings by Braque, though there are three small bronzes of his. The essential characteristic of Hirshhorn's mammoth gift is the prevalence of what museum people call "gaps": for all the eight hundred and fifty items in the inaugural show, it is as porous as a moth-eaten blanket in respect to both art-historical coverage and qualitative texture. It is not only that "names" are missing; it

is that at every step the spectator is in danger of falling from a height of modernist creation (the roomful of Giacomettis, say) into a crevasse of dullness or eccentricity. This unevenness derives directly from the size of the collection and the way it was put together. The lower down a collector goes on the scale of reputations, the more artists he assembles and the larger the number he leaves out. Hirshhorn bought without consulting experts; as he says, he made plenty of mistakes, and "you can't win 'em all." In compensation, the unevenness of the display allows the spectator to exercise his own judgment and prejudices, as Hirshhorn himself did in building his collection. In this museum, no visitor has any reason to feel overawed by authority. There is an impressive number of modern masterworks—from Rodin's "Balzac" and "The Burghers of Calais" to Lipchitz's "Figure" and "Reclining Nude with Guitar," and what amounts to an important exhibition of Matisse's sculpture. But there is no sign of a guiding principle or of a consistent personal taste. The greatness of the collection lies in its being the most, and a lot of the best, but it is not the best.

Washington should be pleased that its new art collection, for all its modernism, is in the American tradition of the gratuitous undertaking of the self-made millionaire. Joseph Hirshhorn brings to mind the nineteenth-century builders of mansions whose endless rooms were stuffed with canvases and statuary. (One Midwesterner I recall commissioned Italian stone carvers to produce an Eden of life-size portraits in concrete of himself and his wife, in poses representing successive phases of their lives.) The Hirshhorn Collection is stocked like the warehouse of an odd-lots buyer. But Hirshhorn differs from his voracious predecessors in that he operated in and through the art world; he confined his buying to artists with at least a minimum of professional standing. Not many visitors to the museum (or "the Hirshhorn," as S. Dillon Ripley, Secretary of the Smithsonian Institution, affectionately personifies it) will identify Yun Gee, Peter Golfinopoulos, Émile Gilioli, or Gregory Gillespie—to pick artists

whose surnames begin with the same letter—but Hirshhorn found each of them in a prominent New York gallery. His collecting shows a respect beyond personal whim for the objective life of art. Yet his forty-year persistence in looking, learning, and acquiring was rooted in his deepest feeling: having begun by collecting European Salon painters of the last century, such as Bouguereau and Landseer, who for so many of his generation represented Art, he soon discovered that works in modernist modes had an affinity with something essential in himself, or with the semblance of a self he could recognize. Thus, art collecting was for him a means of self-discovery as well as of self-expansion—a motive no longer common in a period when art collectors tend to evolve rapidly into specialists.

Hirshhorn bought art not as a connoisseur or art historian or under the advice of connoisseurs. Abram Lerner, for twenty years Hirshhorn's private curator and now director of the museum, testifies in the eight-hundred-page illustrated Inaugural Book/Catalogue issued in connection with the exhibition (Abrams) that Hirshhorn did all the choosing himself and that "expert advice seemed to turn him off." This speculator on Wall Street and in mining properties felt no impulse to win profits in art, although he was no Maecenas, either, and, as happens to most big art collectors, he has been denounced by some as a bargain hunter. Lacking a point of view, Hirshhorn was guided in his buying by the general rise and fall of art-world voices in the four decades of his collecting: he bought art as if he had been chosen by chance from the midst of everybody interested in art in America. The Hirshhorn is an expression of the changing mind of the art world—if the art world can be said to have a mind. To this collective thinking he contributed an untiring enthusiasm capable of transmitting itself to those who visit his museum.

Neither a refined pursuer of the best nor a patron of artists, Hirshhorn is not an art lover, either. Rarely aroused by prolonged gazing at particular works, he has been moved, rather, by the desire to swell his collection toward all-

inclusiveness—a kind of sea-to-shining-sea impulse. He bought art by the armful; tales about him stress the speed of his selecting ("I'll take these, that, that, and that"), his baroque price-cutting techniques, his quick departures. Lerner remarks, "The purchase of a Winslow Homer would be followed by the acquisition of a David Smith, sometimes on the very same day." His passion for art was generalized, and, like the passion of Don Juan, it was an excitement blended with the passion for rolling up a record list. For this diminutive art chaser, to hear a work praised was to covet it: Lerner speaks of his patron's "inspired greed." Besides the sixty-five hundred works given to the museum, Hirshhorn now owns, he told me, another sixty-five hundred, and he is still collecting: the large iron-plate Nakian, "The Rape of Lucrece," displayed near the entrance to the sculpture garden, was acquired a very short while ago, apparently too late to be listed in the catalogue.

In his obsessive piling up of paintings and sculptures, Hirshhorn has performed a feat of prime significance: through his consuming interest in artists and objects he has transcended the ideologies that have ruled art throughout this century. One is tempted to dub him a folk collector, by analogy with the folk artist. Though Lerner speaks of "our determination to retain the historicity of artistic production," Hirshhorn's collection shows no effort to establish the interlacing of ideas and styles cherished by art-history-trained curators. Had he been more respectful of the critical dogmas current during the many years of his acquisition, his collection could never have achieved its present range: the taste of the nineteen-fifties, for example, might have deprived it of Reginald Marsh, Raphael Soyer, Jack Levine; attention to the polemics of the nineteen-sixties would have resulted in fewer de Koonings and many more Frankenthalers and Olitskis.

Responsive to diverse currents of persuasion and free of stylistic inhibitions, the Hirshhorn Collection reflects the art of our era with the neutrality of time itself; Hirshhorn's wholesale choosing comes as close as possible to no choosing

at all. The museum is equally hospitable to a loaf of Italian bread painted blue by Man Ray, a seascape by Rockwell Kent, Warhol's silk-screened lips of Marilyn Monroe, Manzù's cardinal. Hirshhorn collected some artists "in depth;" one is left to wonder on what basis. The catalogue lists fourteen bronzes by Degas but no paintings; fifteen bronzes by Matisse, one terra-cotta, no paintings; twenty-four Daumier bronzes, no paintings or drawings; eighteen David Smiths; nineteen Henry Moores; eighteen Giacomettis; thirteen Rodins; twelve Manzùs; ten de Koonings; seven Cornell boxes and three of his collages—tidy little one-man shows of typical and offbeat works.

To me, however, the most enlightening, as well as the most stimulating, aspect of the collection is its store of transitional and tentative creations by artists who have been much shown and of whom stereotypes have by now been formed in the public consciousness. The large Rothko "No. 24," of 1949, is a lively precursor of the suspended rectangular color masses on which this artist played variations (some four hundred of them, according to testimony in the current Rothko trial) during the two succeeding decades. Albers' glass assemblages of the nineteen-twenties and his oil painting "Proto Form B" (1938) remind us that he was not always paying homage to the square. The tiny "Personage," by Gorky, a heavily painted abstraction in an inner painted frame, is a fully realized anticipation of his later style. Transitional creations such as these—Mondrian's "plus and minus" seascapes are others—are often more moving than the formats in which artists came to rest, especially if one has seen examples of those formats over and over again, owing to the strategy of art dealers, publishers, and the artists themselves of strengthening aesthetic identities through repetition. Hirshhorn's atypical choices, to which his long-term buying has contributed, broaden an understanding of the artists and of how creation in art takes place.

Despite the division of the inaugural exhibition into time periods, in the mistaken notion that to bracket works together

between pairs of dates is to place them in their "historical context," what comes through is a genuine sense of the art, great and small, of our lifetime—of art history as actual creative events instead of the winnowed formal specimens that preoccupy art dealers, museum staffs, and art classrooms. True art history is also served at the museum by the inclusion of marginal artists who figured importantly in the creative life of their time but have been ignored by historians who see only the publicized summits. Four paintings by Arthur B. Carles, particularly the beautifully toned white "Nude" done in 1922, and his Abstract Expressionist "Abstraction (Last Painting)," 1936–41, confirm his right to a place in the permanent gallery of modern American artists. Similarly, Earl Kerkam's self-portraits ought to be kept on display, as well as paintings by Eilshemius, who is perennially rediscovered but remains essentially invisible. Among the "finds" at the Hirshhorn are works belonging to the "earlier-than-you-think" category. For instance, Torres-García's "Composition," of 1932, a canvas divided into rectangles, each of which contains a crude sign or emblem, looks forward to Gottlieb's pictographic paintings of fifteen years later, and one of Torres-García's two 1931 wood constructions named "Untitled" might be mistaken for a Nevelson of the nineteen-fifties. The collection has room, too, for odd triumphs (the portrait in plaster of Hirshhorn by Pablo Serrano), for works in styles now abandoned by the artist (James Rosati's marble figure), for creations in exceptional moods (Edwin Dickinson's erotically opulent "Nude"), and for artists regarded abroad as vital in the art of our era but rarely seen in the United States (Medardo Rosso, admired by the Futurists).

Despite its great collections of modern art, the United States has no museum of twentieth-century American painting and sculpture comparable, say, to the museum of modern Italian art in Rome. Gaps granted, the Hirshhorn Collection comes close to supplying this lack; it does so all the more successfully because of the unexpectedness and unorthodoxy of many of its inclusions. To me, at any rate, its "substan-

dard" and "nonrepresentative" items are among its most precious assets. Museums of modern art in this country have been far too devoted to instructing the public and not enough to showing pictures that spectators might like to see; perhaps this pedagogical impulse arose from the need of the museums to justify themselves as cultural education to a public reluctant to accept their contents as art. The low point was reached in the late nineteen-sixties, with exhibition after exhibition totally devoid of visual appeal and dependent for its interest on the context of formalistic discussion. Hirshhorn's massive collection of works chosen for their attractiveness is a dramatic counterstatement to this trend.

The future character of the Hirshhorn Museum depends on its ability to retain the advantages of the donor's nonprofessionalism. The overpowering impact of the Grand Opening produced a momentary suspension of complaints about the contents of the museum, but even among its strongest supporters there was evidence of the embarrassment that can arise from art-historical habits: Lerner hastened to confess, in his introduction to the catalogue, that "the Hirshhorn Museum, like most other museums, has lacunae," and he anticipated that these "will be reduced in time." As could be expected, spectators soon voiced indignation at the presence of this or that artist and the absence of someone else. In the art world today, everyone is, or feels himself to be, the representative of beleaguered critical values, and under obligation to affirm his views. The time span of Hirshhorn's collection, begun in the nineteen-thirties, encompasses the prejudices, all the more cherished for being acquired with difficulty, of half a dozen aesthetically indoctrinated generations. If modern art is ideological, it is less intolerantly so than modern opinions about art. Were all still surviving views brought to bear on the Hirshhorn Collection, it would be sliced down to zero, leaving only debris to be cleared away by the Conceptualists.

The filling of "lacunae" by Hirshhorn and other donors that Lerner has promised is a happy prospect. But additions,

with their requirements of space, almost inevitably necessi-
tate purgings. If refining the Hirshhorn Collection is to entail
the "de-accessioning" of the benefactor's "mistakes," I
should prefer to see the inventory remain as it stands when-
ever Hirshhorn himself ceases to add to it. Since everything
must in any case reach a limit, the limit of the Hirshhorn Mu-
seum may as well be the life, taste, and times of Joseph
Hirshhorn.

# 6
# Then and Now

I t has been apparent for the last dozen years that American art has been slipping into a deepening lethargy of mind and imagination—a paralysis of the creative faculties that parallels the political and economic crises of the West.

To artists the symptoms of decline have been unmistakeable; they are manifested primarily in a general absence of enthusiasm and a cynical respect for financial success. Art since the beginning of the sixties has been dominated by the self-defensive effort (which could be considered heroic were it not so stupid) to isolate painting and sculpture from the moods and concerns of society, including artists as members of society.

Now that formalist art and art-for-art's-sake criticism have run their course and terminated in exhaustion, a movement has grown up, as is usual in evolutions toward disaster, to attack not the causes of the trouble but those who have been calling attention to the fact that things were not going well. A version of the "new conservatism" in politics is being promulgated, according to which the main obstacle to social stability and progress is not the prevalence of monopolies and

First published in *Partisan Review* 42(1975):563–66.

multinational corporate looting, but the persistence of radical social criticism among intellectuals.

Throughout the sixties the attempt was made to cover up the steady debilitation of American painting and sculpture by flag waving about the School of New York as the heir of the School of Paris art movements. Today, these art movements are seen as no longer worth inheriting. In the view of aesthetic conservatives, modernism itself is finished; we have entered a postmodern era. Art, they say, is capable of mounting to limitless heights, providing it rids itself of the immature illusion, fostered by futurism, expressionism, dada, and surrealism, that art can change the world (as if the world hasn't been changed).

In the May issue of *Commentary*, Hilton Kramer, *The New York Times'* tireless meter maid of the arts, affiliated himself with the burlesque-house song-and-dance monologist Tom Wolfe in order to blast "the 'advanced' middle class" that has supported avant-garde art. "About manners and the volatile ethos of our cultural life," gurgles Kramer, "he [Wolfe] knows a great deal—as much, in my opinion, as anyone now writing"; and to this outstanding philosopher of culture, Kramer offers his partnership in exposing "the class that gave to the votaries of the avant-garde their conspicuous and protracted purchase on our cultural affairs."

This is the "new conservative" line applied to art. Kramer wants nothing less than the "reopening of some fundamental questions about the relation of art to the society that produces and exalts it." In the proposed reassessment, "an art that flatters or at least accommodates itself to established power is not automatically dismissed as contemptible." The double negative of "not automatically dismissed" is typical of Kramer's rhetorical sneakiness—his point is that art ought to accommodate itself to power.

The suggestion that the fading antagonism of artists to middle-class values spells the end of art as a serious pursuit is sufficient to cause the cesspools of Kramer's sarcasm to bubble over. "What class is it, I wonder," he shrieks, "that Rosen-

berg imagines he writes for in the pages of *The New Yorker?* The proletariat?" Apparently Kramer believes that all individuals belonging to the middle class must necessarily have the same ideas—and the ass-kissing ideas of Kramer at that. What will the middle class itself do if every element in it, including artists and critics, follows Kramer's advice and "accommodates itself to established power?"

The basic difference between art today and twenty years ago lies in the increasing amalgamation of painting and sculpture into the United States cultural-educational-entertainment system. Not that the earlier art had revolutionary social ideals; but it did have the advantage of leading a separate existence, if only from neglect.

The coming together of art and society affected art in the following areas:

1. *Changes within the artist.* American postwar art reflected the grandeur of underground ambitions. Action painting and abstract expressionism were adventures in self-transcendence. With the rise of the new art audience in the fifties, art transferred its interest from the myth of self to practice as a profession designed to satisfy the recently emerged corps of collectors, historian-critics, and curators. Instead of seeking a language bearing on his existence, the new-style artist engaged in perfecting the formula for a trademarked product.

2. *Dissolution of the community of artists.* In the forties artists constituted a more or less isolated community. Their social gatherings both in New York and in the summer art colonies manifested a principle of self-segregation. The presence of a bloc of artists provided a conversational underpinning to the solitary work of individuals, and helped to muffle the inevitable outbursts of ignorance, triviality, and careerism.

With the rise of art into social prominence, the habitats of artists became infested with dealers, agents, reviewers, collectors, public-relations people, feature writers, media celebrities. This sudden efflorescence pried apart the cell structure of the artists' community, like roots tearing up a sidewalk. The late Barnett Newman complained that the new stars of

the art world refused to talk. This attitude was encouraged by formalist criticism, which discounted the artists' ideas and feelings as irrelevant to the success of the work. Thus the artists' community and ideas in the art world went down together.

3. *University education of artists.* In the past, artists were trained by other artists in art schools and studios. The student artist lived, worked, and learned in an environment of creation. All this was changed with the transformation of art into an aspect of cultural education. At the university, the student artist is surrounded by persons engaged not in conceiving works but in accumulating knowledge. To meet the requirements of the grading system, demands were pressed for the rationalization of art teaching. If problems and solutions could be defined in nuclear physics, why not in painting and sculpture? In the classroom, painting came to be broken down into essential elements—line, plane, form, color—and solutions were proposed for handling these problems. The history of modern art was converted from an epic of heroic pioneers and intellectual adventures—what Kramer sneers at as "the legendary cénacles of avant-garde incendiaries"— into a step-by-step climb up the formal heights of the "School of New York." There emerged the artist without background who knows the history of art through tracing formal resemblances in slides and reproductions, and who conceives picture making in terms of technical recipes, but who is entirely ignorant of the role of art in the struggles of the modern spirit.

4. *Transformation of art into a mass medium.* The availability of money and celebrity has transformed the production and distribution of art into a big-time enterprise. With hundreds of millions in public and private money spent on art annually, there is an essential need for continuity of supply either through current production or through certification of works produced in the past. Thus art today has been expanded to include the crafts of all times and places, from copper coffeepots to jungle gods. The deluge of aesthetic commodities

has diluted the intelligence of modernism to near-extinction. The subduing of art by the cultural environment threatens to reduce painting and sculpture to aspects of the communications and decorations industries.

Today, the survival of art depends on the capacities of individuals to recover their initiative against the automatic processes of mass society. In exploding the dream of stabilized cultural progress, the present financial and policy crisis among art institutions provides an opportunity to shake off the ideological and bureaucratic structure built upon the arts in the past fifteen years.

# 7

# Inquest into Modernism

The absence of an avant-garde—or the low level of interest in what presents itself as an avant-garde—has begun to seem a normal condition of contemporary art. After several years of disappointed expectation, the conviction has been growing that no significant "advances" in painting and sculpture are around the corner. The most distinguished American work exhibited in 1977 was by old-timers—de Kooning, Lester Johnson, David Hare, Philip Guston, Helen Frankenthaler, Louise Nevelson, Joan Mitchell, Lee Krasner, Joellen Hall, Lee Hall, to name a few—and in modes not long ago considered obsolete. In the museums, art was taken over by the dead—by the craftsmen of King Tutankhamen, by Cézanne, Ensor, Matisse—and shows announced for this year indicate that curators now find the graveyard an inexhaustible source. As a *Times* critic pointed out some years ago, considering what the ancient Chinese, for example, have to offer, new works are by no means indispensable. Indeed, despite the present "lull" in creativity, the art world has never been in better shape. The art public keeps growing; museums are packed; in disregard of economic gloom, new galleries open, it seems, daily; government and industry sup-

Originally published in *The New Yorker*, 20 February 1978.

port for "the arts" increases each year; the art market continues to outpace the Dow. That all this takes place without the stimulus of new creative movements gives some—mainly artists—the uneasy feeling that the expanding social edifice of art is being built around a void. Yet looking for a vanguard may itself be a mere habit left over from the past.

With vanguardism declining as a force in the American art world, a transformation of values has occurred: novelty in art appears unessential. Even the idea of a vanguard is repudiated. In a recent article, a prominent reviewer charged avant-gardists with ingratitude for failing to respect the middle class, who have historically been their patrons. Periods of decline in collective creative energies are by no means unusual, either in art or in politics. What is peculiar to our time is that each lapse into torpor threatens to become permanent. The forecast of an ice age, or "wasteland," is built into present-day culture. Except for intervals of great inner vigor, the weight of institutional inertia seems capable of subjecting all human activities to mechanical laws. To conquer the world, the Grand Inquisitor needs only to bide his time. And modern culture, like some cultures of the past, has enemies within—people who denounce its reflection of the world and strive to cause it to disappear. A lapse of the modernist will such as the present one provides the foes of modernism with an occasion to claim that the entire modernist effort has been a blunder—if not vandalism or a hoax. After more than half a century, it is still argued against modernist art that Picasso would have liked human beings to have both eyes on the same side of their face.

Anti-modern attitudes are a traditional element in modernist thinking and enter into the most advanced art of the epoch; e.g., the primitivism of Klee and Mondrian, the cultural nostalgia of Pound and Rilke. For several years, the term "post-modern" has been striving to gain a foothold. One finds it used increasingly as a label for the contemporary. To some, it seems to signify a condition beyond the modern—a compound of phenomena that had not been contemplated

even in the most radical hypotheses and moods of the modernists: mysteries akin to the Eurodollar and the cruise missile, in the light (or darkness) of which Duchamp, Joyce, Breton, Gertrude Stein, Kafka appear as respectable relics of a quieter age. But "post-modern" also has a contrary meaning: it denotes a period in which the radical aberrations of modern thought and modern art have at last been shaken off. In the wake of student riots and terrorist bombings and kidnappings, the extremisms of the twentieth-century avant-gardes have exposed their nihilistic substance and have been repudiated as legitimate avenues of progress. If some outstanding modernist artists can be admired as masters, it is because, the post-modern critic argues, they are illuminated craftsmen, like artists of other times, and owe nothing to vanguardist dogmas. Whether because the contemporary situation is no longer thought to be manageable by ideas (as the vanguards assumed it was) or because society has become too disillusioned, or too level-headed, to be taken in by utopian fantasies, post-modernism has no use for vanguards. In fact, the essential connotation of "post-modern" may be "a period without vanguards." Though the cultural situation remains unclear, the intuition of the obsolescence of vanguards may represent a historical reality.

In an article entitled "One Hundred Metronomes," in the Autumn, 1977, issue of *The American Scholar*, Edward T. Cone, of Princeton, mounts an investigation not of any vanguard, current or past, but of modern art in general, from such grand marshals as Matisse—"There are still many for whom Matisse's paintings remain daubs"—to local guerrilla activists such as Vito Acconci and Carl Andre. (Symbolism may be discovered in the fact that Mr. Cone is a member of the Baltimore family historically associated with Gertrude Stein and Matisse.) Though Cone is a teacher and composer of music, most of his examples of the weaknesses and fallacies of modernism are drawn from the visual arts. Perhaps music, for all its atomization into noise, is still a limited medium, and so a less disturbed sector of the art front than the

making of images and objects. Some of Cone's performers are well known, some less so—including anonymous authors of characteristically absurd projects, such as the exhibition at the 1972 Venice Biennale of ten thousand hatching butterfly eggs (of which very few actually hatched). Cone's list of modernist culprits is taken entirely from what were once avant-gardes. But though these personages have the aura of avant-gardists, they do not constitute an avant-garde today, since they are extremely different in aim and calibre—for example, Christo, Carl Andre, César, and Chris Burden could no more be thought to belong to the same art movement than could Pollock, Shahn, and Calder. What they have in common for Cone is that they produce objects, conceptions, or, in the case of Burden, physical phenomena (self-mutilations) that belong to no recognized aesthetic medium, and whose status as art is consequently dubious. That art so lacks definition as to be capable of encompassing *anything* is one of Cone's major charges against the art produced in our time. "Works that adhere to no conventions of medium, organization, or expression and yet claim the honorific designation of art" have made the application of standards impossible, and left the question of what is art to be decided by each artist. This de-definition of art opens the door to charlatanism and allows the status of artists to be determined through public relations. Thus, in the name of art the public is subjected to varieties of counterfeits and to boredom, torture, and humiliation. Cone cites a work that requires crawling through tunnels; one thinks of others that call for squeezing between walls and walking barefoot in the dark. Worst of all, this has been going on so long it has ceased to be amusing.

Related to this lack of definition is the tendency in modern art to blur the distinction between art and reality. Here Cone touches on the Action tradition in modern art, ranging from the painter whose inspiration arises from his being "in" his canvas to "happenings"—with the inevitable reference to Rudolf Schwarzkogler, who in dealing with his body as an aesthetic object "sliced himself to a hero's death at twenty-

nine." In pointing to the confusion generated by the artist
who *acts*, Cone resorts to the neo-scholastic distinction be-
tween doing and making which was stressed forty years ago
by Maritain. By viewing works of art as events and events as
art, modernism aestheticizes reality, and deprives it of its
moral dimension—the consciousness of right and wrong. It is
as if photographs were continually mistaken for their sub-
jects, and their subjects (a prison camp, say, or a landslide)
were treated as a "set"—a habit that, according to Susan Son-
tag, in "On Photography," has overtaken man today. Cone,
too, sees the confusion of art and reality as extending beyond
the studio and the art gallery to produce ominous results in
real life. "Most of our leaders," he writes, "tend to see public
events as Works of Art . . . not as matters of life and death
but as scenarios." The breaking down of the barriers between
art and life is undoubtedly one of the dominant impulses of
the modernist revolution; it is at the root of the Impression-
ists' discarding of academic canons of composition, just as it
is more explicitly responsible for the street demonstrations of
the Futurists, the Dadaists, and the Surrealists. The degree to
which new art succeeds in incorporating hitherto untouched
segments of reality has often been the measure of its avant-
gardism.

Cone's remedy for the subversion of experience by mod-
ernist art is simple, almost comically simple: do away with
the words "art," "artist," "work of art." Once the ambiguous
designation "art" has been lifted, the public will be able to
see what individuals are actually doing, and call a spade a
spade. Painters can then be as abstract or as representational
as they choose, but they will be engaged in what all picture-
makers *are* concerned with—making pictures, and not, for
example, biting oneself before a camera. With the distinction
between making and doing restored, it will be possible to
know what to judge aesthetically and what to consider in
moral terms. It is to be supposed that the loss of his immunity
as an artist would make an Acconci or a Chris Burden liable to
misdemeanor charges.

Sol LeWitt, who is now being given a retrospective at the Museum of Modern Art, is one of the personages whose acknowledgment as an artist Mr. Cone questions. Discussing "The Location of Points: 2 Wall Drawings," which was inscribed on a wall at Princeton by a team of assistants following instructions provided by LeWitt, Cone asks, "What, then, is LeWitt's medium?" Elsewhere in his paper, he suggests that the answer might be geometry. LeWitt's retrospective is not as devoid of objects as the "Location" piece. It includes painted metal grids, pen-and-ink drawings, chalk drawings on a black wall, book designs, and other tangible entities; those who are not inhibited from comparing museum objects with other kinds may find resemblances to meticulous chicken coops, hanging sets of cubbyholes, cube-shaped cartons on a stopped conveyor belt. Will these material manifestations of LeWitt's talent induce Cone to acknowledge that LeWitt is an artist? One is inclined to doubt it. LeWitt's basic units are the square and the cube; even where the surface is crisscrossed by lines that seem random, as in a white-on-black drawing, the lines are controlled by a grid of squares in the background. The logic of Cone's position requires him to insist that works in which, according to the MOMA press release, "the linear elements of a cube are explored in 122 eight-inch pieces, beginning with the basic three bars and concluding with 11 bars (12 being needed to complete the cube)" belong in a mathematics-seminar room, not in an art gallery. The fact that on occasion LeWitt materializes his Q.E.D.s hardly distinguishes him from other lecturers in geometry. New Yorkers may recall talks by Buckminster Fuller in which he manipulated an assembled tetrahedron to illustrate the formal composition of matter and the structural units of his geodesic dome. Nor is Cone likely to be reconciled to LeWitt as artist by the statement in the press release that the exhibition includes "71 variations of three stacked cubes in open and/or closed forms." He might respond with indignation to the claim that some LeWitts will instruct him in the "concept of enclosure, or the placing of

one form within another"—a principle accessible to anyone
who has watched a cat at mealtime.

The LeWitt retrospective, together with the literature pro-
moting it, and "One Hundred Metronomes" provide a direct
confrontation between the existing art world and a radically
skeptical outsider determined to accept nothing that fails to
make sense. Cone's pragmatic assault on modernism is not
novel, and is weakened by a lack of close familiarity with the
works he cites and with the processes of the current art
world. For instance, in outlawing the word "art" as the pri-
mary source of confusion Cone proposes to exempt "the
great museums of New York and Boston," and "countless
university departments" as well. Yet these are the most
powerful agents in bringing about the confusion he deplores.
He seems unaware that LeWitt is accredited as an artist not
by mistaken evaluations of his concepts or his sculptures and
drawings but by art history, of which the museum is the em-
bodiment and executive power. In the museum, the geo-
metrical puzzles that LeWitt poses link him with the
Constructivism of half a century ago; by a singular sorcery,
this does not prevent him from being, by the testimony of the
MOMA release, "a pioneer figure in the Minimalist movement
of the 1960s . . . whose work has had a profound influence
on the current generation of Conceptual and post-Conceptual
artists." Indeed, all the artists whom Cone would like to re-
classify out of art are beneficiaries of the magical power of the
museum to continue to discover originality emblazoned with
the authority of the past.

"One Hundred Metronomes," Cone tells us, is based upon
clippings and other materials reporting weird doings in the
name of art, which he has been collecting for some years.
Such a dossier is more useful in building a case for prosecu-
tion than in conducting a serious investigation of a complex
subject. In a manner typical of polemicists of anti-modernism
(and of modernism, too), Cone does not discriminate be-
tween one piece of non-art or meta-art and another—be-
tween, for instance, Christo's grandly conceived, heroic

curtain installation at Rifle Gap and a physically dangerous but uninteresting antic of Chris Burden. Yet, for all his critical limitations, Cone's uneasiness about the de-definition of art and the mixing of art and reality has a serious bearing on the developing situation of art. As art moves farther from its origins in the handicrafts, the possibility of objective standards of value is reduced to the vanishing point. Crafts, with their measurable skills, cannot be reconciled with the interests and practices of art in our time. The skills of the modern artist are the opposite of those of the craftsman: instead of acquiring techniques for producing classes of objects, the artist today perfects the means suited to his particular work. His technique—and, indeed, his self as an artist—tends to be his own creation. Moreover, in industrial society the decorative crafts have been converted into mass media. Only the pressure of new creations *against* art as it has been defined keeps art from merging with the media and allows works to survive for an interval as art. To maintain this pressure of de-definition has been the task of the avant-gardes. That avant-gardes have been accompanied by charlatanism and power tactics makes them no less indispensable. The post-modern world might supply Cone with fewer clippings but also with less art.

# Artists

# 8

# Evidences of Surreality

How much the work of an artist owes to an art movement to which he belongs can never be determined exactly, if only because the movement derives its character from the individual creations of its members. The three hundred thoughtfully selected items of the current Max Ernst retrospective at the Guggenheim exemplify this artist's exceptional ability to flow into the conceptual mold of our century's advanced art movements and endow them with images that seem predestined for them. It is as if modernist styles, from Expressionism to Surrealism, had ceased to be mere names attached to categories of works and were capable of producing pictures that are both consistent with their principles and visually distinct from the art of other movements. Ernst's paintings, collages, frottages, prints, sculptures are readily divisible into art-historical phases; he himself, for example, associates a group of his collages with "the shadow of a great Dada," and adds the reminder "Don't forget, this was 1919." It is rare for artists to locate their work on the calendar with such precision.

Among Ernst's earlier modes represented on the Guggenheim ramp are Art Nouveau designs, Expressionist por-

Originally published in *The New Yorker,* 14 April 1975.

traits and landscapes, Cubist/Futurist adaptations. The most interesting of the Expressionist paintings are two entitled "Landscape with Sun"—one, made up of horizontal masses devoid of detail, is like a heavily painted Rothko; the other, consisting of writhing forms hiding a green sun, brings Pollock and Gottlieb to mind. "Untitled" (1911–12) and two "Battle of Fish" watercolors (1917) are animated abstractions in a manner that Masson was to develop more than a decade later. These works, realized by the time Ernst was twenty-five, leave no doubt about his mastery of painting in modernist idioms.

It is, however, Dadaism and Surrealism, with their anti-art and beyond-art motives, that have inspired Ernst's inventions for more than fifty years and have taken him into regions where traditional formal values are essentially irrelevant. He was a lightning convert to Dada, and his paintings, collages, and drawings dating from 1919 to 1923 span and amplify the compositions of that war-born movement, from the diagrams of feeling-mechanisms of Picabia and Duchamp (e.g., "The Little Tear Gland That Says Tic Tac") to the assemblages of found materials of Arp and Schwitters. The passage of Dada into Surrealism contributes a distinct group of works to the retrospective, but it was as a Surrealist that Ernst realized himself completely. One of the earliest painters of the movement, the most gifted (except for Miró), and the inventor of the widest variety of devices for conveying the Surrealist vision of an estranged world, Ernst comes close to being the personification of Surrealism in painting. His "The Elephant Celebes," with its central figure of a huge machine-animal and its beckoning headless nude, and "Woman, Old Man, and Flower," with an ancient asleep on his feet holding a tiny nude in his arms, and a female with iron buttocks, a see-through torso and arms, and a head in the shape of a fan, are, after half a century of being exhibited and reproduced, imprinted in the modern imagination like memories of actual events—say, the sinking of the Titanic or the Lindbergh kidnapping—so that it hardly matters except to specialists whether they are good paintings or bad.

Everyone knows that Surrealism has to do with dreams and the irrational. In America, the first large-scale survey of Dada and Surrealist pictures and objects—the "Fantastic Art, Dada and Surrealism" show at the Museum of Modern Art in 1936—bracketed them with pictorial conceits, from whimsey to hallucination. Surrealism did, of course, encourage the imagination to release itself in arbitrary expressions, unrestrained by reason or convention, but there are deeper motives in this than startling gallerygoers with soft watches or a horizon of red lips. The identification of Surrealism with fantastic art takes place at the expense of the political aspect of Surrealism; that is, its search for the actual within the "surreal" composition of contemporary life. One can understand why Breton objected to Ernst's participation in the Museum of Modern Art exhibition. Consciousness of the disrupted condition of man in Europe after the Second World War and the anticipation of catastrophes still to come supplied the morality of Surrealism and led to ideological strife and splits within the group which the art world has consistently played down as clashes of temperament. Surrealism wished to shift the historical crisis into the center of the creative imagination as the sole means for apprehending the true nature and direction of present-day life. In its view, art is divination; its practice, as announced in Rimbaud's celebrated "Letter of a Clairvoyant" (which Ernst quotes in his manifesto "Beyond Painting"), is an extension of the ancient profession of the "seer." The artist-diviner comprehends reality not by analyzing facts or trends but through evoking images, verbal or visual. In his book "Surrealism and Painting," Breton speaks of "the mainstream of the great spiritual quest which the last fifty to seventy years have seen develop," and he testifies that the aim of this tradition has been "to express the latent content of our era, the only way in which man can 'tell his fortune.'" Long before the emergence of scientific futurology, Surrealism presented itself as the heir of age-old readers of the stars. With the extinction of the visions of the great religions in the technological age, poetry and painting would conjure up equivalents for them. In a writing on Ernst, Breton

reiterates the Surrealist call for "a new myth"; only in fable can the situation of man be made manifest. In forming its images, Surrealism appropriated Freud's mechanisms of the unconscious, but in its deeper aspects it looks beyond psychology to the metaphysical desolation of the modern psyche: in Ernst's early group portrait of the Surrealists, "A Rendezvous of Friends" (1922; not in the Guggenheim show), Ernst himself is seated on the lap of Dostoevski. A 1930 collage in the series "Dream of a Young Girl Who Wished to Become a Carmelite Nun" presents major ingredients of Ernst's post-Christian disorder and foreboding: in a room invaded by smoke and flying firebrands, a wildly gesticulating mob with a giant crucifix behind it is restrained by a barrier, a child holds up an offering, a fellow in tights (the artist?) performs a somersault, a piratical type strikes a dagger into the ground, and a young woman in sober garb is about to open a huge volume entitled "The 20th Century."

Ernst's techniques for producing drawings and paintings through rubbing, scraping, overlaying, dripping bear a resemblance to the weathering, singeing, growth, and decomposition employed by recent "process" artists. In both instances, chance and the unforeseen play a decisive part. The art image or object is brought into being by procedures unrelated to any specific intention of the artist; he trusts to inherent characteristics of his materials to give rise to more or less unpredictable visual effects. Yet there is an essential difference between Ernst's substance-begotten imagery and the flowering treelets, rusting pipes, and wind-shredded curtains of the nineteen-seventies. With him, the paper or canvas is activated not in order to stimulate naturalistic transformations (as in the prints of Dubuffet) but, rather, to draw to the surface messages believed to be lodged in physical matter, like Moses drawing water from the rock. The visual enigmas at the Guggenheim were conceived as oracular signs; their mystery lies in the way these products of accident and objective process came together to establish a coherent, emotion-laden reflection of their historical period.

In developing his image-creating devices, Ernst was pursu-
ing the tradition of psychic experimentation indicated by the
title of his treatise "How to Force Inspiration"—the tradition
that reaches back to Poe's exercises in suspended sleep and
Rimbaud's "reasoned derangement of the senses," and that
has reappeared, following the Surrealists, in the practice of
Pollock and de Kooning of "getting into the canvas." The
"magic dictation" (the phrase is Patrick Waldberg's) of which
Ernst made himself the vehicle caused the major themes of
the retrospective to spring into view: the bird personages
(from caged doves to menacing vultures, and the serpentine-
limbed impresario Ernst-Loplop, Superior of Birds), the
vengeful cloud-shaped titans, the dark, end-of-time jungles.
Such compositions as "The Horde" (1927), "Barbarians
Marching to the West" (1935), the two versions of "Europe
After the Rain" (1933 and 1940–42; only the second is in the
retrospective) are dreams externalized into spectres haunting
Europe in the years before the Second World War. In an ex-
traordinarily direct sense they represent a collaboration be-
tween the artist and the alienated and bedevilled zeitgeist.

Instead of attempting to induce in himself exceptional psy-
chological states, such as those of Poe and Rimbaud or the
"paranoia" of Dali, Ernst "forces inspiration" through sys-
tematically applied impersonal techniques. His inspiration
consists in totally detaching creation from self, so that insofar
as his imagery has an individual consistency it must be pre-
sumed to be that of an alter ego—in harmony with Rim-
baud's "I is another," which Ernst quotes in "Beyond
Painting." Having elaborated into a major resource of his art
the children's pastime of frottage—rubbings of pencil or
crayon on paper covering a coin, board, or fabric—he finds
the virtue of this method in its "reducing to a minimum the
active part of what until now has been called the 'author,' "
so that the artist can "attend simply as a spectator the birth of
his works." A similar objectification of the Freudian dream
work is achieved by Ernst in his photocollage, paint-scraping,
and dripped-paint compositions. In contradiction of the pop-

ular notion that Surrealists paint their dreams, Ernst prompts his materials to paint theirs. "Carnal Delight Complicated by Visual Representations" suggests the appropriation of the artist's feeling by self-generated picture-making: two nudes are undergoing metamorphosis through the multiplication of shapes that seem released upon them at random by the canvas.

Attacking Surrealism in "Situations," Sartre charged that it brought about the "destruction of subjectivity." "Subjectivity," he explained, "exists when we recognize that our thoughts, our emotions, and our will come from us, when we perceive that they belong to us." Sartre is correct in seeing in Surrealism an opposition to the ego as the source of understanding and decision; a similar charge could be levelled against psychoanalysis. But Sartre seems to have missed the point that the aim of Surrealist automatism, and its experiments with chance and coicidence, is to instigate the operation of an intelligence beyond self—what Rimbaud termed "objective poetry" and Breton "objective hazard." In "Beyond Painting," Ernst quotes Breton to the effect that finding seemingly accidental images "necessitates the unreserved acceptance of a more or less durable passivity," and he calls attention to Breton's prophetic conjecture, "Who knows if we are not somehow preparing ourselves to escape from the principle of identity?" Ernst's "preparation" for loss of self seems to have been largely accomplished by nature. In contrast to such self-propelled personages as Mondrian and de Kooning, Ernst is essentially mediumistic: the outstanding feature of photographs of him and self-portraits is the abstracted forward stare of the clairvoyant. About himself he wrote in "An Informal Life of M. E." that, lacking marks of identification, he "could, if pursued by the police, plunge into the crowd and easily disappear forever."

It may be assumed that Ernst's sense of anonymity was deepened by the drastic alterations in social identity that he underwent throughout his adult life. Born a German and conscripted at twenty-three into the Army of Kaiser Wilhelm, he

became a Parisian of the Left Bank through illegal entry into France after the First World War, was interned as an enemy alien in 1939, fled to the United States to escape the Nazi Occupation, was naturalized, returned to Paris after the war, and is now, at eighty-four, legally a Frenchman. With his uncertain identity, Ernst has found assurance and direction not in himself but in his identification with styles and movements; in confirmation of his crossbreeding with Dada he nicknamed himself Dadamax, and for his Surrealist other self he conceived the mythical identity Loplop. He has been a citizen of art movements, not of nations; Surrealism became his homeland, and when, in 1938, he officially withdrew from it, his gesture amounted to little more than one's refusal to vote.

In the absence of a supernatural order, men are impelled to seek the aid of supernatural powers. If religion is the opium of the people, the fading of religion turns people toward opium. The Surrealist program of continual inspiration—an effort to realize Baudelaire's "infallibility in poetic production"—is, of course, impossible to carry out, even when inspiration is sought through systematically applied procedures. No technique has yet been developed by which revelations can be guaranteed; and in the failure of enlightenment to occur the "seer," being a man of (Ernst reminds us, using a term of Rimbaud) "ordinary constitution," is left with a visual or verbal *product*, which takes its place in the history of its medium as one more poem or painting. The visionary turns into a craftsman, since what else can he turn into? Ernst's methods tend to result in repetitiousness and to become vehicles of obvious ideas, such as the organic-mechanical conflict that is the theme of his "Garden Airplane-Trap" series. Not all of his between-the-wars creations are unveilings of monsters, vulture gods, after-the-deluge swamps, and horrid hints of massacres to come. Nonetheless, his works, taken together, do constitute a visual embodiment of the inner life of the catastrophe-ridden years, including its peculiar light-headed parody and clowning ("After Us, Motherhood" and "Man, a Girl's Best Friend"; not in the

show), its black humor ("Le Déjeuner sur l'Herbe," a family picnic of rutting, snakelike human hybrids), and its cultist militancy ("The Blessed Virgin Chastises the Infant Jesus Before Three Witnesses: A.B., P.E., and the Artist," which Ernst described as "a manifesto-painting executed after an idea of A. Breton's"). And in every phase of Ernst's career there are works whose only purpose is to demonstrate some technical experiment; for example, "Young Man Intrigued by the Flight of a Non-Euclidean Fly" (a painting that originated in flecks from a perforated can of paint swung by the artist at the end of a cord), and a striking small abstraction, in the extensive "Surrealism in Art" show at Knoedler's in February and March, of a figure that consists of triangular head and feet and a torso of sandpaper.

Ernst's creation reached the peak of its significance in the late twenties and the thirties. This is not to say that his work declined in quality and originality after he left Europe, in 1941. In "Sign for a School of Herring" (1958), "where Cormorants Are Born" (1961), "The Sky Marries the Earth" (1964), and "Air Washed in Water" (1969), he continues to display his technical and formal versatility and his ability to surprise. His sculpture, which is based on both primitive imagery and abstract forms, and which he has always regarded as "more of a game than painting" (because it lacks the prophetic element?), is undoubtedly at its best in "The King Playing with the Queen," "Young Man with Beating Heart," "Moonmad," "Capricorn," and "Are You Niniche?"—all done since 1944. But while the postwar Ernst has produced works of subtlety and stature, in the twenties and thirties he was not only an artist but a witness, on a par with Malraux, Silone, Brecht. After the war, this role of reflecting the "latent content" of the time was assumed by the New York Abstract Expressionists.

In the galleries, this has been a Surrealist season, with major recapitulations of Tanguy, Matta, Man Ray, Ernst, plus generous helpings of Dali, Magritte, Arp, Miró, Bellmer. One explanation of this heightened attention to Surrealism is that

1975 is the fiftieth anniversary of the original group show of Surrealist art in Paris; in its present depressed state, the art world is in no position to neglect any occasion for celebration. A deeper reason, however, is that Surrealism is an art of crisis, and its socially critical outlook is thus emotionally compatible with the present economic and political instability; during the 1968 student insurrection in Paris, Surrealist-style slogans and metaphors kept bobbing spontaneously to the surface. With the return of a widespread apprehensiveness, not unlike that of the nineteen-thirties, there can be even less interest than usual in modes of picture- and object-making— such as were dominant in the sixties—that confine themselves to problems of art. In theory and in the daily behavior of individuals, Surrealism developed positions on most vital issues, individual as well as social: creative method, waking and sleep, politics, sex, religion, the press, law and order, masterpieces, science, pedagogy, solidarity. It offered the intellectual readiness of a cult. The literalist style of Surrealist painting and its tactics of social shock never had much appeal to American artists. Its modernity was limited by its preoccupation with its Catholic background (Ernst's "Blessed Virgin" is a striking example), and the anti-intellectualism implicit in its revolt against science and common sense drew it into the orbit of the international set. For both aesthetic and ideological reasons, Surrealism hardly invites revival in the fourth quarter of the twentieth century. Yet the movement did cement together a kind of collage of experience, perceptions, and judgments of the modern situation, and of ways of responding to it, that is rich in hints for the future. The special importance of Ernst's huge Guggenheim retrospective is that—for all the art-historical stress of the show on his manifold stylistic affiliations—the selection of the paintings, collages, and sculptures succeeds in communicating the continual disorientation to which, in the Surrealist view, the modern consciousness is obliged to subject itself as a condition for knowing itself and the world.

# 9
# Lyric Steel

——————

Anthony Caro, the British sculptor whose first major showing in the United States is now at the Museum of Modern Art, is an artist of the nineteen-sixties, but with a difference. The first creation in his mature, along-the-ground style, "Midday," is dated 1960, and it is in relation to the modes and attitudes dominant in that decade that his work defines itself. A principal impulse in the art of the period was to dissociate abstract art from extreme feelings (Rothko's "tragedy," de Kooning's "desperation") and from metaphysical concepts (Pollock's "immediacy," Newman's "sublimity"). In the sixties, these intangibles were rejected, almost with indignation, by artists, art critics, and curators. Art was no longer to be considered a platform for fervid declamations but a learned profession, university-taught and foundation-supported, whose field was aesthetics and the evolution of forms. Emotional utterance was replaced by a militant literalism—"Only what can be seen there [in the painting]," said Frank Stella, "*is* there"—not unlike the anti-idealism of the Russian Constructivists in the early years of the Soviet Revolution. The emphasis was on the work of art as "thing" rather than as representation or symbol; on the clean-edged reg-

Originally published in *The New Yorker*, 7 July 1975.

ularity of geometrical shapes; on the impersonality of industrial materials and the absence in them of art references. The ultimate tone of the decade was set by Minimalism, as the embodiment of intellectual austerity (or, if one prefers, attrition) and detachment. Minimalist paintings and structures reiterated the functional style of the Constructivists, but without the social aims of that movement, as Pop Art repeated Dada, but without its social criticism.

Caro's constructions fit into the aesthetic framework of cool, factory-related sculptures by such personages as Donald Judd, Robert Morris, Ronald Bladen, and of paintings by Kenneth Noland, Ellsworth Kelly, Helen Frankenthaler. Fabricated of steel I-beams, grilles, bars, pipes, rods, sheets, tank ends, and painted (until 1970), usually in monochrome, with thick, evenly applied industrial pigments, like girders or farm machinery, they neither serve any function nor evoke any mood or philosophical reflection. Though for the most part too complex to be assimilated into Minimalism, so closely are they akin to the unruffled "stain" paintings of the period that early Caros have been described as extensions of this mode of painting into the third dimension. "Like 'Twenty-four Hours' [1960]," writes Richard Whelan in the newly published "Anthony Caro" (Dutton), " 'Sculpture Seven' [1961] invites an essentially frontal and pictorial reading. In fact, the sculpture seems to transliterate the effect of staining raw canvas into the language of steel girders." Whether or not this is the case (for me, close scrutiny of "Sculpture Seven," with its massive steel sections, has failed to reveal the resemblance to paintings, and I find it as impossible to "transliterate" stained canvas into metal as into words), Whelan's statement indicates the extent to which Caro's sculpture exists in the mental set of the nineteen-sixties. It is for criticism of the retrospective to determine what, if anything, there is in his work beyond the formulas of a decade ago.

The means devised by Caro for achieving in sculpture—in whatever degree it can be realized—an effect comparable to that of paint spreading into the weave of unsized canvas pro-

vides the basis for hailing him as a formal innovator. "Caro's sculpture," writes William Rubin in a monograph issued by the Museum of Modern Art in connection with the retrospective, "is more abstract than [David] Smith's as much by virtue of its horizontality as its morphology"—and he quotes Clement Greenberg's observation that the key to Caro's sculpture is its "emphasis on abstractness, on radical unlikeness to nature," in order to support the view that "more abstract" is equivalent to "more advanced," and even perhaps to "better." The general format of Caro's pieces is the extension along the ground or on tabletops of metal segments of different weights, sizes, shapes, textures, either fastened together or laid in place in relation to the ensemble. The elements of his sculptures are not erected into a vertical structure in the manner of traditional sculpture or of the piled-up abstract forms of Smith, Caro's chief aesthetic ancestor: they drift out in sideways movements and backward and forward, like an erratic signature. This free movement invites a flourish of afterthoughts, or what seem like them—the curved pipe or bar hooked onto the edge of a cutout steel plate in "Crown" or the angle of the latticed plane in "Span"—that is the liveliest and most attractive feature of Caro's art.

To achieve this unhampered mode of creation, with its continuing openness and its play of random decisions, in heavy substances is more meaningful than finding ways to "have things happen" on a canvas. Bringing a sculpture into being, whether by carving or by welding, bolting, or other additive means, requires a series of acts, whose quality of spontaneity, imaginativeness, daring is directly expressive of the level of the artist's creative power and intuitive rightness—whereas a painter can, more or less passively, allow his pigments to spread and be absorbed into the canvas as patterns of color through the activity of the materials themselves. This distinction between free action and programmed process represents a basic division in postwar American abstract art.

Caro began as an Expressionist, though not, like many other artists of the nineteen-sixties, as an Abstract Ex-

pressionist. His early figurative sculptures strive for maximum emotional impact through dissolving the natural proportions of human males and females, as if he conceived them with his eyes closed, or, as he says, from "inside the body." "Man Taking Off His Shirt" is a swollen mass of metal with truncated arms and a head the size of a pea. Most likely, these attempts to embody extreme feelings were forced—the fifteen years of work displayed at the Museum of Modern Art shows Caro to be essentially mild and reserved in temperament, with none of the "wild man" traits of his American predecessors. Rubin confirms Caro's easygoing outlook in describing his sculpture as "peculiarly English in the way it values lightness of touch, casualness and digression," and in contrasting his meandering with the single-mindedness of Noland's generation, "more rigorous in spirit and less generous in its means." Rubin also endeavors to detach Caro from the original Abstract Expressionists—in particular from Barnett Newman—in noting that Caro's art remains "eminently relaxed . . . never apocalyptic in tone," that "even at its most stately it avoids the rhetoric of 'The Sublime.'"

Caro's conversion to abstraction, which took place during a visit to America in 1959, resulted in an immediate lowering of his emotional temperature. The order of the day among the ex- and post-Abstract Expressionists whom he met through Greenberg was impersonal rationality directed toward art as the solution of formal problems. Most important for Caro was the influence of the later works of David Smith, the only sculptor in this circle of revisionist Expressionism. Smith had begun in the nineteen-thirties as a welder of forcefully animated metal silhouettes, with overtones of conflict and, in some instances, explicit social messages. Like that of his contemporaries Rothko, Pollock, Gottlieb, his watchword was "myth"; that is to say, the total human situation. As politics receded from the art world in the years following the war, Smith's concerns became more self-consciously aesthetic, and he experimented with structural arrangements of simple geometrical volumes. By the sixties, he had won acclaim as a pi-

oneer in post-Cubist weldings of machined metal parts—
from steel plates, rods, and sections of I-beams to giant
wrenches.

The use of industrial materials tends of itself toward a dis-
passionate art. While discarded manufactured objects found
in the street or in junk shops may be richly charged with po-
etic and psychological associations—as exemplified in the
works of Joseph Cornell—this is not the case with new sup-
ply-house items. The choice between used and unused mate-
rials relates to the degree of expressiveness sought in
sculpture. The burnished steel surfaces of Smith's "Cubi" se-
ries produce an effect of august self-withdrawal that is in
sharp contrast with such contemporaneous creations as Mark
di Suvero's improvisations in beat-up railway ties and scraps
of old chain or John Chamberlain's compositions of wrecked-
auto parts. Caro chose his position by rejecting "the pre-
ciousness associated with something because it's old or
bronze, or it's rusty, encrusted, or patinated," and by finding
in steel the virtues of being "anonymous and arbitrary."
These attributes were heightened in his sculptures by their
meticulously monochromed farm-machinery and garden-
décor look—"The treatment and paint surface," says Caro,
"all gave it a blandness."

Like Smith in his later years, Caro is a calmed-down Ex-
pressionist, one in whom stages of distorting and revelatory
passion have been exchanged for a levelled aesthetic sen-
sibility. Yet he does not, like the Minimalists, seek the radical
purgation of art, so as to bring it down into the order of mate-
rial phenomena. In his pieces, feeling is modulated, not pro-
grammatically cancelled. His mode of creation, the factor
most decisive in determining the imaginative texture of an
artist's accomplishment, brings him closer to the early Smith
and to Pollock and his generation than to Judd, Noland,
Stella, and other Minimalist and "color field" designers. "I
don't really know what's going on in my mind when I'm
working, and I don't want to," Caro explained recently. "I
never make models or drawings"—a description of method

that parallels Pollock's by now celebrated "When I'm in my painting, I'm not aware of what I'm doing" and "I don't make sketches and drawings." Like the Action painters, Caro sees the aim of art to be discovery, not the solving of formal problems. At work he "keeps on going," he tells us, until intuition informs him that a culmination has been reached, which is the way Abstract Expressionist painters recognize that a painting is finished. "Really, you discover what you've done afterwards. [Art has] to do with finding out something you didn't know." So Caro stresses that it was an advantage to work in a garage that was too small to let him see the whole piece on which he was engaged, because he wanted to be surprised when he got it outside. And he knew that he couldn't make discoveries and surprise himself if he worked "with an idea of art, or an idea of rightness that I had in my head"—which is, of course, precisely what his ideologically inspired American colleagues were doing. (Conversation in that milieu must have reached an unimaginable degree of ambiguity.)

I do not wish to press the thought that Caro is a kind of latter-day Action artist—although Michael Fried, a leading admirer of Caro and a strict formalist, sees his pieces as "preoccupied" with physical actions, "such as entering, going through, being enclosed," which, however, have been "rendered wholly abstract"; and Rubin adds the suggestion that Caro's sculpture might equally well imply actions of the eye and the mind. The notion of abstract action—that is, actions not performed in particular situations—is associated with dance or music, and it is in the latter that Caro sees an analogy with what he is doing. He is, he says, "composing the parts of the pieces like notes in music. Just as a succession of these make up a melody or sonata, so I take anonymous units and try to make them cohere in an open way into a sculptural whole." De Kooning or Hofmann could have said something similar, except for one important difference: their "units" are not anonymous. The forms constituting "Excavation" or "Liebesbaum" were forged in passionate improvisation, and

the thrusts of singular shapes against one another establish
the dramatic tension of the composition. In contrast, abstract
and anonymous "notes" counterpose no pressures of the
parts against the aesthetic totality. Caro's music contains no
subjective dissonances. The fierce and abrasive features of
Action painting have been washed away in fluid, inter-
penetrating rhythms—the "blandness" Caro has sought.

Caro has restored harmony to abstract art—he has reins-
tated Beauty, against which modernist art movements have
rebelled. His work is, in all likelihood, the most consistently
lyrical of that of any notable artist since the war. The principal
appeal of his pieces, even the largest, lies in the balance and
proportion by which the heaviness of their materials is tran-
scended. "Sun Feast," with its shining yellow-painted arcs
and circles, "Span," with its cherry-red flaunts of see-
through rectangles, are compositions to dance to. Caro's mu-
sicality reaches its peak in his smaller constructions and his
table sculptures—the latter are mostly linear "drawings" in
metal strips and tubes that go over the edge of the tabletop to
exist simultaneously on horizontal and inclined planes. "Or-
angerie," which is set on the ground but includes its own
internal tabletop, is the pièce de résistance of the retro-
spective. Framed in the doorway at the far end of the main
gallery, it is indeed a "sonata" of suave curves, turning petal
(or propeller) shapes, intervals of arrest and release.

The aesthetics of musicality aspires toward timelessness. In
Caro's hands industrial materials lose their contemporaneity.
Separated from the *Zeitgeist*, his steel sculptures might as well
be made of silver or platinum. His art is deliberately confined
to intimations of mood and sentiment, rather than to state-
ments of them, and the air-conditioned-nightmare atmo-
sphere of some nineteen-sixties sculptures—for example,
some of the metal and plastic boxes of Judd and Larry Bell—is
outside the scope of his interest. Talented, prolific, and varie-
gated, Caro appears to have little inclination to impose his
rule on the future of sculpture. In his unpainted, rusted, and
varnished pieces of the past five years, which follow the lead

of Newman's weathered Cor-Ten steel sculptures—"Durham Steel Flat" and "Straight Up" are powerful upright compositions in this new mode—Caro has in fact returned in spirit, past the neutral art of the sixties, to the greater strength and expressiveness of the immediate postwar years. In this instance, to go back has been to go forward.

Unfortunately, Caro's retrospective is shrouded in rhetoric that remains uncompromisingly sixtyish. Publications issued to coincide with the show interpret Caro in terms designed to present him as setting the future direction of sculpture. Whelan's "Caro" contains an article by Greenberg that envisions a "breakthrough" by Caro that "expands taste" (Greenberg does not tell us whose) and is "compelled by a vision" (Greenberg does not say of what); in fairness, it should be noted that this text was written in 1965. Rubin's monograph begins on the same note: he sees the "destiny" of constructed sculpture as passing from the hands of Smith into those of Caro—in effect, to paraphrase Clausewitz, Caro is a continuation of Smith by other means. We need not examine here this stepping-stone theory of art history, according to which art progresses by leaping from one personage to another. Caro's own conception of art—that it has to do with showing "what it's like to be alive"—is free of art-historical strivings. Nor does the artist appear to believe that he, or anyone else, can push past the existing limits of art by inventions restricted to form. As he sees it, genuine novelty has a more radical character: it effects a violent cancellation. "When the new thing does come," he told a *Times* interviewer, "it's going to blow everything sky high. I hope I'll be able to recognize it."

# 10
# Purifying Art

During his lifetime, Ad Reinhardt, celebrated for his square black paintings, badgered his contemporaries with what was to him the paramount issue in American art: "corruption." Most artists of the past twenty years have been acutely conscious that the art world is not a sanctuary for the righteous; suspicions of behind-the-scenes rigging of reputations and prices hover in the studios like a layer of pollution. Compared to Reinhardt, however, his colleagues were mere dilettantes of suspicion. In him, delinquency in art found its Grand Inquisitor. Not only was he the most persistent attacker of the "public profiteers" in the galleries; his indictments went beyond dealers, collectors, museum curators and trustees, critics, and art historians to include artists, and even art itself. For Reinhardt, practicing "our overcrowded, ignoble profession" was like spending one's life in a plague spot; survival was possible only through constant bathing in antiseptics. "Someone," he wrote, "is always asking you to betray yourself as an artist."

Reinhardt's assaults on his fellow-artists, which kept expanding and gaining in intensity until his sudden death, in 1967, were highly unusual. As in fraternities and professions

Originally published in *The New Yorker*, 23 February 1976.

generally, derogatory opinions in the art press and at meetings and lectures tend to be kept within limits set by the presence of outsiders—Reinhardt himself in heated moments at the Artists Club used to call out, "No names, please!" It may have been this rule of reticence that induced him to make exposing the depravity of other artists a matter of principle. "The first word of an artist is against artists," he reiterated. The "public profiteer" is only the "second enemy": the corruption of the art world stems primarily from the careerism and intellectual self-indulgence of artists. It is the kind of pictures they paint that brings into being their degraded social environment. "Now, what is corrupt then, what's rotten?" Reinhardt cried at the Club during a panel that he had turned into a kind of grand-jury investigation. "It's been easy to say that the institutions are at fault, the critics are at fault, the collectors, curators, or the managers or the middlemen are at fault, and I think I would attack"—he had—"however, I think that the artists are responsible. If there is anything rotten or corrupt, it is the artists' fault."

In the present period of scandals and disillusionment, Reinhardt's absorption with corruption lends special interest to his writings collected in a volume of the Documents of Twentieth-Century Art series entitled "Art-as-Art: The Selected Writings of Ad Reinhardt" (Viking). The black paintings of his last period, and his interest in the Far East, are seen from his texts to owe at least as much to his search for an antidote to the art of his time and for a counter-statement to its artists as to aesthetic admiration for Oriental art or metaphysical insight into it. The effect of his repeated denunciations is more obsessive than the repeated image of his black paintings, which when shown together are rarely examined one after another. The success of American art in the fifties appears to have produced in Reinhardt a sense of isolation— "I've had the idea for a long time now," he complained the year before his death, "that I was the only unacceptable abstract painter"—which he attributed to the meretricious elements in advanced art that appealed to the public, "the pop

art, the plaster hamburgers and everything else." In his view, the primal defect was one of outlook: the tendency in modernism to confuse art and life. The academy had rigorously separated art from non-art, paintings from mere pictures. It had erected canons to which every artist was obliged to conform. In art since the war, all standards had been swept away by "expressionist debauchery and neo-surrealist delinquency." Artists were played up as "heroes" and aspired to the glamorous lives of movie stars. In the resulting chaos of values, anything could be art and anyone could be an artist. Following Plato, Reinhardt found the cause of moral collapse in a deficient aesthetic. The very vocabulary of values had been undermined. "Selling out," which formerly denoted the shameful abandonment of standards for the sake of money, now signified the triumph of having one's exhibition of paintings entirely bought up by collectors.

To the prevailing degeneracy Reinhardt proposed the antidote of "pure" painting, or art-as-art-and-nothing-but-art. Moral health required reinstating the gulf that had divided art from everything else. If elevating art to a realm of its own implies restoring the academy, so be it. "Artists come from artists, art forms come from art forms, painting comes from painting." "Art-as-Art" contains four selections on the need for a new academy—essays that seemed intellectual oddities when they originally appeared in art magazines but that reveal their full meaning in the context of Reinhardt's attacks on "corruption." Far more removed from reality than the old academy, in that it favors an art that is totally abstract, Reinhardt's academy derives its substance largely from what it opposes—its intellectual content consists of Reinhardt's exhaustive list of what art is not. Foremost among the anathematized influences are the "hyphenated abstract schools," such as Abstract Expressionism and Abstract Impressionism, and Action painting, which provided the dynamics that placed the new American art in the leadership of the world during the postwar decades. Reinhardt's "Twelve Rules for a New Academy" bans every currently practiced mode, from

Realism to Constructivism, and every method and formal device, from brushwork to large canvases. In the last analysis, Reinhardt's theory of an academy is a way of celebrating his own all-black paintings as morally superior, in their absence of seductiveness, to all other paintings and sculptures of our time. In their negation, they represent for Reinhardt the aesthetic culmination of truly abstract art. To describe this art cleansed of all associations he does not hesitate to adopt as virtues the terms of denunciation applied to abstract art by "humanist" critics. His rules require that art should be useless, changeless, monotonous, invisible (unostentatious), and above all, "meaningless" (though in his early days he had made the usual defense of abstract art that it is "a challenge to disorder and disintegration").

"I finally made a program out of boredom." Reinhardt liked to repeat that "interest is of no interest in art." In his writings, however, he strives for humor and verbal virtuosity, heavily salted with puns, against a background of aggressive earnestness. In a typical list he enumerates the tricks of the painter's trade to be avoided: "brushworking, panhandling, backscratching, palette-knifing, waxing, buncombing, texturing, wheedling, tooling, sponging, carping, blobbing, beefing, staining, straining, scheming, striping, stripping, bowing, scraping, hacking, poaching, subliming, *shpritzing*, soft-soaping, piddling, puddling, imaging, visioning, etc. The soft sell on the clean hard edge by the new artists was as much of a sellout as the hard sell on the soft edge was by the dirty old artists." As a writer, Reinhardt's "expressionist" temperament is unmistakable. In meditative notes taken from unpublished documents, he skirts the borders of inexpressible feelings and mixes quotations, random thoughts, unfinished phrases, dissociated words in incantatory sequences:

"Archaic" man, abolish time "live in continual present"
Abolishing guilt, abolish time, defense mechanism of
    denial

Archaic economy, gift-giving, share guilt, cyclical time
Magic use of objects instead of own body, share guilt
Guilt into aggression, guilt is time, city time, ownership

and so on.

Reinhardt's humor, and the fact that his paintings seemed obviously affiliated with Mondrian and the neo-Plasticists, though they share the aura of individual mystery characteristic of American Abstract Expressionism, created the impression during his lifetime that his moral denunciations were not to be taken seriously. His background as a cartoonist on art themes for *PM* during the forties, and the engaging "trees" from whose branches he suspended painters, sculptors, schools, and critics as clusters of leaves, reinforced his reputation as a comedian, while his very outspokenness and the absence of shading in his gibes at the "Bauhaus bacchuses and housebroken samurai" recalled the ancient privilege of the clown. There was, too, the appeal of his postcards, written in a peculiar kind of lettering, in which he presented himself to his numerous correspondents as a modest, neglected person asking simply for common fairness. A postcard to Bernard Karpel, chief librarian of the Museum of Modern Art, that is reproduced in "Art-as-Art" begins by inquiring, "You remember me?" reminds Karpel that the Museum has "documented pretty much everything, except me," suggests that Reinhardt, too, be added to the files, "not only Motherwell" (reputed to be the Museum's most documented subject), and offers to supply "a picture of me next to my easel or something like that." It is difficult to think of the author of this cute but slightly whining note as the Savonarola of anti-success. Indeed, Reinhardt made no attempt to hide his maneuvering to obtain notice and arrange exhibitions and retrospectives of his work—in 1965 he managed to have three shows covering different phases of his paintings running simultaneously. With few exceptions, his contemporaries thus saw Reinhardt as an artist like most others, and

considered his speeches and writings, no matter how bellicose, to be part of an effort to capture the spotlight. When, at a round table in Philadelphia, Reinhardt attacked his fellow-panelists, they unhesitatingly rallied to his defense as the organizer of the event attempted to respond in their behalf.

Against this background, Reinhardt's "empty" repetitive paintings, "five feet by five feet by five thousand dollars," with their barely perceptible cross floating underneath the all-black textureless surface, defined themselves objectively (that is, in terms of their relation to other art rather than to the stated intentions of their creator) as a species of neo-Dada provocation, not too distant in negative substance from the erased de Kooning on which Rauschenberg founded his fame. Late in Reinhardt's life, an interviewer questioned him on the relation of the black paintings to the "negative acts" of the Dadaists; Reinhardt replied that they were "the exact opposite." But the opposite to Dadaist anti-art ceases to be opposite when, in the same interview, Reinhardt claims that he has succeeded in getting rid of everything in painting, that "I'm merely making the last painting which anyone can make," and that artists following him would do well to adopt his formula and make their own paintings by copying his. He and his disciples, if any, either could go on reproducing the same painting or could quit—art was finished in any case.

For all its instances of levity, "Art-as-Art" lacks sufficient lightness to offset page after page of aggression against artists and the reiterated listing of qualities of which art ought to be purged. Especially since it omits his art comics and satires (a volume of these, edited by Thomas B. Hess, has just appeared), the collection of writings leaves no doubt that Reinhardt was in deadly earnest, and this is confirmed by the thinning of his humor in his later years, allowing his morality-inspired irascibility—sharpened by the lagging of his fame ("The Museum of Modern Art got to showing me about twelve years after they showed Still and Rothko and those guys")—to come through. Jokes or no jokes, for Reinhardt

every other artist's credentials were in question. Toward the end, he also dropped his "No names, please!" and hammered away at artists who had "made it."

Plainly, Reinhardt's thrusts against his generation have a genuine basis in what has happened in American art during the past twenty years, though "demoralization" might be a better word than "corruption" to describe the condition of some too rapidly successful artists. Reinhardt's notion, however, that ambition and vanity arise out of the prevalence of a faulty aesthetic can only be taken as a joke—by this reasoning, Pollock and de Kooning are also responsible for Richard Nixon. And to believe that "pure" art represents cleansing in more than its name is to be taken in by a pun. Reducing painting to zero actually tends in our culture (whatever the "doctrine of great emptiness" may have produced among the ancient Chinese) to augment, rather than repel, art-world corruption, since the work can be made attractive only through promotion and market status.

Granted that art comes from art, as Reinhardt kept insisting, the art of the past from which it comes is as varied as the world. At least since the Renaissance, the appeal of art, including religious art, has rested on the sensuousness of experience; de Kooning, toward whom Reinhardt displayed a particular antipathy, contends that oil paint was invented in order to represent flesh. "Pure" painting comes not from painting but from an idea of painting, from an aspect of it that has been theoretically isolated as its essence. Reinhardt's art-as-art is an effort to detach art from its cultural surroundings in order to deal with it as a thing in itself. In less extreme forms, this approach is widely accepted by American artists, art critics, and historians. Art-as-art is not, as Reinhardt imagined, a dissent; most conservative opinion in the art world is based on this view, however reluctant it might be to conclude with Reinhardt that art is "meaningless."

Much has been made of Reinhardt's Orientalism; Barbara Rose, editor of "Art-as-Art," sees his black paintings as nothing less than "a synthesis of the polarities of Eastern and

Western art." Reinhardt was drawn to the paintings, sculptures, and architecture of the Far East and Asia Minor, took two trips to these regions, and snapped innumerable photographs, which he subsequently presented in lectures. The aesthetic ideals of his later years—repetition, stillness, void, withdrawal from the senses, "worldlilessness"—appear to have been strengthened by his readings in Buddhist literature. His enthusiasm for the civilizations of Asia is comparable to Rothko's for ancient Greece, or Gottlieb's for African and American Indian symbolism. The absorption of bits of alien cultures into the informal style of modernist thinking— for example, Reinhardt's "Action arts speak louder than voids"—together with the repudiation of the Western aesthetic tradition, has been a continuing factor in the cultural dislocation of our epoch. "Pure" art compounds the confusion instead of diminishing it. Reinhardt's aesthetic absolutism did not, as he expected, act as a wall dividing him from the art world. His pictures have not been "unmarketable," "unphotographable," "unreproducible," "inexplicable." They have been sold, photographed, reproduced, explained. Despite his assertion that "I never say anything about my paintings," "Art-as-Art" is a protracted explanation and defense of them. They have accommodated themselves as fully as any paintings of the time to the "corruption" of art.

The current weakness in American art is in large part the result of too much feeding on art, to the exclusion of experience. In the thirties, when Reinhardt began his career, abstract art was a counterweight of the mind to excessive "reality." Today, abstraction tends to exist through adapting what has already been done. Corruption in art cannot be eliminated by a virtuous style, since no style is inherently virtuous or capable of keeping its qualities unchanged. Reinhardt's concern about the moral situation of art was well founded. Yet his unremitting one-against-all polemics damaged the solidarity among artists which is their chief basis for resistance to alien influences. In a late document in "Art-as-Art," Reinhardt appears to grasp the connection be-

tween the rise in "corruption" and the fading of friendship among the New York painters. "There isn't anything that doesn't go now," he remarks in tones of nostalgia. "The artist community is completely dissolved and artists aren't even talking to each other. They're all geared to the public, at least intellectually." Reinhardt seems touched by this alienation, to which he had made the maximum contribution. But he goes on to blame the loss of communion on the pop artists, and follows this by denouncing Pollock and de Kooning for their ways of life. Perhaps he did not intend to be taken seriously after all.

# 11
# Mediumistic Artist

The André Masson retrospective at the Museum of Modern Art is an exhibition beset by problems. One of the earliest Surrealist painters, Masson, now eighty years of age, has been an outstanding personage in advanced art for half a century, his reputation on a par with that of such distinctive figures as Arp, Magritte, Schwitters. Masson has had numerous shows in the United States since the thirties, he was one of the Paris vanguard who took refuge in this country during the Second World War, and he is said by critics—including, with nationalist vehemence, André Malraux—to have exerted a considerable influence on the American Abstract Expressionists, and particularly on Jackson Pollock. For all his large body of creations, however, and his art-historical importance as a link between postwar American painting and the immediate European past, the art public has no clear image of what "a Masson" looks like, in the sense that it recognizes a Miró, a Giacometti, a Dali.

Unfortunately, the show at the Museum of Modern Art does not make it easier to know a Masson when one meets one. Not only is the exhibition uneven in quality but it lacks stylistic coherence to a degree that, even in this century of

Originally published in *The New Yorker*, 16 August 1976.

weak and changeable identities, is extraordinary in an artist of Masson's eminence. The effect of the show is to throw the spectator into a state of aesthetic bewilderment. Occasionally, he comes upon a drawing or a painting ("Rape," "A Knight") that seems to be the key to an original sensibility, only to have this response cancelled by adjacent pictures in entirely different modes. He is left with the impression that the retrospective could represent the creations of three or four artists, perhaps half a dozen, one of whom might be "the" Masson. The 1938 "Ariadne's Thread," a fluid improvisation in black and orange calligraphy on an even ground of red sand, shares, with its interjections of erotic signs, the austere lyricism of Miró, while "The Labyrinth," also of 1938, is a garish "precisionist" personification with cut-open head, torso, and limbs, densely packed with imaginary viscera, not unlike a poster for a horror movie. Paintings in dark, viscous browns, reds, blues, and purples with symbolic overtones ("Iroquois Landscape," "Meditation on an Oak Leaf") seem especially out of tune with what is important in Masson, as do his dream stage sets ("Aragon Sierra," "The Landscape of Wonders"), his metaphysical compositions ("Portrait of Goethe"), and his orthodox Surrealist fantasies ("Louis XVI Armchair," "Gradiva")—although some of these paintings are undoubtedly among his major efforts.

Even the organizers of the retrospective, professionally committed to displaying their subject in the best possible light, confess to embarrassment at the failure of the show to reveal an aesthetic persona. In the catalogue, Carolyn Lanchner, a curator of the museum, mentions "much criticism" of Masson on the ground of his "frequent radical divergence of styles." William Rubin, the director of the museum's Department of Painting and Sculpture, who with Ms. Lanchner organized the exhibition, adds the interesting comment that Masson has *resisted* "that commitment to a stylistic identity which is sought by most professional painters." Both curators attempt to rectify their subject's deficiency by attributing to him a unity beyond that manifested in his paintings. Ms.

Lanchner perceives in Masson's thinking the ingredients of a philosophy that has remained basically unchanged through most of his life—it has to do with his expressed belief in "the precariousness of existence and its continual cohabitation with the void"—and she makes use of this outlook and of his vocabulary of erotic signs to explicate the pictures. For Mr. Rubin, in contrast, the unifying principle of Masson is biographical; it resides, he says, not in Masson's style or imagery but in his "unique personality . . . the unity is thus that of the man."

The difficulty is that neither Masson's sense of precariousness nor his psychological singularity can resolve the spectator's confusion over the works that confront him in the museum. The curators' concepts are tools of interpretation, and they indicate theoretical relationships that can be grasped only through the text of the catalogue. Their exposition may aid in understanding how Masson made his way from one painting to the next and from style to style, but getting a glimpse of Masson's thinking is not an effective substitute for the impact of an expanding style manifest in visual images. What is wrong with the Museum of Modern Art show is that it is a retrospective—a format that is poorly suited to artists who do not evince either a steady evolution or a dramatic transition from one mode to another. Why present a survey of a lifetime of creations that fail to illuminate one another or to deepen a common idea or vision? There is no more reason to expect that the entire career of a painter will lend itself to a valid exhibition than to expect that the life story of a field commander will demonstrate the originality of his battle maneuvers. The biographical obsession has less to do with art than it has to do with the need of museums for significant-sounding shows. The retrospective has come to be the prize offered to both the artist and the public. Presumably, such an exhibition, together with the catalogue that inevitably accompanies it, conveys the full spiral of the artist's development and marks off his place in art history. Not that retrospectives always reflect the full accomplishments of their subjects.

Some artists suppress portions of their creations in order to highlight a style for which they have become known. Curators make selections that will support their critical conceptions. Decisive pieces are often omitted because they are unobtainable. Whatever the degree of its comprehensiveness, however, the retrospective is put forward as the final synthesis of what needs to be seen and known about the artist.

The Masson show at the Museum of Modern Art is a model retrospective without being an acceptable exhibition. The drawings and paintings on the wall represent the major phases of Masson's half century of production, and the catalogue leaves very little to be learned about Masson or about the imagery and formal meaning of his various modes. Mr. Rubin has coördinated the events of Masson's career with the history of art in our time and, to his credit, has urged that Masson be appreciated on his own merits rather than as a forerunner of American Abstract Expressionism. With enormous patience, erudition, and ingenuity, Ms. Lanchner has pursued the twists and turns of the artist's attitudes into changes of style and iconography and has elucidated the philosophical, literary, and erotic references in each of the works. But all this is of little help to the spectator floundering among exhibits in different styles and moods. The excellence of the catalogue only emphasizes the disparity between art scholarship and the experience of works of art. Masson has had two or three periods of genuine inventiveness, and an exhibition of the products of these intervals would make his work as easily recognizable as his signature. In establishing identity, the whole is less than some of its parts.

Masson's distinction as a painter lies in the visual poetry that springs out of animation and action. His universe, said Kahnweiler, is "not a world of forms . . . but one of forces." His is an art of encounters, in which is enacted the ritual of loss and recovery of identity—titles such as "The Rendezvous," "Animals Devouring Themselves," "Cosmic Song" indicate aspects of this celebration. Only recently,

Masson again recalled that his ego was "pillaged forever" in the First World War, when he was severely wounded and then sent to a mental hospital for defying a military superior. Automatic drawing, in which he pioneered before it became a standard resource of Surrealism, is a practice of setting aside the ravaged self in order to replace it by the flow of impersonal energies. This effort is the line at which art touches on metaphysics (religion), and which unites artists—in this century of widespread immersion in the waters of destruction—from Klee and Ernst to Pollock and Rothko.

Placing himself in the tradition of Heraclitus and Nietzsche, Masson strove ("if our eye were only more acute") to see everything in flux and metamorphosis. His invocation of outside powers begins in the activated Cubism of the canvases he executed in the years after his return from the First World War. Masson has said of the paintings of this period that "always forms have a tendency to interpenetrate and to melt into each other." A 1925 painting such as "Bird Pierced by Arrows," with its sharpened, elongated wedges speeding up and down the diagonal of the canvas, distinguishes itself from other Masson Cubist paintings of that year as the creation of a sensibility heightened by the apprehension of forces in motion. "Bird" is Masson's equivalent of Futurist activist composition—represented by, say, Balla's "Fist of Boccioni; Force-Lines of the Fist of Boccioni" or Boccioni's "Riot in the Gallery"—in which static objects are replaced by linear tracings of the flight of birds and machines and the rhythms of combat. Like the Futurists, Masson resolved to make collisions rather than things the subject matter of painting, and he went on to discover in struggle the principle of a reconstituted self. In notes on a recent gallery showing of Masson, L. Saphire writes that the artist has long believed that the violence of combat results in a "metamorphosis of the participants," and that he "developed this idea as a major component of his art," settling on such symbols of physical destruction as the detached feather, blood, the whirling of contestants. Unlike the Futurists, Masson did not extend his

action aesthetics into a political position, though his political inclinations are shown by his activities in support of the Loyalists during the Spanish Civil War.

The darting forms of "Bird" link Masson's Cubist canvases visually with his later automatic compositions, his "Massacre" paintings, and his restless calligraphic abstractions ("Rape," "Entanglement"). Together with two or three highly dynamic canvases of the same period ("Nudes and Architecture," "Man," "The Amphora"), "Bird Pierced by Arrows" sets the spectator on the road to the "essential" Masson—provided that such static emblematic compositions in Cubist format as "Opened Pomegranate," "Man with an Orange," and "Still Life with Candle," which are done in a different spirit, are excluded. The misty landscapes of the preceding years and the portraits of friends (Limbour, Leiris) might, for all their biographical interest, also be excluded to Masson's advantage, at least until the artist's distinctive note has been conveyed.

Through his discovery of automatic drawing, Masson passed from the quasi-Futurist picturing of force-motions in "Bird" to the acting out of conflicts with himself. At this point, the issue of style in Masson's compositions is decided by their degree of abstractness, by the ability of the artist to abandon by juxtapositions of images—head, heart, feet, flowers—of "The Armor" and "Woman" in favor of initiating movements of the pen and brush as a means of evoking unnamed tensions, as in "Horses Attacked by Fish." Quoting Masson's description of his canvases of 1924–25 as "space furnished with forms arranged as in a showcase," Ms. Lanchner asserts that in the automatic compositions this formula has been discarded. Masson never sought pure abstraction, any more than did de Kooning or Hofmann, but his strongest work is that in which his subject has been left in abeyance, to emerge of its own accord. In the sand-and-glue paintings that represent his earliest liberation from preconceived motifs, and from Cubist structure as well, intimations of human and animal figures, landscapes, and hostile encounters emerge

from the action of the materials. From "Battle of Fishes" and "Horses Attacked by Fish" (1926), through "Horses Devouring Birds" (1927), to "Fish Disembowelling Another" and "Great Battle of Fish" (1929), movement, conflict, merging bodies spring into being before they are conceived by thought. Masson's line swings in curves, sharpens into angles, quakes and trembles; "Painting (Figure)," of 1926–27, anticipates de Kooning's almost cartoonlike improvisations of the sixties, probably because it is the product of a similar kind of unleashed drawing.

Totally automatic drawing is not possible. Even under drugs, the mind exercises a certain degree of selection. What distinguishes automatism as a discipline in art is not absence of direction by the intellect but suspension of intention by the will. A hack writer working at top speed functions more automatically than a master of free association, but the hack is aware of not only what he is doing but why. Automatism makes lack of intention positive; its surrender of the self is practiced as a program, a discipline. The artist gives himself up to the unknown; that is to say, to processes inherent in the brain and the hand. He renounces himself in order to be a passive medium of supervening influences, though this may make him the agent of their aggressions. Automatism is a form of affirmation, a gearing of vital resources that is capable of transforming itself into action. Masson says of his "Massacre" paintings of the nineteen-thirties that they are "so spontaneous, they are nearly automatic drawings," and this underlines the distinction between the passive and the willed—although the difference is difficult to discern in compositions where, as one observer puts it, "every movement crosses another movement, where each act proceeds from the other act by a secret and rigorous development."

Masson's sand-and-glue painting is the high point of his self-assurance in self-abandonment, and the style in which he comes closest to postwar American Action painting. Having discovered that automatism tends to decline into repetition (as it did also in the case of Pollock), Masson brought the

series to a close after some twenty pieces. Another defining movement occurs in his "Massacre" series, though the over-literal figuration in some of these (which remind me of Carl Holty's playing-field abstractions) seems retrograde in comparison with the magical personages of the sand paintings. Instances of inspired letting go which diverge from but complement the sand and "Massacre" compositions occur in the decades that followed: "Rape" and "Entanglement," 1941; "The Kill," 1944; "Genesis I" and "In Pursuit of Birds," 1958; "La Chute des Corps," 1960; "In Pursuit of Hatchings and Germinations," 1967. An interesting bypass is indicated by the painting "The Rendezvous," 1929, and the collage "Street Singer," 1941. In the first, Masson represents an event in terms of abstracted gesture; in the second, he augments gesture with lyrical symbols (a leaf, sheet music, a skirt pattern). But the possibilities inherent in these works were not pursued.

Against such flights, there is in Masson a pressing atavistic didacticism that diverts him from the activity of self to metaphorical clutter, metaphysical emblem-making, and a glossary of sex symbols à la D. H. Lawrence. The extreme of this tendency is exemplified by the one sculpture of the first twenty years of his career: an amorphous, visually pointless plaster entitled "Metamorphosis," described as "an animal-mineral-vegetable being in the process of devouring itself." He was attracted, too, to explicit references to Greek myths—the Minotaur, Andromeda—which were a major vein of Surrealism, and which survive today in American art derived from that movement; for example, in David Hare's recent show of powerful paintings and sculptures devoted to the Cronus legend.

Perhaps the paradigm of Masson's art is his remarkable ink drawing "Torrential Self-Portrait"—an aesthetic summation equivalent to Gorky's "The Artist and His Mother." Concentrated in the center of the drawing paper, the artist's face floats up in an entranced, inwardly directed meditation from eddies of curves, flecks, and flickerings of line in varying

lengths, thicknesses, and "speeds." Concluding his study, Mr. Rubin contrasts Masson with "most professional paint-ers" for having abandoned the sand paintings when he found that automatism could, as he said, "become routine." To Rubin, this is evidence not only of Masson's refusal to com-mit himself to a stylistic identity but of "an attitude of doubt and suspicion with regard to the métier of the painter." Rubin's accusation that Masson hesitated to turn out Mas-sons because he was "unsure . . . of art itself" amounts in my mind to the highest praise both of the artist's insight and of his integrity. There are enough professional painters with identities contrived, like trademarks, to insure their public recognition. If Masson's practice was not regulated by the success drive of the professional even to the extent of re-straining divergent impulses, it was because he saw painting in our time as a means by which the artist could achieve the portrayal of his deepest self.

# 12

# Ben Shahn

For those who respond to them, the paintings of Ben Shahn are enhanced by a species of moral and social virtue. That the paintings say the right things makes them look right, regardless of their individual quality. Shahn is among the most extensively collected artists of the past forty years: more than sixty private collections and museums are credited as lenders of the one hundred and eighty paintings, drawings, prints, posters, and photographs that constitute his retrospective at the Jewish Museum. Even subjects such as "Stop H Bomb Tests," "Tom Mooney and His Warden, J. B. Holohan," and "Scabbies Are Welcome" appear to have been unable to discourage acquisition of Shahns for living rooms and institutional galleries. The often seen and reproduced "The Passion of Sacco and Vanzetti" (not in the show) is received as an emblem of Injustice Recalled, rather than as a tempera painting of a group of figures in a setting of classical steps and columns. The general impression left by Shahn's paintings and graphic works is one of an artist constantly embattled along a line of contemporary history—the line of issues supported in the nineteen-thirties by the majority of men and women of good will.

Originally published in *The New Yorker*, 13 December 1976.

Still, the notion of Shahn preëminently as a painter supporting social and political causes is only partly correct—even in the thirties, when his dedication to victims of oppression was at its height, he went off in directions unconnected with the ideology that seemed central to his work. In the same year (1931) that he composed "Sacco and Vanzetti: In the Courtroom Cage," he designed "Haggadah for Passover," and in that decade, too, he produced such "neutral" works as "Photographer's Window," which is a literal rendering of the display in a neighborhood studio, and "Seurat's Lunch," in which white dots are scattered over a storefront in a comically awkward homage to the celebrated Neo-Impressionist. In his own view, Shahn represented a humanist, rather than a narrowly political, position. If the humanist artist was sensitive to instances of injustice, past and present—to the Dreyfus case, Sacco and Vanzetti, Tom Mooney, slums, urban and rural poverty, unemployment, strikes, minorities, concentration camps, Nazi brutality, the menace of nuclear bombs—he was also moved by children at play, spring and the flowering countryside, meditations on man's fate, the Scriptures, and by abstract emotions, such as rage and brotherhood, and metaphysical insights expressed in symbolic terms, as in "Age of Anxiety" and "Everyman" (a clown doing a somersault in the company of two reflective figures with their hands clasped).

The Shahn retrospective is a reminder that the so-called Social Realism of the thirties was not a style so much as a mood and a moral outlook. Shahn borrowed from the great artist-polemicists of the past, Goya and Daumier, who were the common idols of the painters of the Depression and the threatening war; but he took more from modernism—from the Cubists and Picasso, from Mexican muralists, German Expressionists, Surrealists ("The Red Stairway" is creditable Max Ernst), and American and European naïve artists. "Hunger" is a figure in elongated perspective in the manner of Tchelitchew and Dali, and "Handball" is another version of distance exaggerated in this way. Shahn even tried his hand,

not unsuccessfully, at nonrepresentational abstraction in a backdrop and poster for ballet, and in a sketch for a mural, "Fragment of Poet's Beard." To all indications, he never hesitated to derive modes of handling from other artists or from alien styles, whatever their ideological backgrounds. Trained as a lithographer and in lettering and illustration before he became a painter, he was from the start a professional in his readiness to appropriate what fitted his purposes.

What links Shahn's art to the paintings of more literal contemporaries such as William Gropper, Jack Levine, Philip Evergood, and the Soyers is not a shared manner, or even a common subject, but a pervasive moralizing and its perhaps inevitable accompaniment, an ineradicable drabness. These are embodied in Shahn's pinched drawing of faces and torsos, in his omnipresent walls as background, and in his watery and indecisive color. Even at his most spontaneous, exuberance seems outlawed by his conception of the nature of our times. It is interesting that when, in his later years, he turns to glorifying Old Testament texts, he resorts to interlacings of gold leaf, as if pigment were an inadequate vehicle for his enthusiasm.

Among artists and intellectuals of the thirties, the moralizing impulse goes far deeper than particular political allegiances; it accounts for the sense of innocence and self-righteousness (for example, in Lillian Hellman's "Scoundrel Time") which survives proof that they had been acting in the service of a hateful tyranny. Their moral universe was a closed sphere, complete in itself, and nothing done outside it could affect its rectitude. In the art of the thirties, a nude or an interior often seemed to make a moral point of the same order as a painting appealing for better health care (Shahn's "The Clinic") or deploring the victims of Nazism ("Concentration Camp"). In Shahn's "Spring," the couple lying in the grass are *right* to be there, as it is right for Shahn as a Jewish artist to make symbolic patterns out of the Hebrew alphabet ("Pleiades," "Tenth Commandment"), even if he isn't religious and doesn't know Hebrew.

The presence of righteousness and of the miserable victims of unrighteousness, from unjustly imprisoned militants to neglected children, constitutes the "Social Realism" of the thirties, regardless of individual style or political commitment. (Soviet "*Socialist* Realism" eliminates victimization under capitalism and replaces it with righteous joy in "Socialist construction.") Victimization was the mark of truth in paintings of the thirties, as boredom was in the sixties of Warhol and the Minimalists. Shahn's ultimate image is the staring mask of despair, which turns up in every phase of his career, even after his political passions have diminished. An angular face drawn in line, cartoon style, on a shaped area of flat color achieves intensity by fixing its gaze directly on the eyes of the spectator or by staring off into space: "The Clinic," "Spring (Democracies Fear Peace Offensive)," "Portrait of Jean-Paul Sartre." Symbols auxiliary to the troubled physiognomy are oversized hands and blind walls with glimpses of tenements behind them. There is no outstanding creation in Shahn's retrospective—no single work or group of works which sums up his position or his talent, or comments on the period in which he lived. Instead, there is a central effect generated by the reiteration of hurt and complaint, within an ambience of casual insights, sentiments, and fantasies.

The Jewish Museum catalogue carries as its epigraph a quotation from Shahn in 1949: "I believe that there is, at this point in history, a desperate need for a resurgence of humanism, a reawakening of values. I believe that art—art of any kind—can play a significant part in the reaffirming of man." This statement seems to represent a shift in Shahn's attitude. With his triple use of the prefix "re," he now seeks the good in a revival of previously existing ideals rather than in radical change. This revival of human values can be furthered by "art of any kind," not just art that takes sides on social and political issues. Why had the "desperate" need for a restoration of man and his values arisen in 1949? Because the moral-political certainties of the previous decade had been visibly crumbling under the impact of the Nazi-Soviet Pact, the Sec-

ond World War, and the Cold War that followed the German
defeat. An artist could no longer take it for granted that in
applying his art to good causes he was identifying himself
with mankind. The virtue of these causes had been tainted by
the manipulation of them by the Soviet tyranny. In 1948,
Shahn could still, as a supporter of the campaign of Henry
Wallace's Progressive Party, produce a caricature of Truman
and Dewey as a vaudeville team doing a duet of popular
numbers. But by the early fifties, says Shahn's widow, Ber-
narda Bryson Shahn, in a monograph on the artist, "he had
begun to find thin some of the social philosophy that he had
heretofore accepted uncritically."

At the same time, he had begun to explore new subjects for
paintings—for example, the male torso. In "Artists and Pol-
iticians," an ink drawing of 1953, a perturbed figure in the
foreground, clutching a handful of paintbrushes, is flanked
by two tough-looking characters with big fingers pointing at
him. According to Mrs. Shahn, the politicians in this drawing
are members of the House Un-American Activities Commit-
tee, but they are just as likely to represent Shahn's former
friends and political mentors. At any rate, from this point to
his death, some fifteen years later, Shahn's paintings are in-
creasingly engaged with abstract emotions—"Anger" and
"Discord" (both 1953)—and such private images as "Byzan-
tine Isometric" (1951), the Hebrew themes, and various "Al-
legories." Occasionally, as in the "Lucky Dragon" series,
which deals with the burning of the crew of a Japanese fish-
ing boat by fallout from an American nuclear explosion,
Shahn returns to historical subjects. A "Lucky Dragon" item
at the Jewish Museum is one of the largest paintings in the
show (which some might find non-contemporary solely be-
cause of the small dimensions of the works), and derives
force from the male-torso format evolved in the fifties and
from the device of including a hand-lettered verbal statement
in the picture.

Humanitarian feeling would seem sufficient ground for
protesting the H-bomb. Yet at the height of the Cold War

(and in the jockeying for advantage between the super-powers today) taking a public stand on even that issue was bound to arouse suspicion of a concealed political motive. Banning the bomb favored the Russians. In sum, "human-ism" had been hopelessly undermined by the total politiciza-tion of all matters affecting human life—from the world food supply to air and water pollution and tribal wars in Africa. There remained no universally respected cause from which art could derive the support of moral conviction. The genera-tion of artists that followed Shahn avoided the evils of cer-tainty where no certainty was possible by making art abstract. Shahn himself in his "Goyescas" of the late sixties, which comment on the war in Vietnam, arrived at, for him, an un-precedented level of generalization and symbolic indi-rectness. Still, its pervading assurance of doing good gives his retrospective an atmosphere not of the present time.

In her monograph, the artist's widow states that one pur-pose of the book is "to place a balanced emphasis upon that period of his career when its imaginative horizons were most far-flung." What she has in mind, she makes clear, is to over-come the "stereotype" of Shahn as the painter of Sacco and Vanzetti, Tom Mooney, the Russian "peace offensive" dur-ing the Nazi-Soviet Pact, the Henry Wallace front of 1948, which was manipulated by the Communist Party—the ster-eotype that, for example, prompted Hilton Kramer in his re-view in the *Times* of the Jewish Museum retrospective to reject Shahn *in toto* as an illustrator enlisted in the propagan-da of the Old Left. By shifting the focus of attention from his early compositions to the nonpolitical creations of his last years—Hebrew and classical themes, abstractions, illustra-tions of poetry, mosaics, stained-glass windows—Mrs. Shahn has attempted to establish a final image of her hus-band as a free and independent artist obedient only to his feelings and imagination.

The Jewish Museum retrospective fails to contribute to this revision of Shahn. Regardless of the number of neutral sub-jects, its general effect is to continue the identification of

Shahn as a political artist. To alter this impression would be to present an unfamiliar Shahn, albeit one justified by the actual count of his creations. Moreover, the new Shahn would be inferior to the "stereotype." For it is only in his social and political compositions that his work attains an insistent and continuous passion that lends identity to his disparate concepts. Accustomed to working on assignment, he drew heavily—perhaps excessively—from his subjects, in contrast with artists who draw their works out of themselves and their medium. From his earliest efforts, Shahn habituated himself to *stating* his feelings rather than discovering or developing them on the paper or canvas. This is another way of saying that his emotions lie on the surface of his works and are not brought into unity by an underlying vision or temperament. With the collapse of the moral assurance of his public, and his own gradual withdrawal from politics, his visual statements ceased to be heightened by participation in virtue and became the diffused products of a gifted craftsman. What was needed then was not a wider range of topics—that could only result in further dilution—but a new approach to art.

# 13

# Beating the Game

---

James Ensor, the Belgian modernist painter, has been largely overlooked in this country. Two new books—"Ensor," by Roger Van Gindertael (Little, Brown/New York Graphic Society), and "Ensor," by John David Farmer (Braziller)—and a major exhibition of his paintings, drawings, and prints currently at the Guggenheim Museum, which organized it jointly with the Art Institute of Chicago, are contributing to rectifying this neglect. Given the originality of Ensor's paintings and his independence of art movements and dogmas, he could well provide the model needed by artists in today's chaos of doctrines and mannerisms. They might be heartened, too, by his denunciation of "false innovators who soon become pale and bloodless."

Ensor's rejection by the society and the art world of his time was not untypical of the fate of advanced minds of his generation, but his triumph over that rejection had a flavor of its own. Ensor was born in 1860, to a couple that ran a shop selling curios and shells in the seaside resort town of Ostend. During his twenties and early thirties, he conceived macabre tableaux, fantasy paintings, and still-lifes of a highly original character. By the middle of the eighteen-nineties, his major

Originally published in *The New Yorker*, 14 March 1977.

creation had come to an end. His sudden decline, however, appears hardly to have disturbed him, and he lived comfortably for more than half a century longer, reaping the increasing rewards of his early talent as if he were his own widow or heir. One thinks of de Chirico making a good thing of his past during his long life, except that Ensor apparently gained similar advantages without the effort. Through his gift of longevity, he survived to be named a baron by King Albert, to be exhibited in retrospectives both in his own country and abroad, to be visited by famous personages and admiring pilgrims, and to enjoy the serene routine of a town's official genius. Yet in the work for which he is celebrated Ensor is more explicitly alienated than other modernists not only from the humanity around him but from life itself. While the anguished isolation of his contemporary van Gogh is conveyed in the tones of yellows and greens, as in "The Night Café," Ensor's psychic estrangement takes shape in a nightmare theatre in which the personae of his world are reflected as drunkards, masks, skeletons, demons, corpses. The artist identifies himself with Christ, mocked and tormented and escorted into Hell by a pair of bushy-tailed devils. Nature is represented in his still-lifes by dead fowls, with their bloody necks hanging over the edge of the table, by that most hideous of humanlike fish faces, the skate, and by groupings of empty seashells, which are a kind of skeleton. But Ensor's pictures are saved from bathos and sensationalism by the direct, felt quality of his handling, by his matter-of-factness, and by their separation from the banal stage settings of nineteenth-century genre painting. Though Ensor spent three years at the Royal Academy in Brussels, his mature style has the forthrightness and improvised look of a naïve artist and the fervor of a social satirist. His carnival of disguises culminates in the masquerade of the artist himself as a genial, prosperous senior citizen, with a white beard, on a balcony overlooking the crowded beach at Ostend.

Neither of the two new studies casts much light on the attitudes or inner life of Ensor, whether as a raging recluse or as

the custodian of his growing fame. The Van Gindertael volume has the fuller text, which attempts to set Ensor within the context of the society, ideas, and art of his time, and its color illustrations are of better quality. The Farmer volume, which serves as the catalogue of the current Ensor exhibition, contains a checklist of the more than two hundred works in the show, and has the greater number of color reproductions. It is available in paperback, and includes a useful bibliographical note and an essay that outlines Ensor's career and the changes in his style.

# 14
# Outrageously Unique

The major creations of James Ensor—those "macabre" and "fantastic" paintings, drawings, and prints, at times viciously sardonic and farcical, which he produced between 1883 and the end of the century—have been troublesome to spectators, critics, and art historians since their appearance. Today, although Ensor is admired as an important contributor to various twentieth-century styles, uncertainties about the works themselves remain. There are numerous reasons for this, including the failure of Ensor actually to fit into any modern art movement. In the Ensor retrospective of more than two hundred items which is now at the Guggenheim Museum, there are canvases and drawings that come close to Impressionism, Symbolism, and social caricature, and some that are proto-Surrealist or Expressionist. Ensor himself, adopting an attitude not uncommon among modern masters, claimed to be the forerunner of everything, including Cubism, Dada, and Constructivism. But he can be identified with none of these modes; if he is a forerunner, it is of something all too rare in the art of his generation (van Gogh, Cézanne)—the avant-garde outcast who achieves fame and fortune not posthumously, for his heirs and descendants, but

Originally published in *The New Yorker*, 11 April 1977.

in his lifetime, for himself. This he managed by living to be eighty-nine.

The chief drawback to appreciating Ensor seems to me to lie not in his eluding historical and critical classification but in the fact that his paintings and drawings are *pictures* in the popular sense; that is to say, their interest centers on the persons and situations depicted. For all the praise of Ensor's color and light, his paintings are received as experiences of often disagreeable actual situations. In the great, unforgettable Ensors ("The Entry of Christ Into Brussels," "Adam and Eve Expelled from Paradise," "The Tribulations of Saint Anthony") as well as in many of the drawings ("The Artist Decomposed," "Skeletons Playing Billiards"), the subject matter calls attention to itself to a degree that overshadows the response to the work as art. It is as if the apples of Cézanne overtly enacted the erotic biographical scenario attributed to them by Meyer Schapiro. Or as if Picasso's girls of Avignon pantomimed the stories of their lives as harlots according to the version of Leo Steinberg. The rising to the surface of the narratives hidden in these paintings could hardly fail to result in critical bewilderment. Carried away by the scene before him, the spectator might distort, or neglect to consider, the aesthetic value of the work or its position in the hierarchy of art. Ensor poses a problem related to that of assessing naïve art: with him the incarnation of meaning takes place in full view. "The Painter Skeletonized in His Studio" shows the artist, with the head of a skeleton, at work in a blue suit, a palette in his left hand, two brushes sticking out of his breast pocket, while a death's-head perched on top of his easel curiously observes him with liquid eyes. The "message" of the skeletonized painter is not hard to grasp. Ensor has carried to the extreme the nineteenth-century theme of the alienated and despised artist.

Estrangement is fully realized only by madmen and the dead—others, no matter how far they may have descended into the underground, retain points of communication with society. In the eighties and early nineties, Ensor's alienation

was more extensive than that of his most troubled contemporaries, though perhaps not as deep, since, unlike van Gogh and Nietzsche, he did not go mad. His milder state lent itself to symbolism, and death had become fashionable in Belgian painting around the time of Ensor's self-skeletonization. Yet, though not mad, he was isolated culturally, socially, and professionally. A Belgian who, except for a few very brief visits abroad, never left his native land—and hardly even left his birthplace, the seaside resort town of Ostend—Ensor was an outsider by nationality to new developments in art, more like an American than like a European. He could have complained with Whitman that originality was forced upon him—that, deriving nothing for his art from his surroundings, he had "all to make." Socially, he was no better off. His parents ran a shop that sold seashells and curios; family wrangling was continuous; and the shopkeeper neighbors had no use for the young man who wasted his time in the studio above the store. Not much more gratifying were Ensor's relations with his fellow-artists—the group, Les Vingt, with which he was associated excluded his best paintings from its exhibitions. Thus, at twenty-six he already pictured himself as "The Artist Decomposed," and two years later he made an etching, "My Portrait in 1960," which depicts the pile of bones he would be a century after his birth. He followed these with "My Portrait as a Skeleton."

Ensor complements his skeletons as symbols of self-estrangement with masks, demons, murdered men. In primitive and early cultures, masks are portraits of inhabitants of another world, including gods, demons, and the dead. In our time, they are a means of concealing identity, for the purpose of crime or entertainment. In all instances, the mask replaces the natural self with another. In carnivals, the mask is the means by which the individual blends into the crowd. Ensor exploits all the associations of the mask—death, the supernatural, disguise, anonymity—to evoke distance, as in "Self-Portrait with Masks" (not in the retrospective), in which his head stands out among animal masks and masks of Indians,

blacks, devils. In "Portrait of an Old Woman with Masks," the face of the woman is itself a mask, though the golden flesh tones distinguish it from the grinning fabrications that surround it. The spectator is reminded that nature, too, is a maskmaker, using age as its favorite way (it has others) of turning human faces into unchanging apparitions and into that ultimate undifferentiated mask the fleshless skull. Ensor's most direct depiction of the natural masquerade of likenesses, from which Darwin drew so much, is his still-life of fish, shells, and a huge skate, or ray, its body shaped like a bell and its head a mask of human malevolence. This painting, entitled "The Ray," exemplifies the tendency in Ensor's still-lifes to show the heads of fish and fowl hanging over the edge of a table to emphasize their deadness.

Ensor's Biblical pictures develop the same emotional design as his skeletons and masks. In the powerful "Adam and Eve Expelled from Paradise," two small naked creatures, separated from each other, are fleeing across a muddy terrain, pursued by a strange, machine-like angelic construction in the sky. Many Ensor paintings and prints show Christ being tormented by demons or engulfed in a crowd as he enters Jerusalem or Brussels. There is no celebration of him as the Saviour. Ensor identifies himself with Christ harassed: "Christ Tormented by Demons" is accompanied by "Demons Teasing Me," made in the same year.

Awareness of the alienation that pervades the works of Ensor's great period is, however, of minor help in grasping the content of individual paintings. There is a kind of wildness in Ensor's imagination, and his lack of aesthetic and ideological affiliation allows it to run unchecked. An art movement, no matter how much it might encourage the irrational, supplies an adherent with a vocabulary of visual forms which illuminates his work with the outlook of the movement as a whole. With Ensor, the imagination takes control without drawing on any common storehouse of aesthetic or intellectual references. "Scandalized Masks" represents a sinister and apparently decisive confrontation that is like an encounter in

"Crime and Punishment," but with no hint of the story. The spectator is left suspended among possible interpretations. "The Good Judges," a bloody caricature that features tools of dismemberment and fragments of the body and face, is like an illustration of an unknown fable or a partly forgotten nightmare—a pictorial equivalent of a tale by Kafka. A self-derived imagery comparable to Ensor's appears in the painting of Philip Guston after his rejection of abstract art. In his canvases now at the David McKee Gallery, the disposition of identifiable objects—boot soles, a ladder, a closed fist—results in a narrative mystery with metaphysical overtones which is moving but indecipherable. Incidentally, Guston, too, has made extensive use of masks and caricature. Like the naïve artist, the outsider to accepted styles is constantly on the verge of being outside art itself. Isolated subject matter constitutes the essential difference between Ensor and Ernst or Dali, whose strangeness soon yields to identification within the Surrealist idiom.

Ensor's "Skeletons Fighting for the Body of a Hanged Man"—in the center of which a wretch with a foot-long tongue hanging out of his mouth is suspended from the ceiling while two harpies dressed in old finery and armed, one with a pole or curtain rod, the other with a parasol and a feather duster, duel with each other above the body of a skeleton clown collapsed on the floor, and a crush of masks led by figures with knives push in from the sides of the canvas, all in a complex harmony of colors—partakes more of the crazy vivacity of a circus poster or an amusement-park sideshow than of the exhibits in an art museum. Indeed, Ostend as the physical site of Ensor's imagination is a kind of old Coney Island—including the Coney Island Mardi Gras. It was the annual carnival at Ostend, for which Ensor's parents sold masks, that, according to biographers, inspired the artist's adoption of this motif. Related to the amusement park, too, are Ensor's powerful reds, blues, and glowing golden hues, and the animation that makes him kin to the Expressionists. With their sideshow aspects, even his most

gruesome conceptions take on something of the frivolity of the waxworks chamber of horrors and of melodramatic vaudeville. His works are saved from bathos by their matter-of-factness and black humor. Like Poe, another isolated original, Ensor conveys the assurance that his melodramas evoke real issues of the spirit. His slices of narrative frequently consist of ominous horseplay—for example, "Dangerous Cooks," a drawing of a respectable-looking restaurant whose waiters are critics who serve on platters the heads of Belgian artists, including one with a card stuck in it saying "ART ENSOR." The artist's celebration of the grotesque in misery and death is exemplified in such a title as "The Devils Dzittz and Hihahox, Under Orders of Crazou Riding a Furious Cat, Lead Christ to Hell." Frolicsome morbidity reaches its peak in "Skeletons Playing Billiards," in which one player takes advantage of the open structure of skeletons to make a shot by thrusting his cue through the rib cage of a player in front of him.

The autobiographical impulse in Ensor's images relates his work to American subjective abstraction of fifty years later, such as Gorky's "Garden in Sochi" series and the compositions of the Action painters. But Ensor achieves his inwardness within a broad range of interests. As with Melville, objects in his hands tend to transform themselves into symbols without losing their character as things, so that his masks, demons, and other paraphernalia of horror exist in an environment of credibility. Ensor's fiction of being dead by no means made him dead to the world. His images are forceful because even at their most arbitrary they are built out of actualities—police, beggars, drunkards, street crowds—and retain associations with experienced emotions. Despite his withdrawal into himself, his outlook was that of a whole individual, immersed in his surroundings and judging them. Paintings such as "The Gendarmes," with its two bloodied corpses stretched across the center of the panel, and "The Strike," with its obscure violence, files of soldiers, and sky filled with a swirl of banners, are direct responses to official

brutality. "The Good Judges" and "At the Conservatory" are bitter caricatures of representatives of social authority. In etchings such as "Pride," "Avarice," "Lust," "Gluttony," Ensor states his opinion of mankind itself.

Ensor's sensitivity to politics, popular feeling, social and intellectual issues, and the function of art and his absolute originality as well are summed up in his masterpiece, the huge (if not by today's standards—it is roughly eight and a half by twelve and a half feet) "Entry of Christ Into Brussels." In the foreground is his mob of variegated masks, including one of a death's-head with a high hat, to the right of which, on a green platform, are clown orators and, perhaps, acrobats. Behind the masked crowd, columns of soldiers almost conceal Christ on a gray donkey, behind whom masses of microscopic humanity stretch to infinity. Above and to the sides are banners and placards carrying slogans: "LONG LIVE SOCIALISM," "LONG LIVE JESUS, KING OF BRUSSELS," "DOCTRINAL FANFARES ALWAYS SUCCEED." The colors of "Entry" match the animation of its compositional masses. Instead of being guided by natural light and hue, Ensor chose his pigments for their psychological resonance, as in children's paintings and folk art—and in the paintings of Fauvists and Expressionists who were to follow.

By the end of the nineteenth century, Ensor's bloody-mindedness had begun to fade, and, with it, his creative powers. In 1907, the catalogue of the retrospective asserts, he began "to copy some of his earlier works in bright versions." Under the influence of his more cheerful mood, his "fantasies" assumed the character of legends and fairy tales, as in the decorative "Finding of Moses," with its princesses, swans, and peacocks. Some of his sardonic skeleton themes were revived as jokes. The old power reappears in "The Artist's Mother in Death," a composition in pale yellows done in 1915, which shows the corpse, a crucifix clutched in gnarled fingers, reclining diagonally behind a surprising barricade of medicine bottles. It is, however, his complex, and at times impenetrable, pictures of the eighteen-eighties and nineties

which place Ensor in the front ranks of modern art. As late as 1971, a Belgain biographer, and one, moreover, who had access to much unpublished source material, could entitle her study "Ensor the Unknown." In that his major paintings are episodes in an invented autobiography, Ensor is likely to remain unknown. But his inaccessibility makes him a model of the artist who in a dry season accepts the challenge of relying on his own creative resources.

# 15

# Souvenirs of an Avant-Garde

Robert Rauschenberg is undoubtedly America's No. 1 artist of the 1976–77 season. His current retrospective of more than a hundred and fifty creations in various mediums was a Bicentennial feature last fall at the National Collection of Fine Arts, in Washington, D.C., and was hailed by record crowds and with appropriate enthusiasm in the press. *Time* awarded him a cover story entitled "The Most Living Artist," and this was matched by the *Times'* "Art That Sings," illustrated with a half-page montage announcement by Rauschenberg himself, when the show opened in New York, at the Museum of Modern Art. John Russell found in the retrospective "some of the finest art that has been made in our lifetime," and he opined that "Mr. Rauschenberg's 'combine paintings' of the mid-1950's were the epitome of all that is best in the traditions of this country." Mr. Russell's feelings ran so high that, although he is customarily the booster of everybody, he was carried into an attack on members of the art public who had failed to appreciate early enough "that these works represented a critique of pure painting as radical as anything in Immanuel Kant's 'Critique of Pure Reason,'" and he abused the late Hans Hofmann for having "beaten

Originally published in *The New Yorker*, 16 May 1977.

into his students" the use of blocks of color whose "crashing obviousness" in Hofmann's hands was the extreme opposite of their "singing" in a canvas by Rauschenberg.

It is a stereotype of the nineteen-seventies that the original Abstract Expressionists (Pollock, de Kooning, Hofmann, Kline) went around bowed to the earth by inner anxieties and profound metaphysical ponderings. The image of their black sufferings, to which Rauschenberg himself has been an important contributor, provides the intellectual background for the current homage to Rauschenberg. The theme of his celebration is "Joy." "He is," wrote *Time's* art critic, "a model of the joy of art." "Brash and joyful work" was the lead of the Museum of Modern Art's press release announcing the show; it went on to describe Rauschenberg as "perhaps the most innovative, prolific, and audacious artist since Picasso." Dr. Joshua Taylor, director of the National Collection of Fine Arts, found that Rauschenberg had achieved a state of "continuous freshness" by lifting himself above a consciousness of art history: "His career has been characterized not by a set of styles but by a persistent creative exuberance that has the happy effect of belittling categories, invalidating definitions, and freeing the viewer to discover beauty and meaning where he might least expect it." Joy and exuberance provide an alternative to ideas; in literary circles this set of values is known as anti-intellectualism. One is urged to believe that the art world has been overburdened with thought, and that Rauschenberg has come as an embodiment of inarticulate energy—a kind of Mynheer Peeperkorn or Harpo Marx—to liberate art and the art public from excessively precise thinking.

Rauschenberg has claimed again and again, to rounds of applause, that he never starts with an "idea" but that his works evolve through "collaborating" with materials. In the interest of clarity, one feels obliged to point out that an artist needn't start with an idea when the ideas he employs have been at work long before he began. Finding in the street or in shops things that art can be made of has an extensive and complicated history in the twentieth century. From Josef Al-

bers, under whom he studied at Black Mountain College, Rauschenberg learned about Bauhaus students' combing city streets after the First World War for debris to make up for the scarcity of art materials. His buying a stuffed goat from a store window in order to incorporate it into a sculpture was a reënactment of the Surrealists' street-foraging expeditions of fifty years ago. It is true that Rauschenberg has never been respectful of the thinking or the history behind the works on which his creations have been based. He has maintained that he owes little to art, and that for anyone to call attention to influences upon him is an affront. "Influences in my case," he recently told an interviewer, "are rarely art works." In his view, the origins of his paintings, collages, and assemblages (for some reason, the art world has accepted his term "combines," as if he had conceived a previously nameless form) lie in the actual objects that are incorporated or reproduced in his compositions. The notion that the artist's materials—canvas, paint, ready-made images, found objects—can be made to "work with" the artist in determining his creations is a traditional element of twentieth-century avant-garde magic. Miró, for example, believed his canvases to be alive with energies that could be induced to generate significant signs. Anything added to a surface is sufficient to animate its space and set the image-forming activity in motion; Hofmann's "push and pull" and Pollock's "contact" with the canvas are variations of the same approach. The painting surface becomes the equivalent of the artist's unconscious, and he could say with Rauschenberg that his "method was always closer to a collaboration with materials than to any kind of conscious manipulation and control." Instead of moving toward resolution in a structure, the spontaneously conceived composition remains open, to attract an indefinite quantity of visual data (images, brush marks, accidental stains, objects) that seemingly place themselves at random. In employing this method, Rauschenberg has added data provided by photographs and by silk-screened or otherwise transferred images. The powers attributed to the artist's materials are

insufficient, however, to qualify these accretions as works of art. That involves the evolution of modern ideas and modern taste, in which the pioneering of earlier artists is indispensable.

Rauschenberg's claim to aesthetic autonomy in the face of his obvious debts—to Schwitters' buildups of random scraps on painted areas, to Abstract Expressionist untidy surfaces, to Dada dissociation, to commercial photomontage, to bizarre combinations of objects in Surrealist window dressings—implies a state that is hardly joyous. Reviewing Rauschenberg's first exhibition, in 1951, Stuart Preston, of the *Times*, described it as "stylish," which is more to the point than the current critics' formula of unpremeditated discharges of delight. From the start of his career, Rauschenberg has been in and of the art world; he is an art-world wit, attuned and responding to prevailing opinions and phases of taste. He is frequently quoted as saying that he wishes to function in the gap between art and life; but for him there is no gap—art *is* life. There is nothing discreditable in his role of Mannerist of postwar American vanguardism. But his performance has been anything but playful, particularly in his disengaging himself from artists to whom his work is indebted. Mr. Russell may have instinctively reflected the spirit of his subject when he accompanied praise of Rauschenberg with an attack on an ancestor.

Rauschenberg's relation to art is stated with maximum succinctness in his explanation of "Erased de Kooning Drawing" (1953), his first major coup in calling attention to himself: "I was trying both . . . to purge myself of my teaching and at the same time exercise the possibilities." He wanted, in sum, to discard the philosophical and emotional motivations of the Abstract Expressionist mode while elaborating on its visual traits. One wonders whether he was aware that he was embracing a formula for parody—for it is parody adjusted to changing art-world fashions which best characterizes his accomplishment. When Rauschenberg effectuated his erasure of the de Kooning (it took, he has said, a month of labor, and

traces of the original are still apparent), Abstract Expression-
ism was the reigning advanced mode in painting, and hence
the gateway to recognition as a member of the vanguard. One
of the aspects of the Abstract Expressionist style which are
responsible for its effect of freedom is the accessibility of the
artist's forms to his whims and afterthoughts. The triumph of
this style over the fear of overt disorder makes it receptive to
non-art images and objects, thus harmonizing it with aspects
of Dada. Pollock and John Little glued driftwood into paint-
ings; de Kooning pasted into his paintings fragments of ad-
vertisements and segments of discarded canvases, and he
retained fingermarks and used offprints left by newspaper
columns and pictures on wet paint.

With the deletion of the subjective content on which the
tension of its compositions depends, Abstract Expressionism
could appear a program of wantonness. But along with the
Action painters—Pollock, de Kooning, and so on—the Ab-
stract Expressionist movement included painters of ex-
pressive colored rectangles: Newman, Rothko, Reinhardt.
Like hundreds of other artists of the nineteen-fifties,
Rauschenberg reflected the Abstract Expressionist mode in
coagulations and drippings of pigment on geometrically orga-
nized grounds. The "Black Painting" (1951–52) in which he
divides the canvas equally into an all-black area and one acti-
vated by strokes of color is a compositional duplicate of a
Newman that combines the two poles of the Abstract Ex-
pressionist manner. Rauschenberg, however, was among the
first consciously to discard the "expressive" program of the
Abstract Expressionist leaders, and this left him free to "exer-
cise the possibilities" of the apparent randomness of the style
by building his compositions out of an unlimited range of ma-
terials: rags, photos, soft-drink bottles, earth, painted-over
reproductions of masterpieces, bits of wood and metal. (He
seems especially attracted to neckties.) A major work in the
retrospective is the significantly titled "Collection" (1953–54),
which consists of three vertical wooden panels on which ver-
tical bands of red, yellow, and blue of different widths, like

boards in a patched-up fence, are overlaid with scribbles and runnels of paint and a collage of items that include rectangular cuts of cloth, torn newspapers, and a picture of a man on horseback. A good part of the Museum of Modern Art exhibition consists of variations on Abstract Expressionist clutter—at first actual substances but later largely ones simulated through montages of images silk-screened or transferred from photographs and reproductions.

Rauschenberg's reputation has grown through a series of *succès de scandale*. The earliest of these, and the most effective after "Erased de Kooning," were "Bed" and "Monogram"; more recent efforts, including staging himself as a dancer, collaborating with engineers, and, in the "Carnal Clocks" show, exhibiting photos of sex organs, never quite came off. "Bed," done in 1955, is, I think, the artist's most original creation and, almost accidentally, the most comprehensive and symbolically intelligible of his works. It transcends his often expressed ideal of impersonality—his desire to be, or present himself as, a "material," like the materials he uses. "Bed" affirms the autobiographical essence of Abstract Expressionist painting by constituting itself out of one of the most intimate of objects at the same time that it underlines, by acts of mutilation, the formal structure of that object as a rectangle fastened to a frame. "Bed" consists of a patchwork quilt under which Rauschenberg slept for several years and to which he has added his pillow and a sheet. This assemblage is daubed with paint and hung vertically, like a canvas. Nostalgia is recurrent in Rauschenberg's early collages—later his associations became more public. The quilt of "Bed" evokes rural domesticity, while the serial pattern of squares associates it with advanced abstract art. At the meeting of the quilt with the pillow and bed sheet there is an effect of something cut open; stained with red paint, the gash suggests violence and, in the context, nightmares. According to the exhibition catalogue, "Bed" has, since its first appearance, "stirred heated controversy"—in 1958 it was banned from the international exhibition at Spoleto—but we are not told why or

about what. In any event, it is, in my opinion, the apex of Rauschenberg's inventions: an authentic Abstract Expressionist vision brought to fulfillment by utterly original means.

In contrast, "Monogram" (1955–59) seems to me to be a disagreeable and pointless work. That it is Rauschenberg's best-known and most extensively reproduced piece is a comment on the kind of admiration that accounts for his current preëminence. In its final form (despite his belief in things as they are, Rauschenberg strained over it for five years), "Monogram" is an assemblage of a stuffed Angora goat with an automobile tire around its belly mounted on a wooden platform on wheels, to which a variety of objects—a tennis ball, a rubber heel—have been affixed. Rauschenberg bought the goat on impulse, and his problem over the years was how to transform the goat, with its heavy fleece, which descends almost to the floor, into art by fitting it into a setting, or "frame." One may see this as essentially a decorator's problem. On another plane, however, it is an extension of Duchamp's aesthetics, in which a ready-made object is "aided" to become art by means of changes that leave its identity intact—as with his urinal and bicycle wheel—while situating it in the orbit of art through mounting, signing, and display in an art gallery. Rauschenberg solved the problem of his goat by applying the Surrealist principle of incongruity: he ringed its body with a tire whose tread he painted white. He also slopped paint on the face of the goat. "Monogram" has always struck me as offensive—particularly the disfiguration by paint of the noble face of the goat, like a pie landing on the face of an old lady in a slapstick comedy. There is an element of slapstick or college humor (collage humor?) in Rauschenberg's approach to art which is often gratifying—including the deadpan nonsense by which he explains what he has done: the tire around the goat was "something as familiar and unavoidable as the goat." But recently I have learned, with surprise, that many spectators have objected to the goat's paint-sullied face, and that Rauschenberg has offered a

practical excuse for the paint: the goat's muzzle was damaged when he bought it, and he applied the paint to hide the defect. If this is a fact, it is inconsistent with Rauschenberg's philosophy of "with me, it's a matter of just accepting whatever happens."

The major strength of the retrospective is to be found in its takeoffs of Abstract Expressionism, and in its resort to Dada in sculpture: "Empire II," "Oracle," "Sor Aqua." "Factum" (1957), a two-part painting, is a model of intra-art-world satire. A composition executed with apparent spontaneity is duplicated almost exactly, down to the last drip, smudge, and collaged photos, on a second canvas. Seeing the pair together demolishes instantly the spectator's belief in the spontaneous improvisations of the Abstract Expressionists—and also in Rauschenberg's own spontaneity. (Oddly, the paintings have been separated, one having gone to Milan, the other to Chicago, and this dissipates the interest of both.) Rauschenberg's art depends for its substance on the art that it negates—his richest period was the nineteen-fifties. Later vanguard modes have failed to arouse his reactions to the extent that Abstract Expressionism did, and he has had to repeat himself in experiments with different techniques. His stream of compositions assembled from silk-screened and transferred images in paintings, prints, and posters seems endless. All his novelties have acquired a fully developed familiarity. The 1975–76 "Jammer" series—beautifully designed assemblages notable for their spareness and air-lofted fabrics—suggests an attempt to take a new direction. But, without an art-historical analogue to flesh them out with references, these works are a reversion to decoration, and could serve as nautical displays in the windows of Abercrombie & Fitch.

Whatever the condition of art itself may be, a vanguard art public still exists, its energies concentrated in its professionals: museum directors, art journalists, history-conscious collectors. This public needs avant-garde artists, and if no genuine ones present themselves it will take what it can get. The slogan of contemporary art showmanship can only be

"Great Events As Usual." The fervor over the Rauschenberg retrospective has something about it of a closing of ranks against a threat—the threat of running out of living sources of masterworks. That Rauschenberg's energetic search for novelties, if only in his experiments with materials and technologies, has not declined qualifies him as the standard-bearer of the partisans of the new, regardless of whether his discoveries are new, aging, or old.

# 16
# Kenneth Noland

In art, the nineteen-sixties was a decade of stylistic program-ming and public-relations coups rather than of outstanding creations. The Kenneth Noland retrospective at the Gug-genheim Museum raises the question: What remains of art inspired and made publicly acceptable by critical doctrine after that conceptual cover has begun to disintegrate? Do the paintings revert to simple visual fact? Or do some tatters of their thought systems continue to cling to them? Noland was one of the spearheads of American formalist painting and sculpture—the simplified structures that increasingly pre-empted space in galleries, museums, private collections, and art magazines in the latter half of the sixties. Whatever their differences in appearance and handling, these fabrications were united by a preoccupation with problems of the material nature of painting—problems of surface, dimension, edge, color. The retrospective of Noland's twenty-year career di-vides itself into groups that pursue these problems in five for-mats: concentric circles (targets), wedge-shaped images (chevrons), diamond-shaped or horizontal paintings com-posed of colored stripes, and eccentric colored shapes on ec-centrically shaped canvases. These more or less neutral,

Originally published in *The New Yorker*, 20 June 1977.

rationally conceived patterns have been much lauded for re-
ducing painting to a single fundamental element—color—
and for eliminating superfluities, such as emotional ex-
pression, personal narrative, and symbolic references. It has
been argued that because the central impulse of modernism is
to reduce each art to its essence—poetry to words, music to
sound, drama to rhetoric and gesture, and so on—Noland
and those who think like him constitute the avant-garde of
painting today.

The formalist approach seemed to promise the possibility
of new art that would not dissipate itself in eccentricities but
would embody the essentials of the masterpieces of the past.
By the first years of the present decade, however, the for-
malist aesthetic, with its systematic exclusion of everything of
import to the mind and the imagination, had begun to expose
its poverty as a basis for persuasive works. Indeed, it ap-
peared to more than one observer that the formalists' verbal
dialectics were stronger than the paintings and sculptures
that illustrated them. In 1971, the magazine *Artforum*—the
central source of formalist emissions, in which articles on
Noland and representations of his various formats had fol-
lowed one another with obsessive frequency—changed its
editor and its editorial policy. Since then, formalist domina-
tion of the art world has declined into the holding action of a
handful of diehard theoreticians, plus a few docile curators of
East Coast museums; the pioneers of the movement seem to
be edging into other areas, and no new talent has emerged.
In a recent article about *Artforum*, Jack Burnham, a critic who
dates modes of art as if they were perishable groceries, flatly
characterizes Noland and his peers (Olitski, Stella) as "fading
wallflowers of the 1960's." Reviewing the Guggenheim retro-
spective, Robert Hughes, the art critic of *Time*, recalls the "in-
timidating" effect of the "supporting criticism" piled up in
behalf of Noland's canvases, and exclaims, "Who, under that
shadow, could call a stripe a stripe?" Quoting the closing
paragraph of the Guggenheim catalogue, in which Diane

Waldman, the curator who directed the retrospective, ranks Noland with masters since Delacroix, Hughes denounces as spurious and transient the version of art history on which Noland's elevation rests. "This litany," he writes, "might have read better ten years ago than it does today; it is incantatory rubbish. Delacroix was not a 'color painter' in any sense of the word that can be applied to Noland." Hughes then mentions some motifs to which color is applied in Delacroix's canvases: "theatricality, lust, tigers and Arabs."

A reassessment of the thinking on which an artist's recognition rests compels a reassessment of his work, particularly when thought and work are as closely identified as they are in Noland. The Guggenheim Museum deserves credit for delaying its presentation of Noland until the artist was, so to speak, out in the open intellectually and aesthetically. Premature celebration of artists by major museums both here and abroad, which in effect make public money and institutional prestige available to reinforce a promotional apparatus, is a primary obstacle to critical evaluation. Only when the selling of the artist has run its course can a valid consensus be reached regarding the level of his work as an aspect of contemporary culture. It is not that the spectator, as Hughes suggests, should feel free to call a stripe a stripe but that he should be aware of distinctions in the ways that stripes are employed in art, and of the aesthetic, social, and philosophical consequences of those distinctions. Noland's striped canvases have rich decorative possibilities—although these are not fully realized at the Guggenheim, owing to the monotonous symmetry of the hanging, and in general because of Noland's bland sense of color (doctrinal emphasis on color does not guarantee talent in handling it). If the paintings' effectiveness as ornamentation were all that was in question, the determination of Noland's merits could be left to each spectator's taste in interior design. But the intellectual context of his canvases has involved them in a redefinition of painting itself—an issue that transcends decoration. Between one

mode of art and another, what is at stake is nothing less than contemporary man's (to use a favorite phrase of Hans Hofmann's) "search for the Real."

Noland has drawn on a tradition, but one wonders what he has contributed to that tradition. He has been influenced by, among others, such painters of stripes and experimenters with color as Jasper Johns, Mondrian, Albers, Klee, Bolotowsky, and Newman—above all, by Newman. Johns' "Target with Four Faces," an immediate precursor of Noland's concentric circles, intimates a dramatic relation between the target shape and a shooting gallery or a firing squad by inserting in a space left above the circles sections of sculptured faces at which the marksman might be taking aim. In her catalogue essay, Mrs. Waldman attempts to distinguish between Johns' and Noland's targets on exclusively formal grounds. Noland, she writes, "concerned himself totally with flatness, achieved . . . by enlarging the circle as much as possible within the limits dictated by the square canvas." In fact, not all of Noland's targets approach the edge of the canvas, those that do are no "flatter" than those that don't, and "Target with Four Faces" crowds the edge more than Noland's "Winter Sun" or "Burnt Day." But what is the consequence of an artist's concerning himself exclusively with "flatness"—in itself an aesthetically meaningless quality, since it has been characteristic of the paintings of numerous unrelated cultures? Mrs. Waldman's formalist description of Noland's intentions supports the conclusion that concentration on flatness means that imagination and observation of phenomena have been excluded in favor of exercises in the optical behavior of colors: Do colors advance or recede when juxtaposed in circular bands? Nor are Noland's exercises carried out consistently, as are those in Albers' researches into the interactions of colors. For all its pretense of intellectual discipline, formalism has no content to explore—its sole ambition is to produce "good" paintings. Noland's early targets achieve an emotional effect through reference to Abstract Expressionist animation in their loosely

brushed outer rims, which contrast with cores of hard-edged rings, as in "Rocker," "That," and "Round," all done in 1958–59. "Globe" (1956), a single hand-drawn circle on a vaguely spotted ground, is a suggestive hybrid that combines Abstract Expressionist informality with a kind of languorous desire for order which seems part of Noland's temperament. "Untitled" (1958), "Lunar Episode" (1959), and "Mesh" (1959) introduce a whirling motion into the target format by activating the outer circle through staining and directional brushstrokes, although the core of the target remains static to the point of rigidity. Noland's 1960 targets and his later "cat's-eye" paintings (circles within ovals) become increasingly mechanical as the artist deletes all effects except those that illustrate formalist doctrine.

More fundamental than his difference from Johns is Noland's difference from Newman—a difference that is also more subtle, since the works of both artists are totally abstract and devoid of visual reference. Newman's striped paintings provided Noland with his most contemporary model, one that even seemed relevant to the goal of "flatness." Yet the meaning of Newman's work places it at the opposite pole from Noland's. Newman's paintings, too, are predicated on the conviction that "less is more," but for him the decision as to what is superfluous is made in accord with the profoundest feelings of the individual artist. With Noland, committed to "objectivity," the elimination of elements of painting, like the elimination of subject matter, is carried out in obedience to a presumed principle of evolution in art. For him, Mrs. Waldman writes, "the primary function of shape is to serve as the vehicle for color. . . . Shape [is a] carrier of color." "Vehicle" and "carrier" are terms introduced by Newman, but for a purpose entirely different from the subordination of painting to color. The abstract shape, said Newman—rectangles, squares, chevrons—was for the Kwakiutl Indians of the Pacific Northwest "a living thing, a vehicle for an abstract thought-complex, a carrier of awesome feelings." In painting, Newman sought the power to transmit a reality beyond

painting. Purging his format was a means of expanding its content. In contrast, Noland uses his colored stripes as a sufficient substitute for content. The resulting differences in the paintings of the two artists are enormous. A Newman, though it is composed of the same elements as other Newmans, has the tension of a singular creative act. A Noland, in which personality has been renounced in favor of theory and method, lacks the variousness of actual experience.

Whether by accident or intent, in Noland's most successful designs the primacy of color is sacrificed to other aesthetic factors. Extreme disproportion of length and width—a formal device in which Noland was preceded by Newman's "The Wild" (96 × 1½ inches) and "Outcry" (82 × 6)—lends tang to his horizontal paintings "Sound" (30 × 216) and "Intent" and "Kind" (both 10 × 144) and to "Plaid's Time" (103 × 14½), a vertical rectangle. Their odd dimensions give these paintings an Expressionist effect, which supersedes any reaction that their undistinguished pigments might induce. A successful exploitation of shape also occurs in the compressed diamond format of "Approach" (96 × 22) and of "Untitled," "Deep Pillot," and "Dry Shift" (all 96 × 24). The radical disruption of the rectangle and the diamond (a square set on end) changes a painting from a surface on which to transmit an image, or a "vehicle for color," into a thing. Noland's declared intention to "neutralize the layout" in order to stress color—a program similar to that of Albers' "Homage to the Square" series—is inconsistent with elongated and squeezed-together forms that distract the spectator by introducing elements of arbitrariness and surprise.

Paintings still more in violation of the formalist program, and the most enticing in the retrospective, are two horizontal lozenge-shaped canvases—"Shift" and "Shade" (both 1966)—that appear to float away from the wall, owing to an illusion created by perspective. Here, as in the elongated strip paintings, color plays a minor part. In "Shift," the illusion of a square receding from the spectator is heightened by the greater width and stronger colors of the bottom two bands.

Since the bottom two bands of "Shade" also produce the illusion of being closer to the spectator than the top two, one may perhaps assume that the spatial illusion was deliberate and that Noland was quietly exploiting effects not contemplated by the formalist scheme.

In both its origin and its presentation to the public, however, Noland's is a collective art, bound by rules and principles rather than by an effort toward the realization of individuality (condemned by formalism as "romantic self-expression"). In different degrees, all art is, of course, a sharing—without imaginative and conceptual interchange, there could be no art movements or "schools," and certainly no style of a given place or period. But extremely refined gradations exist in the degree and manner of the intervention by others, from instruction and commands from above to hints derived from fellow-artists. All art study begins in doctrine, and the way out into art is through works. Centered on a set of predefined problems having to do with paintings as objects of a certain kind, and firmly repulsing chance, whim, accident, dream, and the irrational, American formalism achieved a conscious group purposefulness that had not been evident in art since the functional aesthetics of the nineteen-thirties. For the public, the authority of the formalists may have been augmented by their presentation of themselves as nonpersons, guided in their responses to works by objective axioms rather than by developing sensibility. One is interested to find Noland quoted in the Guggenheim catalogue as seeking in his preformalist days a way "to arrive at making art that was more personal" than that of the Abstract Expressionists. Yet his biography is charted by encounters with critics and like-minded painters and sculptors which seem more collaborative than "personal." Decisive for Noland was his meeting with Morris Louis in 1952 and their visit the next year to the studio of Helen Frankenthaler under the guidance of the critic Clement Greenberg. With Greenberg, whom Noland met frequently in Washington and New York, and with David Smith, who accompanied Greenberg on his Washington vis-

its, Noland established what the catalogue describes as an "intense relationship." Extending the collaboration story are Noland's colloquies with Olitski, Caro, and Jack Bush, the critic Michael Fried, the curator Kenworth Moffett, and other members of the Greenberg "family." Apparently, Noland's temperament made him ideally suited to personify the extroverted formalist outlook.

For all his awareness of the critical "intimidation" at work in behalf of Noland, Robert Hughes exemplifies the difficulty of shaking off its aftereffects. While he demolishes the absurd contention that the essense of the masterpieces of the past is crystallized in the A-B-C shapes of formalism, he remains convinced that Noland is an outstanding, though limited, painter. Noland's targets seem to Hughes to possess "an airy energy that few American painters (and no European ones at the time) could equal." They "bloom and pulsate with light. They offer a pure, uncluttered hedonism to the eye." In short, Hughes has accepted the judgment of Noland as a spectacular colorist, though he insists that praise of Noland stop with that. Everyone is entitled to what he finds in paintings, but for me there is nothing distinctive in Noland's color. Contiguous bands of paint are always effective, either through harmony or through conflict. As wall decoration, stripes can't go wrong. As to "flatness," the point is not that the two-dimensionality of the canvas should be preserved by making the pigment one with it through soaking but that the act of painting should evoke counteractions from the hidden life of the surface. Noland's inert patterns rarely awaken the energies inherent in his materials.

# 17

# American Surrealist

The "Cronus" series of David Hare revivifies the beyond-art impulse of the original Surrealists. It took about two hundred and fifty works in various mediums, created over a ten-year period, to complete the project—that is, for Hare to exhaust his theme. Of this enormous production eighteen paintings, ten drawings, and five sculptures now on display at the Guggenheim Museum provide a bird's-eye view, and an impressive one. André Masson summarized the Surrealist aesthetic when he explained that he had resorted to automatism in his sand paintings because he had "an intuitive feeling that by this means I would soon find something that I could make my own." To arrive at an image that the artist could recognize as his unique sign, or the clue to it, was conceived by the Surrealists as both self-fulfillment and the unveiling of a truth. Hare's "Cronus" creations began in doodling—a popular term for "automatic drawing." Through doodling, the artist was endeavoring "to find out what I was trying to do." The conjuring up of Cronus—the Titan who overthrew his father, Uranus, and was himself overthrown by his son Zeus—came later, with the emergence of human and animal figures and organs, together with atmo-

Originally published in *The New Yorker*, 24 October 1977.

spheres generated by Hare's highly individual drawing, color, and handling of sculptural materials and symoblic suggestions. These the artist has interpreted as involving universal phenomena, such as time, repetition, rebirth.

Automatism and other Surrealist-devised techniques for tapping the unconscious have entered into American art movements since the war, from Abstract Expressionism to scatter sculpture. In general, United States artists have exploited psychic processes and chance combinations as devices for picture- and object-making in accepted styles. For the Surrealists, in contrast, art itself was only a means; officially, at least, they held the professional artist in low esteem. The true calling was to be a "seer," or oracle, as pictured by Rimbaud. In his prefaces to Surrealist exhibitions at the Museum of Modern Art, William Rubin has stressed the "attitude of doubt and suspicion with regard to the métier of the painter that was typically Surrealist." Surrealist paintings, objects, collages were conceived as modes of magical research—the activation of the unconscious was to result in an unanticipated glimpse of the self and the world. Surrealist practice aimed not at form-making but at divination through signs and talismans. "The emergence of a figure was solicited," Masson added. In the crisis between the wars, the creation of a new myth that would transform human consciousness was central to Surrealism—its alternative to the political revolutions of the left and the right.

Through its search for the myth, Surrealism passed over into postwar American painting and sculpture. This overlying motive of Surrealism was grasped by American artists (in institutional circles, Surrealism was and still is considered to belong to the tradition of "fantastic" art) only with the arrival in New York of leading Surrealist writers and painters as refugees from Nazi-dominated Europe. In a memoir composed for the catalogue of the recent "Paris-New York" exhibition at the Centre Beaubourg, Hare describes the transforming effect of the physical presence of the Surrealists. "An idea," he writes, "is a marvellous thing. But one can do nothing with it

before knowing the relation that exists between it and a human being. And that is what we saw during those years. Avant-garde art was not just a pure idea—it had a head, two arms, and two legs." Hare, a beginning artist in the war period, became editor of Breton's magazine *VVV* and exhibited in the Julien Levy Gallery, the showcase of Surrealist art during the thirties and most of the forties. A work such as his sculpture table "Magician's Game," with its echoes of Giacometti and Ernst, is an early example of the new American sculpture that began to carry a charge of legendary reference. Hare's "Cronus" series extends the symbiosis of Surrealism and American sensibility which in the forties and fifties produced the myth-inspired paintings of Pollock, Rothko, Newman, Gottlieb, Baziotes, and other Abstract Expressionists and the sculpture of David Smith, Nakian, Bourgeois, Lipton—all summed up by Herbert Ferber in the title "Surrational Zeus." The American art that has followed, relieved of the socio-historical pressure of the pre-war and war years, has tended to abandon the oracular aspects of Abstract Expressionism in favor of its formal (color painting, Minimal sculpture) and methodological (random collages, aleatory structures) implications.

The "Cronus" creations constitute an act of faith that a signifying language is still attainable in art—that painting and sculpture can convey meaning beyond parody and exercises in the elaboration of forms. The essence of Hare's accomplishment lies in his almost obsessive persistence in pursuing the clues that arose out of his decontrolled drawing and are reënacted in his paintings and sculptures. The line drawings at the Guggenheim, most of them executed in 1967–68, when the series was begun, are sketchy fragments of anatomy and scene brought to light by the released pen or pencil. In their lack of formal or Expressionist intent, they amount to an overture of provocative and occasionally erotic riddles. As episodes of Hare's dreamlike narrative, however, they take on interest from their emergence as refrains—in the paint-and-collage "Cronus Descending" (1968), as the arm and

mouth shapes and the body folds of "Cronus" (1969), in "Cronus Hermaphrodite" (1970), and as solidified statements in the colored steel-Plexiglas-and-bronze sculpture "Cronus" (1973). These motifs recur as abstract or near-abstract shapes and as recognizable entities, realized to different extents and in different materials: they become for the spectator recollections that are at once vague and ineradicable.

A similar combination of transitoriness and persistence is achieved in the large canvas "Young Monster" (1967) through hints of anatomy in sheets of acrylic washes tacked to the surface by small bands of tape. Another train of associations is initiated by the painting "Ice Dog" (1967), an Expressionist representation of Cronus-as-animal whose whiteness and fangs of icicles embody, as if invoking the theme of whiteness in "Moby Dick," the ferocity emanating from Arctic regions of being. "Asleep in the Cave" (1971) is a magnificent abstract painting, which provides no representational clues but relies on its nuancing of color to convey the mood of the series. Hare, who used to be known as a sculptor, succeeds in this exhibition in demonstrating that he can control pigment to serve his subtle expressive ends. "Blue White Red" (1967), another early canvas, is unidentifiable by me in the "Cronus" context, unless the circle in the center represents the Titan's head; I prefer to believe that a slippage from the theme occurred as a result of the artist's surrender of intention to the automatic process—a similar derouting is suggested by "Deep Summer" (1969), which is not in the show.

By 1968, Hare had stabilized his images into flat, emblematic abstractions that retain eye-shaped discs as human/animal leftovers. In "Cronus Descending No. 2" (1968), the discs may also represent breasts, and the inverted crucifix in the center of the composition is the nose or the phallus, or an anticipation of the trunk in the painting "Cronus Elephant" (1975). In the sculptures at the Guggenheim, done from 1973 to 1976 in mixed metals and plastics, the chief features of the paintings and drawings have

congealed into signs: the arm rising out of the earth and the nose-phallus-crucific are the outstanding elements. Perhaps the key to these images of eroticism and resurrection is Sartre's observation in 1950 that Hare "offers at the same time . . . religion and the sacred object"—or, if not religion, its anthropological content.

The Cronus legend is one of the most primitive and savage in Western culture. It accords with the nocturnal, jungle feeling of Hare's spiny sculptures of the fifties. Cronus, lord of the Titans, castrated his father, took his sister for consort, and devoured his children. In his scale of conduct, cannibalism and incest were as normal as sleep. Cronus is a subterranean deity: Hare has conceived his insigne to be an arm reaching out of the ground either in supplication or as a sprouting of the dragon's teeth. Cronus is part earth, part animal, part demon, part human. He is both young and old, asleep and awake, a dog, an elephant, hermaphrodite, mad. He is force without form, a hound of hell, the night mind, with its criminal desires and horrors—after "Ice Dog" comes "Night Dog" (1973). As an expression of the artist's personality, as symbolic autobiography, the present work tends to support Sartre's view that Hare "sculpts horror," and the late Robert Goldwater's detection of "cruelty" in his forms. For Hare, however, the fierce disorders of "Cronus" extend beyond the individual: they are manifestations of "a primitive, undirected, chthonic will" at large in the world. They presuppose an image of the present time as a jamming together of the whole evolutionary range of human urges, from those of the pygmy village to the utopian world state. Cronus, Hare declares, is mud "growing into man but always remembering his beginnings." In philosophical terms, he is "half man, half time." (The misidentification of Cronus with Chronos goes back to antiquity.) What is crucial in this conception of man is the "remembering," the survival of barbaric residues in the civilized psyche—the lesson gleaned by Surrealism from Freud and Jung. Hare's Cronus is a personification of the chaos, violence, and dissoluteness of contemporary life, and

his drawings, paintings, and sculptures constitute a "portrait" of this personification. The ancestor of Hare's Cronus (given his Roman name) is Goya's nightmare "Saturn Devouring His Children."

Hare's imaginings of Cronus shift from one technique to another, one medium to another, one stage of realization to another. The flux is the measure of the inchoateness of his idea; what he has to say can be touched on but not conceived—despite which he insists on stating it. The difficulty is that an art of signals and hints can convey its emotional substance only within a communion of experiences, ideas, beliefs. The Surrealists attempted to mold such a communion through their interchange of below-consciousness experiments, their games, and their group compositions of poems and drawings. Among the Americans, solidarity on this level never came into being. Artists who attempted to perform oracular feats were obliged to achieve them in isolation.

A one-man myth is almost a synonym for pathology. The "Cronus" creations have a psychological authenticity that leads one to assume that Hare has survived visits to troubled areas of the imagination. In the absence of the Surrealist community as mediator, art since the war has found itself better fitted to convey aesthetic pleasure than subrational enlightenment. Even works that arose out of depths of fury, such as Picasso's "Dream and Lie of Franco," have been quickly translated into episodes of formal development. The history of Abstract Expressionism includes the abandonment of its mythical motive and the substitution of stylistic affirmations; examples are David Smith's late-period "Cubi" sculptures and the "evolution" of color painting out of Pollock and Newman. The persistence of Hare in dedicating his art to what it could disclose is underlined by his refusal in the thirty-five years of his activity to arrive at a format capable of being appreciated for itself and adapted for formal purposes by others. He has frustrated the impulse of the spectator to bypass the artist's content in favor of a glorified trademark. Though Hare is an unusually accomplished craftsman, his

works are still at times described as "crude"—a characterization that Smith applied to himself in his great days of improvisation. Style with Hare is a superbly flexible instrument in which each painting and sculpture must find its own form, as with de Kooning and, recently, Guston. For example, in the two "Cronus Old" paintings Hare relies on indistinctness to cause the god-monster to appear to be fading away, but other paintings, such as "Asleep in the Cave," are the opposite of indistinct. The "Cronus" show at the Guggenheim is a rich sampling of an undertaking that is extraordinary yet central to the art of our time.

# 18

# Twenty Years of Jasper Johns

━━━━━━━━━━━━━━━━━━━━━━━━━━━━━━

What is pure art according to the modern idea? It is the creation of an evocative magic, containing at once the object and the subject, the world external to the artist and the artist himself.

*Charles Baudelaire*

Back in the fifties, Jasper Johns solved the problem of supplying subjects in painting that everyone could recognize: the American flag, targets, numbers, letters of the alphabet. The problem had arisen out of Abstract Expressionism, then the dominant mode in art. The abstract painting derived from Cubism had brushed Cézanne's apples off the table, then brushed away the table. But postwar American artists were not satisfied with an art of meticulously balanced rectangles and bands. The Abstract Expressionists were "abstract," but they insisted on subject matter. Barnett Newman declared that the basic issue for him and his friends was what to paint. A school for art students formed by Newman, Rothko, Baziotes, and Motherwell in 1948 was entitled "Subjects of the Artist." Social and regional themes had been exhausted, and the dissociated imagery of Surrealist "dream-

Originally published in *The New Yorker*, 26 December 1977.

work" had been turned into light comedy by Dali and Holly-wood. Convinced that there was nothing to paint but that subject matter was the heart of painting, the Abstract Expressionists conceived an ingenious strategy: they approached the canvas with no subject in mind, got the picture going through random marks—a number 4 by Pollock, a slash or blot of color by Kline or Hans Hofmann, letters of the alphabet by de Kooning—and, taking off from these forms, relied on the spontaneous activity of painting to supply (or reveal) a subject of its own. In short, the motif of the Abstract Expressionists did not exist either in the mind of the artist or in the outside world; it was entirely a creation, in that it was brought into being by the act of painting. Newman formulated the matter: "An artist paints so that he will have something to look at."

In his newly born subject, the artist made contact with an inchoate myth, which was called in the rhetoric of the period the Unknown. For Newman, his rectangles divided by vertical or horizontal bands were ritual evocations—of Ulysses, the Biblical Abraham, the Stations of the Cross, shafts of power or light. For most of the art public, Abstract Expressionist paintings—stripes (Newman), ovals (Gottlieb), strands and drippings of pigment (Pollock), aerated blocks of color (Rothko), contours and color masses (de Kooning, Hofmann), chromatically keyed brushstrokes (Guston), bars of black (Kline)—were abstractions; that is, organizations of line, color, and form without external relations. Their subjects, real to the artist, came and went, depending on the psychic collaboration of the spectator. In terms of meaning, this collaboration was the point of the painting: immersed in the possibilities of the artist's sign, the spectator could share the creative élan of bringing it to light. An Abstract Expressionist painting completed itself in making an artist of its spectator. Critics, curators, and much of the public, however, rejected the invitation of the Abstract Expressionists to enter into the aesthetic adventure and preferred to peruse their products as decorative images.

With his first one-man show, in 1958, Johns swept aside
the dilemma of Newman and the Abstract Expressionists. If
the answer to "What to paint?" was an unintelligible sign
that troubled the spectator like a leftover of a bad dream, it
was only necessary to eliminate the mystery, and the gap be-
tween the artist and his public would be closed. By such rea-
soning, Johns became one of the first to hit on the idea of
producing signs that were familiar to everyone. His use of
flags, targets, numbers, letters of the alphabet, objects of
daily life was supported by a childlike logic—or the humor-
ous shrewdness of a farmer who outwits the city slickers with
a practical solution too obvious for them to have noticed.
Flags, numbers, nouns, and names (Johns' "Liar," "Ten-
nyson") belong to the order of phenomena that loom large in
the consciousness of children and plain folk. When its subject
matter consists of, in Johns' phrase, "things the mind already
knows," painting is relieved of the effort of discovery for both
artist and spectator—familiarity with Old Glory and the
number 3 blocks speculation about them, even when they ap-
pear in works of art. With Newman, the painted image repre-
sented a "thought-complex." With Johns, it represented
nothing. It was what it was, like a stone or a fence—in brief, a
thing, clearly labelled with an image (target, flag) or a concept
("Liar," "Tennyson"), as in a mail-order catalogue. At one
stroke, Johns extinguished speculation about the meaning of
individual paintings and directed attention to them as objects
among other objects.

Johns' subject matter did not need to be invented or dis-
covered, nor did it have to be evoked out of psychic states
that were difficult to maintain—for example, Pollock's "con-
tact" with the canvas or de Kooning's "inspiration." It lay
ready to hand. Better still, his flags, numbers, and targets
were already on the way to being paintings, in that they were
signs inscribed on a flat surface, apt for placement and han-
dling in any manner the artist chose. Banners of sorts had
appeared among the Abstract Expressionists: Gottlieb's three
solid ovals above a horizontal field of black; Pollock's "Blue

Poles," which one could easily imagine being adopted by a Third World republic. Dispensing with riddles, Johns' subjects were ideally suited to reduce the strain of both thinking and feeling in painting. Confronted by images that it had had no part in creating, painting was as if struck dumb—its guiding axiom after Johns became "You see what you see."

Johns had split Abstract Expressionist painting into two halves: its signs and its agitated handling. Thus divided, both halves were emptied of meaning. Having ceased to embody the artist's psyche, the signs on the canvas joined the order of insignia outside of art—for example, the insignia on packing cases, from which Johns has tended to derive his lettering. Deprived of its goal of discovery, the liberated brushwork of de Kooning, Hofmann, Kline became merely a newly fashionable mode of ornament. As put together in Johns' flags, targets, and numbers, the two halves of Abstract Expressionism became substances of an art completely manageable by the artist, and entirely void of meaning. Every attempt at interpretation was thrown back by the artist's disavowal of purpose. The principles he was prepared to proclaim consisted exclusively of negations of Abstract Expressionist truisms. No more romantic fumblings, supported by declarations that "when I am in my painting, I'm not aware of what I'm doing." No more pretensions of invading the Unknown. No more "self-expression." To Johns could be attributed a philosophy linked with postwar phenomenology—homemade with him but capable of being stretched by his interpreters to any dimensions they chose. Thus, exegesis of Johns has become a major part of art criticism during the past twenty years, in the midst of which the artist himself has been privileged to preserve a strategic silence. What has been insufficiently stressed is that—apart from Johns' ideas and his interpretations of them—in his paintings both sign and method have become subject matter, modelled on the canvases of his predecessors but transformed by his determination to keep himself out of the picture. The contrast between the agitated surfaces of Johns' flags and targets and the inertness of

these motifs presents a lesson in the illusory effects of style considered as expression, since the flags and the surface textures were chosen with the same detachment. Johns' cold-blooded rearrangements of the ingredients of America's passionate postwar abstract art amount to a double parody.

The relaxation of the tensions of Abstract Expressionism which Johns brought about was seized upon with relief by his contemporaries and by artists who came after him—his translation of the recondite sign language of the Abstract Expressionists into commonplaces provided a manageable approach for the generations of painters streaming out of the new university studio departments. It is difficult to believe that Johns himself, a beginning artist from South Carolina in his mid-twenties, could have comprehended the long and complex interchange that led to the Action paintings of Pollock, de Kooning, and Hofmann and the emblematic paintings of Rothko, Gottlieb, and Reinhardt. One of Johns' contributions to the art scene was to cut painting down to his own size, and to help keep it there. Just the other day, a California artist echoed the early Johns in explaining to an interviewer that "almost every object that I use is something we all know, that we all have reference to." Abandoning his shamanistic role, and the rites required to realize it, the post-Johns artist could anticipate a career not too different from that of his nonartist neighbor. In contrast to the vanguard tradition of anxiety (Cézanne), Surrealist self-induced abnormality (Rimbaud's "disorder of the senses"), and "failure" (de Kooning), Johns introduced into American modernism an era of undelayed success: the Museum of Modern Art, in a unique display of foresight, bought three paintings from his first show.

Beyond any innovation introduced by his paintings, Johns' strongest influence lay in his renovation of the artist as a type—an act of dramatic originality. The new artist, an emotionally detached craftsman whose work represents a kind of expository chalk-talk on the rudiments of painting and sculpture, was in intellectual harmony not only with the art-de-

partment classroom but with the ever-growing mass of new museum- and gallery-goers being initiated into the enigmas of modernist art. Reacting to painting as a social reality, Johns and other post-Abstract Expressionists looked back to Duchamp, as the disillusioned analyst of the relation between art today and other man-made things, and forward to Andy Warhol, as the artist changed into media celebrity and manufacturer of art substitutes. In this perspective, the one factor in modernism that became irrelevant was the inner self of the artist—precisely the animating principle that Abstract Expressionism had elevated to supremacy. Johns' watchword was impersonality. His exclusion from the art image of any underlying objective reality was completed by the exclusion from it of the aura of the artist as well. Like Ad Reinhardt and certain American followers of the Russian Constructivists, Johns strove for a condition of metaphysical aloofness akin to a quasi-religious asceticism. Leo Steinberg, who contributed the most elaborate speculations concerning Johns' early works (though unaccountably neglecting to take note of the degree to which those works derived by antithesis from Abstract Expressionism), has testified that Johns told him that his aim was to achieve total removal from his products. "He wants his pictures," Steinberg wrote, "to be objects alone." Johns' "Coat Hanger," which features a wire hanger centrally suspended against a dense ground of black crayon, is a public declaration that the artist prefers the identity of an anonymous, commercial object to his own. "Coat Hanger" is an idealized self-portrait of Johns as Mr. Anything.

Johns' redesigned artist plays dispassionately with the possibilities of his craft, including its ability to simulate emotion by technical means—for example, the muscular paint strokes, the impulsive blottings of the Abstract Expressionists. In some instances, Johns' subjects are painted as if the artist had never heard of painting but had simply wanted to reproduce the Stars and Stripes or a target as faithfully and attractively as he could. Together with this takeoff of the naïve artist ("Flag," "Flag on Orange Field"), Johns dis-

played a virtuosity in transmuting his images that was seemingly without limit. The American flag ceases to be a flag and becomes an abstraction—a rectangle divided into bands of color, with a smaller rectangle containing even rows of stars in the upper left-hand corner. Apparently, Johns sought the ready-made form in order to give free play to his talent for remodelling. "Flag (with 64 Stars)" is an indication that for him the flag is a design that he has the privilege of altering at will. Besides having an enlarged number of stars, "Flag" is drawn in pencil, and its stripes, without color, at times blend into each other. The Stars and Stripes is by no means a model design—Betsy Ross would not have distinguished herself at the Bauhaus. There is a disturbing fussiness about the stars, clustered in the upper left corner. The best painting in Johns' flag series is "White Flag," in which the visual annoyance caused by the stars is reduced by coördinating them into the textured monochromatic surface. A similar gain through reduction of contrast is obtained in "Green Target" and "Tango," but such one-color paintings come close to eliminating their subject matter (in "Tango" it is invisible), and thus returning to their Abstract Expressionist origins. Once a given subject has been established, it can be counted on as a presence affecting the spectator's response, as in de Kooning's "Woman" paintings. Some of Johns' canvases, drawings, and prints—for example, the "0 Through 9" series—tend toward pure abstraction, as if the artist had found his way back to Constructivism. On the whole, however, he has rarely relinquished his Abstract Expressionist resources. And throughout the passage from painting to painting, and from paintings to drawings to prints, an ironic dialogue persists between his subject/no-subject and the technique of representation which he has chosen.

About fifteen years ago, in an article entitled "Things the Mind Already Knows," I analyzed some of the paradoxical effects obtained by Johns through his impersonal juggling of style and subject matter. These effects were concentrated in his flags, targets, numbers, coat hangers. After this period,

however, Johns' work seemed to me to begin to abandon shared subjects in favor of ones that were personal symbols or souvenirs. Perhaps the first of these more personal works was "Device Circle," done in 1959, which could be read as an autobiographical sketch of Johns' painting career to that date. On a square canvas covered with interlaid patches of paint and newsprint fragments a circle has been inscribed by the semblance of a nail at the end of a paint-spotted stick, which is fastened in the center of the canvas, as if in preparation for another target painting. This is Johns' first painting about Johns rather than about "Target," "Flag," or "0 Through 9," and in it Johns is presented as a "device" for making paintings. "Device Circle" is followed by other paintings of studio subjects—"Painting with Ruler and 'Gray'" (1960), "Good Time Charley" (1961), "Device" (1961–62), and "Fool's House" (1962)—and by sculptures: the bronze Ballatine ale cans and the paintbrushes in the Savarin coffee can. Contemporary with these are such narrative-suggesting compositions as "No" (1961), "Liar" (1961), "In Memory of My Feelings— Frank O'Hara" (1961), and the ink drawing "Disappearance II" (1962).

During this period, Johns continued to work in lithography on his old themes, but the universal signs diminished, and in 1963–64 the subjectivity of his paintings seemed to deepen to the level of desperation. A series of paintings and drawings bear titles referring to water—"Diver" (1962), "Passage" (1962), "Land's End" (1963), "Diver" (1963)—and in several compositions oblique bars are thrust upward and terminate in blotted hands, like arms raised in a call for help. "Periscope (Hart Crane)," done in 1963, identifies these water-associated canvases with the poet, who committed suicide by drowning. The blotted hand of "Land's End" and the two "Diver" works also appears in "Periscope" and in two "Study for Skin" drawings done in 1962; it represents the theme of water-related death again in "Skin with O'Hara Poem" (1963–65).

Johns' symbolism of self is neither very lucid nor visually

very attractive. "Periscope (Hart Crane)" and the "Diver" compositions share with works by Rauschenberg a kind of willful messiness designed no doubt to represent directness and spontaneity (though spontaneity ought not to be a goal for an artist who doesn't want his work "to be an exposure of my feelings"). Johns' parody of Abstract Expressionism becomes an obstacle when he resorts to that style to express emotions. In the current Jasper Johns retrospective at the Whitney Museum, I found several works of the middle sixties which continue the morbid theme of the water paintings. One of these, "Watchman" (1964), features a motif that Johns repeats in several works of the decade: a wax cast of a leg "seated" on a fragment of a chair and attached to an upper corner of the canvas. But the outstanding works in the retrospective are the early paintings and sculptures. Since the flags, the targets, and the numbers, Johns has occupied himself chiefly with translating these explicit subjects into drawings and prints. He has also executed several salon "machines" with assorted objects attached. Among these are giant compositions, such as "According to What" (1964), that are far more incomprehensible, both as subjects and as paintings, than any Pollock or Hofmann—except perhaps as anthologies of Johns' favorite motifs, including his canvas on a stretcher with its face flat against a larger canvas, and his cast of a severed leg.

"Flags" (1965), "Two Flags" (1973), and "Target" (1974) are attempts to revive the old magic. But the art-historical drama of twenty years ago—replacing Abstract Expressionist enigmas with familiar signs—cannot be repeated, and this defines the position of Jasper Johns at the end of 1977. Johns' new motifs keep getting more arbitrary and whimsical. In 1967, he hit on the "flagstones" that constitute the left section of "Harlem Light" and consist of irregular shapes of flat red and black scattered among similar shapes indicated in contour on a gray ground. According to the exhibition catalogue, Johns picked up this image from a wall in Harlem which he passed in a cab—an act of finding analogous to Rauschen-

berg's seeing a stuffed goat in a store window. The flagstones have become an element in Johns' repertory. Like the American flag, they are "things the mind already knows," though it doesn't know why it should pay attention to them—unless in obedience to the Duchampian edict that a thing is art because the artist says it is (a demand that, in my opinion, has used up its credit).

Another new motif that appears in the retrospective consists of cross-hatchings in varieties of color, thickness, and solidity. The hatchings are more suggestive than the flagstones. For one thing, through constant shiftings of direction they constitute a form of animation, and impart a surface shimmer to the canvas akin to, though unlike, Pollock's skeins of thrown paint. In that respect, the hatchings are late Abstract Expressionism. "Weeping Women" (1975) and "End Paper" (1976) demonstrate the capacity of this motif for arousing feeling through color, as in a storm-darkened landscape. Johns' use of the hatchings in a poster that he executed for the retrospective, and in a lithograph that appears on the back cover of the catalogue, seems to me to sum up his essential vision. The poster presents an image of his Savarin-can-with-paintbrushes sculpture in which the brushes consist of vertical paint strokes against a background of the zigzagging strokes of the hatchings—a synthesis of Johns' theme of things changed into paint and paint into the images of things. The masterwork among the current signs included in the retrospective is "Untitled" (1972). A huge painting and collage, it consists of a panel of hatchings, two panels of flagstones, and a panel of wooden slats crossing each other at random, on which are mounted parts of the human body in pink plaster (the body parts, a third new motif for Johns, are a reminiscence of inserts of plaster faces and organs in two early "Target"s). The lack of reference of the motifs of "Untitled" stresses the arbitrariness that has replaced Johns' original objectivism—an arbitrariness far exceeding that produced by Abstract Expressionist inwardness, since inwardness imposes necessities that tend toward an order.

# 19
## Artist of Our Time

Oskar Kokoschka begins his autobiography, "My Life" (Macmillan; translated by David Britt), by reflecting on how one becomes a human being. Since he is a painter, it seems to him that development takes place primarily through seeing. Studying human faces and the contours of avenues and countrysides has been his basic mode of learning. In the view of OK (this is how he frequently signs himself), the benefits of seeing are not only for artists; at Salzburg, during the fifties and early sixties, he conducted a School of Seeing, whose influence spread throughout Europe and the Americas. "Art cannot be taught in a school," he noted, but "I would be able to educate young people to *see*." The italics are his. (Hans Hofmann had anticipated this with his own pre-war "learning-to-see" teachings in Munich, New York, and Provincetown.) "My Life," published in Germany in 1971, when Kokoschka was eighty-five, is an eyewitness spanning of European history and art history in this century. As a portraitist, OK had the opportunity to scrutinize at close quarters the physiognomies of individuals prominent in politics and the arts, from Adenauer and Masaryk to Pound and Toscanini (Kokoschka thought him too coldly remote to

Originally published in *The New Yorker*, 24 February 1975.

paint). Crossing and recrossing Europe between the wars, making an extended tour through North Africa and the Near East, finding refuge in England from the Hitler takeovers, he became intimate with the changing moods and physical character of harbors, cities, mountain retreats, deserts.

Yet the interest of "My Life" is not primarily in its visual description. Imagining and theorizing have been as natural to Kokoschka as looking. He has managed to elude, one after another, the great catastrophes of his time—"I have my own skin to save, and that is my greatest concern"—but he has opinions about the calibre of this age and all sorts of related matters: democracy and progress, the advantages of multinational empires, the spiritual characteristics of the ancient Greeks, the relative merits of Céline and Joyce. He even predicted, he tells us, on the basis of topographical observation, that oil would be discovered in the Libyan desert. Though he is resolutely opposed to political ideologies as well as to the ideologies of art movements—"I contributed no manifestoes, not even a signature; I was not going to submit my hard-won independence to anyone else's control"—he has nothing in common with those who believe that a painter ought to think of nothing but painting, a poet of poetry, and so on. What he wants to say he will say, in any medium he can use. His first success in gaining public notice came not through his canvases but through "Murderer, Hope of Women," a play he wrote, produced, directed, and proclaimed with a scandal-raising poster; it is regrettable that "My Life" does not include a synopsis of this play, generally described, according to Kokoschka, as a pioneer Expressionist drama. His book of semi-fanciful narratives, "A Sea Ringed with Visions," is a work of genuine literary quality; some episodes of "My Life" are imaginatively elaborated in it, and it repeats the dreamlike story of his being stabbed by a Russian in the First World War.

For Kokoschka, the twentieth century opens in prewar Vienna—"Wittgenstein's Vienna," as it has recently been dubbed—a city of cast-iron conventions and prejudices, of

fiery polemics (Karl Kraus), of ultra-radical intellectual experiments (Schoenberg, Freud, Adolf Loos), of Secession and the Jugendstil movement in art. The crisis that was to become the normal condition of Western culture in our era attained its articulated form in this capital of the Hapsburgs. From the start of his career, Kokoschka found himself struggling to keep his footing on constantly unstable ground; in this respect his life has matched the history of twentieth-century art itself. Inwardly, he was troubled by problems of belief (the "atmosphere" of Catholicism captivated him, but he resisted its credo) and sex. "The erotic advance of the female principle," he explains in typical, metaphysically overloaded mid-European lingo, "almost at once put my hard-won equilibrium in jeopardy." He was, however, consoled in his unrest by the realization that "I was not the only one treading dangerous waters. The whole world seemed to be in the grip of an existential malaise, no longer believing in the possibility of individual action or the control of one's own future."

Kokoschka's strategy for coping with the unruliness of the times was to travel light; he has kept on the move with the minimum amount of physical and mental baggage. In his fictional "Sea," his favorite nickname for himself is "the Traveller." Since his student and café days, his social manner has been genial and even gregarious. He made many influential friends (the first one was Loos), who collected his paintings and put him in the way of portrait commissions. But close as he might come to anyone, OK has been wary of affiliation. A founder and collaborator of the Expressionist periodical *Der Sturm*, he has steadfastly denied that he is an Expressionist, though art historians continue to list him in that category. "What is said about it today is entirely misleading—the whole core of the idea is lost. There is no such thing as German, French, or Anglo-American Expressionism: there are only young people trying to find their bearings in the world."

In any case, OK was determined to mind his own business, if only because "I, above all, had no money." What he did have was the indispensable talent of the serious modern art-

ist—the talent for going hungry. In Berlin, during his employment by *Der Sturm*, his diet consisted of one mark's worth of sausage on Sunday, bread and tea for the rest of the week; the hallucinations brought about by semi-starvation inspired the lovely story in "Sea" of his and his roommate's imaginary daughter Virginia. Even after his paintings were much in demand, he continued to find himself with empty pockets. In England, in 1938, at the age of fifty-two, while John Rothenstein, director of the Tate, kept talking enthusiastically about acquiring one of his paintings for the museum, Kokoschka was wondering whether he would be served dinner. (He was forced to settle for sandwiches.) In "Sea" he proposes what might be called a missed-meals interpretation of modernism: "Artists have always been good at going hungry, but no other epoch has ever provided so many technical expressions for the artistic sublimation of hunger: Expressionism, Futurism, Cubism, Dadaism, Surrealism, abstract art."

Kokoschka's status as a hunger artist (to adapt Kafka's term) may have been a factor in qualifying him for inclusion in Hitler's "Degenerate Art" exhibition of 1937. Though he was neither Jew nor Socialist, his art was offensive to the Nazis because of its "distortion" of natural appearances, which is inherent in extreme experiences, strong feelings, and an individual way of seeing. It was also totally lacking in nationalist fervor. OK is a "good European," but without local ties; though he was born in Austria, his father was Czech. Nor does Kokoschka feel loyal to his epoch; to him it's "the prosaic present." Modern in sensibility, he is philosophically anti-modern, a foe of democracy, of the ideal of Progress, of the exaltation of science and technology.

Many of his attitudes belong to the backward aspects of the time and place in which he grew up. He is possessive toward women, inclined to consider himself irresistible to them ("she never forgave me for repaying her in cash, instead of in the manner she had expected"), and as jealous as a schoolboy. His three-year love affair with Alma Mahler, widow of the

composer, broke up when Kokoschka flew into a tantrum because she had in her house a death mask of Mahler that "I had forbidden." He recounts without a trace of embarrassment, and with even a degree of gloating, that his mother, to prevent his reconciliation with Alma, threatened to shoot her and paraded in front of her residence pretending to have a pistol in a coat pocket. Later, in Cairo, there is the "beautiful Princess Eloui," who promises to spend a night with the artist among the columns in the desert but is turned down by OK because she had had a similar rendezvous with a French poet; he regrets the missed opportunity when he learns that the poet is not interested in women (as if this would have saved Eloui from the sin of being unfaithful to him before they had met).

Kokoschka's self-engrossment appears to go hand in hand with a certain detachment in regard to moral issues in the public life of the period. Though from his student days on Jews were among his closest friends, and he himself was hounded out of Europe by the Nazis, his comments on Hitler are surprisingly bland. He cautions against singling him (or Stalin) out as a "scapegoat," preferring to blame the "technostructure of Progress and Enlightenment" for the atrocities of the Third Reich. In England, during the war, he took a position above the battle, condemned the British bombing of Dresden, and exhibited an allegorical painting, "What We Are Fighting For," that equates Fascist and Allied leaders and policies. Praising the British for allowing him freely to speak his mind in the midst of the war for survival, he contradicts himself by insisting that "people are all the same."

For all his antipathy to ideologies, Kokoschka seems to have absorbed from his intellectual background an ingrained disposition to explain events, and even individual behavior, with historically determined concepts: a mind is rarely as independent as it thinks it is. Discussing the emergence of the Third Reich, he questions whether "other nations would have behaved differently in the age of mass society, itself the consequence of the uncontrollable development of tech-

nology." He castigates Joyce's "Ulysses" and "Finnegans Wake" (which is misspelled) on the ground that they reflect the evil effects of the same technological impetus. Pound's broadcasts from Italy during the war were, in OK's opinion, occasioned by his "mistaking the true nature of technology. . . . His crime, like that of Socrates, consisted in failing to conform to the official view of what democracy is." And Kokoschka "washes his hands" of Pound as another casualty of democracy.

Kokoschka's eccentric notions are consistent with his dramatization of himself as "the great outsider," and with his generally low opinion of mankind. The substance of his experience and his vision is, of course, in his paintings and eloquent drawings. It is regrettable that many of his views support the contention that painters ought to paint and shut up. Yet few genuine artists today are content to function as neutral makers of objects; a life spent in the phases of a continuous crisis demands a total response. In his autobiography, plays, and other literary works, Kokoschka employs words to reach into areas of thought and feeling not attainable by the brush. He writes as a writer striving for expressive statement, not like a specialist giving an account of episodes in his career. His life story ends with a complex gloss on Dürer's "Melencolia," in which he sees prophetically embodied the inescapable fear and loneliness of the post-Renaissance individual in his solitary quest for "the experience of becoming truly human."

# 20
# Willem de Kooning

Willem de Kooning is the outstanding painter of the ideological epoch in American art, the period since the 1930s when painting and sculpture have been contending with one doctrine after another, political and/or aesthetic. A factor of de Kooning's supremacy has been his astuteness in handling himself and his talents in relation to prevailing ideas. His canvases are permeated with intellectual character, yet never illustrative of a concept. They have the strength, surprise, emotional range, and, on occasion, the arbitrariness, of a temperament. In a milieu of nervously interlaced borrowings, the de Kooning signature is unique. While art under the pressure of preconceived formulas has been undergoing steady imaginative shrinkage, de Kooning's creations have gained steadily in formal inventiveness and symbolic reverberation. As against what might be called the self-starving tendency in contemporary art—the effort to produce masterpieces by minimum means, such as color or shape—a de Kooning canvas is as unrestricted as Union Square. His compositions devour everyday sights, odd thoughts, moods, theories old and new, paintings and sculp-

Originally published as the Introduction to *Willem de Kooning*, text by Harold Rosenberg (New York: Abrams, 1973).

tures of the past. He has the hungry multifariousness of the Renaissance humanists, the "vulgarity" of Rabelais and Cervantes. His abstractions and female figures are no less accumulations than if they had been put together out of newsprint, rags, and rubbish (some de Koonings do incorporate strips of tabloids, cutouts of magazine advertisements, sections of discarded canvases). Ready-made materials are, however, too clumsy a medium to carry the lightning darts of de Kooning's insight. The constant interchange of image and symbol, direct impression and analytical generalization, can be seized only through the action of the brush. A creation such as *Excavation* or *Woman, I* could not be the result of a mere combination of displaced elements, as in collage or Pop Art. Transformation had to be total, that is, it had to take place simultaneously in the psyche of the artist and on the canvas.

De Kooning's stubborn refusal to submit to any external discipline or to adopt a contrived identity is the philosophical substructure of his art. "The only certainty today," he wrote in 1949, "is that one must be self-conscious. The idea of order can only come from above. Order, to me, is to be ordered about and that is a limitation." For thirty-five years he has continued to find the means to keep his art in touch with the flux of his self and with changes in his intellectual and physical environment. Symbols of metamorphosis and instability dominate each phase of his work—woman and the sea are the most constant. For him, the female and the seasurface are at once concrete realities, and metaphors for the "tremblings" of nature and the "I" which he long ago discerned as the leitmotif of Western art since the Renaissance. In de Kooning's mature work, landscapes and the human figure become, in Shakespeare's phrase, "dislimned and indistinct as water is in water." Rejecting any definition of himself or his surroundings, he conceives painting as a performance through which the self interacts with things with increasing subtlety. "I get freer," he observed a few years ago, indicating what might be considered the purpose of art in our ep-

och. "I feel that I am getting more to myself in the sense of having all my forces. I think whatever you have you can do wonders with it, if you accept it. . . . I am more convinced about picking up the paint and the brush."

De Kooning believes that the artist must begin with art as he finds it; in creating he is free, but he creates within a given context. In the twentieth century, this context is the avant-garde art movements. In regard to these movements de Kooning's thinking evolved slowly toward a decisive conclusion. From the thirties to the middle forties he absorbed Cubism, Social Realism, Neo-Plasticism, Surrealism—but in absorbing he deranged. For example, in the face of the socially conscious paintings of the pathetic (and potentially heroic) Little Man popular in the Depression, he produced the strange staring males of *Two Men Standing* and the brooding lonely figures, vaguely "proletarian," aristocratic, and hermaphroditic, of *Man, Glazier,* and *Seated Figure (Classic Male)*—images that are near self-portraits executed as recondite experiments in perspective. In the same period he participated in the Neo-Plasticist tendency of American abstract painting with *Abstract Still Life* and *Pink Landscape,* in which the picture space is symmetrically apportioned and geometrical shapes are placed in balance—except that in de Kooning's Neo-Plasticism the dividing band of *Abstract Still Life* fails to reach the bottom of the canvas, and the balance of *Pink Landscape* skids on the bootlike forms, while its rectangles and circles are neither rectangular nor circular.

In brief, absorbing the modern modes, de Kooning refused to adhere to their disciplines or to the ideas on which they were based. By the end of the 1940s he was prepared to denounce the ideologies of the twentieth-century art movements, except insofar as they served as creative stimuli to individual artists. "In art," he proclaimed, "one idea is as good as another." Very soon afterwards, in a memorable speech delivered at The Museum of Modern Art in 1951, he settled his account with modernist aesthetics and with Futurism, Neo-Plasticism, and Constructivism. "I have learned a

lot from all of them," he said, "and they have confused me
plenty too. . . . The only way I still think of these ideas is in
terms of the individual artists who came from them or in-
vented them. I still think that Boccioni was a great artist and a
passionate man. I like Lissitzky, Rodchenko, Tatlin and
Gabo," and so on.

De Kooning was well aware that vanguard theories are the
source of modern styles, and that in attacking them he was
undermining the basis of any shared forms in art. The genius
of his assault lay in going all the way. "Style is a fraud," as-
serted this veteran of eight years study at the Rotterdam
Academy of Fine Arts and Techniques. "It was a horrible idea
of Van Doesburg and Mondrian to try to force a style. The
reactionary strength of power is that it keeps style and things
going." Actually, de Kooning asserted, confirming what
every thoughtful observer had known for a century, "there *is*
no style of painting now." The attempt to generate a style
artificially through formal analysis and derivations from the
art of the past—e.g., through transforming Cézanne into
Cubism—distorts the true situation of art today. "To desire
to make a style," de Kooning charged, "is an apology for
one's anxiety." The time has come to end the futile game of
seeking contemporary equivalents for cultural forms that
have long since disintegrated. For his own part, de Kooning
was to arrive, after tormenting experimentation, at his con-
cept of "no style."

The rejection of style is a way of asserting that a gap exists
between the artist and contemporary society—they have no
forms in common, not even the forms of yesterday's avant-
gardism. (Social estrangement was reasserted program-
matically by "anti-form" artists of the late sixties.) Artists of
our time, de Kooning testified in his 1951 speech, over-op-
timistically it now appears, "do not want to conform. They
only want to be inspired"—a proposition that is like a red
light signalling the distance between the postwar American
artist and his audience-conscious predecessors. To the artist
who wants only to be inspired, all values depend on his state

of being: concern for anything external is self-betrayal, including the production of objects intended to satisfy the taste of a public, or the promulgation of an idea designed to change that taste, such as Mondrian's "preparation for a universal realization of beauty" through an art of straight lines and "the unchangeable right angle." De Kooning had come to see that the artist today has no deep impulse to accommodate himself to the norms of society, aesthetic or moral. Yet de Kooning was neither a mystic nor an anarchist. The inspiration he sought could not be a gift of passivity, as with Rothko, for example, nor of chaos, as in Surrealist automatism or art composed under the influence of drugs. Inspiration for the painter, in his view, could come only through the act of painting.

And while the painter sought a heightened state in painting, painting itself, released from tradition, would receive its forms through the uplifted activity of the painter. "Painting," de Kooning wrote, "any kind of painting, . . . is a way of living today, a style of living so to speak. *That is where the form of it lies.*" (My italics.) Transient and imperfect as an episode of daily life, the act of painting achieves its form outside the patternings of style. It cuts across the history of art modes and appropriates to painting whatever images it attracts into its orbit. "No style" painting is neither dependent upon forms of the past nor indifferent to them. It is transformal.

Beginning with anything—a random daub of color, letters of the alphabet (as, for example, in *Orestes*), the sketch of a nude—the artist "lives" on the canvas alert to possibilities for a new coherence. As his action progresses, his originating gesture is blotted out in the accumulation of "events" that take on body through the starts and stops of the brush. A single painting can be protracted for months or even years (*Excavation, Woman, I*), or the action can shoot like a flash fire from surface to surface, as in some of de Kooning's paintings and drawings of the sixties. (I shall discuss later de Kooning's "long" and "short" paintings, and some of his techniques for springing an image into a succession of metamorphoses.) In

de Kooning's approach, painting as an objective historical continuum extending toward the future has ceased to exist. It is for each painter to bring painting to life again out of his own life and the shifting residue of art memories embedded in his (and the spectator's) sensibility. The artist juts out of art history and, in the last analysis, composes the format of his past and even his own culture.

In denying that the artist is obliged to follow a logic of historical development—e.g., from Cézanne to Cubism, from Cubism to Mondrian—de Kooning was enabled to take a fresh, unhampered look at the art of the past. He could go backward in time and explore byways of art at any point that seemed relevant. Art history, de Kooning's attitude proposed, is full of open prairies that have been passed over by the covered wagons of the avant-garde, territories still suitable for cultivation. Thus as early as *Glazier* and *Seated Figure*, both done around 1940, de Kooning applies the Cubist device of dislocated anatomy to figures modelled in depth. Cubism is stretched not forward but as far back as Ingres, and de Kooning leaves a clue to his time-mixing by placing colored squares in the background of his portrayals of pathos. In these first instances of his overt jamming of different periods of art history, de Kooning challenges the so-called "laws of historical development" by setting against them the will of an artist with a consciousness of history. In the paintings of men and such other early works as *Seated Woman, Woman Sitting,* and *Pink Lady*, de Kooning restates the formal choice offered to the contemporary painter: either to accept the deep-space concept of traditional painting or to work within the layered surfaces of painting after Cézanne—and refuses to choose. For de Kooning the traditional has lost its power to command, and the new, no longer new, has become a commonplace. Both perspective and two-dimensionality are devices for the painter to use as he wishes; to regard either as an ideal of painting is nonsense.

The artist today receives existing art in the context of his own possibilities. As potentials, the works of all ages possess

the same status: the paintings of ancient Egypt or medieval Europe, or of an Expressionist in a Manhattan loft, stand in a similar relation to the art of the future. As for inherited ideas, those of yesterday's avant-garde are no more compelling in regard to painting today than is the philosophy of Michelangelo or the religion of Rembrandt. Mondrian is an important painter; but what is so remarkable, de Kooning asked, about the Neo-Plastic idea, especially after it has been stated? Speaking at a round table at the Artists Club a dozen years ago, he said, "We are all basing our work on paintings in whose ideas we no longer believe." By returning to the works themselves and disregarding the ideas in which they originated and their historical "necessity," the artist can unlock what is creative in them, hence new.

To detach painting from the social, aesthetic, or philosophical values of a given time and place is basically to redefine the profession. No longer seeking to satisfy the wants of a public, including its desire for what Nietzsche called "metaphysical consolation," painting has as its sole purpose to stimulate further creation: *The Last Judgment* is valuable not for the feelings it aroused in persons now dead but for the creative acts it may instigate in the living. That works of other times are charged with potentiality for the future unites the past with the present, and refutes the notion that the new must be sought in phenomena that belong exclusively to this century—for example, films, speed, electronics, abstract art. Art comes into being through a chain of inspiration which has no end and no beginning—and inspiration is its ultimate content. Said Brancusi, "It is not difficult to make things; what is difficult is to put ourselves in the proper condition to make them." The work of art is a memento of this interval of potency.

Art exists today because artists continue to create it, and artists exist because art makes creation possible for them (the reason why individuals who call themselves artists but keep aloof from any particular art are trapped in an absurdity). Both art and the artist lack identity and define themselves

only through their encounter with each other. They are sus-
pended upon one another and are held aloft only through
their interaction. The artist's high-wire act is the model of the
effort of individuals to give shape to their experience within a
continuing condition of social and cultural disorder. One of
de Kooning's antagonisms to the modernist schools is that
"in that famous turn of the century, a few people thought
they could take the bull by the horns and invent an esthetic
beforehand." Given the difficulties of extracting form from
the painter's "way of living," it was to be expected that this
bull would be seized by the horns again and again through-
out the rest of the century. But in each instance, the liberating
potentiality of art is sacrificed. When, to follow de Kooning,
art discovers its form in the actuality of the artist's life (includ-
ing "the vulgarity and fleshy part of it" which de Kooning
stressed as the heritage of the Renaissance), it does not im-
pose values upon its practitioners as other professions do
upon theirs. Art becomes a way by which to avoid a way. De
Kooning discards the traditional image of the artist in order to
begin with himself as he is; and he discards all definitions of
art in order to begin with art as it might become through him.
By their mutual indetermination art and the artist support
each other's openness to the multiplicity of experience. Both
resist stylization and absorption into a contrived order. "No
style" is a proclamation of release for the painter which pre-
supposes a liberationist philosophy of the self.

In the triviality, commonplaceness, and chaos which mod-
ern life cannot exclude, creating art is a force against dissolu-
tion. With de Kooning, painting is a total vocation, in that
painting makes him what he is. He is aware that acts of cre-
ation do not shed an uninterrupted light and that the prob-
lems of modern man will not be solved by art. He is aware,
too, that the transition between high and low in what he has
called "the drama of vulgarity" is the human condition.
Without the slightest affectation he takes pleasure in corny
music and movies, comic strips, television programs and
commercials. That de Kooning experiences the psychic in-

stability of contemporary man without hedging, and with full comprehension of its implications for creation in the arts inherited from the past, has contributed to making him the foremost painter of the postwar world. In his synthesis of critical analysis and passionate self-affirmation, painting is restored to its ancient tie with man as he is, in his "own height." Tensions varying from the almost unsupportable strain of *Woman I* to the soarings of *Door to the River* or *Two Figures in a Landscape* (1967), raise his art to the sublimity of paintings of other times. Art as a single concentrated energy, capable of remanifesting itself in creations from cave paintings to the present, takes possession of the artist and elevates his performance: painter and painting become one in the action on the canvas. In de Kooning's work from the thirties to the present there often appears an inexplicable shiver and heightened luminosity as of a metaphysical presence—it runs through *Excavation* and *Pastorale* (1963). Then this presence, source of what de Kooning has termed "the 'nothing' part in a painting," that is, its "beauty, form, balance," dissolves, and both the artist and art sink into confusion. For years it was customary for de Kooning to speak of the artist today as "desperate."

Through the middle forties de Kooning juggles ambiguities of new and old, depth and flatness, as his relativistic intelligence tries out combinations of techniques, attitudes, and feelings suggested by different schools and periods. *Pink Angels* (1945) culminates a sequence of drawings and paintings of apparitions, dissociated parts of the body, abstract shapes, random calligraphy; recalling Duchamp and paralleling the ironed-out organisms of Matta and Gorky, this painting stands at an intersection between Cubism and Dada. With its thinly painted tones of pink and yellow, its superimposed linear swings, floating and thrusting ambiguous shapes that are just short of abstraction, it is a transitional work of the utmost significance. It brings into focus an invention of de Kooning's that has continued to survive his work: suggestive but undefined forms flicked by his inspired drawing from im-

pressions of the human figure, streets, and interiors, from flashes of memory of Old Masters, and from spontaneous motions of the hand. The beautifully lucid contours of *Pink Angels* sum up de Kooning's experimental wandering from mode to mode in a unique alphabet of forms—at this stage de Kooning already reveals a signature impossible to mistake.

In 1946, a portentous year for American painting generally, de Kooning's foraging among the approaches of predecessors led him to discover a new relation between post-Cubist abstraction and the late works of Cézanne, through which painting could be recharged with emotion-laden traces, comparable to the self-transforming symbols of Mallarmé's poetry. Symbolist visual and verbal metaphor lie at the root of psychoanalysis, which in postwar American painting provided a bridge between Surrealist automatic drawing and abstract sign-making, as in the "totems" of Pollock. The Cézanne-Mallarmé discipline of building a formally coherent entity out of synthesized associations was exactly suited to de Kooning's passion for an all-inclusive art of re-created experience. In reaching for form through activating the psyche de Kooning brought about a leap in his work; no longer attached to recognizable sources, it suddenly discovered an open road between the artist's sensibility and paintings of the past. In the context of Symbolism, the residual contours of limbs, breasts, safety pins, paper matches, of de Kooning's "Untitled" paintings of 1941 to 1945, evolve into an idiom of visual metaphors (comparable to the creased tablecloth that, with Cézanne, could double for a mountain), out of which the hieroglyph of a unique feeling can be created. With de Kooning, however, in contrast to Cézanne, half a century of abstract art had made it possible to free the metaphor from specific objects, thus enabling it to animate more extended fields of emotional resonance. Forms emerging spontaneously from the action of the brush could bring to light areas of the psyche in which feelings had not yet crystallized into an identified image. Yet—and this is crucial to the distinction between de Kooning's arduous composing and Sur-

realist-derived automatism in American Abstract Expression-
ism—de Kooning's evocation of the unknown takes place
under the control of the artist's total sensibility, as in Mal-
larmé or Joyce, with the result that, instead of fragmentation
that at best appeals to taste, as, for example, in Motherwell,
there is statement on several planes of meaning.

Formally, the abstracted metaphorical shape, which is both
a sign, like a number or a letter of the alphabet, and the repre-
sentation of a thing, like the outline of a torso, can skirt the
conflict between the illusion of a third dimension and the ac-
tual flatness of the picture surface: an oval with a dot inside it
is simultaneously the image of an eye that appears to possess
volume, and a design without depth. The white-on-black
*Light in August*, done around 1946–47, is the first masterwork
of de Kooning's Symbolist abstractions originating in action
on the canvas, and the fact that its title is derived from
Faulkner, an heir of the Symbolists, seems to me
enlightening.

Dissociated from their sources in nature, organic shapes
carry potential emotional charges, as do also triangles,
squares, or series of parallel lines: five irregular bands may
seem like a hand and awaken memories, a square may signify
order or the sense of being enclosed, a curved line stand for
an erotic posture. In de Kooning's paintings of the period of
*Light in August*, a head shape becomes an "O" (or vice versa),
a square becomes a window or a chest frame, the contour of
the breast a loop in an abstract configuration or a passage in a
landscape. De Kooning's extensive vocabulary of motifs and
his multiplex use of them has been much noted. As a device
of painting, ambiguity of form is nothing new; it was re-
discovered by the Surrealists in Leonardo, and Fernand Lég-
er, under whom de Kooning worked on a mural commission
in the thirties, delivered a paper in connection with his film
*Ballet Mécanique* in which he spoke of a planet represented by
the close-up of a fingernail.

Visual metaphor is meaningful not in itself (as some "sec-
ond-generation" Action Painters have seemed to think), but

through the artist's use of it. Faithful to painting values, de Kooning employed his repertory of signs to organize his imagination in meaningful visual terms. The Surrealists had been content to handle their dream creations as if they were natural objects: Dali's pianos on crutches and Ernst's feathered bric-a-brac were, in respect to painting, things no different from ordinary pianos or birds and could be incorporated into conventional picture structures. De Kooning, on the other hand, ever conscious, as he has said, that "the idea of space is given to an artist to change if he can," releases the shape that is both an abstract sign and the emblem of a concrete experience from the stasis of objects located in deep space, in order to make it function in a new kind of psychodynamic composition. Produced by a gesture, as in writing, but differing from calligraphy in preserving the sense of solidity characteristic of traditional Western art, each of his forms is engaged as a separate integer of suggestion in a complex interaction, at once formal and subjective, with the others. While the figurations of the Surrealists and of Gorky remain immobile as representations set against a conventional background, those of de Kooning, coming into being through inspired flaunts of the brush, sideswipe the mind in passing from one into another with a continuous effect of meaning grasped then lost—the reality which the artist has denoted as "slipping glimpses." Thrown off balance, the consciousness is compelled to reaffirm its unity through the act of regaining its equilibrium. This is equally so with the artist and the spectator; by inducing such mental affirmations de Kooning draws the onlooker into the act of creation. Without abolishing its elements of disorder, each of de Kooning's paintings achieves a coherence of energies.

Metaphorical abstraction makes it possible for the painter to act freely on the canvas while discovering, in a manner analogous to automatic writing, new linkages of meaning in the signs that come into view. It is characteristic of de Kooning's attitude toward intellectual systems that free association entered his painting through his painting practice itself,

rather than through an ideology or therapy of the uncon-
scious such as those which inspired Gorky and Pollock. Thus,
as noted above, de Kooning's spontaneous compositions
never allow automatism or doodling to have the last word;
though they may start with a scribble or a mark, his forms are
animated by conscious intuitions in which his ideas of paint-
ing play a major part. Without being premeditated, de Koon-
ing's canvases are produced under the pressure of an
unrelenting fidelity to a feeling for exactness—and this has
caused some of them to be worked on for years.

*Excavation*, brought to resolution in 1950 after months of
strenuous doing and undoing, displays a density of reference
more often encountered in poetry than in modern painting.
Measuring approximately seven by eight feet (a size modest
by today's standards but conforming to de Kooning's concep-
tion of aesthetic space as restricted to the artist's reach), the
work is, internally, limitless in scale. Its shapes, crowding in-
vention upon invention (no living artist can match de Koon-
ing in throwing up interesting forms), neither confine
themselves to the picture surface nor recede behind it but car-
ry on a continual delving or "excavating," as of planes edging
into one another. One thinks of Yeats's

> Those images that yet
> Fresh images beget,
> That dolphin-torn, that gong-tormented sea;

except that the yellowish monochrome of *Excavation*, lit by
flashes of bright red and blue, is like a sea of jarred rock. This
glorious canvas, a masterwork of becoming, in which the
"static" medium of painting mocks the need for materials
that actually move, was for de Kooning an end and a
beginning.

*Excavation* is a classical painting, majestic and distant, like a
formula wrung out of testing explosives. If, as de Kooning
liked to say, the artist functions by "getting into the canvas"
and working his way out again, this masterpiece had seen
him not only depart but close the door behing him (the paint-

ing was literally concluded with the image of the door in the bottom-center). In reaction against the calm shared by *Excavation* and Cézanne and the Symbolists, de Kooning next chose to ally himself with the tradition of Van Gogh and Soutine. From *Woman, I,* which followed *Excavation,* no departure was possible; the artist continues to inhabit the painting as its emotional subject. It was as if, returning past Cézanne in the direction of Van Gogh, he had been carried back also from the Symbolism of Mallarmé to its primitive root in the laboratory of Rimbaud's "infernal bridegroom." In *Woman, I,* de Kooning carried painting as action to the verge of magic, the modern magic that strives to bring forth real beings through activating the materials of communication. Rimbaud believed that he could evoke new flowers, new stars, new flesh, out of his sorcery of vowels and consonants. By analogous magic, de Kooning willed the spontaneous manifestation of a goddess through discharges of the energy in paint.

The black-and-white paintings exhibited in his first one-man show in 1948, and *Excavation,* shown at the Venice Biennale in 1950 and winner of the first prize at the Chicago Art Institute in 1951, established de Kooning as a leader of the new American abstract art. Precisely at this point, he was moved to dissociate himself from abstraction and to formulate his conviction that the glory of Western art lay in its physicality—"flesh was the reason why oil painting was invented," he asserted in 1950. Not abstract signs of the female but the actual image of woman now became his preoccupation. "Forms," he explained later, "ought to have the emotion of a concrete experience."

In the same year (1950) that he began work on *Woman, I* he announced his position that painting is inseparable from subject matter. That subject matter had become an issue of modern art, de Kooning contended, was the result of an historical aberration: the opposition between form and subject was, in his opinion, conceived by the middle class who had lost touch with the meaning of human gesture. In Renaissance painting, de Kooning explained, "actually, there was no

'subject-matter.' What we call subject-matter now, was then painting itself. Subject matter came later on . . . when the burghers got hold of art, and got hold of man, too, for that matter." Particularly repugnant, de Kooning brought out, are modernist theories that reduce painting to "essentials" (no wonder criticism in the sixties has been poisonously hostile to him). In the effort of purists to liberate painting from what it can, theoretically, do without, de Kooning detected a kernel of tyranny—Mondrian was to him "that great merciless artist . . . who had nothing left over." Though de Kooning shunned politics, he recognized in the impulse to purge painting of the actual matter of the artist's existence a tendency toward totalitarian discipline which tailors life to fit dogmatic ends. "The question, as they saw it," he wrote regarding Neo-Plasticists and the Constructivists, ancestors of the Minimalists and Color painters of the sixties, "was not so much what you *could* paint but rather what you could *not* paint. You could *not* paint a house or a tree or a mountain. It was then," he concluded ironically, "that subject matter came into existence as something you ought *not* to have." (His italics.)

Abstraction, de Kooning maintained, is present in all modes of painting, but it does not exist in isolation from other aspects of the work. Abstraction is that "indefinable sensation, the esthetic part." To arrive at the abstract, de Kooning said, the painter in the past "needed many things—a horse, a flower, a milkmaid." The non-objective artist, however, conceives abstraction—"the 'nothing' part in a painting"—as something existing in and for itself, perhaps attaining its perfection in the circle, square, or cube. Thus abstraction becomes an ideal reality on the basis of which an aesthetic can be formulated in advance of the paintings themselves. The result is to make creation subservient to theory. Following this line of thought, de Kooning denounced both mathematics and "theosophy" in art and pledged himself to nature and the concrete. The particular fascination of Western art, he held, from its earliest animals and idols to Picasso or

Giacometti, lies precisely in its respect for the corporeal "as is," for the fact, for the instance, that a human being has such given attributes as a face and a body. "When I think of painting today," de Kooning asserted, "I find myself always thinking of that part which is connected with the Renaissance. It is the vulgarity and fleshy part of it which seems to me to make it particularly Western." And he associated abstraction with the Orient, with the "state of not being here. It is absent," he declared, adding, "That is why it is so good."

The meaning of this vigorous polemic largely escaped de Kooning's contemporaries, then caught in the enthusiasm for the "new abstract American painting." They continued to count de Kooning as an "abstract artist," and discussion of his work tended to ignore its content in favor of schoolroom art history concerning the influence of Cubism and the problem of "homeless abstraction" (cribbed from Berenson's "homeless paintings"). In his determination, however, to add concreteness to his metaphors by reattaching forms to flesh, de Kooning had entered upon a new relation with his primary symbol, the Woman, in order to investigate new possibilities of illuminating experience through painting. The seriousness of this move is indicated by the fact that *Woman, I* took almost two years to "finish" (it was never finished) and that several years were to elapse before admirers of de Kooning's black-and-white abstractions were able to accept his Woman. "If I had character," de Kooning complained, paradoxically, thinking of the craftsman's code of making works that satisfy one's public, "I'd paint abstractions."

From 1940 to the present, Woman has manifested herself in de Kooning's paintings and drawings as at once the focus of desire, frustration, inner conflict, pleasure, disdain, humor, and irony, and as posing problems of conception and handling as demanding as those of an engineer. In *Seated Woman, Woman Sitting, Queen of Hearts, Pink Lady, Woman*—all done between 1940 and 1944—a seated female with legs crossed or cut off below the knees appears in a variety of modes, some approaching caricature. The pencil sketch of *Reclining Nude*

turns the figure into a nubile doll, and the green and yellow *Woman* (1944) gives her a comic mask. The pastel and pencil body fragment, *Untitled* (1945), is a spare part that reappears in *Still Life* of the same year, an early example of de Kooning's conversion of a natural form into an abstraction. In these early Women, Cubism is constantly invoked, but is put aside in the artist's effort to find a precise match for his feeling about his subject. The figure in *Pink Lady* breaks up into motions; in *Woman Sitting*, arm, shoulder, neck, and oversized head are swept into a single movement in anticipation of de Kooning's later figures that surge out of gesture. *Woman* (1949) is a magnificent dance of forms struck off in the course of painting: that these forms constitute a female figure, rather than an abstract composition like *Attic*, done in the same year, and that the complex shape that crowns the central mass is a head elongated and twisted in ecstasy, adds a dimension of emotional reality to the painting, as does the fact that the thrust from bottom center leftward is a gay kick of the lady's right leg. Anatomical displacements, comparable to those in de Kooning's "Men" of 1938–40, bestride the anomaly of aesthetic structure fused with direct experience. Constantly there and constantly changing, at times torn apart, the Woman complements the unstable "I" of the artist. "I could sustain this thing all the time," de Kooning has said of painting the Woman, "because it could change all the time; she could . . . not be there, or come back again, she could be any size. Because this content could take care of almost anything that could happen."

With the dissociation of the shapes and contours of the female figure in *Pink Angels* and *Still Life* (1945), forms retaining erotic suggestiveness are transmuted into an emotional sign language susceptible to free, rhythmic organization. In the Action Paintings of the late forties—*Light in August, Black Fridays, Orestes*—in which de Kooning's earlier stylistic hesitations and mixed handling are whirled into a new, firm, and self-consistent affirmation, the Woman is diffused into strangely humanoid countrysides containing passages of pas-

sionate heat and cold. Overt traces are the graceful bust in the
upper right center of *Light in August,* the profile of a breast
that outlines a shoulder in the lower left quarter of *Mailbox,*
the bosom in the lower left of center in *Excavation.* Concur-
rently, de Kooning produced the heroic-comic *Woman* (1949)
referred to above, *Two Women on a Wharf* (1949), plus such
significantly entitled "abstractions" as *Boudoir; Warehouse
Manikins; Woman, Wind and Window,* in all of which the female
torso is unmistakable—Thomas Hess has even discovered
the faint print image of a nude in *Attic.*

A radical feature of de Kooning's art is its rejection of radi-
cal clichés. For the avant-garde artist woman is a "forbidden"
subject. In a remarkable interview with the British critic
David Sylvester, de Kooning reveals how his paintings of the
Woman came into being behind the wall of thought he built
against accepted ideas. The female has been "painted
through all the ages," he conceded, and for an artist today to
paint her again is absurd. But to refuse to paint her is equally
absurd—if for no other reason than that by this time the com-
mands and prohibitions of vanguardism have cancelled each
other. For de Kooning what mattered was that the Woman as
a subject was *there* as a traditional interest of art, and "that
was what I wanted to get hold of." In short, the givenness of
the subject coincided with the givenness of the artist's per-
sonality—given, yet always in a state of change. To think of
Woman was to confront "encounters like a flash." But her
very evanescence was a guarantee that as a subject she could
never be exhausted, and that the attempt to seize her reality
through the act of painting could be prolonged indefinitely.
("I could sustain this thing all the time because it could
change all the time.") The performance was the aim, to hang
on to the process of creation-discovery and keep it going
("They only want to be inspired"). As the subject of the
painter's action, the Woman is thus limitless. In action the
mind makes use of whatever it finds ready at hand both with-
in itself and in the outer world. *Woman, I* was for a brief phase
a girl in a yellow dress whom de Kooning noticed on Four-

teenth Street. The painting also came to contain mothers passed on East Side park benches; a madonna studied in a reproduction; E—— or M—— made love to. All these ladies, and many more besides, manifested themselves in the course of the painting, then vanished in the cement mixer of de Kooning's processes. The surviving feature became, de Kooning told Sylvester, the "grin . . . of Mesopotamian idols . . . astonished about the forces of nature."

For de Kooning technical problems (how to draw the Woman's knees, how to keep the pigment from drying too fast) do not exist in isolation; they arise inside the shifting amalgam of the painter's experience. There is no formal goal which a painting may reach ("I never was interested in how to make a good painting"), as there is no ultimate fact of which it can be the equivalent. One event makes another possible, on whatever level it has come into being. Designing a studio-dwelling for himself, de Kooning completes a set of plans that fulfills his current desires. But no sooner are the plans finished than he starts a new set. Formulating the first conception has given rise to new problems, new possibilities. Any solution is but a point to be passed through on the way to another approximation. Perhaps the next gesture will bring the artist closer to his true self, that is, to something in him he did not know was there. But "closer" is only a figure of speech; for whether it came closer or less close to some presumed self of the artist, the work has been lived and is therefore the actual substance of his existence. "In the end," de Kooning told Sylvester of his Woman paintings, "I failed. But it didn't bother me . . . ; I felt it was really an accomplishment." Failure or success, he could claim with Jaques of *As You Like It*, "I have gained my experience." Painting the Woman was an "act" in the arena of art history, a display of skill and imagination put on before an imaginary gallery of the great masters. "I didn't work on it," said de Kooning, ". . . with the idea of really doing it. With anxiousness . . . fright maybe, or ecstasy, . . . to be like a performer: to see how long you can stay on the stage with that imaginary audience." What saves

him from presumptuousness is that he did not expect Michelangelo or Rubens to keep their seats until the curtain.

The intimate presence in his mind of the geniuses of Western painting is the secret of what is often referred to as de Kooning's ambitiousness. In his canvases, painting in the twentieth century recovers the metaphysical concentration on self, being, appearance, and action of the most elevated moments in art. This fidelity to what he has termed "life and death problems" pits de Kooning's paintings against the grandest efforts of the Western creative consciousness. He has disdained to dodge this comparison by resorting to the avant-garde pretense that comparisons have been vitiated through discovering new directions for art. "I'm no lover of the new—it's a personal thing," he summed up to Sylvester.

Symbol of inexhaustible mutability, the Woman merged for de Kooning into other themes that he "could sustain all the time because [they] could change all the time." His concept of "no environment," with which in the fifties he resolved the problem of locating his giantesses, equates the changefulness of the Woman with the perpetual shiftings of people, things, events, and impressions on the streets of Manhattan. In the series beginning with *Woman, I,* de Kooning advances from the indications of interiors or background walls in the early studies of males through *Woman* (1949) to a rejection of both traditional illusory space and modernist composition in planes. By the mid-twentieth century these conventions, the new as well as the old, have lost their raison d'être. In actuality, a woman is perceived neither as a static image with a table behind her and a dog at her feet nor as a figure in a pattern of colored shapes. She and her environment are apprehended simultaneously as a complex of evanescent sensations, passions, and transient moods—and this soluble amalgam can be recalled to life only in the act of painting. The formal solution of de Kooning's early 1950s series thus consists in destroying the boundary between figure and setting through enacting on the canvas an interplay of actions that are the equivalent of a stream of visual encounters. By the

time *Woman, IV* has been reached, the inner and outer contours of the figure have been all but torn apart by the thrusts and counterthrusts of the painter's gestures, like a figure spotted through a crisscross of fast traffic. A residue of "eyes" and "arms" identifies the subject as the congealing of physical and psychic forces (the woman-environment) into an ironic manifestation. Under scrutiny, *Woman, IV* reconstitutes herself as a monumental caryatid with crossed arms and a fixed, classical stare. She is a goddess of No Place risen from the sea of unrelated events.

The charcoal drawing *Monumental Woman* (1953) sketches a complementary idea which de Kooning was to develop fully in his paintings of the sixties, that of the Woman as herself a "place" through having absorbed the forms of the landscape. *Monumental Woman* is Washington, D.C.—the nose is the Washington Monument and under the curve of the right breast the sweep of columns probably derives from the Jefferson Memorial. *Woman and Bicycle* solves the problem of environment in a different way. Having asked himself, What can I put next to her, and where? the artist closed his rumination with an amused wink at the device of juxtaposing to the human subject a horse or a tree. The bicycle consists of the oval in the lower left corner that repeats on the same picture plane the ovals of the woman's breasts.

The forms of the crowded cityscapes of the mid-fifties— *Gotham News, Saturday Night, Police Gazette*—belong, as their titles indicate, to news and the calendar, to the flow of events in time, rather than to objects situated in space. They are forms in passage: broken angles, loops, open-ended squares, disconnected bosoms and groins collide in de Kooning's Nowhere and explode in streaks and flashes of paint. Or, if one prefers, the forms constitute an environment in which no person or object can claim an identity. The compressed composition, thick, ragged edges, gritty surfaces, and uncertain, nondescript colors of *Gotham News* and *Easter Monday* are siphoned from de Kooning's grim years in his Fourth Avenue and East Tenth Street lofts, from the decaying doors of the

buildings, the rubbish-piled areaways, the Bowery cafeterias, the drunks on the stoops. When in 1957 the artist begins painting in Springs, Long Island, his compositions open out as if with a sigh into lyrical panoramas keyed to drives in the countryside. The new symbol of metamorphosis is the highway. *Parc Rosenberg, Suburb in Havana,* a recollection of a visit, *Door to the River* are unlocated landscapes bred out of the artist's new surroundings.

In de Kooning's oeuvre there are long paintings and short paintings, in terms not of size but of the time they took to paint. His key works have tended to be the long ones: *Excavation,* "finished" in the spring of 1950, *Woman,I,* begun almost immediately thereafter, on which de Kooning worked almost two years. These protracted acts, like the scores of hurried ones executed on small cardboards in 1957, took place at critical stages of de Kooning's development and produced dramatic alterations in his work. It is remarkable that in de Kooning tenacity is matched by a mastery of the rapidly executed, almost instantaneous, gesture; in many of the landscape-figure-abstractions of the last few years he has achieved through speed a lightning clarity and briskness unattainable in his more pressured compositions. One of de Kooning's outstanding qualities (compared, for instance, to Pollock or Kline) is the variety of tempo he has been able to introduce into his action without destroying its continuity.

No art of our time is more immediately engaged than de Kooning's with the organic life of its creator. Each phase of his work contains the matter of his psychological condition, his intellectual activity, and his physical surroundings. It might be said that paintings of the Woman as landscape could have come only from one who is, at least in part, a painter of landscape. De Kooning's compositions of the past dozen years are a compound of sea, sky, greenery, beaches, and beach girls absorbed during solitary bicycle rides on the roads around Springs or in gazing at the shores in winter and when the sands are crowded. A good portion of de Kooning's consciousness consists of sheer sense-reflex to phenomena,

like an animal's. Water, in its flowing, splashing, dripping, and reflecting of light is the pervasive element of his most recent work. He has found in the seasurface another metaphor for the "slipping" of things and the self ("Here I am Antony;/Yet cannot hold this visible shape"). The reclining figure in *Woman in a Rowboat* (1965) sinks into a sunlit reverie beneath the waves of paint that form her torso and her environment—a masterpiece of object as event.

Like his other symbols of metamorphosis, the sea has an autobiographical meaning to de Kooning as the link between his present and his past, between the Dutch city of his birth and boyhood and New York, to which he came in 1926 as a twenty-two-year-old stowaway. Crossing the Atlantic is the Great Event to which he keeps returning in anecdotes and recollections of individuals—"I don't give a damn about the Pacific," he asserted recently in an oddly belligerent manner. *Untitled*, the earliest painting in his 1968–69 retrospective, was done in 1934, eight years after his arrival in the United States; it is made up of shapes suggesting portholes and decks, with sea and sky in the background, and in the right foreground a masked head looking inward to land. The architecture of ships, the perfect joints and polished surfaces of marine woodwork, the spotless quarters of Scandinavian seamen are for de Kooning emblems of intrinsic order and well-being. When, after thirty years, he quit Manhattan for the eastern tip of Long Island, he designed a studio of beams and struts, turret staircases and lookout platforms; and in paintings bearing such titles as *Clam Diggers, Woman, Sag Harbor, Woman Acabonic, Woman in a Rowboat*, he combines his fable of the sea with his other fabulous theme, Woman.

The Women of the sixties are no longer the massive icons of "no environment"; they are today's cuties in their beach settings. But these spindly, physically diffused girlies serve an experimental function in de Kooning's self-investigation: they are products of his latest devices for circumventing his willful mind and his trained hand, which are bound to assert themselves in any case within the very process by which they

are circumvented. He has practiced drawing the figure with both hands, with his left hand, with two or more pencils simultaneously, with his eyes closed, while watching television. In 1971 he made sculptures by handling clay in comparable ways. To extract unanticipated figurations from his canvases de Kooning breeds one image out of another ("I could take almost anything that could be some accident of a previous painting"); for example, by plastering newspaper on a wet painting he produces, when the sheet is removed, two decontrolled compositions which can be kept as they are or worked over. Compared with his earlier canvases, the paintings of the 1960s show gains in rhythm, luminosity, and surface vibration through the quiver of his line and the chromatics of his reds, pinks, greens, and white. As in the past, de Kooning keeps gambling with the possible destruction of each work-in-progress by holding it open to associations that spring up in the course of its creation. Some of the paintings—e.g., *Untitled* (1967)—are among the most lyrical creations of the century, but de Kooning has not excluded images arising from currents of spite, disgust, and vindictiveness. As always, his paintings came into being on the edge of dissolution. For them to exist has required a heroic endurance of uncertainty, as well as a reasonable rate of good luck, or favors from the unknown. Consistent with his principle of constant renewal, de Kooning's primary aesthetic quality is freshness, the freshness of things as they appear in a dream—his admiration for Matisse's late paper cut-outs and his experimenting with paint mixtures and driers have to do with this pursuit of freshness. Compared to his Eastern Long Island Women, most of the younger-generation paintings and sculptures originating in the rationalist aesthetics of the sixties look as if they were aged at birth.

De Kooning has never attempted to attribute political meaning to his work. The arena of art as action is the canvas not the community. As noted above, de Kooning was alone among the Action painters in introducing into painting elements of popular culture, such as imprintings of news col-

umns and cuttings from ads, but in his work these materials carry no implications about the society in which they originated. Yet under the conditions of the ideological pressure characteristic of the past forty years, unbending adherence to individual spontaneity and independence is itself a quasi-political position—one condemned by Lenin, outlawed in totalitarian countries, and repugnant to bureaucrats, conformists, organization men, and programmers. Improvised unities such as de Kooning's are the only alternative to modern philosophies of social salvation which, while they appeal for recruits in the name of a richer life for the individual, consistently shove him aside in practice. De Kooning's art testifies to a refusal to be either recruited or pushed aside. His expansion of the resources of painting as a means by which the sensibility can interact with chance, impulse, the given, and the unknown, presupposes that the individual as he is will continue to oppose himself to all systems. If ideology is the ghost that haunts postwar painting, de Kooning haunts the ghost. He is the nuisance of the individual "I am" in an age of collective credos and styles.

# 21

# Interview with
# Willem de Kooning

**De Kooning:** I am an eclectic painter by chance; I can open almost any book of reproductions and find a painting I could be influenced by. It is so satisfying to do something that has been done for 30,000 years the world over. When I look at a picture, I couldn't care less for when it was done, if I am influenced by a painter from another time, that's like the smile of the Cheshire Cat in *Alice;* the smile left over when the cat is gone. In other words I could be influenced by Rubens, but I would certainly not paint like Rubens.

I was lucky when I came to this country to meet the three smartest guys on the scene: Gorky, Stuart Davis and John Graham. They knew I had my own eyes, but I wasn't always looking in the right direction. I was certainly in need of a helping hand at times. Now I feel like Manet who said, "Yes, I am influenced by everybody. But every time I put my hands in my pockets, I find someone else's fingers there."

**Rosenberg:** You once said that you could not draw like Rubens because you were too impatient. You said that you could draw a foot as accurately as Rubens, but that you didn't have the patience. Do you remember that? that—

**De K:** I don't remember, but I could very well have said it.

Originally published in *ARTnews,* September 1972.

I also think that maybe I don't really have the talent for that kind of drawing. I think that certain talents come into being at certain times, but that doesn't make them dead or alive.

**R:** I suppose nobody in our period could paint a detailed tableau of figures in the manner of the Renaissance?

**De K:** I think there might be people who could do that. For example, the Spanish painter Sert, who made the murals at the Waldorf Astoria. He was no Rubens, but he was a remarkable painter. He just didn't have as great a talent as Rubens.

**R:** You think there could be someone like Rubens today?

**De K:** I would say there is no reason why there couldn't be. George Spaventa and I were openminded, and we thought there was no reason why, after 40 years of power, maybe one or two Russian artists would be gifted in the kind of painting that the Russian government demanded. We went to the Russian exhibition at the New York Coliseum with open minds. It turned out to be terrible painting—awful; the kind of painting done in this country in 1910 for the *Saturday Evening Post.*

**R:** Illustration?

**De K:** Not that so much, because you could say that Rubens is an illustrator too. I felt that making portraits of Lenin and Stalin and workingmen and genre—there was no reason why someone couldn't be very good at it. But they were not good at all. I had thought that maybe after being under pressure, which you slowly get used to, they might have found a way. But it seems that the Russian pressure wasn't the right kind.

**R:** But that's the idea that there are limits on what people can do in certain cultural situations.

**De K:** Yes, I guess; to come back to Rubens and to Sert, there must be something in the idea that a certain kind of art can only exist at a certain time.

**R:** That would be the point, wouldn't it?—A kind of historical pressure works against some forms of creation, though not necessarily in favor of something else?

**De K:** I take that for granted. But that's why I said before that I am an eclectic painter, and that I could be influenced by Rubens, but I would not paint like Rubens. The smile without the cat. For example, I object strongly to Renaissance drapery. There is so much cloth involved in that period—it looks like an upholstery store. To paint like that would drive me crazy. The drapery covered so many sins. Whenever the painter came to a difficult part he put another piece of cloth over it. That was the style, and it came to a high point. . . .

**R:** You once said you were opposed to any kind of esthetic an artist might have before he produced his work. I believe you were talking about Mondrian and the fact that the Neo-Plasticists tried to work out an esthetic in advance. You said that, at the turn of the century, "a few people thought they could take the bull by the horns and invent an esthetic beforehand." You had the feeling that such a program is a form of tyranny. It interferes with the freedom of the artist.

**De K:** Well we can go back to Russia. That's probably why good art did not come about there. You can't build an esthetic beforehand. They have canons of art, an Academy.

**R:** The Russians believe in an Academy, and they believe that art is a definite kind of work for which there are canons. The most admired artists in Russia are called Academicians. But what you were talking about was a modern Academy. . . .

**De K:** I remember that when I was a boy, on a cigar box they had "The Modern Age," the age of freedom and enlightenment, together with the great modern inventions. There was a blacksmith, barechested, with a leather apron, and a sledge-hammer over his back, which was considered a modern tool. And the wheel of progress was the biggest gear you ever laid eyes on—it certainly wasn't something that was made by a computer. Those symbols were a Romantic way of expressing the feeling of freedom.

**R:** Impressionism is very much involved with that—horse racing, ballet, all those things.

**De K:** I think Cubism went backwards from Cézanne be-

cause Cézanne's paintings were what you might call a micro-
cosm of the whole thing, instead of laying it out beforehand.
You are not supposed to see it, you are supposed to feel it. I
have always felt that those beautiful Cubist paintings exist in
spite of the Isms.

**R:** If you start with an idea . . .

**De K:** But they didn't. They were influenced by Cézanne
and they could never have the patience to do all that again,
once they knew what he was doing. But he didn't know.

**R:** They were influenced not so much by the pictures as by
their analysis of the pictures. If you were influenced by
Cézanne's pictures you would start imitating his look or
style. But the Cubists didn't do that. They analyzed the pic-
tures, and made rules out of what they found in their own
minds.

**De K:** They made a superstructure, and for young peo-
ple—I'm not being derogatory—for young people that was
marvelous. It is unbelievable to think that men in 1910 or '11
could do such fantastic things, yet I don't think theirs was a
particularly great "idea." It resulted in marvelous pictures be-
cause it was in the hands of fine artists. It depends on who
was doing it. As a matter of fact, Cubism has a very Romantic
look, much more than Cézanne has. Cézanne said that every
brushstroke has its own perspective. He didn't mean it in the
sense of Renaissance perspective, but that every brushstroke
has its own point of view.

**R:** What's amazing is the problems artists in the early 20th
century were able to conceive. Instead of painting so that the
result would look impressive, they brought to light all sorts of
problems. That's what has led to the idea of the desperation
of painting. Because if painting isn't desperate—if it isn't in a
crisis—why should it have so many problems? Simple re-
sponses don't count anymore, or being talented. Modern art-
ists have genius for perceiving problems.

**De K:** It is interesting that the late Baroque artists were so
empty. There is Bernini's Minimalness. He was a virtuoso of
genius—terrific. You look at it and it doesn't say a thing. It

says nothing about the enormous amount of work. If I ever saw Minimalism, there it was. It says nothing. Like a saint's gesture, looking upwards to heaven. . . . It takes your breath away to see that done with such grandeur—and not say anything.

I don't want to defend myself, but I am said to be Cubist-influenced. I am really much more influenced by Cézanne than by the Cubists because they were stuck with the armature. I never made a Cubistic painting.

**R:** Suppose you have the idea that you'd like to paint a tableau of a tree with people or cats sitting under it. Isn't it true that, while you are painting, you must see yourself come into it? The action of painting has to catch the totality of object and subject. You cannot think it out beforehand. Isn't that why you mentioned Wittgenstein's saying, "Don't think, look!"? Then you go farther, "Don't look, paint!"

**De K:** That's right! There is this strange desire which you can't explain. Why should you do that? I think I like it because of the ordinariness, so I am free of an attitude, in a way. Of course, that in itself is an attitude, but it would help me in my work, I think . . . The landscapes I made in the 1950s, such as *Parc Rosenberg*, were the result of associations. But I had a vast area of nature—a highway and the metamorphosis of passing things. A highway, when you sit in a car—removed . . . Now I'm having the same difficulty. You might say that I'm going backwards by wanting to paint a tableau and not just the mood of it, a kind of double take. In contrast, one might paint something holy, like Barney Newman with his measurements and those divisions of colors (though the word "division" is a bad word). It was fascinating when Annalee [Newman] showed me his studio.

**R:** You are talking about the linoleum on his painting wall, those squares?

**De K:** Yes. I had thought that the linoleum would be squared off in feet—1 foot, 2 feet, and so on. So that you could say, this canvas is 8 feet, 6 inches. But I found the squares to be 9 inches, and it's hard to measure by 9 inches.

Ten is 1 with a zero. Nine is a mysterious number, because we stop there, and then we repeat the digits. In Europe there is the decimal system, but here the measure is twelve inches, with an eighth of an inch and a sixteenth of an inch. . . .

**R:** Well, one could do a simple calculation. Ten of those squares would be 90 inches.

**De K:** Sure. But 9 is also a holy number. There is the mystery about why it is 9—and then 1 -zero, and start over again. This is contrary to our usual measurement system.

**R:** Based on tens.

**De K:** Everything is based on tens, but then it isn't based on tens but on the human foot. That's 12 inches, and then the inch is divided into the half-inch, and then the quarter inch, the eighth inch. It is a peculiar thing. There is the great invention of the Egyptians of a rope with twelve knots, which makes a right angle—3 + 4 + 5. Barney was interested in the Cabala, I was told.

**R:** Tom Hess found evidence of that.

**De K:** Before I knew that I wondered why he bought linoleum with 9-inch squares.

**R:** You think it was on account of the sacredness of the number 9? Maybe he couldn't find linoleum with 12 inch . . .

**De K:** Oh, come on. There are so many linoleums with a foot-square design. Or he could have painted one. I wouldn't even paint the squares; I would just make marks on my wall.

**R:** Why then did he want that linoleum?

**De K:** Because he wanted it in 9 inches, as a thing to measure with. So I wondered what he wanted the number 9 for. Then, later, they found his interest in the Cabala. That was why, I felt, he wanted 9 inches. He could have had any measurement he wanted. He could have said, "why not?"

**R:** You mean 9 didn't mean anything to him in particular?

**De K:** Not particularly. He just liked it I guess. Actually paintings in the dimensions of 9 are hard to place in an ordinary room, because most rooms are only 8 feet 6 inches high. As for me, I like squarish forms. So I make paintings 7 to 8; 70 by 80 inches. If I want it bigger, I make it 77 by 88 inches. That

is kind of squarish. I like it, but I have no mystique about it. Also, I like a big painting to look small. I like to make it seem intimate through appearing smaller than it is.

**R:** Usually, the opposite is the case. Artists want small paintings to look big.

**De K:** I can see that, if you really make a small painting. But if I make a big painting I want it to be intimate. I want to separate it from the mural. I want it to stay an easel painting. It has to be a painting, not something made for a special place. The squarish aspect gives me the feeling of an ordinary size. I like a big painting to get so involved that it becomes intimate; that it really starts to lose its measurements; so that it looks smaller. To make a small painting look big is very difficult, but to make a big painting look small is also very difficult.

I'm crazy about Mondrian. I'm always spellbound by him. Something happens in the painting that I cannot take my eyes off. It shakes itself there. It has terrific tension. It's hermetic. The optical illusion in Mondrian is that where the lines cross they make a little light. Mondrian didn't like that, but he couldn't prevent it. The eye couldn't take it, and when the black lines cross they flicker. What I'm trying to bring out is that from the point of view of eyes it's really not optical illusion. That's the way you see it.

In a book on optical illusion there was an illustration with many lines drawn in a certain way. There were two parallel lines, then little lines like this and little lines like that from the other side. The figure looked narrower in the center than on the top and bottom. I don't call that an optical illusion. That's the way you see it. It looks narrower in the center.

**R:** You see it that way, but if you measured it, it would be different. That's the illusion.

**De K:** But in painting, that's the most marvelous thing you can do. That's the very strength of painting, that you can do that. It is "optic" naturally, because you have to have eyes to see it. All painting is optic. If you close your eyes you don't see it. But if you open your eyes with your brain, and you

know a lot about painting, then the optical illusion isn't an optical illusion. That's the way you see it.

**R:** The way you see something doesn't mean necessarily that that's the way it is. [ . . . ] Putting a stick in water so that it looks as if it's broken . . .

**De K:** Well it is. That's the way you see it.

**R:** What do you mean, it is broken? If you pull it out of the water it's not broken.

**De K:** I know. But it's broken while it's in the water.

**R:** The break is an illusion . . .

**De K:** That's what I am saying. All painting is an illusion. Mondrian gives you one kind of illusion, whatever you call it, tension. . . . He calls it "dynamic equilibrium," or "clear plasticity." I don't care what he calls it. That's the way you see it. You have the illusion of this horse. I feel it, but that's the way I see it.

**R:** In that case he is an illusory painter in regard to you.

**De K:** To me, a cow by Courbet is no more illusory than Mondrian is. I know how it's painted. . . .

**R:** You can do what you wish with a picture. Once after a meeting with art teachers at the University of Kentucky we were standing before a large painting of a side view of a cow in front of a house. One woman said: "Tell me what you see in this picture." For the fun of it, I began to find all kinds of images painted into the cow, between its head and its tail. It turned into a Surrealist painting. The more we looked at it the more figures began to appear. It became a game—everyone found something—here is a clump of trees on the side of the cow, there is a river running down the cow's neck. All this began to appear, as if the artist had actually painted it.

**De K:** You mean he didn't paint it there?

**R:** No, they were accidental effects that appeared when you looked at it in a certain way—as if you were watching clouds. A human profile emerges, a cathedral, an animal. We were standing in this idle way and began to see babies and motorcycles on the side of the cow and around the cow. The art teachers behaved as if I had given them a kind of magical

lecture, because at first they had seen only a cow and a house.

**De K:** I know now what you mean. I use that a lot in my work.

**R:** You mean accidental effects?

**De K:** I don't make an image such as a baby, but I use it. . . .

**R:** That Abstract-Expressionist painting by Perle Fine that's hanging in our bedroom is so loaded with images—Arabs, masked bandits—I can hardly look at it any more. I don't see the painting, but the cast of characters that has come out of it.

**De K:** You know, those figures are very well drawn. If you asked her to draw a head she couldn't do it that way. That's the strange thing.

**R:** You are absolutely right. No artist could do it.

**De K:** That's the secret of drawing, because the drawing of a face is not a face. It's the drawing of a face. When you look at a Rembrandt, it's just an association that there is a man standing there that makes it realistic. Next to him there is a black shape. You know it is a man also. But if you look at that spot for a long time, there is no reason to think that it is a man. It happens with so many drawings and paintings—in Chinese art, in all kinds of art—and all the works come together.

**R:** What do you mean by coming together?

**De K:** That they become separated from their period. Chinese artists did something a thousand years ago, and somebody else today does something very similar.

**R:** They are not divided by history.

**De K:** No division by history at all.

**R:** What has been going on in the past couple of years? Copying photographs or using actual photographs. Apparently young artists want to create the feeling of a *mise-en-scène*, a sort of tableau of people looking at pictures in an art gallery, or standing around at a party. What do these activities mean to you? Why sould artists make art of pho-

tographs, instead of taking photographs for practical purposes, or for the sake of sentiment?

**De K:** Well, such art has a certain psychological effect. It's almost Minimal Art, as if one said, "Never mind what the meaning is, here it is." This art has a kind of atmosphere, a psychological overtone that is make-believe. You know it is painted and yet it looks like a photograph. I don't understand the meaning. The people look ordinary, and the cars are brand new and look sleeker than the people do, unless they have a beautiful model in front of them, and then the model looks sleeker than the car.

**R:** What's the reason for it? You would expect that works of this sort would advertise something, or on the other hand have a political message to tell.

**De K:** On television you often see shots, as in scenes televised from Vietnam, that look exactly like painting. If you have that kind of eye, you may say: "That looks like a Manet." Of Course it's a coincidence. Sometimes a painted portrait looks like a photograph, and sometimes a photograph looks like a portrait. There is something fascinating for me about photography.

**R:** You don't feel that painting has a particular purpose, or one that you would like to see it have? You don't care why people paint whatever they paint?

**De K:** The main thing is that art is a way of living—it's the way I live. It's not programmatic. When I read *The Brothers Karamazov*, I liked the father the most.

**R:** I happen to agree that Fyodr Karamazov is the most important character.

**De K:** In the end he is really all there, and the others couldn't break out of a paper bag by themselves. The father isn't a nice man, but I was painting a picture and all of a sudden it came to me that I liked the father the most. . . . It came like a revelation. It hung in the air somehow. A novel is different from a painting. I have said that I am more like a novelist in painting than like a poet. But this is a vague com-

parison because there is no plot in painting. It's an occurrence
which I discover by, and it has no message.

**R:** You mean your painting is an event?

**De K:** It is an event, and I won't say it is kind of empty,
but . . .

**R:** An event without an interpretation.

**De K:** Yes. I have no message. My paintings come more
from other paintings. Here is ARTnews, and I become fasci-
nated. I could paint the head of this horse. But that would be
an abstract painting. There seems to be something constant
for me in painting. This man, you could say, is like a Matisse.
But this one is made by a Greek, 3,000 years ago, and it looks
like a Japanese drawing. I don't know how old these things
are—I see them with my eyes. The caption says: "The golden
age of Greek painting comes to life in this bucolic scene of a
herdsman leading his horses" done between 340 and 320 B.C.
That's a long time ago. It's fascinating, isn't it, that this was
painted 2,300 years ago and you know right away that this is
a tree. I am interested in that. It seems it could only happen in
the Impressionist period. But once you have Impressionist
eyes, you look at those small Pompeian paintings—not the
big classical ones—the little paintings with a tree and a rock,
and they are almost the same as Impressionism. This is my
pleasure of living—of discovering what I enjoy in paintings.

**R:** Discovering what other people have done, that is like
what you have been doing?

**De K:** Yes, in discovering what other people have done,
and that I can do it too. It is like an overtone of my Woman
paintings, which are supposed to make me a matricide or a
woman hater or a masochist and all sorts of other things.
Maybe I am a bit like any other man, but I wouldn't show it
off in my paintings. . . .

**De K:** Why do I live in Springs? To begin with, my friends
were already there. But also I was always fascinated with the
underbrush . . . the entanglement of it. Kind of biblical. The
clearing out . . . to make a place. Lee Eastman found a large

house for me on Lily Pond Lane, [The Springs is the part of Easthampton where fishermen and workingmen live. Lily Pond Lane is the estate district.—Ed.] but I knew it wasn't for me. There was no underbrush—it had been taken away generations ago. I like Springs because I like people who work. Snob Hill is really nice, too, but the trees have already grown up there and it looks like a park—it makes me think of people in costume and Watteau. As I said, I had friends in Springs and visited them and that made me decide to move in.

**R:** Has working in the country affected your work? Everybody seems to think that it has.

**De K:** Enormously! I had started working here earlier, and I wanted to get back to a feeling of light in painting. Of course you don't have to have it, but every artist has it. Léger has a light. It's another kind of light, I guess; it's hard to go into that. I wanted to get in touch with nature. Not painting scenes from nature, but to get a feeling of that light that was very appealing to me, here particularly. I was always very much interested in water.

**R:** You were interested in light on Tenth Street, too, where the light is, of course, quite different.

**De K:** On Fourth Avenue I was painting in black and white a lot. Not with a chip on my shoulder about it, but I needed a lot of paint and I wanted to get free of materials. I could get a gallon of black paint and a gallon of white paint—and I could go to town. . . . Then I painted the Women. It was kind of fascinating. *Woman I,* for instance, reminded me very much of my childhood, being in Holland near all that water. Nobody saw that particularly, except Joop Sanders. He started singing a little Dutch song. I said, "Why do you sing that song?" Then he said, "Well, it looks like she is sitting there." The song had to do with a brook. It was a gag and he was laughing, but he could see it. Then I said, "That's very funny, because that's kind of what I am doing." He said, "That's what I thought."

**R:** You mean you had the water feeling even in New York?

**De K:** Yes, because I was painting those women, and it

came maybe by association, and I said, "It's just like she is sitting on one of those canals there in the countryside." In Rotterdam you could walk for about 20 minutes and be in the open country. Of course in that time it still looked like the Barbizon School, the idea of farms and . . .

**R:** But then you did *Gotham News* and those rough looking cityscapes.

**De K:** I started doing them later. Then slowly I got more and more involved with being here in Easthampton, and it came to me that one has different periods in painting. There was a certain time when I painted that men series . . .

**R:** In the 1930s?

**De K:** Yes, but it was all in tone. The *Glazier* was influenced by Pompeian murals. I was often with Gorky when I saw those murals, and he couldn't get over the idea of painting on a terra-cotta wall like the Pompeians were doing. I had that yellow ocher, and I painted a guy on the yellow ocher and the wall was really like the yellow ocher, a flat thing. It was never completely successful, but still it had that feeling. Then slowly I changed, and when I started to make those landscapes, I had the idea of a certain kind of light from nature. The paintings I was doing of men had another idea of light, not like on a wall . . .

I knew that if I made some kind of shapes with certain tones or values of paints mixed in paint-cans, instead of having ready-made colors from art-store tubes, that I would be stuck. But if I began arbitrarily, then I would have to find a way to come back with an answer. I don't know if you get what I mean.

**R:** Well, say some more about it.

**De K:** Arbitrarily, I made those bright flesh colors. All I needed was white and orange to give me an ideal, bizarre flat color, like the color on Bavarian dolls. I made it completely arbitrarily. Then for some reason or other—I forget the details—the idea was that I was going to make a liver color, and the liver color I picked out was the color of the liver when it was cooked and sliced as I remember it from Holland. That

was a kind of grey-brownish color and to get it I had to mix about six different colors. It was an uncomfortable color to work with, and I wanted to be kind of stuck with it. It did me a lot of good because it was like a tone; something you can't lay your hands on; almost like a kind of light on a roof. It seems colorless, like a dazed-kind of light. It can be a dark color or a light color. You can make it shade in between things. If you have a light of so-called bright colors, you can make them tones in between. It shapes up to the doings of it.

R: Was this color one you used in the landscapes?

De K: That's right. I even carried it to the extent that when I came here I made the color of sand—a big pot of paint that was the color of sand. As if I picked up sand and mixed it. And the grey-green grass, the beach grass, and the ocean was all kind of steely grey most of the time. When the light hits the ocean there is kind of a grey light on the water.

R: And that was related to the liver?

De K: Well, it came out. I kept forgetting about it, but I was in a state where I could start with that. I had three pots of different lights, instead of working with red, white and blue like Léger or Mondrian . . .

R: Instead of the colors you had tones!

De K: Indescribable tones, almost. I started working with them and insisted that they would give me the kind of light I wanted. One was lighting up the grass. That became that kind of green. One was lighting up the water. That became that grey. Then I got a few more colors, because someone might be there, or a rowboat, or something happening. I did very well with that. I got into painting in the atmosphere I wanted to be in. It was like the reflection of light. I reflected upon the reflections on the water, like the fishermen do. They stand there fishing. They seldom catch any fish, but they like to be by themselves for an hour. And I do that almost every day.

R: You do that?

De K: I've done it for years. As in your lecture about the "water gazers," do you remember, in the beginning of *Moby*

*Dick?* When Ishmael felt desperate and didn't know what to do he went to Battery Place. That's what I do. There is something about being in touch with the sea that makes me feel good. That's where most of my paintings come from, even when I made them in New York.

**R:** How does the figure come in? How do you relate it to the light of the landscapes?

**De K:** I started all over again in the sense of painting those women I painted on Fourth Avenue and on Tenth Street [in 1950–55]. I went back to it here. When I made *Woman Sag Harbor* [1964] I just titled it that, because I go to Sag Harbor and I like the town and I frequently have this association. While I was painting it I said to myself, "That's really like a woman of Sag Harbor, or Montauk, where it's very open and barren." I started to make them more in tone. You can see that; in brightness of light, which makes me think I have some place for her.

**R:** In those tones?

**De K:** Yes, in those tones. There is a place there. When I say Montauk . . . Oh, I could find other places. There is no difference between the ocean beach nearby and at Montauk, but I have an association because I go there quite often. Particularly in the off-season, in the late fall, or even in the wintertime. It would be very hard for me now to paint any other place but here.

**R:** The light, of course, is quite different in the wintertime, isn't it?

**De K:** It gets very pure. Blue skies and very pure light. The haze is gone. Some of my paintings have that light and develop that haze.

**De K:** If you have nothing to do and want to meditate and have no inspiration, it might be a good idea to make a sphere.

**R:** Out of what?

**De K:** Out of plaster. It's easy. You can add to it, you can sandpaper it. But you mustn't use calipers or any other instrument. You could never make that sphere because you would never know.

**R:** You mean, you wouldn't know when you had produced a perfect sphere? Or you wouldn't know how to go about making it?

**De K:** You can imagine yourself doing it. Let's say you make it about 12 inches, but you don't use a ruler. It is very hard to know what 12 inches is without a ruler.

**R:** Do you want it to be a sphere of a certain size or just round?

**De K:** Well, you could start to make it 12 inches. Then you turn it around and say, "Gee, I have to sandpaper this a little more." Then the next time you say, "I have to add a little more here." You keep turning it around and it will go on forever because you can only test it by eye.

**R:** If you didn't feel that you had to add or subtract, would you be convinced you had a perfect sphere? I mean, if you got to the point where you felt there was nothing you could do to it. Then it would be a sphere, wouldn't it?

**De K:** Yes, but that can never happen.

**R:** You don't think one would ever get that feeling?

**De K:** No, because a sphere is social. If they give you a ball bearing, you know it is absolutely right?

**R:** You would take their word for it.

**De K:** Most things in the world are absolutes in terms of taking someone's word for it. For example, rulers. But if you yourself made a sphere, you could never know if it was one. That fascinates me. Nobody ever will know it. It cannot be proven, so long as you avoid instruments. If I made a sphere and asked you, "Is it a perfect sphere?" you would answer, "How should I know?" I could insist that it looks like a perfect sphere. But if you looked at it, after a while you would say, "I think it's a bit flat over here." That's what fascinates me—to make something I can never be sure of, and no one else can either. I will never know, and no one else will ever know.

**R:** You believe that's the way art is?

**De K:** That's the way art is.

# 22

# Saul Steinberg

Saul Steinberg is a frontiersman of genres, an artist who cannot be confined to a category. He is a writer of pictures, an architect of speech and sounds, a draftsman of philosophical reflections. His line of a master penman and calligrapher, aesthetically delectable in itself, is also the line of an illusionist formulating riddles and jokes about appearances. In addition, it is a "line" in the sense of organized gab. Because he is attracted to pen and ink and pencils, and because of the complex intellectual nature of his products, one may think of Steinberg as a kind of writer, though there is only one of his kind. He has worked out exchanges between the verbal and the visual, including puns on multiple planes of verbal and visual meaning, that have caused him to be compared to James Joyce. His art-monologues bring into being pictures that are words, and words that have the solidity of things, and that suffer the misfortunes of living creatures, as when HELP! is bitten in half by a crocodile[1] and in

Originally published in *Saul Steinberg*, commentary by Harold Rosenberg (New York: Knopf/Whitney Museum, 1978).

1. The vulnerable part of the man in danger is the cry for help, which is the part by which the crocodile holds him and which has the function of an appetizer. What do I want to say? That he who cries his terror becomes the victim of his statement. —*S. St.*

WHO DID IT? the WHO causes the DID to crush the I of the IT.[2]

Steinberg's compositions cross the borders between art and caricature, illustration, children's art, *art brut,* satire, while conveying reminiscences of styles from Greek and Oriental to Cubist and Constructivist. His work is notably of the present day, yet it has an aura of the old-fashioned. As a cartoonist, Steinberg tantalizes those who wish to separate high art from the mass media. Granted that he is witty, formally ingenious, a great calligrapher, "Is he an artist?" Steinberg is aware that he is a borderline case, and seems content with the ambiguity of his position. "I don't quite belong in the art, cartoon or magazine world," he has reflected, "so the art world doesn't quite know how to place me." To display Steinberg's drawings and paintings in an art museum is, however, to define them as art. Since Marcel Duchamp showed a bicycle wheel in an art gallery more than fifty years ago, objects have been identified by the company they keep. By this rule, the present retrospective closes the debate about the works contained in it—but it will not determine the nature of a Steinberg reproduced in a magazine next week. Art today, cartoon tomorrow.

More important, however, than the obsolescent issue of "Is it art?" is the fact that all of Steinberg's creations form a single continuous and developing whole; that they are coherent with one another through the unique cast of this artist's thinking, skill and sensibility. It is this ultimate mental/manual signature that has brought Steinberg recognition as a master with a wider public throughout the world than any other artist now alive.

2. It's obvious that WHO did it. And exactly the H of WHO shaped so as to push the D of DID, another word who obviously *did* it by its nature of *doing* and by the inclination of the two D's to roll and crush IT; more exactly, the I of IT.

And who asks the question? None other than the Question Mark itself, facing and judging the fact. The three men are around for the sake of scale and animism.—*S. St.*

Steinberg emerged among the American artists who in the immediate postwar years revolutionized painting and sculpture by introducing into it a new subject matter: the mystery of individual identity. "The self, terrible and constant, is for me the subject matter of painting," wrote Barnett Newman. Self or not-self (impersonality) has been the issue on which art movements in the United States have risen and foundered in the decades since the war. In their mythic researches, Arshile Gorky, Jackson Pollock, Willem de Kooning, Philip Guston, Barnett Newman, Mark Rothko each sought a unique idiom in which to unveil a being underlying consciousness.

Like them, Steinberg conceived art as autobiography. But autobiography of whom? The hidden metaphysical self. Man today? The immigrant? The stranger? In the mid-twentieth century the artist is obliged to invent the self who will paint his pictures—and who may constitute their subject matter.

Steinberg's approach to the self has been the opposite of the Expressionists'. It has also distinguished itself from that of the "impersonalists," such as Ad Reinhardt, Frank Stella, Donald Judd, and other minimalists. Instead of seeking "contact" (Pollock's term) with the singular, unattainable self, Steinberg conceived the theater of Abstract Man, Mr. Anybody (and his wife), in their countless poses, self-disguises and self-creations. Each of the women in *Bingo in Venice, California*, for example, is an invention produced by collaboration between herself and the artist's pen.

A virtuoso of exchanges of identity, Steinberg is naturally inclined toward comedy. His concept of the comic relates both to the fantasies of human beings and to their rigidities. Comedy also arises out of his consciousness of self-invention. Steinberg's art is a parade of fictitious personages, geometric shapes, items of household equipment, personified furniture, each staged in a fiction of what it is—or in a dream of being something else. His little man, anonymous citizen, is burdened with projects and conditions, from sneaking up on a question mark with a butterfly net to dreaming of a woman

who is dreaming of him. A roughly drawn, freehand cube has a dream of glory in which it is a perfected cube with ruled edges and neatly lettered corners (*Cube's Dream*). An E built of massive blocks fancies itself as an elegant French É. In Steinberg's view everything that exists is an artist and is engaged in refining its appearance—a curious version of Darwinism. "The main thing to find out," he declared to an interviewer, "is what sort of technique the crocodile employs to show itself."

There is also a grim side to this universal self-transformation. Becoming someone else is a crisis situation. Steinberg's drawings are full of figures on the edges of precipices, statues falling from their pedestals, solitary individuals staring into voids.

In contrast to the impenetrable but suggestive signs evoked by Pollock and de Kooning from the spontaneous action of the brush, Steinberg's figurative language, equally mysterious, derives from the gallery of images firmly fixed in the public mind. In this respect, as in others we shall discuss later, Steinberg is a forerunner of Pop Art—though he transcends the limits of Pop, since he is above all an artist of the free imagination. From the faked official signatures and governmental seals in his drawings of the 1940s to the rubber stamps of his 1970s paintings and assemblages, he has been telling his story in terms of impersonal and repeatable commonplaces, distorted, as in dreams, by exaggerations, displacements and wit. Impresario of Abstract Man, he stages him in a universe of accepted ideas that he suddenly strips of their acceptance; for example, his use of Uncle Sam. It is not surprising that a specialist in the riddles of identity—is this what the Sphinx stands for in Steinberg's recent paintings?—should be aware that autobiography is a species of fiction writing. Those who strive to lay bare the "facts" of their lives are victims of the delusions of the style called Realism. Steinberg's presence in his visual narrative is personified by a cast of invented characters who serve as his disguises: the little man in profile (the citizen, more or less Solid), the cat (the

little man with a tail and whiskers), the dog (a more dignified cat), the fish (Sphinx to the cat), the artist (the hand with the pen, the little man with an easel), the hero (a knight on horseback). These personae perform in varieties of domestic and comic-strip situations, from watching TV and scrutinizing pictures in art galleries to marching in formation on mathematical moonscapes. Instead of presenting himself as protagonist, Steinberg projects an alter ego who is detached, curious, passive and fearful—one of his most memorable trademarks is the gentleman inside of whose head is a rabbit peering out of the man's eyes, a frightened creature, both trapped and protected (*The Rabbit*). Accessible only through his metaphors, Steinberg becomes "someone" in his demonstrations of how his anonymous inner being is constantly representing itself.

To investigate individual identity in terms of its social reality is to function in the realm of farce. Comedy is what makes Steinberg immediately attractive, and it is the basis of his popularity. His narrative art looks back to Molière, at the same time that it takes its place with the absurdist literature of this century. The restrictions of the line drawing have not prevented Steinberg from being the peer of Pirandello, Beckett, Ionesco. To a style founded on the drawings of children, he has added the dimension of playful juggling with the gravest issues of art and self.

The artist tells his story of "becoming someone else" through pictures that suggest possibilities rather than recount facts. In *Hotel Plaka*, two conversational balloons are erotically intertwined on a bed covered with a massive comforter.[3]

3. Hotel Plaka, a hotel in Athens. This is part of a series of erotic drawings—a parody of pornography, showing how conventionally we are exploited by eroticism. Here the eroticism is represented only by the location: a bedroom in a hotel, the most banal setting for eroticism. Love here is a dialogue in bed; two balloons merge. In another drawing, a Cubist element is in bed with the Impressionist technique, and here is another one again where a Pythagorean triangle transfixes a question mark. One could say that the question mark, fat and voluptuous, is the woman, while the triangle, precise,

Steinberg narrates but he does not reveal: in the Hotel Plaka bedroom two voices met; that's all you'll ever know. Steinberg has said that at the age of ten he decided to become a novelist but that he has still not made up his mind about what to be. The advantage of being a borderline artist is that it allows the decision to be put off indefinitely. With his name multiplied in every big-city telephone book, Steinberg can come close to anonymity without effort. In an apartment house in New York where Steinberg lived, there were two Steinbergs on the same floor—and in East Hampton where he has a house there is another Saul Steinberg. The absence of an identity of one's own can become oppressive, as Willie Sutton discovered when he lived incognito in Brooklyn. A few years ago, Steinberg lost his patience and telephoned his East Hampton namesake.

"Is this Saul Steinberg?" he inquired.

"Yes" was the answer.

"But are you the *real* Saul Steinberg?"

"No," replied the poor fellow.

"Are you sure?"

Yet, knowing and not knowing who he is, the artist can "express himself" as if he were somebody. In his drawings Steinberg records everything about himself but without providing information—except what he has been making up. His art is the public disclosure of a man determined to keep his life a secret.

Steinberg's adventures in disguise begin with his birth in Romania, which he has dubbed "a masquerade country." The moment he opened his eyes he was convinced that his operetta environment, with its costumed peasants and mustachioed cavalrymen, was calculated to trick him. His defense

---

geometric, the symbol of logic, is the man. But this exposes our prejudices, because one thinks always of the man as the logical part, while the woman is a simple question mark with all the insecurity implicit in this symbol. It could be in fact an affair between a fat man and a smart woman. In other drawings, I put in bed certain numbers that are erotic because of their construction: 5 and 2, for instance (1, 4 and 7 have no sex appeal). —S. St.

was to learn without delay how to render himself invisible by blending into his surroundings. But Romania was ready for him: "At school I had a military uniform and a number like a license plate, so anybody could take my number and denounce me."

At eighteen, Steinberg left for Italy, a country not without its own operatic delusions, especially during the reign of Mussolini, when businessmen paraded after hours in black shirts and spurred boots and Il Duce harangued mobs from balconies. For the next six years, dividing his time between studying architecture (reflected in the ornate bridges and railroad stations, fairy-tale castles, period-design skyscrapers, stylized interiors, Utopian city layouts and ornamental cloud formations that provide exotic elements in his drawings) and making cartoons for Milanese periodicals, he adopted the look—spectacles, long hair and bushy mustache—of the typical professional-school student.

Mussolini's partnership with Hitler and the spread of the war forced Steinberg to seek a new setting, and with it a change of costume. The place for him, obviously, was the United States, a land where everyone is busily engaged in becoming someone else—thus, in Steinberg's terms, an artist. To reach this Promised Land was not easy in wartime. Steinberg arrived in Lisbon with a "slightly fake" passport—one that had run out but that he resuscitated by means of forged rubber stamps. (Steinberg's studio today stocks enough rubber stamps to get him safely around the entire cosmos.) At the airport Steinberg was arrested, not on account of the passport but through a mistake of identity (another Steinberg or someone who resembled him physically was wanted) and because he infuriated the Portuguese police by denying that he spoke Portuguese, which they took as an insulting pretense. Shipped back to Italy, he managed, after some painful experiences about which he prefers to remain silent, to make his way to the Dominican Republic, where he emerged as a colonial gentleman, planter style, in a white linen suit and a broad-brimmed panama.

Admitted to the United States—in contrast to Romania a
nation of civilians—Steinberg found himself once again in
uniform, this time the outfit of a naval officer. Now mas-
querading professionally, and in deadly earnest, he was sent
to China by the Navy as a "weather observer." His actual
mission was to act as a means of communication with the
Chinese guerrillas by means of his ability to say things
through pictures. The hitch, Steinberg insists, was that while
he and the Chinese understood each other perfectly, he could
not communicate with the Americans since he knew no En-
glish. His theory is that his real mission was to confuse en-
emy intelligence agents by compelling them to wonder what
this foreigner was doing with the United States Navy in
China. The fiction within fictions of the intelligence service
made Steinberg feel at home.

To wear a uniform and be an alien underneath is to experi-
ence style as disguise. For Steinberg, place is dress (e.g.,
*Moscow Winter Coats*) and dress is playacting. Every self-affir-
mation is a masquerade. The world is a Romania. The West is
the Wild West of *High Noon,* sombreros and cartridge belts,
hand on the pistol, the Fastest Gun. The cowboy appurte-
nances form a design—the barroom boaster is a piece of ar-
chitecture, his legs arched like a bridge. Steinberg's
succession of uniforms sharpened his conviction that the
style hides the man. Not only the artist but everyone "be-
comes someone else" in becoming someone. One is thought
about, thus invented. Or, as Steinberg put it with memorable
succinctness in his *Cogito* drawings: "I think, therefore Des-
cartes is." One creates not oneself but another. Being is in
the act. A drawing of women is called *Four Techniques,* as if
the existence of each were someone's "how to." Another
drawing carries the idea further: in *Techniques at a Party* seven-
teen different styles of drawing have replaced the human
substance of a crowd.

In America masks are worn less tightly than in Europe,
where they are affixed permanently by class and vocation—
"in order," says Steinberg, "to make the job of tax collecting

easier." In America it is even chic to shift periodically to the mask of anonymity, providing it is transparent and can be seen through by everyone. Thus professors and poets jitterbug to pass as common folk, tycoons address each other as "Joe" and "Frank" and Presidents are headlined in monograms as FDR and LBJ. Conversely, people whom nobody knows disguise themselves in dark glasses in order to pretend to be incognito—that is, someone who is making an effort to remain unknown. Individuals unmasking themselves only to reveal other masks, verbal clichés masquerading as things, a countryside that is an amalgam of all imported styles (*Rainbow Landscape*), an outlook that is at once conventional and futuristic—America was made to order for Steinberg. In the nation of "The Man That Was Used Up," as the title of Poe's tale put it, Steinberg's life of ruses and disguises could fulfill itself.

Steinberg's own mask after becoming an American was one of imperturbable curiosity, that of a species of unofficial inspector (*The Inspector* is the title of one of his published collections of drawings), most approximately an inspector of insect life, a mask which in time was divested of its mustache and most of its hair but on which still glitter the old student's eyeglasses. What chiefly occupied the attention of this investigator was the remarkable capacity of his fellow citizens to contrive selves without limit in an environment that was the projection of what each desired to be at the moment. His observations gave rise to the series of drawings in which a man or a cat draws a line that outlines his own shape and frames him in a scene (*The Spiral*).

Among the American artists who after the war made the experience of self-creation central to their work, the majority—Gorky, de Kooning, Hofmann, Rothko, Gottlieb, Newman, Guston, Baziotes—were immigrants or sons of immigrants. This aspect of their situation has rarely been mentioned, much less analyzed in relation to their creations. With Steinberg, his condition of being an immigrant affects his work to a degree that cannot be overlooked. With the im-

migrant, the issue of "Who am I? What shall I become?" is sharpened by "Where am I?" All the artist identity-seekers have been painters of mythical landscapes. With them, figure and setting, self and nature-symbol are one. Self-creation and man-created nature go hand in hand. In de Kooning's "Woman" canvases, the human torso loses its contours and dissolves into fields and bodies of water. Gorky entitles an abstract landscape *How My Mother's Apron Unfolds in My Life.* Hofmann testifies that "I bring the landscape home in me," while Gottlieb invents signs that indicate new solar bodies on his cosmic maps. Steinberg's America, with its distorted distances, Uncle Sams, eagles, Masonic pyramids, Last of the Mohicans, matrons, hookers, crocodiles and cats, though made up of fact and popular legend, is no less the projection of an estranged self than Rothko's floating plateaus of tint.

Steinberg may be said to have begun discovering Steinberg America in the Immigration Office. Official documents are among the most stylized elements in modern society. Passports, drivers' licenses, bonding stamps, ID cards change very little. Also tax receipts, protocols, birth certificates, citizenship papers. The rubber stamp hovers over society's business as did formerly the king's seal. Diplomas, proclamations, bank drafts are signed and countersigned. All these are affirmations of form—that is, art as the antidote of anarchy. People also leave formal traces of themselves in doodles, laundry tickets, albums.

Steinberg noted that a fingerprint has the oval shape of the human face; outfitting this unfailing mark of individual identity with a collar and tie also made of fingerprints provided an improved version of a passport photo (*Passport Photo*). A fingerprint photo is an abstraction, yet it is the essence of a portrait. It doesn't resemble the sitter but it is his organic signature. To emphasize the point, Steinberg accompanied fingerprint portraits with parodies of conventional album pictures. The concrete representation fades, the abstraction holds firm.

In another drawing, the fingerprint portrait, affixed to a

legal-looking document complete with counterfeit official seals, stamps, watermarks and ornate signatures, provides a certificate of status. The immigrant is now legally "here," though his proof of identity is forged. Or, one might say, the artist's pen has taken over the function of government, as it has the molding of nature and its inhabitants. Steinberg's fake government instruments, self-generated global identification papers, are his equivalent of Gorky's self-documentation in *The Artist and His Mother*, based on an old flashbulb photo.

But Steinberg was not finished with the fingerprint. There are drawings in which the texture of the finger ends constitutes the substance of the heavens (*Fingerprint Landscape*). The artist is encompassed by the physical sign of his identity in the same way—and with the same implication of a world emanating from self—as he is in the circle that the little man draws and stands on and that closes him in. The fingerprint and the pen are equally the sources of this newcomer artist's universe. Finally there is a drawing of the artist painting a landscape with a bunching of fingerprints at the horizon that produces a lowering mood like the cypresses of van Gogh. With his rhetoric of signs, Steinberg melds self and surroundings into an ego/cosmos as explicit as that of Rothko and Pollock.

The immigrant digs in where he can obtain security. Gorky, de Kooning, Newman, Rothko settled in New York City, Connecticut, Long Island, places from which they explored their environments of projected self. In contrast, Steinberg arrived in New York only to keep moving. Being an immigrant was a condition that he apparently preferred and that has taken him a long time to overcome. That fingerprint self-portrait had perhaps a deeper meaning than he realized. To keep arriving and identifying himself are, it would seem, among his deepest impulses, and the places from which he has departed supply him with rich veins of nostalgia—the lonely goodbyes in his travel "postcards," bearing names such as *Abidjan* and 2 *Eastern Sunsets*.

"By putting oneself in the uncomfortable position of the immigrant, one is again like a child." But a child of oceanic or global sensibility. Marc Chagall paints the *shtetl* of his White Russian childhood, Gorky his fabulous Armenia. Steinberg's art lacks a centrifugal location. His nostalgia, fabricated of yesterdays, is skin deep.

For Steinberg, as for his Abstract Expressionist contemporaries, the landscape is an emanation of the artist. There are Steinbergs with skies made of rhythmically repeated pen strokes, zigzags and scribbles, fields composed of parallel horizontal lines, ornamental patterns, script—as arbitrary as Pollock's wavy strands of paint. Even the horizon is not immune to molestation: in a 1962 Steinberg it curls up into an erratic S producing two landscapes (two universes) joined in different eye levels, with a void between them.

But Steinberg's invented landscapes are not totally subjective or metaphysical. Here again his position is on the boundary line—between the self and the not-self, between the internal and the factual. He is a reporter of fictions, as well as an originator of them. His story of himself includes the record of his travels. His pen has journeyed from Milan to Greenwich Village, to Colorado and Hollywood, to Zurich, Moscow, Samarkand, Murchison Falls—to a prison city called *Law and Order*, to a pitted terrain that could be the moon. His mythical landscapes are also the settings of collective myths, scenes and cities fabricated by the dreams of their inhabitants. In his fantasy of America are embedded fragments of popular symbols, the romance of frontier history and the bad taste of automobile designers, Hollywood architects, fashion experts and dog groomers.

The theme of a world unfolding out of the artist's act of drawing is reiterated in numerous ways, from the calligraphic landscape mentioned above, in which the horizon explodes into a flourish of penmanship, to drawings in which objects are repeated upside down because a line indicates a body of water in which they are reflected. To Steinberg the line of the horizon, which marks the limit of the visible, is just another

line that his pen can manipulate as it sees fit. All things in Steinberg's pictures—scenes, people, cats, crocodiles—have their source in art. But art is not restricted to pictures. Everything that exists has its source in art; that is, in human invention. The skin on the fingertip is an organic product, but the fingerprint is a device of society. It is a mark produced with ink for the purpose of recording the identities of individuals and arranging them in files. The fingerprint is art imposed on nature by society.

Only objects as they are transformed by society's invention are proper subjects for Steinberg. Originating in an art-conceived universe, Steinberg's metaphorical images spread like varieties of mold throughout his compositions of the past thirty-five years, from the wartime cartoons and faux-naïve chickens and human heads (*Hen*, 1945, *Head*, 1945) shown in the Fourteen Americans exhibition of the Museum of Modern Art, New York, in 1946—and collected in *All in Line* (1945), with the self-originating hand holding a pen on its cover—to the most recent oil-on-paper landscapes and drawing-table assemblages. Analyzing the means by which things are commonly represented in art and out of it provides Steinberg with access to a Pandora's box of deceptive equivalents, as in his drawing of cats clinging to an imprisoning screen consisting of a sheet of graph paper on which the cats are drawn (*Graph Paper Cats*).

Steinberg himself has formulated his conception of nature as a human fabrication, a conception epitomized in his remark made several years ago: "When I admire a scene in the country, I look for a signature in the lower right-hand corner." Nature, in Steinberg's view, bears the imprint of the social and political world, including the forms provided by the accumulated styles of the past. "I can't draw a landscape," he has said, "but I draw man-made situations. . . . What I draw is drawing, [and] drawing derives from drawing. My line wants to remind constantly that it's made of ink."

Perhaps it is his conviction that his personae, buildings,

animals can be dripped back into the ink bottle that gives Steinberg his lightness of touch, which eludes his scores of imitators. "Drawing derives from drawing" is the creed of the aesthete, and there is no doubt that there is much in Steinberg's drawing that is owing to the pure pleasure of execution. But Steinberg has no use for aestheticism. "To be involved in aesthetics only . . . ," he has said, "that for me is worthless. I want to say something." Beyond his aestheticism are his researches into self; and autobiography, whatever its form, is deadly serious. In Steinberg's compositions there is, besides drawing and what can come out of drawing, the grit of reality, of personal experience, at times painful.

Everything springs from the artist's act. The hand that makes the drawing has drawn itself and the pen with which it draws. In one complex Steinberg, the man with the pen has drawn a horizon, complete with trees, a road, a house, that has wound up into a spiral in the sky that he goes on drawing as it tightens around him (*Spiral*). "It gets narrower and narrower," Steinberg said. "This is a frightening drawing. It could be the life of the artist who lives by his own essence. He becomes the line itself and finally, when the spiral is closed, he becomes nature." One begins with fictions and converts them into realities through performance.

The material in Steinberg's art is neither things as they are nor the appearance of things, but the art in things, their style. Style is a disguise, but one that represents the history of the object and its social reality. It is the "imprint of the society and the political world" that makes people interesting to Steinberg. Steinberg finds these "imprints" everywhere: on the faces of living people, on places and objects, not merely in the comic books and advertising that inspired Pop artists. He ranges from wildly improbable coiffures, a face structured like a hat rack or flowing like rippling water, meditations of a dog, to Mickey Mouse strumpets that are all legs.

What we call "nature" is the sum of styles that coexist in any given period. The historical consciousness of modern times has provided the artist with a vastly expanded "po-

liticized" nature in which to work. Like Joyce, Steinberg par-
odies styles spotted throughout history as potential costumes
for the contemporary ego. The old platitude "Nature imitates
art" has been raised to a higher intensity by the multiplication
of styles, as well as by the physical superimposition upon the
earth and its creatures of man-made contrivances. For Stein-
berg, anything that has escaped being made over by man fails
as subject matter for art. "A beautiful woman is like a rain-
bow, a sunset, a moon—all stuff that should be looked at but
not painted." Of course, Steinberg does paint rainbows, sun-
sets and moons and even, occasionally, a beautiful woman,
because these, too, are "imprintings" of society in his sense.
But he paints them as products of the techniques of painting.
"Dogs and cats," he has explained, "are man made. I also
draw lions. They entered society through allegory and coats
of arms." At any rate, his point is clear: the matter of his art is
artifice, the way people and things make themselves up, or
are made up, to present themselves to the world. The more
made up the better, since masquerade is evidence that the
imagination has been at work. "I don't touch children much,
except the sort of midgety ones that have been rendered po-
litical by being dressed in tiny Brooks Brothers suits."

In essence, art is, in Steinberg's terms, a "political" activity;
that is to say, conscious of the spectator as someone to affect,
either as critic or as potential admirer and patron. Art is a
response to the temptation to put on an act and to transform
oneself—into an anonymous citizen, a cat, a movie star, a
knight, a Sphinx. In the absence of the passion for playacting
and social recognition, art is inconceivable. Thus art leads not
toward reality but away from it, toward makeup, costume
and role playing. Its highest gift is fame, on which Steinberg
meditates in his numerous drawings of figures on pedestals.
But fame, far from stabilizing the self, envelops it more com-
pletely in a maze of social abstractions. So the artist, too, is
"man made," an object rather than a subject.

Nature not only imitates art, it imitates artists. After millen-
nia of human image-making, it has gotten into the habit of

showing off its versatility. Nature *arts*—people, animals, skies get themselves up to look like objects in pictures. Trees try to resemble trees; some (as in *Bird and Insects*) only manage to look like insects. In *Battle,* as in other Steinbergs, women resemble birds. Art birds, not real birds. Cats delude themselves into thinking they are cats—Steinberg says, "They think they are people." Yet with a few minor changes his *Giant Cat,* which resembles a work of American naïve art, could become a rhinoceros. Other cats are really coiled springs asleep in blue milk. Mountains ham the craggy look. Nature is engaged in improving its appearance under the direction of Darwin, or in dressing up for parts in *A Midsummer Night's Dream.* Steinberg's sensibility has a touch of the Shakespearian: personifying nature, he refers to a chipmunk as "he." Even a plant on his lawn is a character who somehow got the idea of appearing in green, being six inches tall and having petals for a face.

Nature is an artist and, like all artists, is ruled by clichés. Nature repeats itself, with and without variations, and in time the repeated image becomes an indelible sign. "For nature," says Steinberg, "and for whatever is untouched by people, I use a series of clichés." This is another way of saying that he replaces nature with residues of art.

The Rocky Mountains, lakes, cloud masses have been reiterated in pictures until they have become forms purged of content. Yet the earth and the creatures that inhabit it strive constantly for aesthetic effects—and succeed. When Steinberg came to America, he has said, it "amazed me to see old women dressed up in the most elaborate, sexy way. It took me some time to realize that this was a way to clown the situation of not being so young or beautiful any more; the way autumn clowns nature: red and yellow trees, dead leaves dancing and crossing the highway gaily." But while Steinberg employs clichés, he never uses them as is. Rather, he energizes the inert matter of the collective mind with his own imagination and endows it with the capacity for metamorphosis. In *Tuscarora Sphinx,* Steinberg's old friend Uncle

Sam, with his Abe Lincoln stovepipe and chin beard, shows up transformed into a Sphinx sitting on guard before the pyramid on the backside of the one-dollar bill that represents the Novus Ordo Seclorum of the United States. In the drawing, the American eagle, also reduced to being an emblem on the back of the dollar, has managed to get off the ground and is reflected in a one-line lake, together with an Indian and a dog in a canoe, a swan, a side of the pyramid and two trees, only one of which appears on land. With a toy cannon at his side, Uncle Sam Sphinx is crouching in front of the pyramid of the New Order, defending it against a stick-figure Indian warrior on horseback armed with a lance and carrying a curious device like a street lamp or an architectural ornament. The desert scene, with its sun or rainbow of concentric circles, impossibly continued in the depths of the lake, is as full of mysteries as Rousseau's *Sleeping Gypsy*, which, come to think of it, is also composed of remodeled clichés.

The strategy of the cliché is to escape notice. It is a form of statement, in words or in pictures, that through repetition achieves unscrutinized acceptance. How many Americans are aware, for example, that the dollar bill has a human eye on its backside and a pyramid that is a tribute to Freemasonry? The cliché replaces thought with the set phrase, and experience with the set image. It represents the parts of conversation we manage not to hear, the pictures on the wall we never see. Today, with the help of the media, the cliché is more effectively camouflaged than the contents of the lowest depths of the unconscious. Steinberg is as alert to clichés as a tax inspector to concealed income. Because he was an immigrant, what was commonplace to natives was an oddity to him; through persisting in reimmigrating, he has preserved his newcomer's astonishment. Rather than overlook repetitive images, he has been inclined to take them literally, like the rubber stamps with which he authenticates his landscapes. In the ubiquitous American emblems, he believes he has established contact with the bottommost layers of the American mind. His fellow with the high hat and scimitar-

shaped whiskers, his American eagle with an E Pluribus
Unum tape in its claws, his Statue of Liberty in a nightgown
are as pungent figurations of the American past as the paint-
ings of backwoods naïves or the sleigh scenes of Currier & Ives
(*Sam's Troubles*). *Five Uncles* is as captivating in the ar-
bitrariness of its draftsmanship as Edward Hicks's *The Peace-
able Kingdom*, with the added feature that it relates mythical
America to the myths of the East by perching the Washington
Monument on the back of a turtle.

Like a jungle witch doctor, Steinberg inhabits a universe of
signifying signs, recondite yet immediately recognizable. On
the other hand, he has produced drawings that cannot be
fathomed even by himself. Though his work probably has a
larger circulation than that by any other artist alive, his pub-
lished pieces include some that are in fact impenetrable. Per-
haps the explanation is that this artist on the borderline of
genres also operates on the borderline of the consciousness of
his time. "I appeal," he has said, "to the complicity of my
reader ["reader" indicates the degree to which Steinberg
thinks of himself as a writer rather than as a graphic artist],
who will transform this line into meaning by using our com-
mon background of culture, history, poetry. Contempo-
raneity in this sense is a complicity." There is an echo here of
the New Testament dictum "the children of this world are in
their generation wiser than the children of light"—an esoteric
tribute to the capacity of those living at the same time to com-
prehend by contiguity what they cannot grasp by reason.

Perceiving reality as the art in things is the root principle of
Steinberg's aesthetics. This is another aspect of his work that
relates it to Pop Art. By means of formal analogies, Pop suc-
ceeded in transmuting everyday objects and images (con-
tainers, ads, labels, comics) into paintings and sculptures in
the museum tradition. Essentially, Pop is a continuation of
the insight of Duchamp regarding the situation of art in an
age of mechanical reproduction, when masterpieces compete
with copies of themselves and manufactured products circu-
lated on a mass basis, in which the *Mona Lisa* and a bicycle

wheel are placed on the same aesthetic plane. Art is art because the museum can elevate common objects, including refashioned reproductions, into art by accepting them as such. Thus Pop artists have woven connections (e.g., Benday dots and the paint dots of Seurat) between comic strips, food containers, five-and-ten objects and art in museums. Yet the entire undertaking, from Duchamp onward, of converting aesthetic social substances into art through their likeness to physical features of works in the museum is essentially academic and frivolous. Pop Art begins and ends with objects to be admired as art on the basis of resemblances of the new work to the art of the past.

Reversing the practice of Duchamp, Steinberg surpasses the aestheticism of Pop Art. Instead of transferring usable objects into the museum, he siphons museum forms into his own popular art. In Steinberg's people-looking-at-art drawings, the spectators are more far-fetched stylistically than the pictures they are scrutinizing. In sum, Steinberg demonstrates that the art-making of life affects people and things before contemporary art gets to them. In its double derivation from art, Pop erects a superfluous barrier between fact and imagination, while Steinberg sees the imagination as the origin of the forms of facts.

In connection with a magazine interview of a decade ago, Steinberg is shown wearing a mask consisting of a drawing of his face on a paper bag. Once again, as in the fingerprint portraits, he had chosen to represent himself by means of an artifact produced by himself. Discussing his false face, he attributed it to a wish for the objectively lasting, as opposed to the constant metamorphosis of real things. He felt intimidated when a photographer pointed a camera at him. "So I made paper-bag masks of my face. I was able to relax inside the mask [the rabbit in the human head] and show a constant public image of myself to the camera." The mask, in a word, has the stability of a cliché, of the fixed idea. Steinberg says nothing about the expressiveness of which masks are capable, as in Japanese theater, for example. In this instance, he is

merely thinking about the mask as a fabricated substitute that serves as a cover of the real face; it is not another self. But in *Two Dogs* (1975) the paper-bag faces have turned into savage grotesques; one is a female monster.

In the interview, Steinberg went on to say that it was gratifying to have the photographer take a photo not of Steinberg but of a drawing of him, "not reality but a symbol—a fantasy created by me. . . . Instead of catching that famous fleeting moment (which, photographers insist, reveals the essence of the sitter), that peculiar expression of my face, I gave them something steady that I made." However ephemeral drawings on grocery bags are, they transcend nature and time through the fact that they are made by man. In his discussion of the mask as self-portrait, Steinberg reverts to the antique version of the portrait as a simplified and abstracted summary of the subject's features, rather than the rendering of a visual impression of an actual face.

Nature differs from other artists in that it has no objection to mixing styles; it tolerates baroque clouds in the same scene with biomorphic lakes and mathematically layered cliffs. It is also prone to throwing in arbitrarily designed lakes or anatomies, forms that represent nothing but simply are. Steinberg's art identifies itself with the eclecticism of nature in his ability to absorb any style of picture-making that attracts his attention as distinct from the determination of most artists since the war to achieve singleness of form and effect. He objects neither to the juxtaposition of mutually exclusive modes nor to the merely impulsive. In a drawing in which "Sennelier" changes into "Steinberg," the artist seems to have let himself ride from association to association. A realistic drawing or a photo is as fully a mask as an abstract drawing, a cartoon or a fantasy, and Steinberg does not hesitate to use all these modes, and even to combine different ones in the same drawing. In compositions such as *Three Women*, he makes a point of posing modes of representation against one another. In *Waiting Room*, two male heads are shaped like daggers, exclamation points or Giacometti's elongated fig-

ures, and two children have the heads of cartoon animals. Bodies, with or without clothes, are also masks, as can be seen in Steinberg's drawings of torsos in bathtubs. Steinberg comes closest to imitating nature in the multiplicity of his devices. In this era of reductionist art, it is difficult to think of a motif—cities, deserts, railroad stations, hotel lobbies, words, industrial and military compounds, cafeterias, animals, people—that his idiom does not encompass.

Together with the story of his life, Steinberg's ultimate subject matter is style—the forms that things, places, people have assumed through moods of nature and through human invention and copying. Style is used for psychological effect in *Bingo in Venice, California,* in which the faces of the old ladies in the foreground are composed of descending rows of dots, parallel lines, squiggles and feathers. *Two Cultures* (1954) makes its point through its title: two women are passing each other on the street; one is a staid Puritan matron of middle age, drawn in straight lines, the other a painted and bangled Carmen striding through the music of sprays of dots and curlicues. In *Techniques at a Party,* seventeen people consist entirely of the different manners in which they are drawn, their differences being the subject of the drawing. Style is a means of dating things culturally, and Steinberg juxtaposes styles of different times in order to create an awareness of the constant proliferation of anachronisms. A structure of machine forms in a post-Cubist still life, a plane containing Spencerian handwriting, a female figure composed of a bundle of dots call attention to different layers of cultural history that coexist in our time. Or he compresses his demonstration of anachronism into a Mondrian-like abstraction with a Douanier Rousseau signature.

In his shorthand of styles, Steinberg records the heritage of disparate moods to which current society is subject. His sober little man passes from an Impressionist sketch of a house in the sky down a ladder to a simple contour drawing of a house and over a bridge to a chain of concentric rings suspended in space (*Biography*). Discussing this drawing, Steinberg invites

the spectator to collaborate with him by discovering in it any meaning that occurs to him—in sum, to explore within himself the feelings aroused by this encounter with the three prominent modes of aesthetic statement constituting the drawing. For his own part, Steinberg offers the explanation that "it means that evolution doesn't lead to perfection but to the invention or discovery of new regions." (To speak of the "invention" of a region is pure Steinberg.) With or without evolution, the three distinct styles in which the drawing is composed synchronize three cultural time periods and their characteristic emotional colorations: sexual, practical, mechanical.

Varieties of style-jamming appear in numerous Steinberg drawings, such as the assembly of a dozen chairs composed of penmanship decorations in designs from African woven to Eames chromium. A couple seated side by side on a sofa are separated forever by the fact that she consists of a shower of short pencil strokes, he of thick contours. Avant-garde artists seeking a style exclusively appropriate to the present day exclude masses of existing phenomena, from subjects too often seen in the art of the past (apples on a plate) to out-of-date furniture, scenes and people. One reason that Steinberg's drawings appeal to such a wide public is that in them the twentieth century is as rich in leftovers as a flea market or a boardinghouse parlor. The general atmosphere of his drawings is Victorian, even in his architectural fantasies of Las Vegas and science fiction. He likes plazas and Grand Hotels, busts and potted plants, admirals covered with medals, birds in cages, gold-leaf lettering, ladies' hats with fruit and plumage, monarchs and grandees of small countries (his America is a small country). These, plus men in armor, animals in armor (crocodiles) and fruit in armor (pineapples), are obliged to accommodate themselves to robots and rockets and Cities of the Future. Like Joyce, Steinberg appropriates styles wherever he finds them, whether on the midway or in the museum, and refits them through parody as expressions of contemporary experience. His ever-active little man is kin to Here

Comes Everybody of *Finnegans Wake* and is subject to HCE's countless dreamy reidentifications.

Style, with its power of creating assent, is society's major instrument of deception—authoritarian governments are more violently outraged by rebellions against the officially approved manner in the arts than by the depiction of unwelcome subjects. Each mode in art is, in its beginnings, the realization of a mood or sentiment—for example, Rembrandt-like depth in contrast to Art Nouveau chic or Impressionist vivacity. This characteristic mood remains sealed into the images done in the given style, whether in its masterpieces, in its run-of-the-mill creations or, finally, in its mass-produced imitations. As the style keeps reappearing, however, in works of diminishing quality and in printed copies, its emotional content is coarsened and reduced to effects induced by its most easily recognized features, as in the piled-on paint of late Abstract Expressionist "10th Street" paintings. Thus the style survives in parodies or masquerades of the original feelings embedded in them.

Steinberg grasps the power secreted in styles regardless of their status as art. Degraded styles, including the junky ornamentation of city life as well as grand modes abandoned by sophisticated tastes, are welded to the masterworks of the past, on the one hand, and to the aesthetic reflexes of the public, on the other. Steinberg understands the history of art as a form language of ready-made sentiments, at once self-evident and spurious, situated on the border of comedy and nostalgia, like the beard of Santa Claus or the red heart of a valentine. Steinberg's analysis of pictorial conventions on every level, from Kasimir Malevich's to those of anonymous tattooers, is his recoupment of the past. Art history in its actual survival into present-day existence as the content of museum catalogues, varnish-darkened family portraits and Cubist masks is the ideal vocabulary for a pictorial autobiography in which to recall feelings without giving details. "My drawing," said Steinberg, "contains often parodies of drawing. It's a form of art criticism." He refers to a drawing

(*Biography*) that "shows a man crossing from one technique to another, or from one meaning to another." And for him this transition represent♦ "conflicts, emotions."

The decline of art into popular decorations and emotional stimulants is a major source of Steinberg's philosophical comedy, as it was for Duchamp in painting a mustache and goatee on a reproduction of Leonardo's *Mona Lisa*. Steinberg collects bad art, such as the tapestries sold in Broadway closeout shops, though the ones he chooses always have something special about them. He sees this kitsch as the legacy inherited by the modern world from the art of earlier centuries. Religious and romantic motifs—Madonnas, a lion attacking a mounted African warrior, a stag reflected in a lake—are made into low-priced designs. The French, he explains, have a word for this stuff: *bondieuserie*, which comes from *bon Dieu*. "All that region behind Saint-Sulpice in Paris is a big center for selling plaster-cast Jesuses, sweet Madonnas, and so on. So many things become *bondieuserie* in the end—respectable and beautiful, but comical because they are such clichés." Each artist's work, whether he is aware of it or not, is subject to conversion into clichés—and he himself is subject to the same transformation. A frequently reproduced Steinberg shows an artist at his easel inside the jaws of a crocodile. "The crocodile is Aztec. It has the rigidity of extinction." This animal is Steinberg's symbol of an insatiable society that gobbles up everything, including works of art that are digested into a common breakfast food of the emotions. It is society that makes forms stiff, lifeless and repetitive. In time, the distance between the researches into self of Pollock, de Kooning, Newman and Steinberg's autobiographical explication of visual clichés was bound to narrow, as the works of the former overcame their estrangement from the public consciousness and achieved the familiarity of a comic strip. In Steinberg's universe, the alternative is either to begin with a cliché or to end as one. Like Baudelaire, he sees the cliché as formed by endless human movements within the same rut, thus adumbrating depths of meaning.

Steinberg's early drawings tend to gain their effects through visual jokes and surprises. An artist painting an EXIT sign with a pointing finger uses his own pointing finger as a model. A man holds up a child to look at the moon as if it were a parade (*The Moon*). In an art gallery, a crush of spectators fights to get a peek at the painting of a solitary figure in a desert (a motif, incidentally, of Steinberg's late watercolors and canvases). A nude is painted on a bathtub as if half immersed in painted water but with her head out of it. Another woman is painted on the back of a chair and on the seat. Musical staff paper held horizontally supplies an elastic exerciser for a man drawn on it; held vertically, its lines rain down on a pedestrian. Music paper also provides the ground for Expressionist drawings in heavy lines of musicians and dancing couples. Fairly early, too, are drawings of signatures changed into things that are carried around like constructions made of steel bands and wires.

Inventions extending into Steinberg's middle period are his signs (e.g., the question mark) and speech and sound structures that acquire the substantiality of objects and creatures. Thus visual effects of drawing, popular art, handwriting acquire new life through new uses. A horizontal line keeps changing its functions—from a table edge it turns into a railroad trestle, then into a laundry line with clothes hung on it, finally an abstract flourish (*The Line*). The devices of drawing place the real, the imaginary and the abstract on the same plane of being. A question mark arises as a sign above the little man's head. It becomes an object that, on another occasion, he carries under his arm like a piece of furniture. Again, he holds an armful of question marks like a bouquet of flowers.

One of Steinberg's richest veins has been his elaboration of the comic-strip balloon. With Steinberg, the usual oval outline in which speech is rendered visually has been transformed into varieties of shapes and substances that are both things in themselves and also suggest the quality of the statements, their sounds, their aesthetic and emotional effects.

The balloons take on materiality—they are held in the hand like platters or tennis rackets. They turn into animals that swallow the speeches of others. They are joined by the speech of cannons, which is blasted apart by the rocket of a mathematical formula. A speaker himself turns into a balloon loaded with sheets of script that dart out of his mouth as though he were a coin machine. Out of the mouths of ephemeral persons come huge constructions of words, complex clockworks of reflections, solid grills, architectural ornaments; a dog barks a fierce zigzag; a piano builds a cascade of hatchings; a cellist leaks a spreading worm of black; on a mountain of gibberish that he is in the process of enunciating gesticulates an orator who is a scribble. Sitting behind his desk, an authoritative gentleman directs at a petitioner a screen of discourse that takes the shape of NO. A tuba releases a baroque plaster ornament of sound, a horn ejaculates an aural flowerpot, a cymbal scatters stars and seed formations. In a family discussion (*Three Speeches*), the daughter's plantlike statement competes with her father's severe geometrical edifice and her mother's mollifying string of jewels and feathers.

Having risen to the status of three-dimensional entities, the speech balloons take to meeting secretly in hotel bedrooms (*Hotel Plaka*). Perhaps as a result, the balloons develop images within themselves that in turn produce their own speech balloons, indicating that talk and its imagery result in thoughts that have thoughts of their own—layers of consciousness that again suggest Joyce. Steinberg has expanded the cartoon balloon into a means for dramatic monologue: a thin scratchy female emits a balloon containing the bust of a woman from whose mouth emerges a balloon of inverted script and above whose head ascend bubbles (indicating thought) leading to a balloon in which a man in a landscape speaks a balloon-enclosed message. The spectator can reach his own conclusion as to what the woman protagonist is saying and what the woman she is talking about is thinking. Interpreted "politically," the speech structures can often be seen as forming bar-

riers between speakers and their hearers, rather than communications. At times a speech replaces the forepart of a speaker's head, leaving only a design.

Counterpointing the materialization of speech and sound, words behave as "characters" who undergo experiences derived from their own meaning, as in the incomparable series of drawings in which SICK lies flattened out on a couch, HELP! topples off a cliff, TANTRUM explodes into a rocket display. Steinberg's personified words reflect, decide, march in formation, choose directions. On the rocky formation of I AM is balanced a flimsy wooden I HAVE, while in the sky above whizzes a dynamic I DO.

Steinberg's personifications provide a means of approach to the thinking from which his images are formed. In his later works, his drawings have become increasingly philosophical and abstract and this has brought them into closer relation with words, as in the examples of word-actions mentioned above. The jokes still leap out of the images, but they hint at more complex interpretations than the drawings of nudes on the verge of slipping into bathtubs. The late drawings tend to present themselves as visual incidents in a complex mental happening; they are the outcome of the kind of unique reasoning that one encounters in Steinberg's talk. Beginning with an abstract proposition, his discourse heats up through associations of ideas until its chemical mixture gives rise to the fading in of an image as in a decalcomania. The pen of the artist-monologist brings into being pictures that strain toward a concept but are incapable of reaching it, like the dog-artist in a Steinberg who is trying to leap at his easel but is kept at a distance from it by a rope around his neck.

Steinberg sets the spectator's mind to work and keeps it going by frustrating his desire to reach a conclusion. A word, a number can now be analyzed as a hypothetical situation seen in dramatic perspective. A cat with his head poked into the upper part of a wire number 4 planted in the ground is the product of the following Steinbergian analysis of the digits as material shapes—an analysis carried on from the point

of view of cats as creatures famous for (that is, labeled with the cliché of) their curiosity (*Cat and 4*). "Four is an interesting number because it is a shape that would arouse the curiosity of a cat. Most numbers are either open or closed. Number 8, for instance, is closed; a cat has no business to look inside. A cat likes to peer into something that is half open—a little bit open—a mystery. Number 3 is obvious; number 1 is nothing; 5 perhaps is more intriguing, but 4 certainly is perfectly designed and engineered for a cat to look inside and find out what is going on. So here I combined an illusion of reality with an abstraction. The abstraction, number 4, became a reality and the cat became an abstraction because it combined itself with this number. It rendered the whole thing plausible and, from a drawing point of view, perfectly workable."

Readers of this vaudeville monologue in the high style of comic rationality may become aware that the number 4 is being dealt with as a shape that has been deprived of its function in the numerical system and has "become a reality." It is a found object of the same order as a tree or a tin can. This metaphysical reordering of the familiar is a resource of Steinberg's imagination that places him in the forefront of later artists, such as Jasper Johns, who have also conceived readymade signs as material objects. In staging the cat as a seeker of the digit best suited to its objectively conceived personality, Steinberg adds a psychological dimension to his drawing that is lacking in the aestheticism of Johns's number paintings with their references confined to art history—that is, to Abstract Expressionist paint handling and *I Saw the Figure 5 in Gold*, by Charles Demuth.

Another drawing of the same period draws on a theme that appears throughout Steinberg's work, the theme of fame and its constriction of life. The drawing is an abstract biography developed out of the parentheses in which vital statistics are supplied on tombstones and in encyclopedias. *Between Parentheses* is a landscape with flowers in the foreground, above which rises a parenthesis in which 1905 is followed by a hyphen. After the hyphen, instead of a second date comes

Steinberg's little man, who is about to be crowned by a bird with a laurel wreath. Steinberg explains that "this is the portrait of a famous man. He was born in 1905—and he is still alive. He walks, followed by his birthday and facing his death day. That dash [the hyphen] hints at his end, eagerly awaited by historians who can thus officially close the parentheses. The essential thing about him, and this is the essence of his fame, is that he is between parentheses. He is not free. This monumentalization of people, this freezing of life, is the terrible curse of consciousness of fame. Anybody with instinct destroys conventional fame and misleads his admirers and biographers by being unreliable and therefore unpleasant. This gives him the possibility of looking instead of being looked at." Obviously, this explanation of the drawing is a passage of autobiography, although the drawing lives up to Steinberg's principle of disguise by "misleading" spectators with the wrong birthday.

A final example of Steinberg's rare public analyses of his drawings presents the free-ranging associations out of which his drawings spring into being. "A giant rabbit is being attacked by a hero on a horse. But the mark of the hero is the size and quality he picks out for himself to fight. Any hero who fights a rabbit is not so good. What is a giant rabbit? It is weakness carried to an enormous degree. Maybe it has to be destroyed. I made another drawing of a hero fighting a giant baby. A giant baby can be very dangerous. You cannot reason with him: he cannot be controlled. If we were subjected to 6-month-old babies with iron muscles, we would all be murdered. There is something equally dangerous about the giant rabbit, but should he be destroyed, or should he be educated? Anyway, it is a moral situation. But many people thought it had to do with sex and I'm not surprised." The drawing plus the interpretation constitutes a metaphysical fable, one relating to the Nietzschean issue of the menace of the feeble. Steinberg's picture-plus-words illustrates how he derives ideas from manipulating the meaning-laden figures he has developed over the years—knights, rabbits, cats, little men—

at the same time that he augments the significance, private and public, of these originally commonplace images.

Steinberg has insisted that his own interpretations of his drawings are not the only ones possible. As noted, he regards the spectator as his collaborator. Yet the view persists that Steinberg's drawings express a systematic outlook toward life today. Especially among Europeans, he is an irresistible source for composers of existentialist sermons. His drawings are held to depict the absurdity and isolation of modern man and to point to an all-encompassing pessimism. Do not his ever-active abstractions—a wiry YES assaulting an imperturbable NO; his representations of man (*Comic Strip*, 1958) as disintegrating into every conceivable slapstick absurdity of thought, speech, motion, feeling, including, in one frame of animal figures, a hint of Picasso's *Dream and Lie of Franco*—state propositions that add up to a black view of the human condition? Steinberg has confessed to a Mozartian "seriousness, or melancholy, camouflaged as gaiety," and it is true that some of his social panoramas of the past few years—such as *Law and Order* and *Street War*—have a grim tone. In a one-line cartoon, the artist draws himself into a circle. Since the line starts with the head, the drawing may be interpreted to mean that to begin with reason is to tie oneself up in a never-ending line, a labyrinth of arguments, which the thinker-artist renders more complex and difficult to escape from with each move he makes. The drawing could be taken to represent the history of civilized man. And so on.

Yet it is a mistake to believe that one can get to the bottom of Steinberg, that even Steinberg can. His drawings are to be understood not as illustrations of a doctrine or world view but as experiences in what he has described as the complicity of the contemporaneous. The drawing means to each spectator whatever he can find in it. Steinberg's art is an act that brings forth an insight, at times in the form of a riddle, and in return demands an act of comprehension. Too much interpretation makes this responsive act more difficult. "Every explanation," said Steinberg, "is over-explanation." Despite

the popular imagery on which his art is based, it is, in the end, as gnomic as that of his Abstract Expressionist contemporaries.

Steinberg copes with his present experience by circling back to earlier phases of his art and re-creating their language for new purposes. His Tables of the 1970s are assemblages on boards of pictures and handmade, eye-fooling fakes of his art instruments—pens, pencils, brushes, rulers, drawing pads, notebooks—plus such trademarks as his speech balloons and rubber-stamp seals, which serve the same function of identification as his fingerprints and official signatures of the 1950s. The largest of the boards are mounted on sawhorses and become actual tables. As neatly arranged as in the showcases of a police agency, the implements of Steinberg's art represent another plane of his autobiography, the objects of his deepest emotional attachment—his "erotica," as he likes to call them. These objects have been rendered more intimate than the usual studio materials of an artist by the fact that they are not merely things the artist has used but simulacra of them which he has made. They are extensions of himself yet, like his paper-bag masks, "not reality but a symbol." Once again, Steinberg presents a fabrication that stands for him but also hides him. The Tables continue his autobiography in personal terms that betray no secrets.

Steinberg began the Tables by idly whittling wooden copies of pencils, paintbrushes and drawing pads and painting them to resemble the real things. Unlike Cubist, Dada and Surrealist collage, nothing in the Tables is a found object, though most of their original content—that is, the stuff copied—could have been obtained in an art-supply store. The paraphernalia of the studio connect the artist and his creations, hence are objects that symbolize their subject. Their subjectivity is underscored in the Tables by the fact that they were not taken from the real world but were created by the artist. In putting together these whittlings as objects to be exhibited, Steinberg assembled bits of himself—his organs, so to speak. The Tables offer to the public reproductions of things grown

intimate to the artist through daily use. Those enclosed in Plexiglas are a parody of objects in the display cases of a museum. The satire includes the bitter point that in making himself visible the artist is also entombed by the same means—a point related to Steinberg's drawing of the famous man in the parentheses. Arranged in symmetrical groupings, as if by a neat head clerk, the contents of the Tables have an atmosphere of administrative order. But not of today's administrator—they convey the nostalgia of offices supplied with worn wooden penholders, chewed pencil stubs, imported bonbon boxes used to hold paper clips.

As collections of memorabilia, Steinberg's Tables are comparable to Duchamp's *Valise*, which enabled the artist to carry his past with him to the United States in the form of reproductions of his paintings and a phial of air of Paris, an equivalent to the grandmother's featherbed brought by other immigrants. In regard to nostalgia, Steinberg's Tables are much less emotionally incriminating than *Valise*, since they cope with the artist's attachment to his past not through preserving representations of things done and objects valued but through counterfeits of them by which they are both memorialized and falsified. The faked nostalgia of Steinberg's Tables is less nostalgic than the real nostalgia of Duchamp's *Valise*, hence less sentimental and more "modern." Steinberg's nostalgia is there but is ameliorated through new acts of creation. The Table called *Portrait* recapitulates his odyssey in typical Steinberg shorthand. In the upper right-hand corner, a plaque labeled "Milan, 1935" commemorates the city where Steinberg began his career as an artist and the date when he arrived there. A wooden cutout of a comic-strip balloon inscribed with a seal and illegible handwriting represents floating speech without a speaker, perhaps the talking Steinberg engaged in during those voluble student years. A fake pen, pencils, brushes and a ledger are relics of the artist at work. An open page of a faked drawing pad shows a pencil portrait of the young woman who is the artist's present companion. Symbols of Steinberg's active life, they have the advantage

that they will never be used up as are the actual implements of the artist but, like his paper-bag mask in contrast to a snapshot, are "something steady that I made."

Steinberg is a craftsman whose skill drifts into ideas and through them into visual enigmas. Yet he frequently makes drawings and paintings for the sheer pleasure of putting the hand in the service of the eye. *Country Still Life* is a lyrical drawing in colored pencil of flowers in a vase, a bottle and a pitcher set against a view through the glass doors of Steinberg's living room in East Hampton. A more recent drawing, *Still Life Cover*, though it includes elements of the Tables, similarly makes no intellectual demands on the spectator. Yet most spectators will scrutinize them with care to make sure that these pictures, given their author, are as innocent as they seem.

Related to these pictures, which—compared to the often recondite conceptions of his cartoons and collages—were produced for nonintellectual pleasure, are Steinberg's landscape souvenirs of recent travels, which he calls "postcards." They differ from Steinberg's earlier travel drawings in that they make no overt effort to seize the essence of a particular place. The watercolors and oil-on-paper landscapes of the 1970s convey overtones of nostalgia through touches of stylistic anachronism and visions of loneliness.

By externalizing and depersonalizing his feelings, Steinberg causes estrangement itself to be estranged and made to belong to other times, thus avoiding romantic self-expression. Many of the "postcard" landscapes bear rubber-stamped insignia floating in the sky like gasbags or planets; these may be intended as evidence that the landscapes are "documents," stamped on their way through Steinberg's metaphysical post office and certified as authentic by the authorities that rule his made-up world.

Another oddity of some of the landscapes is their division horizontally into one or more separate scenes, as if they were photographs taken at different times—a typical Steinberg adaptation of another medium. In their drab enunciation of de-

tails, they might be illustrations accompanying an old report of a surveying expedition or an oil-drilling operation. In some of the landscapes there are queer-looking machines with buildings in the background, and in front of them barely perceptible figures whose costumes suggest that they are either natives or adventuring Westerners. They confront the spectator full face, as if getting their pictures taken, or stand with their backs to him waiting in what might be a desert. Where these activities occurred and what happened, if anything, cannot be determined from the paintings, but a sense of distant places is conveyed by such titles as *Abu Dabu, Kunming* and *Ottumwa,* which sound Asian or African, though Ottumwa is actually in Iowa.

Some of the landscapes identify themselves as Egyptian by pyramids towering in the background, while another kind depicts scenes on Long Island in the luminist style common in nineteenth-century American landscape painting. In one group of paintings, low-lying foregrounds and immense empty skies with a pinkish-yellow glow at the horizon mimic the shoreline panoramas of America's age of exploration and pioneering, an age to which, it may be presumed, Steinberg feels he still belongs. His rubber-stamped (in oil paint, not ink) male figures placed along water edges or ground rises heighten the sense of loneliness; once more the immigrant artist has found a nostalgic self-reflection in the history of painting.

That Steinberg's art-making and philosophizing usually "masquerade as cartoons" (as he puts it) suggests that he is to an unusual degree conscious of his audience, both the worldwide general public, whom most artists tend to ignore, and the gallery-going public, which is the social core of the art world. Steinberg finds in the latter types comparable to Hollywood cowboys, high steppers and stylized females at bingo games. Spectators in art galleries and the paintings that confront them on the walls bear the social "imprint" of common styles, thus meet as mirror reflections of one another. In *Art Lovers* (1965), the figures of the female spectators merge with

the forms within the frames through projecting the eyeball and cranium of the woman on the right onto the picture plane and extending the bottom edge of the frame in the left section to include the other spectator, and fitting her speech balloon to the right edge of the frame. Another aspect of Steinberg's gallery drawings are his mimic exhibitions presented in an illusion of perspective by means of vertical pictures that grow narrower and shorter toward the center in order to form an imaginary corridor of painting (*The Collection*).

Steinberg's merger of the spectator with the work of art is an instance of the tendency in our time for real things to cross over into fiction—and of fictions to be transformed into realities. People and events become indistinguishable from fabricated versions of them that are distributed by the mass media. The history of the last war exists in the public mind as the sum total of popular war movies, while the next war is already under way as depicted in best-seller spy narratives. We have entered an epoch in which nothing is real until it is reproduced. This mixing of fact and fiction is one of the most powerful determinants of form in modern art, as it is, too, of behavior in politics and diplomacy. Art has found ways to transfer raw data into painting and sculpture by adulterating the first with paste-ins (collage), the second with the incorporation of ready-made objects. Yet while functioning on the edge where art blends into existence, artists have been unable to purge themselves of the ambition for masterpieces that dwell on the plane of the timeless. Repudiating a metaphysically separated realm of Beauty, they nevertheless strive to insure the future destiny of their creations as treasures of the museum. This conflict of motives often turns art into a confidence game, in which clumsy works are defended in the name of truth and empty ones in the name of art history.

Steinberg's borderline experience—geographical, psychological, aesthetic—has made him an adept of the postwar consciousness. From the start, he has gone the whole way in dissociating himself from the pieties of art. Among the first to recognize that the contemporary art museum and the popular

magazine are engaged in related projects of mass culture, he cut around the morass of the artist as culture hero by going over completely into art intended for reproduction. In the lowly cartoon he found a medium susceptible of being transformed into an alphabet of meanings as flexible as that of words but with the additional dimension of the visual sign. Borderline experiences demand borderline forms. The intellectual potential of drawings made for publication lay precisely in their being a *modest* medium, in which the spectator responds to the artist's statement without requiring that it satisfy ideals of aesthetic prestige.

While retaining the cartoon as the nucleus of his art, Steinberg has vastly enlarged its scope with ideas, techniques, approaches derived from the history of art and from twentieth-century art in particular: automatic drawing ("the doodle is the brooding of the hand"), drawings by children and the mentally disturbed, naïve art, scrawls on walls and latrines, facsimiles, transferred images (drawings on photographs), parodies of modern and old masters. In works to be printed he resuscitated handwriting, thus turning progress inside out. The Steinbergian metamorphosis of the cartoon into a vehicle for meditating on a seemingly limitless range of issues, including the central ones of art—illusion, self and reality—constitutes an expansion of the intellectual resources of flat-surface composition comparable to that of collage. In his hands the cartoon is made to serve as a major medium. Through forms of representation until recently alien to the museum tradition but present in art since the beginnings of graphic expression, he has forged a means by which to animate areas of the mind outside those chloroformed by the tradition of Great Works.

As noted, Steinberg has been growing increasingly philosophical with the passage of the years. What is remarkable is how he has been able to expand his sign language to match the enlargement of his thought. He has developed an idiom that belongs among those rare recastings of available aesthet-

ic "junk"—e.g., Picasso's assemblages—to serve the exact uses of a unique mind, that have brought new life to art in our time.

Steinberg straddles the contradictory functions that constitute the reality of art in our time: on the one hand, the use of art by the artist to lay bare the pattern of his individual identity; on the other, the making of objects for the art market and to win a place in art history (the museum). In Steinberg's autobiographical art, with its deliberate misdirections and false clues, these conflicting motives have been synthesized, symbolically and practically. Out of Steinberg's ironic saga of modern man as an abstract personage emerges the portrait of a unique individual, while his drawings have endeared themselves to admirers and collectors throughout the world by their elegance of execution—their "politeness," as Steinberg describes it.

Encompassing the dramatic polarities in the motives of creation today, Steinberg's art—with its copying, parodying, counterfeiting and mimicking—is also a central exhibit in the debate concerning the interchange between the art object and non-art fact (nature). In linking art to the modern consciousness no artist is more relevant than Steinberg. That he remains an art-world outsider is a problem that critical thinking in art must compel itself to confront. There may be significance, for example, in the fact that Steinberg is the only major artist in the United States who is not associated with any art movement or style, past or present. Nor has art history to date assigned a place to Steinberg, perhaps for the reason that he has swallowed its subject matter—the successive displacement of one style by another—and regurgitated it as a single mass of expressive leftovers existing in the present. Cubism, for example, which in the canon of the American art historian is the nucleus of twentieth-century formal development in painting, sculpture and drawing, is to Steinberg merely another detail in the pattern of modern mannerisms; in a landscape, he finds no difficulty in combining Cubist and

Constructivist elements with an imitation van Gogh "self-portrait" wearing opaque green spectacles and a Steinberg seal on the subject's slouch hat.

Dissolving art history into its original imaginative components, Steinberg's drawings and paintings are, as he has said, "a form of art criticism" that places him at the outermost edge of current art consciousness, a Duchamp who has transcended anti-art by exposing the power of form-making on every level of human experience, from women's makeup to the unplanned, collective evolution of the letters of the alphabet. In theory, Steinberg is today's avant-garde, except that, by definition, a single individual cannot be a vanguard. Thus his role automatically disguises itself (in harmony with his other disguises), and his performances continue to prompt some to respond with "Yes, but is he really an artist?"—the question that has greeted each authentic avant-garde for the past hundred years. Other avant-gardists—Pollock, Newman, Warhol, scatter sculptors, conceptualists—succeeded in evoking this question for varying intervals, then were "naturalized" into art by the embrace of the museum. The genius of Steinberg is to have kept the question alive about himself for thirty-five years, and to have made it impossible for art to acknowledge his legitimacy without changing its conception of itself.

# American Art

# 23

# MOMA Package

---

This shrewd popularization of the big lie, that modern art isn't modern, succeeded in establishing the position of respectability modern art now enjoys with museum directors and professional art-lovers, but it wrought havoc with the creative forces struggling for a footing wherever this false thesis took root.

*Barnett Newman*

The exhibition at the Museum of Modern Art entitled "The Natural Paradise: Painting in America 1800–1950" is a show with a thesis. It uses the work of about sixty artists to make a point about eight. The eight are Abstract Expressionists—Gorky, Pollock, Rothko, Newman, Still, Baziotes, Gottlieb, and Stamos—and the point the show attempts to demonstrate is that these artists belong not to advanced international modes in painting or thinking, as represented by Kandinsky, Picasso, Masson, Matisse, Miró, or the Surrealists, but right back home, in a continuing American tradition of landscape painting that began in the early years of the republic. Excluded from "The Natural Paradise" are Hans Hofmann, Willem de Kooning, and Philip Guston; in

Originally published in *The New Yorker*, 1 November 1976.

the American-heritage context of the show their omission
seems to be due to the fact that they are "foreigners." But
Franz Kline and Bradley Tomlin—scions, respectively, of
Pennsylvania mountains and New England chapels—are also
absent. And if Hofmann, de Kooning, and Guston are miss-
ing because they're insufficiently American, why is Arshile
Gorky represented? Or, to go back a bit, Thomas Cole, who,
presented as the model American landscapist of high roman-
tic ideals, metaphysical speculations, and sublime scenery, is
the centerpiece of the show? Cole came to this country when
he was seventeen or eighteen—not much younger than de
Kooning was when he slipped in as a stowaway. Evidently,
this show, whose purpose is less to exhibit pictures than to
revise art history, has had to resort to complex forms of men-
tal management.

"The Natural Paradise" is directed by Kynaston McShine, a
curator of the Museum of Modern Art's Department of Paint-
ing and Sculpture. Its presiding genius, however, is Robert
Rosenblum, a professor of fine arts at New York University.
One might say that the hands are the hands of McShine but
the voice is the voice of Rosenblum. Six years ago, McShine
enlightened visitors to the Museum of Modern Art with an
exhibition called "Information," in the catalogue of which he
asserted that painting had become "absurd," in view of "the
general social, political, and economic crises that are almost
universal phenomena of nineteen-seventy." Apparently, art
has now been reinstated for McShine—when leftism reaches
its extreme, it tends to go over into nationalist nostalgia. In
McShine's case, the passage to "Paradise" was expedited by
the researches of Professor Rosenblum, who for about fifteen
years has been contending that the new abstract art which
emerged in New York after the war was not really new, or not
as new as it was claimed to be by the artists who created it
and by the public that experienced it, but was an extension of
nineteenth-century romantic and visionary landscape paint-
ing. In his "Modern Painting and the Northern Romantic Tra-
dition: Friedrich to Rothko," published last year, Rosenblum

traced the roots of Abstract Expressionism to German roman-
tic painting and to Turner. Inspired by the Bicentennial—"in
the year of the Bicentennial it is especially appropriate to ex-
plore the native soil from which the Abstract Expressionists
grew"—he has resolved to renaturalize these modernists as
Americans. Rosenblum, it would seem, is prepared to issue
cards of identity as required. In 1976, he detects in the can-
vases of Pollock, Rothko, Newman the same awesome feel-
ings and luminous and intangible presences that for Thomas
Cole, Frederic Church, John Kensett, Thomas Moran, Albert
Bierstadt were the accompaniments of mountain peaks and
chasms, cloud gulfs and crashing surf. "Thus," writes Rosen-
blum in the "Paradise" catalogue, "Clyfford Still's craggy
paintscapes, with their suggestions of the immeasurably slow
changes of prehistoric geology and botany, can almost be ex-
perienced as abstract translations of Cole's, Bierstadt's, and
Moran's views of the American wilderness." The impulse to-
ward breadth and horizontality which manifested itself in the
"Niagara Falls" of Church is resurrected in the elongated
strip painting "Summertime," by Jackson Pollock. The
watchword of "Paradise" is the continuity of advanced art in
the United States with the American past and the "deities of
American landscape that have now reigned for two
centuries."

Conservative politicians, chronically suffering from memo-
ries of the New Deal, talk of "turning America around." In
preparation for his present effort to restore postwar New
York abstraction to the painted wilderness of the nineteenth
century, Rosenblum executed a dry run in the catalogue of
the "America 1976" exhibition that was held at the Corcoran
Gallery in Washington last spring, under the auspices of the
Department of the Interior. The show, of contemporary land-
scape paintings, represented for Rosenblum "not only the re-
mains of the American wilderness but also the primeval
animal, vegetable and mineral kingdoms," and, invoking the
"spirits of Cole and Inness, Kensett and Bierstadt," he hailed
the display of landscapes as a kind of Armory Show in re-

verse—by which he could only have meant the advent of counter-revolution. A related use by Rosenblum of the museum as an instrument of anti-modernism was the recent "Age of Revolution" extravaganza at the Metropolitan, which offered a counterweight to contemporary tastes by exhuming masses of discarded eighteenth- and nineteenth-century canvases from basements throughout Europe.

Rosenblum's task of historical revisionism in the "Paradise" show is not an easy one. The first obstacle is the paintings themselves. Visually and emotionally, they fall into three stylistically distinct groups—almost constituting separate exhibitions—which reflect different degrees and sources of European influences, and different relations between the artists and American society. Ironically, the first group, the Hudson River painters, who represent the root feeling of American romanticism which is the show's theme—who, according to Rosenblum, express feelings arising from the land itself—were the most deeply influenced by European models. Their theme was the nationalist idealism and the interest in far-off places of the rising American middle class, expressed with decorum and echoing as closely as possible the masterpieces of Old World museums. "Instances of nationalist rhetoric," writes a biographer of Cole, "exhorting the artist to a concern with American subjects, were commonplace in the formative period of our native school of literature and painting." In any case, this "picture postcard" portion of "Paradise" is quite clearly cut off from the later realist and modernist creations—some spectators wondered what these landscapes were doing in the Museum of Modern Art. The second group, the early American modernist painters—Dove through Hartley, Marin, and O'Keefe—are equally distinctive artists, who have been described as "precursors but not parents" of the postwar abstractionists. Omitted from this group, again for hidden ideological reasons that prevent "Paradise" from being a survey of American landscapes, are such leading, if not "elemental," landscapists as John Twachtman, Childe Hassam, Alden Weir, Maurice Pren-

dergast. The third group, of course, is the Abstract Expressionists.

Each group contains interesting paintings—some that have been shown again and again (Church's "Niagara Falls," Cole's "The Titan's Goblet"), others unfamiliar to the New York art public (Bierstadt's "Beach Scene," Edwin Dickinson's "Stranded Brig"). Among the romantic landscapes, some achieve renewed interest through visual association with Surrealist and ultra-naturalist imagery. Washington Allston in his chalk-on-canvas "Ship in a Squall" found a technical equivalent for the uncanny, and the sharp-focus "Moonlight Coastal Scene," by Robert Salmon, is as operatic as Dali. One of the principles apparently overlooked by the organizers of the "Paradise" show is that what we think of the art of the past is influenced at least as much by the present as the art of the present is influenced by the past. In terms of contemporary sensibility—rather than theory— paintings that for Rosenblum and his colleagues seem suffused in mystical silences are distinguished by their theatricalism; for example, the luminous coves of Fitz Hugh Lane or the storm and night-scene backdrops of Martin Johnson Heade. (The waves in Heade's "Approaching Storm: Beach near Newport" fold over like silver skins.)

Indeed, if Rosenblum had chosen to link together American artists of all periods by an impulse toward theatre, he would have fared much better than in his quest for what another contributor to the "Paradise" catalogue calls "the continuing American association of its vast landscape with the national identity." American painters from Allston to Dickinson and from Frederic Remington to Pollock and Gorky have tended to put on a performance, usually with at least a modicum of ham and a more or less conscious intent to deceive (as is suggested in Melville's conception of the national character in "The Confidence-Man"). Church's huge "Rainy Season in the Tropics" is one hundred per cent stage curtain and, with its compass-drawn rainbow, comes close to being a sideshow feature, while his "Our Banner in the Sky," in

which the Stars and Stripes are exuded by the skyscape, is on
the verge of camp. Yet his "Aurora Borealis," no less the-
atrical, conveys a genuine chill of both climate and human
abandonment; Bierstadt's "Sunset in the Yosemite Valley"
and Moran's "The Chasm of the Colorado" are Natural Won-
ders seen in a stereopticon. With or without depth of insight
and seriousness of mood, the American landscapists pour on
feeling with everything at their disposal. Their real heir is not
Abstract Expressionism but the Kodak. Elihu Vedder is a pro-
to-Surrealist who to be persuasively touching demands only
that the spectator give a little in the direction of vaudeville. In
two small oils by George Catlin—landscape backgrounds for
"An Indian Council, Sioux" and "Elk and Buffalo Grazing
Among Flowers"—neither Indians nor animals are anywhere
to be seen; the Catlins thus symbolize this exhibition, whose
theme is invisible against its background of painted scenery.

The pictures in the "Paradise" exhibition have been care-
fully selected to suggest resemblances between Abstract Ex-
pressionist paintings and earlier creations. A surprise
inclusion among the show's early moderns is "The Con-
querors (Culebra Cut), Panama Canal," by Jonas Lie, a deep-
space landscape with a plume of smoke rising in the
foreground and another in the distance. The mystery of its
inclusion would, however, seem to be solved by the fact that
this painting is presented in the book on Newman by Thomas
B. Hess as a possible inspiration for Newman's vertical
bands. Resemblances such as this among artists of different
generations are Rosenblum's means of affirming a fundamen-
tal identity between the Abstract Expressionists of mid-cen-
tury New York and the itinerant romantics of the mountains
and beaches of a century earlier. On the basis of one sort of
detail or another, Rothko is hooked to Avery (in this instance,
an acknowledged influence), Avery to Heade, Heade to Ken-
sett and Lane, until, finally, "the uncongealed cloud shapes
that hover in Rothko's paintings" allow them to merge with
any painting of a vague and distant scene. A prime discovery
of Rosenblum's is that the paintings of Augustus Vincent

Tack, mainly known for a big theatre curtain in Washington, D.C., constitute "the closest imaginable prophecy of Clyfford Still" and provide a "firm American foundation for the forms and mystical ambitions of Still's art." Still is by no means the typical Abstract Expressionist, but Rosenblum appears to claim that in tracing Still to Tack he has unveiled the secret of the entire movement. According to Rosenblum, Tack has been "unaccountably" overlooked in surveys of twentieth-century art and in histories of Abstract Expressionism, but Rosenblum seems majestically assured that this neglect will now be rectified, and he predicts, intimating the shallowness of all previous judgments of Abstract Expressionist painting, that "there are going to be many such shocks of recognition in the works of as yet unstudied American artists."

The weakness of Rosenblum's position is that his comparisons of individual painters and paintings are supported by neither the eye nor the mind. Certainly they are not supported by the attitudes or the creative experience responsible for the works in question. One can imagine the horrified reaction of Clyfford Still to Rosenblum's notion that his paintings are "abstract translations" of Cole and Moran. I have quoted Newman's warning concerning efforts such as Rosenblum's to amalgamate new art with the old. Rosenblum's discovery of a common project for American painters throughout the generations hardly improves matters. "From Cole to Newman," writes Rosenblum, "these American painters have all sought a wellspring of vital forces in nature that could create a rock-bottom truth in an era when the work of man so often seemed a force of ugliness and destruction." The phrase "in nature" also puts Rosenblum at odds with Rothko. "The romantics were prompted to seek exotic subjects and to travel to far-off places," Rothko declared in 1947. "They failed to realize that, though the transcendental must involve the strange and unfamiliar, not everything strange or unfamiliar is transcendental." Rosenblum's talk about Rothko's art in terms of "cloud shapes" is not very different from the description, some thirty years ago, of Pollock's drip paintings as

"baked spaghetti," or the jocular characterization of New-
man's paintings as the closing of elevator doors. One need
not be a formalist to reject too facile likenesses between im-
ages in paintings and images in nature. Seen in reproduc-
tion—the art historian's customary mode of perusing
paintings—certain shapes in a panorama by Tack have bro-
ken edges similar to details in a Still, and there are passages
that seem to consist of a comparable overlaying of planes. But
the feelings generated by the two painters are totally differ-
ent, and while Tack can be said to be a painter of cloud forma-
tions, Still, like Rothko, cannot. Tack nowhere challenges the
spectator with blank walls of pigment, and he shows no im-
pulse toward Still's aggressive reductionism. That Tack has
not been mentioned in connection with Abstract Expression-
ism is thoroughly understandable; less understandable,
though more significant, is that he should have been brought
forward today in a museum of modern art in order to associ-
ate Still, Rothko, Pollock, and other pioneers of American
modernism with decorative painting. Other "finds" by
Rosenblum—for instance, Gottardo Piazzoni's Symbolist
"Decoration for Over the Mantel"—perform the same func-
tion of casting a film over Abstract Expressionist originality.

All significant American artists have been romantics—
what else could they have been? But does the romantic con-
sciousness consist in a single outlook and mode of ex-
pression—with Pushkin, the Lake Poets, Claude, Ruskin,
Walt Whitman? Is romanticism always a nationalist sentiment
emanating from attachment to the native ground, and are
imaginary landscapes, such as Gottlieb's, the same as real
ones? Or does romanticism, too, have a history, with mod-
ernism representing a reaction against the bombast of "sub-
lime" concepts of which, as Still says, "the dictator types
have made a cliché"? From Poe, Baudelaire, and van Gogh to
Mallarmé, Klee, Giacometti, one strain in art has consisted in
refining the terms of the transcendental in order to make it
more real. It is through affiliation with this strain that post-
war American art emerged as *abstract* art. The "Paradise" ex-

hibition is based on the conception of a continuity of feeling that seeps out of the soil like oil out of Texas. It endeavors to establish as a norm for art today a romanticism of wide-open spaces, which it is difficult to believe that even Rosenblum takes seriously. "Certain people," observed Adolph Gottlieb, "always say we should go back to nature. I notice they never say we should go forward to nature. It seems to me they are more concerned that we should go back than about nature."

Abstract Expressionism was, through and through, a big-city art movement, as the Hudson River landscape painting belonged to the frontier. Cole, Moran, Church went to the wilderness. Pollock *came* to Manhattan. "Living is keener, more demanding, more intense and expansive in New York than in the West," Pollock is quoted as saying. The word "expansive" is decisive, in view of recurrent attempts, including Rosenblum's, to relate the big canvases of Pollock (and those of Newman, Rothko, Still, Gottlieb) not to experience in mid-century New York but to the American mountains and prairies. The profundity of Abstract Expressionism lies not in the "translation" by Still of Cole into abstraction but in the means by which the abstractionists of postwar New York succeeded in salvaging metaphysical feelings from the debris of natural imagery and the international warehouse of accumulated symbols.

Nor is it without significance that the majority of the Abstract Expressionists were immigrants or sons of immigrants. "The Natural Paradise" is based on an oversimplification. Its idea of an indigenous landscape art that survived into the present impedes realization of the back-and-forth interaction between Europe and America throughout the history of American art. Newcomers became leading American artists, while self-trained American backwoodsmen went abroad to study and often stayed to become European painters and sculptors. The Abstract Expressionists were the first American artists for whom this dialectic was disrupted. Despite the late arrival of many of them, they were the least European of American artists, and hence the least influenced by the Amer-

ican past. Most of them reached maturity without having been to Paris, and their approach to the great modernists was guarded and suspicious. In presenting Abstract Expressionist art, the need is to differentiate its content from all earlier art, both American and European, as the means of clarifying its creative potentialities for the present and the future. "Paradise" does exactly the opposite: it systematically blurs the distinctiveness of the new work with meretricious comparisons, and its catalogue rhetoric of "poetic" platitudes—"primal landscape scene," "strange, haunting openness," "unbounded void of sunset"—tells us nothing about either the art of the past or of our own time.

# 24

# American Drawing
# and the Academy of
# the Erased de Kooning

████████████████████

Taken together, "Twentieth-Century American Drawing: Three Avant-Garde Generations" at the Guggenheim Museum and the recent "Drawing Now" show at the Museum of Modern Art provide a concise overview of developments in advanced American art since the early years of this century. (About a fourth of the artists in "Drawing Now" were Europeans, but their work is stylistically so close to that of the Americans that the difference in nationality does not affect the survey.) That art since the 1913 Armory Show was presented in terms of drawings rather than of paintings and sculptures sharpened the intellectual definition of each phase. The first principle in drawing is concentration on essentials: the artist states his ideas with maximum directness; he resorts automatically to the basic elements of his art; and he exposes his sensibility without the decorative disguises that may be part of his finished creations. Drawings are often a species of visual notetaking, intended only for the artist's own use. In recording observations of nature, illustrating abstract concepts, suggesting the outlines of a work to be executed in a different medium, their natural vehicle is the sketch pad. At the "Drawing Now" exhibition, I found my-

Originally published in *The New Yorker*, 22 March 1976.

self appreciating geometrical patterns, instructional charts, diagrammatic layouts, columns of words and signs by artist-theoreticians whose typical paintings and constructions I had considered intellectually pretentious and tiresome. Perhaps Bernice Rose, who organized the show, had a related response in mind when she described drawing as "the major two-dimensional work of the late sixties;" that is, as a genre preferred to painting.

Most drawings are small, and are produced with implements of writing and marking—pen, pencil, charcoal, crayon—but drawings as art are not defined by size or the means used. The biggest work by Arshile Gorky that I recall is a drawing, in charcoal or pencil; at "Drawing Now" there were four or five giants more than twenty feet in width. Watercolors, gouaches, pastels, collages, modified silk-screen prints, airbrushed pigments, and lines incised or scratched on stone, metal, bark, earth with any tool, including plows and motorcycles, are today all acceptable as drawings. In the Guggenheim show, Willem de Kooning, Hans Hofmann, and Franz Kline are generously represented by oil paintings. In practice, "drawings" has become synonymous with "works on paper"—except that, as noted, drawings don't have to be on paper.

The encroachment of the methods, qualities, and aims of drawing on what had been considered more important mediums was furthered by Abstract Expressionism, which related painting to handwriting (calligraphy) and sign-making as a means of reaching into areas of the psyche previously untouched by the visual arts. In the flaunts of the paint-loaded brushes of Hofmann, Kline, de Kooning and the dripped or thrown pigment of Jackson Pollock, any effective distinction between painting and drawing is eliminated. The notetaking of drawing is carried over into painting and is maintained until the artist "works his way out of the picture"—declaring it to be completed by the cessation of his activity. At the Guggenheim, the energy clusters of the Action painters appear in unmistakable formal contrast to the structured drawings of

the first generation of American vanguardists: Joseph Stella, Charles Demuth, Marsden Hartley, Man Ray, Stuart Davis. Their contemporaries Arthur Dove and Georgia O'Keefe are closer to the animation of the later style, in their echoings of Futurism and Expressionism—for example, the riptides of black diagonals in Dove's "Field of Grain Seen from Train" (a typical Futurist motif) and "Nature Symbolized" anticipate Kline, while the wafting forms of O'Keefe's "Evening Star" resemble Helen Frankenthaler's, though O'Keefe is somewhat closer to nature.

The transition from the drawings of the first generation to those of the second is dramatically realized in Gorky's ink, wash, and crayon "Composition": the freely wandering line seems to change of its own volition into figurative images with organic and erotic references, then ambles on to mark off the spatial divisions of the drawing. Flowing linear improvisation, executed with a sign painter's liner brush that enabled Gorky to paint as if he were drawing with a flexible pen, provided the innovative element in the canvases of this artist's final period.

The founding of painting on drawing as a discipline of search and self-release is even more intrinsic to the creations of de Kooning: a first-rate small retrospective at the Guggenheim consists of fourteen works on paper, eight of them in oil and in pastel—they range from such early, tightly concentrated pencil drawings as "Working Man" (1938) and "Elaine de Kooning" (1940) to the extraordinarily inventive charcoal-and-pastel 1974 figure-in-the-landscape that is as unrestrained as rain. Techniques for loosening his drawing have been the basis of de Kooning's progression from the tremendously impacted, Renaissance-inspired draftsmanship of the thirties and forties (the "Elaine" drawing) to the protracted spontaneous composing of his mature period which responds to the complex vibrations of his temperament. In his work, an epoch of American art subservient to the forms of the past is seen being transformed by experiments in self-liberation.

Perhaps the final translation of painting into drawing takes place in the drip paintings of Pollock, exemplified at the Guggenheim by "Number 34," in which painting has been synthesized into screen upon screen of inscribed and sprayed pigment accumulated in varying densities, topped by a string of paint dropped at random on the picture plane. Pollock's drawing by dribble and splash is followed up in Robert Motherwell's tasteful "Beside the Sea." By scribbling in several mediums on different grounds, Cy Twombly explores the visual possibilities of undirected marking. The paintings in drips, blots, splashes, and runnels of color which Hans Hofmann conceived several years before Pollock's drip compositions are excellently represented at the Guggenheim by "Untitled" and "Ambush," both done in 1944; that these and several Hofmann oils are exhibited as drawings indicates the extent to which Action painting brought painting and drawing together. Similarly, almost all of Kline's Guggenheim entries are paintings "drawn" with massive sweeps of the brush.

In the third-generation portion of the show, the Abstract Expressionists give way to their outstanding parodists, Robert Rauschenberg and Jasper Johns. (Other early deviators, such as Larry Rivers, would also have been pertinent.) Once past them, "Twentieth-Century American Drawing" relapses into the conventional representational draftsmanship of the Pop painters and the flat pattern-making of the Minimalists, such as Ellsworth Kelly and Frank Stella. Among the Pop artists shown, Claes Oldenburg is by far the most gifted as a draftsman, Andy Warhol at diverting attention from his childish drawing with provocative subject matter—dollar bills, Chairman Mao.

Survey exhibitions inevitably remind spectators of artists who have been omitted. That Saul Steinberg, whose drawings undoubtedly rank with the best of this century, is not represented either at the Guggenheim or at the Museum of Modern Art reflects the narrow-minded indoctrination that has become standard among curators of contemporary art.

Mentioning artists who should have been included in "Twentieth-Century American Drawing" is no doubt futile, but since the high quality as well as the chief historical interest of the exhibition lies in the sections devoted to the Abstract Expressionists, one might perhaps complain that extra attention ought to have been given to this mode. Philip Guston, for example, in his Action-painting period, produced countless drawings that parallel and converge with his paintings. Esteban Vicente worked in torn-paper collages as consistently as Motherwell and with as careful attention to the edges that act as contours of the forms. A phase of the career of Jack Tworkov consisted of a kind of vigorously painted "penmanship" that is a richer and more energetic and fulfilled complement to Twombly's slanted scrawls. The omission of Joan Mitchell and Norman Bluhm, with both of whom painting begins and ends in drawing, seems as arbitrary as (to move over to Pop) that of George Segal, whose plaster-cast figures evolved out of his drawings. In a show of "three generations" that finds room for six of Warhol's feeble sketches, the exclusion of Reginald Marsh, Edward Hopper, John Marin, Arthur Carles, and Rube Goldberg, to pluck names out of the air, must be attributed to trained prejudice, ignorance, or accommodation to current fashion.

The post-Abstract Expressionist segment of "Twentieth-Century American Drawing" overlaps the opening portion of the "Drawing Now" exhibition at the Museum of Modern Art, which closed March 9th. It is plain that the curators of the two shows share the belief that Rauschenberg and Johns are the bridge between the older vanguardists and the art of today. "It is noteworthy," writes Diane Waldman, organizer of the Guggenheim exhibition, "that this investigation of the medium [of drawing], which actually began with Johns and Rauschenberg, became the basis for the conceptualization of the 1960's and early 1970's." Rauschenberg and Johns reappeared in "Drawing Now" as heralds of the new era of "investigation," along with Minimalists such as Ellsworth Kelly, Frank Stella, Donald Judd, and Sol LeWitt and Conceptualists

such as Lawrence Weiner and Carl Andre. Pollock, de Kooning, and Hofmann were not included, since by museum logic they personify the nineteen-fifties and therefore have no bearing on the present. Nevertheless, "Drawing Now" kept harking back to Action painting, and to de Kooning in particular, repeating his ideas and attitudes, positively or negatively, though not always crediting the source. For Joseph Beuys, one of the non-Americans in "Now," drawing is an aspect of action, which he conceives as fulfilled in politics and magic, while the art object, the drawing, counts for little; Mrs. Rose speaks of "his compulsive scrawling" and notes that with Beuys drawing is "transformed into action," is "an act that insures freedom." Since Beuys thus represents a belated version of Action painting, the only legitimate reason for introducing his inconsequential markings would have been to compare his interpretation of "action" with that of Pollock or de Kooning, but apparently this was not in accord with Mrs. Rose's "now." A thirty-three-foot drawing by Robert Morris consisted of three parallel strips done by staining the floor and the wall with his feet, knees, and hands dipped in pigment. Here drawing is the act of imprinting the artist's limbs on a surface, and repeating this act without significant variation. In short, Morris's drawing is a derivation from Action painting that resembles the creations that Yves Klein produced some fifteen years ago by dipping nude girls in blue paint and imprinting their bodies on canvas.

The period covered by "Drawing Now" began with parodies of Action painting by Rauschenberg and Johns and the revival by these artists of Duchamp's questions regarding the nature of the art object in the contemporary world. Near the entrance to the exhibition was Rauschenberg's "Erased de Kooning," which served as the keynote of the show. Erasing the de Kooning (in part only—outlines of the forms are still faintly visible) and exhibiting it as Rauschenberg's own work was a comical gesture, a revival of Dada, especially since it was accompanied by the story that Rauschenberg and de

Kooning had discussed the importance of choosing a drawing of high quality to erase. Art-historically, the erasing could be seen as a symbolic act of liberation from the pervasive force of Abstract Expressionism, while exhibiting the drawing signified that the negating art still clung to Abstract Expressionism for support with the public. In thus explicitly dramatizing the transition from one mode of art to another, "Erased de Kooning" (1953) is the first work with an exclusively art-historical content and produced expressly for art historians; it is this that insured its prominence in museum shows of the next two decades. "Erased de Kooning" became the cornerstone of a new academy, dedicated to replacing the arbitrary self of the artist with predefined processes and objectives—that is to say, Minimalism and Conceptualism.

The hero of the elimination of Abstract Expressionism by asserting its principles in reverse is Jasper Johns. Mrs. Rose gives accounts of one repudiation after another. Johns, she writes "functioned with reference to the preceding generation. Johns' facture was a reorganization of the expressionist strokes of Abstract Expressionism in relation to subject." This means that Johns painted *as if* he were expressing an emotion or seeking an image, but his Expressionist handling was meaningless, since his subjects—targets, flags, the alphabet—were already familiar and left nothing to be discovered. Johns' parody of Expressionist drawing with the brush was duplicated on a more patently amusing level in Lichtenstein's drawing "Brushstrokes" (at the Guggenheim), which meticulously copies a liquid swirl in pencil. By the evidence of "Drawing Now," the development of art from the fifties to the present consists largely of further counterstatements to Abstract Expressionism. Barnett Newman's call for "subject matter that is tragic and timeless" was answered with a hail of hamburgers, Coca-Cola bottles, and comic strips. "Abstract Expressionism," writes Mrs. Rose, "was concerned with one kind of risk-taking; the artist staked all on the drama of self-expression, on revelation as a moral issue." To the

post-Action painters, strenuousness of this sort was an impediment to the good life of professionals, and Warhol "rejected the personal in terms of the handmade."

After Pop artists, "Drawing Now" showed draftsmen, mainly Minimalists and Conceptualists, who elaborated further on what Mrs. Rose calls Johns' "questions about essences." The academy of the erased de Kooning set itself such problems as: What is a painting? A sculpture? A drawing? When is an object real? When illusory? The answers, whatever they turn out to be, have one feature in common: they approach art through argument, and generate works that illustrate abstract conclusions. The following statement by Mrs. Rose is as good a summary as any of the outstanding tendency in the art of the sixties: "The rationalization of art which had been initiated with Johns continued, but under a more literal series of conditions." (She probably means in more literal terms.) Frank Stella dealt with Johns' discovery that a canvas is an object (a conclusion easier to reach when the image on the canvas has been erased). Stella arrived logically at the anti-de Kooning program that, in Mrs. Rose's words, aimed "to get the sentiment out of painting" and "against drawing in painting"—he found, she says, "drawing unnecessary to painting." Judd went further; he achieved a vision of what was "wrong with painting"—a problem familiar enough, but this time related not to the discovery of the camera, or the mass production of images, or the popularity of motion pictures, but to the nature of painting as such. "The main thing wrong with painting," wrote Judd, "is that it is a rectangular plane placed flat against the wall"— which, like the fact that people speak prose, had apparently gone unnoticed for centuries. In any event, the problem of painting had been transferred from the studio to the philosophy department.

The next step was taken by Sol LeWitt, who, recognizing that a painting is a thing that hangs on a wall, and thus a three-dimensional object, put ruled straight lines in hard pen-

cil directly on the wall, in order to capture the two-dimensionality that is the "essence" of painting—and who eliminated the possibility of de Kooningesque expressiveness by having the lines drawn by other people. His "Straight Lines in Four Directions Superimposed," owned by the Museum of Modern Art, is twelve feet high and almost twenty-seven feet long; given the fact that LeWitt's drawings are what one critic called "non-visual structures" (equivalent to an erased drawing?), it could just as well have been executed in inches.

A description of the "systems" philosophers of the seventeenth century quoted in Mrs. Rose's catalogue provides an apt characterization of the outlook of the artists in the "Drawing Now" exhibition. The systems thinkers "constructed elaborate systems, long chains of deductive reasoning where every link depended upon all those which preceded it and upon which all further links depended." "Drawing Now" was, in effect, a visual seminar initiated by Rauschenberg and Johns and conducted throughout the sixties, until it culminated in the Conceptualists' elimination of drawing (and of painting and sculpture) and its replacement by verbal propositions affixed to the walls of art galleries. Mrs. Rose speaks of the "generalized areas of agreement" among the artists of the period. It is necessary to add that this agreement was grounded in the changed intellectual situation of art. The shift of art training in the fifties from the art school and studio to the university art department, which was stimulated by the G.I. Bill, had the effect of imprinting on painting and sculpture classroom modes of inquiry, concerned not with emulating great works but with elaborating problems and solutions. In this period, the pressure of the university on the understanding and practice of art, and its role in providing careers for artists, became comparable in degree to the influence of the government projects on the art of the thirties. Not only were the minds of artists formed by the university; in the same mold were formed those of the art historians, the critics,

the curators, and the collectors by whom their work was evaluated. With the rise of Conceptual art, the classroom announced its final triumph over the studio.

In the sixties, each new crop of art graduates could advance the debate on the nature of a painted surface along a broad front of art galleries, museums, private collections, publications, and lecture halls. The coming of the economic recession, however, dampened the market for these pedagogical exercises and their diagrams on paper and canvas. With thousands of diploma-bearing job seekers turning up at each annual meeting of the College Art Association, there was a widening time gap between the classroom and the career. Former art students found themselves stranded, like artists of the past, in bohemias such as SoHo. The change in the situation of the artist has made inevitable a return to the practice of art for reasons of individual feeling and insight rather than to demonstrate theories of "objectness."

Aware that the chain of problems has culminated in the linguistic void of Conceptualism, Mrs. Rose closes her catalogue analysis by invoking a revival of interest in "the interior space of the self." She believes that art has "come full circle" from Rauschenberg, as if the figure in the erased drawing had risen to the surface again. In the diagrams of LeWitt and Dorothea Rockburne she sees the restoration of drawing "as a private and intimate art." Inner space is not, however, an organization of verticals, horizontals, and diagonals; as de Kooning said long ago of Renaissance drawing, it "trembles." The Museum of Modern Art exhibition was misnamed. It represented not "drawing now" but drawing of a recently concluded phase in the history of American culture, in which, responding to a sudden vast expansion of popular interest, art attempted to rationalize its premises in order to achieve professional status and stability. With its uncertain position restored, art may be compelled to return to larger ambitions.

# 25
## Ideal and Real

––––––

The twenty-eight-foot blowup of Hiram Powers' "The Greek Slave" that is bolted to the canopy above the entrance to the Whitney Museum as the emblem of its "Two Hundred Years of American Sculpture" exhibition recalls the high point in the popularity of sculpture in the United States. As an advertisement for the Bicentennial survey, Powers' neo-classical nude enters the order of cigar-store Indians and other shop signs—tilted forward a few degrees, she could serve as a figurehead for the Ship of Art, sister to Colonel Charles A. L. Sampson's rather heavily garbed "Belle of Oregon" on display inside. The public success of "Slave" in the mid-nineteenth century was due to her combination of exposed nakedness and lofty moral sentiment—a formula that often worked to win acclaim for academic compositions of the period. Sent on tour throughout the United States, "Slave" allayed the moral qualms of her beholders by arousing their sympathy for her plight as a modest Christian put on the block by lecherous Turks, to be delivered, for obvious purposes, to the highest bidder. "The subject," one promotional announcement declared, "is a Grecian maiden, made captive by the Turks, and exposed for sale in the Bazaar of

Originally published in *The New Yorker*, 14 June 1976.

Constantinople." "Slave" stood for a woman in the most urgent need of liberation, and this was sufficient to overcome the uneasy pleasure aroused by meeting her stripped barer by her captors than Duchamp's bride by her bachelors.

Powers' statue, regarded by the Whitney as a "key work" in the history of American sculpture, invokes an ideal—that of freedom. It is this idealism that makes "Slave" typical of the sculpture of its century: the heroic Washingtons and Franklins, the allegorical Proserpines, the equestrian statues, the figures of Justice and Truth, the portrait busts and reliefs of generals, statesmen, and preachers. In the transition from the awkward forthrightness of self-taught carvers of the early Republic to the Italian-inspired neo-classicism of Horatio Greenough, Powers, and Thomas Crawford, and to the various naturalisms of Henry Kirke Brown, Daniel Chester French, and Augustus Saint-Gaudens in the late nineteenth century, elevation of mood was a constant goal. The busts of the notables are all noble-looking, as is the head of every one of Saint-Gaudens's black foot soldiers. (One suspects that the bust is a genre that in itself confers nobility.) The folk carvings—which the Whitney deserves praise for including on equal terms in a "fine"-art survey—are similarly imbued with high moral or religious content, and Charles M. Russell's and Frederic Remington's cowpunchers, and even the animal sculptures of the first quarter of this century, reaffirm in their physical dignity that striving for an uplifted tone, or sublimation, which gives American sculpture from the Revolution through the Second World War its coherence, regardless of differences in style or aesthetic concept. In an introductory essay (one of seven) in the catalogue of "Two Hundred Years," Daniel Robbins notes that throughout the nineteenth century sculpture remained a public art dedicated to "the values that American society wished to enshrine." Among sculptors of the early years of this century, moral seriousness was present in the social realism of Saul Baizerman, Mahonri Young, and Abastenia St. Leger Eberle, or was replaced by the new European-inspired aestheticism and formal ideals of

such artists as Paul Manship, Alexander Archipenko, Robert Laurent, and Elie Nadelman.

Modernism is, among other things, a repudiation of moral idealism in art and of the exalted sentiments of the middle class. In its appeal to mid-nineteenth-century Americans, "The Greek Slave" exemplifies typically dubious aspects of academic loftiness. Foremost among these is a lack of concreteness. Created in the eighteen-forties, at the height of the anti-slavery agitation, "Slave" calls attention to the bondage of white marble girls with classical profiles but not to that of black human ones. As an act of the imagination, the work owes more to Greek sculpture than to participation in contemporary anguish, whether in Greece or in Alabama. Its remoteness saved "Slave" from controversy of the kind that enveloped Miss Eberle's underworld-flavored plaster "White Slave" when it was displayed at the Armory Show of 1913. This remoteness extends to the physical modelling of "Slave" as a nude, with its resigned expression of a museum cast—not a naked woman suffering humiliation. Transcendence of sex is built into her style in much the same way that sublimated lewdness was to become the style of the heroic child-bearing Valkyrie of Nazi sculpture of the nineteen-thirties. Though billed in its circuslike showings as the triumph of "the genius of our own American artist, Powers," "Slave" and its creator had little relation to American life, either in subject or in manner. Once he left the United States to pursue his career in Florence, Powers remained an expatriate for the rest of his life. In terms of fact, "The Greek Slave" is a piece of Italian sculpture fashioned by an ex-American, sold to an Englishman, and promoted as a sensational spectacle in somewhat the same way as the publicizing of a shady tableau by Edward Kienholz.

The modernist outlook, first absorbed by Americans in the late nineteenth century, and reinforced by the Armory Show, had the dual effect of bringing American sculpture (as it did painting) closer to daily life, on the one hand, and to exclusively formal and decorative aims, on the other. Both ten-

dencies turned sculpture away from popularly accepted
moral, patriotic, and religious concepts. Fictional and histor-
ical personages ceased to be taken as credible embodiments
of abstract ideals. One might say that the emotions of artists
overflowed particulars of the common life and, no longer re-
sponding to Diana or an Admiral Farragut as ready-made
signs, sought to generate their own mythical and semi-
mythical personifications. Lachaise's "Standing Woman," a
nameless contemporary goddess, celebrating sex by her gran-
diose female forms, represents the antithesis of the transcen-
dence of Eros in "The Greek Slave."

Gradually shedding its symbols of unfocussed generaliza-
tions—the Liberty, Wisdom, Columbia of the academicians
as well as the regional and class stereotypes of the nineteen-
thirties social realists—American sculpture in the period fol-
lowing the Second World War reached toward a new, non-
figurative grandeur, in which significant emotions would be
conveyed not by cultural or physical references (the chains on
the wrists of "Slave") but solely by the visual elements of
which the work was composed. The ambition to translate the
profoundest feelings into psychological equivalents inherent
in art materials was first realized in the canvases of de Koon-
ing, Pollock, Hofmann, Kline, Rothko, and other Action
painters and Abstract Expressionists. Barnett Newman's in-
vocation of "the Sublime" as the essential content of art can
be seen as an extension of the earlier idealism of American
painting and sculpture—purged of literary, mythological,
and ideological associations, and hence abstract in the most
extreme degree possible. This salvaging of metaphysical feel-
ings from the wreckage of religious, philosophical, and politi-
cal credulity through a vocabulary of sensual fact potentially
present in words, paint, quantities of sound constitutes the
fundamental heritage of modernism in the tradition extend-
ing from Poe and Baudelaire to Klee and the Surrealists. It
took shape in American sculpture in the myth-oriented early
metal weldings of David Smith (which are well represented at
the Whitney) and in the related creations of Lipton, Hare,

Ferber, Chamberlain, Ibram Lassaw (the last unfortunately restricted at the Whitney to uncharacteristic pieces of the nineteen-forties).

The drive toward concreteness of twentieth-century art has encouraged withholding from works any concepts or metaphors not realizable in the works' material components. But the limiting of art to what is actually there can be subject to a wide range of interpretations: it can include both sensitivity to intangible presences and the most stubborn literalism. One who denies that truth combatting ignorance is anywhere to be seen in John Storrs' nude male with a serpent coiled around his right leg may in the name of an uncompromising vanguardism also reject the manifestation of force in a di Suvero construction of heavy beams and chains. That the emotion conveyed by a Smith or a Rothko is indefinable save in terms of the work itself means that this emotion is present solely as an aura of the visible forms, and thus its existence is as impossible to prove as that of Hamlet's ghost. To a leading earthworks artist of the sixties, the metaphysical aims of Abstract Expressionist painting and sculpture were a hangover of the "myth of the Renaissance" in the form of "mushy humanistic content," while to the public the psychic action in a Pollock or a Smith was translatable into therapy, self-expression, or theatricalism—superfluous and irrelevant to painting and sculpture, however decisive the artist's formal innovations.

If one had to choose the single outstanding feature of the art of the nineteen-sixties, it would be the attitude, varying from indifference to soured ideological hostility, taken toward the metaphysical feelings and exalted psychological states of the Abstract Expressionist generation of painters and sculptors. Artists such as Rothko, Gottlieb, Reinhardt found themselves to be virtual exiles among their formal and technical disciples. Pollock's mystical "contact" with the canvas, Newman's sublimity and awe, Hofmann's élan were negated in how-to formulas derived from technical aspects of these artists' creations. Pollock was recast as the master of "over-

all" painting, Newman as the father of color-area composi-
tions, Hofmann as the synthesizer of Cubist geometry and
Expressionist brushwork. The new, anti-metaphysical aes-
thetic may have been a reassertion in art of American know-
nothingism, corresponding to the support by the majority for
the Vietnam war. Or it may have sprung from the search for
simplistic definitions by the proliferating university art
departments.

The movement toward literal tangibility is carried to vari-
ous logical conclusions in the sculpture displayed on the
fourth floor of the Whitney. In the portion of the "Two Hun-
dred Years" survey labelled "1950-1976," the revolt against
the ideal, as it appears in changing aspects on the two lower
floors, has been consummated. Everything is as specific as a
shovel and proved by the smoking pistol. From Carl Andre's
patterns of copper squares laid out on the floor to Robert
Rauschenberg's arrangement of two logs and a piece of a torn
tire, nothing is anything but what it is. No ideas are to be
discerned except ideas of what sculpture can be, and once it
has been relieved of its "mushy humanistic content" sculp-
ture can be anything that is not painting—that is not a flat
surface, which now includes unpainted canvases.

In terms of the Whitney's fourth floor, Powers' "The Greek
Slave" remains a "key work" if attention is transferred from
the original marble carving inside the museum to the giant
"Slave" on the canopy, which was produced on paper by
computer-controlled spray guns and mounted on an arma-
ture of plywood and steel. In another essay in the exhibition
catalogue, Marcia Tucker, a curator of the Whitney, provides
a suggestive analogy. "Andre," she writes, "has succinctly
described the evolution of contemporary art." "There was a
time," she quotes him as saying, "when people were in-
terested in the bronze sheath of the Statue of Liberty, model-
led in the studio. And then there came a time when artists
were not really concerned with the bronze sheath but were
interested in Eiffel's iron interior structure, supporting the
statue. Now artists are interested in Bedloe's Island." To be

genuinely contemporary, the Grecian maiden on the canopy needs only to be undressed of her body in order to reveal the infrastructure of industrial materials in relation to the building to which she is affixed. So reduced, she would qualify as art within the limits of Miss Tucker's admonition that "present-day sculpture has generally rejected anthropomorphic, transcendental, nostalgic, and metaphysical content."

What is sculpture without these infusions of meaning? On the Whitney's fourth floor, the separation between art objects and other objects has been brought to an end. In sculpture, the prime symbol of the elimination of this barrier is the absence of the pedestal or base, which as late as Smith's "Voltri" series and Newman's "Here I" set the work apart from furniture or the landscape. At the Whitney, things sit on the floor, or ground, like rocks, stick out of it like trees, or are supported from the ceiling like vines. Not that the show is completely consistent; it yields to the seduction of fashionable reputations, for instance, in including Nancy Graves' camel. An exception to the no-separation principle is the interior by Kienholz, which, framed by its setting, is out of place in the survey of this "evolution," since it thus becomes a tableau, or three-dimensional picture, instead of occupying humanly habitable space. Out of place for similar reasons are a boat and shark fins in a glass case by H. C. Westermann. The late Robert Smithson's "Non-Site" (a fourth-floor piece, but located below the lobby), which consists of stones in a painted metal box with three parallel openings, is an anomaly: the horizontal slits give the work the effect of stripes painted on a naturalistic backdrop.

The core of the fourth-floor display is its man-made enclosures (tunnels, corridors, mazes, into which spectators are invited) and its intrusions into habitable space by solids, sounds, and lights. Things added to the environment include geometrical structures and modules, by Andre, Sol LeWitt, and Donald Judd, and random scatterings of odd materials and machine parts, by Barry Le Va and Michael Heizer. At the extremes of rationality and accident are Barry Le Va and

Larry Bell (whose names taken together seem to belong to a word game). Photographs of outdoor constructions by Smithson, Walter De Maria, and Heizer emphasize the identification of art and nature, and of the artist and the building contractor. Equally emphasized, except in the borrowings of techniques and forms, is the dismissal of the art of the past and of the kinds of experience on which that art was founded. With the disappearance of the pedestal or base, sculpture achieves its effects not as visual shape, icon, or sign but by usurping the floor (Andre), or confining the spectator (Bruce Nauman, Bell), or threatening him (De Maria). Art becomes an ecological problem, as in the recent suit brought by California environmentalists to prevent Christo (unaccountably omitted from the Whitney exhibition) from building his running fence. In the works on the fourth floor, the drive toward de-idealization has reached its goal, in theory and in practice. With the exclusion of abstract morality, formal beauty, and metaphysical realities, nothing is left to be cancelled. Art has hit bedrock in the irrelevance of how things in an exhibition look, what they mean, and what they leave in the spectator's mind. It seems unlikely that negation has any further possibilities.

That "Two Hundred Years of American Sculpture" terminates in a dead end of values is at least in part owing to the distorted time perspective of the organizers of the show. One-third of the three-floor exhibition space is assigned to one-eighth of the total two hundred years: the period from 1950 to 1976. Aside from this disproportionate attention to the present, the artists shown in the section do not actually represent the past twenty-six years. Smith, Louise Nevelson, Herbert Ferber, Lassaw, Newman, George Rickey, Len Lye, all of them important postwar sculptors, have been relegated to the weirdly conceived "1930–1950" segment of art history, on the third floor, while many others—Kenneth Snelson, Gabriel Kohn, James Rosati, Peter Agostini, Raoul Hague, William King, Chryssa, David Weinrib, Willem de Kooning, to name the first that come to mind—have been omitted. Ac-

tually, much of the work shown on the third floor was executed after 1950, and some of it even after 1960. With similar inaccuracy, or misrepresentation, the majority of the "1950–1976" exhibits were completed after 1960 (I could find only three that were done before that date) and before 1970—many featured in the show are reproduced in Wayne Andersen's "American Sculpture in Process: 1930/1970," and those that were conceived in the past six years are extensions of earlier concepts. In sum, at the Whitney, 1950 to 1976 consists of less than ten years, the products of which are made to outweigh all other developments, values, and possibilities in American sculpture. In its fixation on art-world fashion and the logic of avant-garde innovation, the Whitney has stretched the now largely exhausted aesthetic reductionism of the latter half of the nineteen-sixties—founded upon a particularly disagreeable and disheartening interlude in American social history—to give the impression of a continuing dominant trend.

In a statement introducing "Two Hundred Years," Mr. David Rockefeller, chairman of the board of Chase Manhattan Bank, which is a sponsor of the exhibition, observes that the show "provides a unique insight into the history of the United States." One wonders whether the decline in morality, idealism, and character revealed in the passage from the anti-slavery content of "The Greek Slave," however mild and remote, to the "loose and indeterminate arrangements"—the will-lessness—of the "scatter" pieces representing the Now at the Whitney is the historical phenomenon that Mr. Rockefeller wanted spectators to discover.

# 26
## Jews in Art

---

No doubt by coincidence, two large exhibitions are currently displaying paintings and sculptures by and relating to Jews. "Jewish Artists of the Twentieth Century: A Survey," at the Maurice Spertus Museum of Judaica, in Chicago, is a selection, from local collections, of sixty-three works by almost as many artists. Besides being Jewish, the artists are American, French, Belgian, Italian, British, Hungarian, Russian, Polish, and Israeli, and all but three or four are internationally famous—in the Man Ray-Modigliani category. Stylistically, the exhibits have nothing more in common than would any randomly chosen group on the same level of quality: in regard to art, being Jewish appears to be no more than an accident. The Spertus show is intellectually modest (an uncommon virtue these days): it makes no effort to link the works with one another, and it specifically disclaims any intention of asserting the existence of a "Jewish art"—a position obviously well advised for an exhibition presenting artists as divergent as Avery and Nevelson, Victor Brauner and Lissitsky. Aesthetically, philosophically, temperamentally, the Jewishness of the creator is, by the evidence of this show, irrelevant to the creation—a conclusion confirmed by Arthur

Originally published in *The New Yorker*, 22 December 1975.

M. Feldman, director of the Spertus, when he declares that
the purpose of the show "is simply to present quality works
to the public"—which is the aim of all art shows that lack
ideological motivation. To Joseph Randall Shapiro, Chicago's
ardent missionary of modern art, who assembled the Spertus
exhibition, the exhibit has the virtue of surprising people; it
should have been subtitled, he advised visitors at the open-
ing, "I Never Knew *He* Was Jewish." Chagall, Hyman Bloom,
Jacob Epstein, Rube Goldberg, Chaim Gross, Chaim Soutine,
Adolph Gottlieb could scarcely have been taken for anything
else by one who considered the matter. On the other hand,
the mere fact of being in the show does not prove the Jew-
ishness of Eilshemius, Anuszkiewicz, Nakian, Caro, Moholy-
Nagy—especially since, according to Shapiro, the exhibition
came close to including Gorky, whose mother was descended
from a line of Armenian Apostolic priests. To all appearances,
the research that brought artists into the fold was quite casu-
al—which is harmless enough in a show designed to put on
the best art available.

In its intellectual modesty, the Chicago exhibition raises the
question Why bring these artists together just because they're
Jewish? To this question the concurrent show in New York,
"Jewish Experience in the Art of the Twentieth Century," at
the Jewish Museum, responds with the ambitious intention
of showing recent Jewish history as it is mirrored in the art of
our time. Like the Chicago affair, it avoids the temptation to
assert the existence of a Jewish art, but, rather than display-
ing the best art by Jews it could obtain, it has isolated such
themes as traditional Jewish life, migrations from one land to
another, the Holocaust, and settlement in Israel as the "Jew-
ish Experience;" art, even by non-Jews, that deals with these
themes falls within the purview of the show. Comprising two
hundred and sixty paintings, sculptures, and prints by more
than a hundred artists from many countries, but with an em-
phasis on Israel, it contains a fair percentage of notable
works, among them seven Soutines and contributions by art-
ists such as Anna Ticho and Jacob Bornfriend, who deserve to

be better known in the United States. Primarily concerned
with subject matter, however, "Jewish Experience" ranks far
below the Chicago show in quality, though there is, of
course, a good deal of overlapping—no exhibition related to
Jews in any sense could dispense with Chagall, Lipchitz,
Shahn, Agam, Reuven Rubin, and Max Weber.

Paintings are readily recognized as Jewish when they por-
tray Jewish "types" (identified by caftans and round hats,
beards and *payess*, certain facial characteristics) and scenes in
ghetto streets (peddlers), homes, synagogues, and cere-
monial events (women blessing candles, old men embracing
torahs, weddings, circumcisions), or when they introduce
Hebrew lettering and symbols (the lamb, the Star of David).
For Hyman Bloom, Max Weber, Jack Levine, Ben Shahn, the
Soyers, Leonard Baskin, Chaim Gross, Abraham Walkowitz,
Jacob Epstein, the immigrant Jew of the American ghetto con-
stituted a single historical entity that each could realize pic-
torially in his own manner. "Jewish Experience" does not,
however, confine itself to depiction of Jewish fact and ap-
pearance; it includes symbolic compositions, with and with-
out overt Jewish references, and even paintings and
sculptures that are completely abstract.

The Jewishness of the art of Chagall, the Calder and Henry
Moore of Jewish art in both the West and Israel, raises es-
pecially interesting questions. Chagall was born into the
Orthodox Jewish community of the Russian town of Vitebsk,
and his work appears to touch the authentic folk roots of East
European Jewry. The most persuasive of his Jewish images is
the peddler, or Wandering Jew, in peasant's cap and caftan,
plodding above the rooftops with a pack on his back; "Over
Vitebsk," at the Jewish Museum, is a version of this motif.
Chagall's airborne Jew, however, belongs to the order of his
non-Jewish images—his fiddle-playing donkeys, circus
equestriennes, levitating lovers, mammoth bouquets, the
Eiffel Tower. In his exhibition at the Guggenheim last sum-
mer, Jewish motifs were present in only two or three works
(Hebrew letters in the upper-right-hand corner of "Fête"

seemed to indicate that the holiday was Purim), in contrast to the profusion of Russian landscapes (including churches) and his bestiary and lovers. "Time Is a River Without Banks," in "Jewish Experience," is a loosely brushed composition of a flying fish (with giant wings, and combined with a grandfather's clock) that plays a violin while, below, lovers embrace on the bank of a stream. If this idyllic meditation has anything to do with Jews or the Jewish experience, it must be through the association of the fiddle with other violins in Chagall's work: for example, the fiddler on the roof of "Green Violinist" (not in the show). Or perhaps fish is Jewish because of Friday-evening meals. (Not long ago, Chagall's art of private and folk fantasy, in a unique blend of Cubism, Orphism, and Expressionism, was felt to be too avant-garde to reflect the collective experience of Jews.) When he took refuge in New York, during the last war, he complained that American Jews showed no special interest in his work, and that through the help of Jacques Maritain and his wife, Raïssa, who had written a monograph in praise of Chagall's medieval sensibility, he had received far more support from collectors who were Catholics; at any rate, he busied himself during his stay here with finishing a series of Crucifixions. It is only since the popularization of modern art and the establishment of the State of Israel and of Jewish institutions supporting the most up-to-date styles that Chagall has become the laureate of Jewish art: in the "Jewish Experience" exhibition he is represented by eleven paintings, far and away the largest group by any one artist, and would have had four more had he not withdrawn them.

The fiddler-on-the-roof motif is lyrical Jewish angst and prewar Paris modernism fused into a nostalgic stage set. It is the Russian ghetto as pantomime, and it harmonizes with Chagall's canted villages, blue cocks, and doe-eyed nymphs. His Jewish Crucifixions are more difficult to take. "White Crucifixion," in "Jewish Experience," is an adaptation in 1938 of his Crucifixion of 1912 in the Orphic style of Delaunay. A response to German atrocities, "White Crucifixion" is one of

his best-known creations; in it, the central figure, wearing a Jewish prayer shawl as a loincloth, is nailed to the Cross in a slanting beam of light. Rotating around him are a synagogue and torahs in flames, the pack-toting Jewish peddler in flight, a menorah in a halo of light, a boatload of fugitives, a destroyed village, and an invading mob; over the head of the victim flying rabbis, adapted from Renaissance angels, gesticulate in despair. The painting is a stage curtain that decorates its theme of terror and slaughter but does not express it. In sum, it is an example of "Jewish" art in which aesthetics predominate rather than a "Jewish experience."

The relation of Chagall's paintings to the shared ordeals of Jews is a clue to the weakness of the Jewish Museum exhibition. A "Jewish experience" is presumably a response to a collective situation; that is, one is which all Jews, or a representative portion of them, participate. (An experience restricted to Yemenite Jews or the Jews of Japan would not qualify.) Experience, whether collective or individual, makes its way into the art of the twentieth century through styles developed by art movements, which are in varying degrees themselves forms of collective experience. At least up to now, none of these styles have been founded on Jewishness. Paintings of New York's lower East Side by Walkowitz, Levine, the Soyers, Shahn are aspects of American realism with School of Paris overtones; the poor, picturesque Jews depicted in them are aesthetic blood brothers of American outcasts in the paintings of Sloan, Marsh, Hopper—by the same rule that makes Chagall's torah-clutching Jews kin of Picasso's harlequins, Matisse's Moroccans. In representational art, an accord was possible between visual folk peculiarities, a collectively shared scene and appearances, and a historically dominant style in art. All that art needed to be Jewish was that the artist should turn occasionally to the ghetto or the synagogue for subject matter. Chagall's Jewish mythmaking was in harmony with Surrealist aesthetics to the same degree that were Gorky's canvases of a symbolic Armenia.

Leading modes in more recent painting and sculpture tend

to exclude imagery that reflects a national or regional con-
sciousness. In the perspective of art since the Second World
War, Jewish references in a painting increase the odds against
its being a good painting. Works in the Jewish Museum show
which represent the Jewish experience are likely to belong to
a bypassed style or to be, in a significant sense, outside the
art of the twentieth century. Arthur Feldman seems to have
had this in mind when he wrote that "Jewish artists were
affected by their cultural history, events of the Holocaust,
and the establishment of the State of Israel, yet these experi-
ences find little direct expression in the visual arts." The con-
flict between this view and the attitude responsible for the
prolific display at the Jewish Museum relates to the pos-
sibility of genuine "expression" in outmoded art forms. The
spectator at "Jewish Experience" often finds himself obliged
to set aside the responses of his sensibility out of deference to
artists who participated more deeply in the trials of their peo-
ple than in the vicissitudes of modern art. Sentiments of a
similar sort occur whenever art is required to be loyal to a
cause, be it women's liberation or Canadian landscape
painting.

The distinction of Chagall's ghetto recollections lies in his
tenderness. Other Paris-influenced painters treat their Jewish
subjects as odd human phenomena, and their paintings gen-
erate a kind of involuntary contempt. To judge by "Jewish
Experience," caricature seems inherent in most of the studies
of lower-East Side Jews. (A notable exception is the admirable
"Artist's Parents," by Raphael Soyer.) While the filial sympa-
thies of Max Weber are beyond question, I find his Jews
odiously reminiscent of the skullcapped, hook-nosed, dwarf-
ish pygmies of Nazi and Soviet anti-Semitic graphics. In Jack
Levine's "The Passing Scene," caricatured misery is so
pungent that it makes even the fleshless dray horse look Jew-
ish. Figures wrapped in prayer shawls provide a repeated
geometrical element, like coffins standing on end in a ware-
house, for Jacob Kramer's "Day of Atonement," and Sig-
mund Menkes' "The Uplifting of the Torah" is crowded with

faces that look like painted masks. These are items in "Jewish Experience" that cause one to wonder about the wisdom of displaying in public the whims of artists on so sensitive a subject.

It is a matter of historical fact that the situations reflected in the Jewish Museum exhibition belong to the past—except for the settlement of Israel, which is an experience not of Jews in general but of Israelis. The Orthodox synagogue of Kramer and Hyman Bloom has ceased to be typical of Jewish places of worship, and the people in it have little in common with temple attendants in Westchester or Nassau County today. American Jews have departed from the ghettos and trades of their grandfathers, and, save for the Chassidim, a sect in which clothing is as important as it is to the Amish, Jews are no longer recognizable by what they wear. Traditional ceremonial elements in weddings, confirmations, and funerals have been reduced to vestigial details in the aesthetics of seminary graduates, caterers, florists, and funeral directors. What is left of Jewish experience bears little likeness to the images in "Jewish Experience," nor are the campaigns of the United Jewish Appeal, or family celebrations at the Palace Manor, likely to inspire new art.

To avoid bringing its record to a halt in the art of the past, "Jewish Experience" ventures beyond works on explicitly Jewish subjects to include art that can be Jewish only through metaphysical interpretation. Soutine's paintings, for example, have been said to embody the quintessential *golos* misery. But since there is no sign in these portraits, landscapes, and still-lifes of anything resembling a collective experience, Jewish or other, the spectator must project the presumed Jewish feeling into them—which he can do more readily if he reads about them in a book than if he confronts them in a gallery. The paintings of Soutine exemplify the modernist principle that the work of art is a unique creation in which the social and psychological data of the artist's life leave no trace. Avram Kampf, the director of "Jewish Experience," concedes in his catalogue that "there is not a single painting by Soutine

which we can identify as being Jewish in subject matter." What, then, is Soutine doing in this show, and with a group of paintings second in number only to Chagall? The answer is that Soutine's presence promotes confusion about what is "Jewish" in modern art. Because Hitler's "Degenerate Art" exhibition of 1937 found all modern art in some sense "Jewish," this confusion is no slight matter. Kampf quotes the critic Waldemar George: "The curse which rests on the painter [Soutine] rests on his race, it decided the whole psychic life of the artist. It leads his hand and his brush." The idea that the Jews are an "accursed race" hardly belongs in a publication issued "under the auspices of the Jewish Theological Seminary;" in any case, it is out of place in art criticism.

Matters are scarcely improved when "Jewish Experience" reaches past Soutine to Constructivists and Abstract Expressionists. Again, Kampf concedes, he has included paintings in which "one might fail to find any points of reference to Jewish experience." The excuse is that these works are modern, and that to be modern is "in itself" to be Jewish— once more, an echo of "Degenerate Art." Speaking of the Russian-Jewish Constructivists Gabo, Pevsner, and Lissitsky, Kampf asserts that "certainly the full participation in the intellectual, scientific, artistic work of this century is in itself a major aspect of Jewish experience." The contrary, however, seems true: "full participation" (whatever that means) in twentieth-century attitudes excludes the ethical and religious beliefs inherited from ancient creeds, as well as the rituals and sentiments by which they are enforced. For an artist in prewar Russia to be modern was a way of ceasing to be Jewish, as was the case with both Soutine and Chagall upon their arrival in Paris. The separation of the Jewish artist from the experience of his folk or national comrades cannot be overcome by affixing to a work a Jewish or Biblical title, as if it were a mezuzah. Luise Kaish's circular construction in polished aluminum is no more Judaized by being called "The Cabalistic Sphere" than it would be Germanized by being entitled "Nietzsche: The Eternal Return." Except for its name,

Louise Nevelson's "Homage to Six Million I" is indistinguishable from her other black wallcases of machined wooden forms; while the naming may be valid as a gesture of identification, the work can hardly be seen to throw light on the Jewish experience. Agam's metaphysical christenings of his optical paintings make them no more Jewish than compositions in the same mode by Vasarely.

One small painting by Barnett Newman seems to have been included for the express purpose of appropriating another area of art as "Jewish." Entitled "Joshua," the work is juxtaposed in the catalogue with an illustration from a fourteenth-century Haggadah in which the separation of day from night is rendered by a surface divided into dark and light halves. "If," writes Kampf, "there were a Jewish art, Newman's work would be regarded as its most authentic and classic expression." No doubt it is flattering to be considered the best example of something that doesn't exist. (Newman's widow refused to collaborate on the show, because she feared that the meaning of his work would be distorted in this setting.) Kampf's enthusiasm relates to the imagelessness of Newman's paintings; they seem to avoid violating the Second Commandment's ban on graven images. Newman's paintings are imageless—as is the work of Mondrian and other abstract artists—in the sense that they avoid figuration. His banded paintings do, however, create an image—one susceptible of numberless variations through color, shape, and scale. In his "Stations of the Cross" series, he affirms the conviction that his image—in this instance associated with Christianity—can evoke the most sublime feelings. As for Newman's Old Testament titles, they must, like Chagall's Crucifixions, be read in terms of the privilege assumed by artists of this era to do what they like with the symbols and personages of the religions into which they were born—a privilege that destroys any relation between the paintings and the experience of the community.

The freedom of each artist to conceive in his own way events in the common history lends a maudlin character to

the section of the Jewish Museum show devoted to the Holo-
caust. Philosophers, historians, theologians have not yet de-
veloped the means to comprehend that catastrophe, but
artists have rushed in, and not the most subtle. Ben Shahn's
"Identity," a simple arrangement of vertical stalks that termi-
nate in clasped hands under a strip of Hebrew lettering, pre-
sents a readily decipherable and touching message. Other
renderings of Jewish torment, ranging in style from the imita-
tion-Renaissance triptych of Samuel Bak to the *art brut* of Mar-
yan, are more ambitious. Erich Brauer's "Persecution of the
Jewish People," with its ravening wolves, its figures in Orien-
tal costume, a tower from which hangs a bloody torso and in
whose windows a rape and a murder are taking place, its
architectural decoration that sheds huge tears, and its setting,
which is both plaza and arena, is like the illustration of a per-
verse and indecipherable fairy tale. Harold Paris, a West
Coast artist of "happenings," invisible art, plastic construc-
tions, and floor sculpture, is, for reasons not given, the favor-
ite of the Jewish Museum exhibition: a separate room, a
column and a half in the catalogue, and a separate illustrated
leaflet about his "environment," entitled "Kaddish for the
Little Children," are devoted to him. One presumes that his
pulling at the strings of feeling—visually, and with a poem
by a child who died in a concentration camp—has a strong
appeal to Kampf. In my mind the "Kaddish" associated itself
not with the extermination of European Jews but with nine-
teen-sixties avant-gardism and with environmental items
shown at the exhibition called "Documenta 5," in Kassel.

The conflict that runs through the Jewish Museum exhibi-
tion—between the Jewish experience and the art on dis-
play—also manifests itself in Mitchell Siporin's "Endless
Voyage," in which a shipful of homunculi with stringlike
arms who are bound for Israel illustrates the inability of
American Jewish artists to approach this subject without car-
icaturing misery. It may be that the Holocaust is not a subject
that art can manage, or can yet manage—though it may be
memorialized in other ways. The mass murder of the Jews

was not a Jewish but a German act; not simply an episode in a history of horrors. Picasso's "Guernica" unites the terror of the victims with the ferocity of the assailants, while in the "Jewish Experience" paintings the torments seem to come about of themselves. Also, Picasso possessed a vocabulary of symbols—the bull, the horse, the mother and child—with which he could appropriate to art the theme of political violence. To the artists of "Jewish Experience," interpretational stretching is indispensable to fill the gap between picture and subject whenever the artist departs from depiction. This catalogue statement sums up the inadequacy of the artists' means: "Sigmund Menkes, a painter of joyousness of life, turns to a sombre palette in his paintings of the Holocaust." The Holocaust, however, is not a hue.

The "Jewish Experience" exhibition has exaggerated the possibility of re-creating the scenario of recent Jewish history through paintings and sculptures. The episode of the immigration to the East Side happened to coincide with the urban-scene phase in American art, as the European ghetto episode coincided with the folk-art phase in Russian modernism. (Not only Chagall but Kandinsky and Malevich, among others, dealt with this.) Thereafter, however, Jewish history and art history took separate roads. Avant-garde modes in the art of this century are not hospitable to collective experiences; and Jewish experience is no exception. The inherent individualism of styles since Impressionism is confirmed by the hostility toward them of totalitarian governments, which, like the Jewish Museum show, see art as conforming to a preconceived script. American Abstract Expressionists, among them Newman, Gottlieb, Nevelson, and Rothko (I fail to understand how "Jewish Experience" could have omitted—in view of its interpretative adventurousness—Jewish artists such as Guston, Frankenthaler, Resnick, and, most amazingly, Saul Steinberg), developed a language with which they could embody ephemeral aspects of their identities, in contrast to the social identities conferred by their backgrounds. If the common condition of Jews, artists and non-artists alike, is an am-

biguous, or dual, identity, it is a condition that is experienced uniquely by each individual, and cannot be expressed as a common experience. Moreover, ambiguity of definition is a condition that is not confined to Jews but is a general predicament—in this century of persons displaced from their class, their national, religious, and cultural heritage. When, instead of conforming to their national model, Jewish artists commenced to assert an individual relation to life and to art, they did not give expression to a Jewish experience but entered the mainstream of creation in Europe and America. An exhibition that corrals such artists into a national category violates their aims and falsifies the meaning of their work; it was the sensitivity of Newman's widow to this issue that induced her to withhold his work from "Jewish Experience" and to object on other occasions to his being presented as a "Cabbalist" painter. Abstract art cannot contribute to an image of The Jew, however much it may participate in deepening the consciousness of self in Jews as individuals.

# 27
# Being Outside

The artist is a member of a cultural minority because of the fact that he is an artist. Like other outsiders, he tends to drift into ghettos and is troubled throughout his life by the problem of assimilation. On the one hand, he is moved to end his segregation and reconcile himself to the ways of life of the majority; on the other, he is aware that the qualities that make him what he is are contingent on his separated state. For the artist, mingling with his fellowmen must be weighed against the depletion of his personal identity. He is obliged to conduct his relations with society—including the institutions set up by society to advance the cause of art—with extreme caution, as if he were involved in some sensitive diplomatic negotiation. To be too trusting is to risk losing everything.

The problem of the artist as a member of a cultural minority is sharpened when he is also a member of an ethnic or a social minority—when he is a black, a Spanish-American, a Jew, an American Indian—or when "he" is a woman. In sharing the situation of individuals who, like him, endure minority status but who are not artists, he marches under two flags, each of which marks him off from society in a different way. The art-

Originally published in *The New Yorker*, 5 August 1977.

ist's racial or sexual comrades are eager to achieve equality with the majority, and their leaders urge the priority of this goal upon all who belong to the common category. But to the artist social equality, though morally and practically desirable, is a mediocre ideal. Through art, he can transcend the condition not only of those who share his social disadvantages but of the fortunate majority as well. The notion that his interests are those of his social category is in his view a fiction. As an artist, he has a hidden being that is unique and will one day astonish the world. No conceivable expansion of female equality can achieve for the individual what has been gained by a Cassatt, an O'Keefe, a Bourgeois through her own solitary efforts. For the artist, fulfillment of self consists not in marching in the ranks of liberators but in being entered in the roll of the Masters. The artist tends to find himself in the position of a deserter from his social group—or, at best, one who collaborates, with secret reservations. For he cannot persuade himself that becoming equal with non-artists, whether black, white, or red, Anglo-Saxon or Jewish, male or female, native or foreign, will satisfy his deepest desires. If his work lends support to his compatriots, it is on his part an act of philanthropy (if not of exploitation), and he is prone to take it for granted that his creations surpass and will outlast the social issues that are their subject. The pride of the minority artist (or, in the case of women, the artist with minority status) lies in rejecting the proffered adjective—"black" artist, "woman" artist—even when it entails special favors. He conceives himself as essentially *sui generis* and his social identity as a masquerade, to be thrown off when he has realized himself. At only one point does he feel himself joined to others of his kind: when that link threatens to exclude him from the company of art's immortals. Then he, like his brother who is denied a position to which he is entitled, feels the burden of social injustice.

The inner conflicts of the minority artist, the victim of a twofold alienation, come to life in the exhibition "Two Centuries of Black American Art," now at the Brooklyn Museum

after showings in Los Angeles, Atlanta, and Dallas. Admittedly, the exhibition, of some two hundred items, has an ulterior purpose; that is to say, it is presented primarily to help bring about changes in the situation of black people in America. To thus put aesthetic standards in second place is for some critics a sufficient ground for dismissing the "Two Centuries" show as a whole. One is compelled, however, to wonder what those aesthetic standards are, and what they are based on, in a period when there are as many aesthetic systems as there are art movements. The principles that exalt Mondrian will hardly make much of Dali or de Kooning. Aesthetic propositions today are polemical instruments designed to further this or that philosophy or notion of what art is or ought to do. To speak of assessing the artistic merit of works, as if some underlying scale of values were in operation, is a pretense—and a threadbare one. It was on the basis of "fundamental values," rarely specified, that the masters of modern art, from van Gogh and Cézanne to Picasso and Matisse, were repudiated. Ready-made aesthetic standards—that is, standards that exist apart from insights into particular qualities—tend to be expressions of the taste, morals, and prejudices of dominant elements in society. Indeed, a primary motive for the "Two Centuries" show is the conviction that throughout the history of this country blacks have been discriminated against in the application of presumably universal aesthetic standards; the catalogue refers to "the narrow interpretations of works by black artists given by white critics" and to "the omission of their art from major American exhibitions." Apparently, aesthetics can function as a tool of racism. In any event, the so-called principles of art are a means of affirming the status quo within the loose coherence of taste by which the art world today accepts all anomalies. Whatever its aesthetic unevenness, "Two Centuries of Black American Art" is an important exhibition—one central to major issues in art today.

The tactics of "Two Centuries" are similar to those of most cultural undertakings by groups conscious of being deprived.

First among these tactics is to display the "contribution" of the particular minority, and so to elevate the group in the eyes of its fellow-Americans. Such demonstrations no doubt help to legitimize the group culturally and to increase public awareness of individual talents previously overlooked. The portraits of Joshua Johnston (1765–1830) and the landscapes of Robert S. Duncanson (1821–1872), who could be a stand-in for Thomas Cole, are cases in point. It will be more difficult in the future to omit these artists from the history of American painting. Granted that the power of an art show to augment the roster of American artists is limited—and that black art, like Jewish, Armenian, and other minority art in America, is destined to remain a specialty of already interested spectators for some time to come—increasing the prestige of a minority has the effect of counteracting prejudices ("myths") regarding its intellectual capacities and emotional character. In the case of blacks, one charge successfully refuted by the existence of black American art is that, as the New York *Herald* put it in 1867, "the Negro seems to have an appreciation of art, while being manifestly unable to produce it." To the question "Why are there no great black [Jewish, women] painters?" the minority show endeavors to reply "Oh, but there are!" and to supply the evidence.

Beyond these public-relations objectives, exhibitions of minority art are often intended to make the minority itself more aware of its collective experience. Reinforcing the common memory of miseries and triumphs will, it is expected, strengthen the unity of the group and its determination to achieve a better future. But emphasizing shared experience as opposed to the artist's consciousness of self (which includes his personal and unshared experience of masterpieces) brings to the fore the tension in the individual artist between being an artist and being a minority artist. This tension provides the theme of "Two Centuries of Black American Art" and gives the show a wide significance. Most black artists have chosen not to identify themselves with black people. The observation by David C. Driskell, the director of "Two Centuries," that

black artist A "all but divorced himself from the social con-
flicts of his race" or that B "rarely dealt with the position of
black people in American society" is the leitmotiv of the exhi-
bition. Robert Duncanson "devoted himself to the cause of
making art rather than to a cause that used art to convey a
social message." To see art as a "cause" in rivalry with the
"cause" of black liberation is to underscore the artist's conflict
as a member of a dual minority. For Duncanson, Edward M.
Bannister, or Henry O. Tanner, to become part of the black
movement was to accept the imposition of a false identity.
Through art, they had removed themselves from the paltry
discriminations of poverty, race, and social status. The only
hierarchy they were obliged to recognize was that of talent. In
sum, they had escaped from their blackness into the univer-
sality of Western culture; what was left of their blackness was
only the possibility of oppression by white bigotry. Duncan-
son received help from abolitionists in going abroad, but his
contribution to the betterment of his race was limited to dis-
proving the slander that blacks could not produce art. At the
Centennial Exposition in Philadelphia, Bannister won an
award but was denied admission at the front door because of
his race. Not until the nineteen-twenties and thirties did
black artists generally direct their attention to black subjects.
Their studies of scenes in Harlem slums and in the cotton
fields were, however, in line with American scene painting of
the period, as exemplified in paintings of the Bowery and
Coney Island by members of the Eight, of Union Square and
bearded patriarchs of the East Side by Jewish artists, of mi-
grants and the Dust Bowl by Midwesterners.

"Blackness" manifests itself in the "Two Centuries" exhibi-
tion in choices of subject matter and in mood. Black themes—
manacled slaves, lynch-mob victims, Biblical redeemers, Af-
rican physiognomical types—are fairly infrequent, especially
in the nineteenth-century selections. Portraits are somewhat
more intense and inward-looking than usual, and there is a
bit more praying. The conflict in the black artist between his
identity as an artist and his identity as a black artist keeps

coming to the surface in choices of subject, as it does among contemporary women artists in the issue of "feminine imagery." Nineteenth-century landscape painting and modern abstraction automatically exclude black themes, yet black painters have done their best work in these modes. Alma Thomas, the eighty-one-year-old black woman artist from Washington, D.C., has brought new life to abstract painting in the nineteen-seventies.

Except in certain picturesque aspects, black art is not distinct from majority art; the complaint is that it has been insufficiently incorporated in the national tradition. Mr. Driskell makes the point that his show is devoted to "documenting the quality of a body of work that should never have been set apart as a separate entity." But if black art had not been "set apart" (save for its exclusion through prejudice), how could it have represented black experience? Actually, the Brooklyn Museum exhibition is a small-scale survey of the major phases of the history of American art—evidence that in their work black artists have not been kept out of the mainstream. Blacks have matched the general standard in the modes of art prevalent since Colonial times—in crafts, early-republican portraiture, Hudson River landscapes, genre painting, neo-classical sculpture, Impressionism, Social Realism, abstraction. To the extent that they have existed in art, exclusion and prejudice have affected individual careers but have not prevented blacks from expressing American life in art or becoming figures in American art history. Among the artists in "Two Centuries," some (Tanner, James Audubon, Horace Pippin) have achieved a secure place in American painting; others (Romare Bearden, Jacob Lawrence, Alma Thomas) are on their way to achieving it; still others (Johnston, Duncanson, Bannister), denied the recognition they deserve through the tendency of American museum officials and art historians to be guided by fashion rather than by critical insight, are likely to have their position improved by exhibitions such as "Two Centuries."

Black artists are, then, American artists who have been

subjected to unfair treatment. But most artists in America
have been victimized by bias and incomprehension. As an
artist, Thomas Eakins got a worse deal from his fellow-Phila-
delphians for his advanced ideas about art and art teaching
than his pupil Tanner did for being black. Evidence of the
common despondency of artists in America is the tradition of
expatriation or self-exile which existed from Colonial days to
the depression of the nineteen-thirties. Artists since Duncan-
son, humiliated as blacks, have followed this tradition with
added fervor. It is important to emphasize that the tense rela-
tion of black artists with American society, far from separat-
ing them from the mainstream of American art, has propelled
them into the center of it. If the prestige of Tanner in the
United States was stimulated by the honors he won overseas,
this was no less true of Copley, Cassatt, Calder.

Black and white American artists have also been alike in
their stylistic conservatism. Mr. Driskell wonders in his cata-
logue essay why the black American artist has tended "to
reflect the more conservative and traditional elements." He
goes on, "Those who would have the least to gain by main-
taining the status quo are, more often than not, the
staunchest supporters of values long since abandoned by the
leading thinkers of the majority culture. A classic example is
Henry O. Tanner, who disdained the radicalism of the Im-
pressionists, the Post-Impressionists, and other innovative
artists in France, preferring the academic haven of the salon."
Mr. Driskell seems to have forgotten that a similar conser-
vatism affected the tens of thousands of white Americans
who studied in Paris in the days of the great radical art move-
ments. Like his expatriation, Tanner's aesthetic cautiousness
was typical of the American artist abroad. Whatever his race,
class, or country of origin, the American artist went to Paris
or Rome to assimilate European forms, not to join in the Left
Bank's revolt against them. Only when the modernist revolu-
tion had penetrated the United States itself, through the up-
heaval of the Armory Show and the cultural skirmishes of the
twenties, did Americans begin to rid themselves of their aca-

demic fixation. In regard to the arts, Europe before the Second World War was the "majority" culture, and America a "minority" culture. Here again, black art has been in line with the national impulse.

The tension in the individual artist between being an artist and being a black artist cannot be resolved. Having reviewed the situation historically, Mr. Driskell takes the side of the artist as artist. In his opinion, placing art at the service of a social movement reduces the scope and meaning of the art more than it elevates the group. "Regrettably," Mr. Driskell concludes, "the artist has been intimidated by the implication that his art is trivial unless it is politically oriented." Theoretically, Mr. Driskell is no doubt correct. In the cultural revolution of the twentieth century, the individual is supposed to transcend the social category to which he belongs. But this revolution has not been accomplished either for minorities or for others, and individuals cannot purge themselves of their backgrounds and the demands that those backgrounds make upon them. For the black artist to strive to equalize his status with that of non-minority artists, as if the latter were at one with society, can only lead to black conformism. Contemporaries such as Bearden and Lawrence, with their tangential hold on blackness in their art, meet the dilemma of the minority artist much more creatively than did Tanner and Bannister, who saw their blackness as related to art only when they were personally subjected to discrimination.

# Art & Thinking

# 28

# Art and
# Political Consciousness

There's something pungent about politics, an aroma of gunpowder and scandal and irretrievable mistakes, to which artists are attracted like insects. Novelists complain that real events have become so interesting that people would rather read accounts of goings on in the White House, or the crimes of official intelligence agencies, than regale themselves with stories conceived by fiction writers.

What the novelists ought to complain about is not that truth has become stranger than fiction but that politicians have become fiction makers, competitors and collaborators of fiction writers. One recalls, for instance, that mystery-story writers were invited to participate in think tanks on national military strategy. Also, that busted politicians (government officials), e.g., Spiro Agnew, hastened to retrieve their fortunes through publishing novels. A former assistant secretary of state declared on a radio program in which I participated that propaganda can no longer be successfully carried on by waiting for events to happen and then interpreting them to support one's policies. It is necessary, said he, to create the events that verify the soundness of the policies one advocates. This secretary served under Eisen-

This essay, not previously published, is based on a talk given at the Carnegie Institute.

hower—comparatively a long time ago. Increasingly, incidents are fabricated to fill out those that actually happen, so that the whole may be used to prove a case. Thus Johnson obtained the power he wanted in the Vietnam War through the Tonkin Gulf Incident, and Nixon presented the public with a collage of tapes representing conversations that supported his innocence.

The older generation of political commanders—Churchill, Eisenhower, Hitler—used to paint landscapes. Artists could pat them on the head and say, "Not bad for a twelve-year old. Keep at it." Today, presidents, dictators, and government agencies have given up painting for theater—guerrilla theater, that is, plots enacted in real life. Officials have invaded the trade of the script writer, with far more serious consequences than painting lakes on canvas.

The new political mixing of fact and fiction has the advantage over rival art forms of being protected by security regulations instituted by the politician-artists themselves. These regulations prevent critics from taking the works apart in order to determine the materials—truth, lies, hearsay—of which it is composed. Imagine stalling off for years criticism of a painting or a manuscript by stamping it "Top Security," then leaking versions of it to museums and theaters.[1]

The political playing with reality—reflected in the gameplan of the Defense Department, "dirty tricks" experts in election campaigns, conspiratorial intervention by the CIA—this ceaseless concocting of human history is the social fact underlying the consciousness of art today, whether or not individual artists are aware of that fact. A sculptor forms a corporation, raises hundreds of thousands of dollars, engages lawyers, engineers, managers, mechanics, orders tons of materials, conducts topographical expeditions, obtains hundreds of individual permissions and official licenses in order to construct a 2-foot-high fence 26 miles long that will terminate in the Pacific Ocean, and which will be dismantled

1. At this point in the manuscript, there is the following marginal note: Now that folk art [is] in, why not the art of political happening masters?

and its materials redistributed two weeks after completion. This is a harmless version of playing with reality that mimics the more desperate games of politics, the way a nineteenth-century painting of a battle panorama mimics the actual battle.

Another instance—a photorealist painter composes a self-portrait that duplicates his face pore by pore, hair, blemishes, every detail. But this painter never looks into the mirror. His painting copies not nature but a blown-up photograph of his face. It is the mechanical duplication of reality, the rumor of his appearance produced by the shutter of the camera that he has chosen to represent him, rather than what his eye and his mind might discover in reality. He has made himself up from the public image of him, not from what he knows to be the case. He is a compost of credible visual data.

Art is affected by the quality of the political order, but the influence does not flow the other way. The opinions of painters and poets do not decide elections—unless one concludes that their support of a candidate is a sure omen of his defeat. There is talk of an Artist for Ford Committee designed to get someone else into the White House. As a political weapon, art in this century has proven to be almost totally ineffective. Futurism, Expressionism, Dadaism, Surrealism, Constructivism were art movements with political orientations—they did not prevent history from going its own way. The most famous modern political painting, Picasso's *Guernica*, does not seem to have bothered the Fascists at whom it was directed, and Madrid has shown an interest in acquiring it. The relative helplessness of art to produce political results keeps increasing with the growth of the mass media—only in nations with primitive communications systems can a painting or sculpture still have a significant impact. Some arts—for example, movies and TV—are more politically effective than others. Painting and sculpture are probably among the weakest—even music and dance can be more ideologically stirring. A painting or drawing that conveys an overt message tends to be transformed into a cartoon, and when artists have

wished to assert themselves politically, as in protests against the war in Vietnam or during the May 1968 uprising in Paris, they have usually had recourse to the poster. As a form of art, the poster makes use of the expressive resources of painting—line, form, color—and of design and lettering. But the poster willingly subordinates aesthetic qualities to the verbal appeal for action.

In our time, even the poster has lost much of its power in comparison with other media, such as TV. Today, the political poster is a minor category of advertising art—as such, its strength depends not on its visual quality but, primarily, on the quantity of posters produced and the scope of its distribution. In the United States, political posters play a much lesser role than they do abroad, perhaps because people here walk less through narrow-walled streets. A nation of motorists can be reached only by the largest roadside bulletins, and these must necessarily be reduced to the simplest elements, both visually and in printed matter, if they are to be absorbed at high speed.

For all practical purposes, art can thus have little if any impact on politics. Worse, it may even, as we have noted, provide a kiss of death to a politician or a cause, because the kind of people that make up the art world are not representative of the majority and are therefore regarded with suspicion. Yet the impulse to intervene in political life hovers like a ghost over the art of our century, perhaps because of the crisscrossing of fact and illusion which art and politics share. Recall the list of major art movements which have sought either to transform the political structure of society or to collaborate in its transformation. Not one of them succeeded in realizing its program. The very concept of an avant-garde in art is derived from politics; originally the idea carried the intention that art should take the lead in giving political shape to modern society. In this scheme, [art] represented the cultural side of the social and economic revolutions that were taking place in the industrial epoch. The notion of a cultural revolution, instigated by the arts and realized in education, personal rela-

tions, forms of work, is intrinsic to the modernist tradition in art. In our civilization, consciously induced change has taken the place of immutable being on which values, including aesthetic values, formerly depended.

Radical art and radical politics first broke apart when advanced paintings, sculptures, and architecture were discouraged in the Soviet Union and finally outlawed. This took place in the latter portion of the 1920s. The government [that] had arisen out of the Revolution of 1918 declared itself the foe of artists whose work was revolutionizing the visual forms of things. A political consciousness dedicated to changing the world denounced art in which change was being realized for each individual who confronted it. The official restoration of academic ideals, tastes, and techniques in Russia ended the alliance between radical thinkers and creators that had lasted for the better part of a century. Thenceforth, political art could no longer consist of a free collaboration between radical artists and political activists. It would consist of art commissioned by and acceptable to political parties and institutions. Isolated from all possible allies, art could be free to assert the political views of its creators only if it renounced all expectations of being on the winning side.

The crisis induced by the split in Russia between radical art and revolutionary politics was reflected in Western Europe and, ultimately, in the United States. In the 1930s, the decade of the Great Depression, of the Spanish Civil War, and of preparations for World War II, art became thoroughly saturated with political ideology. The Surrealists, the last and the most comprehensive of the European art vanguards, attempted, in the late 1920s, to enter into a pact with the Communists and for a brief period were recognized as the official French section of the cultural international directed from Moscow. It soon became obvious that an alliance between artists, no matter how far to the left, or how profound in their criticisms of contemporary society, and the self-designated avant-garde of the proletariat meant subservience of the artist to the commissar and an end to independent thought. Nor

was the situation very different with regard to radical artists of the right. In Italy, Mussolini, though deeply indebted to the spirit of Futurism and, specifically, to the ideas and public demonstrations of Marinetti and his friends, early revealed that he had no intention of sharing power, even on the cultural plane, with the aesthetic radicals. Like Russia and Germany, Italy consolidated its overthrow of parliamentary government by placing the power of the state behind the academic foes of modernism. I should like to underline this point, since it represents an issue by no means out of date: *the victory of totalitarian politics, whether of the left or the right, has been a victory at the expense of modernist art and experimental thinking.* The totalitarians cannot tolerate the presence of any rival intellectual élite. Their artificially constructed identity between the ruling party and the masses, or the People, requires that they lend support to the kinds of art that reassure persons of the commonest taste that they stand at the center of society. Thus totalitarianism reinstates academic art in its most grandiose and idealized aspects. Add to this the actual grossness of the totalitarian chiefs. The dictator, whether Stalin or Brezhnev, Mussolini or Hitler, proclaims his common-man origin and his appreciation of art "beloved," as Khrushchev put it, "by all our people." In sum, the political control of art leads to the triumph of a consciously advocated philistinism, any opposition to which is dissolved by police action.

Once the political and aesthetic avant-gardes had split apart, politics asserted a monopoly upon the imagination and ordered artists to make their work conform to fables handed down from above. Thenceforth the role of art in showing how things happen, and how things are, would be taken over by the governments themselves, with powers to seal off their inventions and make them immune to criticism. The first gargantuan product in the new government-as-artist genre was the burning of the Reichstag by the Nazis, which led to the outlawing of all centers of dissent in Germany, a case of an artwork itself providing the obstacles to evaluating it. Nazi

aesthetics followed up with the giant Nuremberg Rallies, which carefully combined rhetoric, rhythm, spectacle, sound, and symbolism.

The second super spectacular in the genre of government-controlled reality was the series of trials in Moscow from 1936 to 1938, which spectacularly condemned the generation that had made the Russian Revolution and led its members to the execution chambers. The outstanding feature of both the Reichstag Fire and the Moscow Trials, as of the Tonkin Gulf disclosures and the Watergate cover-up, was the unrestricted fabrication of data, which were ironed into a surface of indisputable fact to form a government narrative that amounted to a new kind of myth. None of the modern modes in art, from Futurism to Dada and Surrealism, have exceeded in arbitrary fancifulness these inventions of bureaucrats and policemen. By these trials, Hitler and Stalin demonstrated that art as a resource of social revolution could be dispensed with.

Lying by governments is nothing new. But issuing false statements is different in essence from aesthetic manipulation of the public through staged events. In the latter instance, the government itself becomes an artist, making use of the resources of illusion. Squads of new types of talent are retained, drawn from advertising agencies and movie studios, as in the case of specialists who redesign the public personalities of political candidates. The distinction between truth and lying fades, as facts are created out of whole cloth, a process analogous to printing paper money. In Russia victims of the Moscow Trials have been "rehabilitated," which means that their deaths have been officially cancelled, but the testimony on which they were convicted has never been declared to be false.

Since the assault by governments sprung from revolution on the expression of revolutionary thoughts, art has largely, though, as we shall see, not completely, kept apart from politics. Political organizations of artists, such as the American Artists Congress of the 1930s, could not survive the changes of policy that eventuated in the Nazi-Soviet pact. Aware that

they had been duped, artists became suspicious of attempts to enlist them in the service of causes.

More fundamentally, however, art has turned away from politics because of the realization that, taken by themselves— that is, without a broad movement of opinion in the same direction—painting and sculpture are politically impotent. Even such a political masterpiece as Delacroix's *Liberty Leading the People* is essentially contemplative. Today the rhetoric of the older vanguards concerning revolutionary art has been pretty well abandoned. In his last years, Duchamp pointed out that as an instrument for dealing with "the big mass against you" art is "a second-fiddle expression." Artists often contribute paintings and cash to social causes, and in the period of Vietnam agitation there was participation in protest exhibitions, but current styles still remain largely out of harmony with social themes.

Indeed, for an advanced contemporary artist to accommodate his style to social references, to say nothing of conveying political consciousness, requires extraordinary feats of technical readjustment. Some success in this direction was shown in an exhibition in Chicago denouncing the police violence in that city during the 1968 Democratic Convention. Barnett Newman, for example, converted the vertical stripes typical of his paintings into strands of barbed wire on a wooden frame, thus retaining the formal elements of his work while introducing the content of political tyranny. Claes Oldenburg managed to convey sinister overtones by reproducing Chicago's double-fauceted hydrants painted bright red. Around the same time, an exhibition entitled "Protest and Hope" was staged at the New School Arts Center in New York. It comprised forty-three artists, ranging in age and style from Ben Shahn to Andy Warhol and including such vanguard figures as George Segal, Rauschenburg, Red Grooms. The show was uneven in both quality and impact, but the political consciousness of the artists was unquestionable. However, this exhibition was not followed up[; there was] no attempt to develop styles more compatible with political statements. In the

past five or six years, Philip Guston has abandoned the lyrical abstractions for which he was famous throughout the fifties and sixties, in order to experiment with a political symbolism whose signs range from Ku Klux Klan masks to fat fingers clutching cigars. A particularly fierce, though at times hilarious, politically oriented artist is Peter Saul, who has had many exhibitions in New York. In an idiom adapted from comic books and Surrealism, he tore into America's devastation of Vietnam with obscenities and disfigurations that seemed to declare that his style matched his subject matter. His last show contained a side-splitting burlesque on that old copybook standby, Lentze's *Washington Crossing the Delaware*, and one on Custer's Last Stand. He also caricatured Picasso's *Guernica*. Saul is an excellent draftsman with strong political feelings, but so far the art world has shown little interest in him, as in Guston's recent compositions.

Official art opinion—most artists, dealers, collectors, curators—is still resolutely on guard against political content, which, in its view, can be expected to make life less comfortable for all concerned. A few years ago, at a seminar at Penn State in University Park, I was denounced from the floor by the dean of a leading art school for having written an article expressing interest in Philip Guston's departure from abstract art in order to take up the theme of violence in America. "Are you trying to lead us back to the thirties," the dean wanted to know, "when artists were being told what to paint?" I could not help but sympathize with his anxiety. Yes, art in America had been burnt by politics in the thirties and was still sensitive. Now, however, art was being burnt by antipolitics, by its indifference to the world and to emotions aroused by the world, and this can be just as dogmatic as political direction and equally limiting to the imagination. Like everyone else, artists today have political reactions, more or less deep, to events, and the natural impulse is to use one's medium to express what one feels. If this impulse is repressed by the need to seek an ideal called "quality" or to obey the requirements of "art history" or to be in tune with the fashions of

"the seventies," one is being victimized by a form of tyranny just as surely as when artists are bidden to pay attention to the struggles of the working class or to promote the triumph of the nation. A vocabulary of art forms whose main function is to render its users speechless can hardly be very important. To accept it as a rule that paintings must insulate the mind from the drama of history leaves painting and sculpture on the level of hand weaving or furniture design. This reduction has actually been taking place in the past fifteen years, with the result that it has become common loftily to dismiss the creation of images as beneath the dignity of the intellect. Conceptualist artists and theoreticians deem it worthwhile to deal only with abstract concepts, not creations in which the hand and the imagination—that is, the metaphor-making faculty—participate. Determined to mind its own business, art has found itself increasingly challenged to say what its business is. After the experience of the 1930s, disengagement from politics came as a liberation. Now, after thirty years, that disengagement has turned into a rigid prohibition and needs to be reassessed through the self-examination of artists in pursuit of their actual feelings.

I find it baffling and disheartening to encounter artist after artist who seeks his cue not within himself but in some notion of where art is going in the midseventies, that is to say, in what is likely to succeed.

Art cannot do much for politics or for social change. In the opinion of Wyndham Lewis, a great writer of the generation of James Joyce and T. S. Eliot, art can't do much about anything, except, perhaps, itself. "It is quite impossible," wrote Lewis, deploring the idea that art should be linked to progress, "for Cézanne's canvases to have any effect outside the technique of painting." OK, let's agree, in the idiom of youth, that is where it's at.

Some critics believe that they can make intellectual capital out of stressing art's inability to change the world. Radical artists and art movements have fooled themselves, these conservatives gloat. Insofar as it imagined itself to be radical, the

entire modernist development was, they claim, an episode in self-delusion. Now, at last, the modernist episode is over and it has become possible to reevaluate its contributions without being misled by its impassioned rhetoric and its ideologies. Certain works emerge, say these critics, which carry forward the innovations in form conceived by such modernists as Van Gogh, Monet, Cézanne, Miró. These works constitute the genuine modernism, which displays an unbroken continuity with the masterpieces of the Renaissance. In short, the idea of modernism itself is a sham and misleading. Art is art, and the masterpieces of all times and places belong together outside the ups and downs of human history.

Well! We are given beautiful restoration of the academic ideal of art as a realm separate from and beyond the machinations of governments and the formats insinuated by industry and the media into everyday life. Truth, too, must no doubt inhabit its own superior realm, set aside from events, real and fabricated. *Beauty* and *Truth*—also *Justice, Freedom,* all in capital letters.

We have returned to the epoch of Bartholdi's colossus in New York Harbor: Liberty as a mental essence with her upraised torch. Only the scheme of absolute virtues now spreads out to include Matisse and Jackson Pollock, and perhaps Morris Louis and Jules Olitski.

Perhaps someday the fictions of the politicians—the Watergate cover-up, the Moscow Trials—will also be enshrined in the heaven of aesthetic masterworks. Equipped with this philosophy, museum curators can present exhibitions of Futurist and Surrealist paintings in such a way as to emphasize their aesthetic contributions, while obliterating the ideas that lay behind the artists' efforts.

The notion of an aesthetic realm that transcends human existence is convenient for critics, collectors, curators, and art historians in that it locates them, their ideas, and their property in a mental region tightly secured against unhappy interventions. The detachment of art from life offers nothing, however, to artists, nor does it stimulate the creation of art,

since it takes no account of the subjective realities of the times.

Now, as in the past, creative energies in art require stimulation from values—religious, philosophical, political—outside of art, values which art fails to realize, since it does not achieve salvation, self-knowledge, or Utopia. The artist's interest in the textures of his medium, his formal concerns, his delight in his craft set him apart from genuine holiness, as they do from the genuine lover or from total devotion to truth or social justice. But to exclude *emotions* relating to these is to empty art of its substance.

In contrast, there are those who, regardless of what is taking place in the studios and galleries, continue to insist that the revolution of art is still going on, and that the world is being transformed by it. Jean Dubuffet, for example, has for thirty-five years proclaimed his implacable hostility to civilized culture, while continuing to mount retrospectives of his presumably subversive works in the world's leading museums and to execute commissions for banks and municipalities. Other artists have sustained the tradition of aesthetic rebellion through products that are unsuitable for museums or art galleries, thus signifying their repudiation of The System. In addition, there are appeared the phenomenon of the avant-garde curator, who is more militant and politically conscious than art itself, and is determined that art shall continue to attack society if in no other respect than by attacking itself. These gestures have, undoubtedly, a comic ingredient; they are also symbolic of the political consciousness embedded in the art of our time and of its memories of defiance.

The efforts of modernism in art on existing political structures cannot be calculated with any degree of accuracy. Loosening of visual forms, introducing new principles in the application of color, conceiving images that cause reverberations in the unconscious seem to play a part in cracking the shell of conformity upon which coercive regimes depend. At least the dictatorships believe that they do. The world is periodically startled by news from the Soviet Union of clashes

between artists in search of new ideas and the political police. The May 1968 uprising in Paris evoked, unmistakably, the heritage of Dada and Surrealism. The conscious ideology of today becomes the spontaneous folklore of tomorrow.

Regardless of its political effects, political consciousness is a necessity for art. The alternative is to be satisfied to make decorations for office buildings and treasures for speculators. This may be adequate for those who practice art in the tradition of the craftsman. But artists of the past one hundred years have tended to seek a more total outlook and a more rewarding role. The artist today is closer to philosophy than to artisanship. Intrinsic to his outlook was taking part in being responsible for the character of the times. Only in this way can the artist conceive himself as a free individual, in the full range of his desires and his possibilities. As an expert in the fabrication of appearances and realities, he has the training needed to penetrate the fabrications of politics. Freedom in practice is the politics of art itself, regardless of what other politics it may choose to support. A revolution with such an aim cannot be won. It *can* be lived.

# 29

# Tradition—
# or Starting from Scratch

Artists are lovers of freedom, of course. But in art there is
an ambition that goes against freedom—the ideal of the
masterpiece. Masterpieces exist or are recognized only within
traditions. And a tradition is a binding force, not a force for
liberation, the impulse of which tends to be identified with
something called self-expression.

The question is, Does new art need to be a continuation of
the art that came before? because if it must it cannot be free. It
is generally agreed that art is based on art—had there been
no poems or paintings in the past, it is highly unlikely that
someone today would invent these genres. But how much
pressure does the presence of old art exert on the art of the
living?

Many of you no doubt recall T. S. Eliot's celebrated essay of
half a century ago "Tradition and the Individual Talent." It
asserted that the obligation of the poet was not to apply his
talent to works bringing forth something personal and un-
precedented; on the contrary, the poet, this essay held, ought
to amalgamate his feelings with the ongoing life of poetry as
an objective reality in order to contribute a fitting extension to
the heritage of the past. The repression of the artist's natural

Not previously published.

inclinations—that is, of his freedom to respond to individual impulses—was seen not as an unfortunate effect of a tyranny external to art, but as a fundamental necessity of art itself. Eliot spoke of finding an objective correlative, by which the poet's feelings were transformed into the stuff of art. The artist was given the choice between accommodating himself to preestablished forms, ideas, rules, and aims and wasting himself in futile flights of eccentricity. Eliot chose William Blake as an example of genius wasted through lack of connection with a valid tradition.

Traditional arts, such as poetry, painting, architecture, and drama, are of course much older than individual freedom as an ideal or as social fact. Most of the world's masterworks, from Egyptian friezes to Romanesque mosaics and Russian gold crafts, have been achieved under conditions that placed severe restrictions on their makers' range of choices. In medieval Europe the signature on a painting or sculpture was often that of the patron who commissioned the work and perhaps conceived its appearance and subject and directed its execution.

The high level attained by the arts under traditional controls has supplied a powerful argument to the effect that an inherited body of beliefs and practices is an indispensable condition for excellence in the arts. On the other hand, the social situation of the artist—that he may have been a serf or a slave—has been seen as irrelevant to the quality of his product.

In sum, the arts seem to have been able to do very well without freedom, at least in the past, but not without the support and promptings of a tradition. Paintings were based on paintings, poems on poems, not on nature studies, dreams, or personal histories.

## II

In America, founding art upon a tradition has been a decisive issue since the early years of the Republic. For an American to

paint masterpieces required that he make himself adept in a style from which masterpieces had emanated. This meant, of course, reverting to the European past—to the Italian, Flemish, Dutch Renaissance. To draw a horse, the American art student had to learn how horses were formally constructed in classical Greek and Roman statuary and in Renaissance painting.

What about actual horses on the farm or the streets of Philadelphia? After sufficient training in copying exalted models, the artist could sketch the horse from life without destroying its resemblance to the heroic beasts of antique art. The same for the human figure: the artist, conditioned by classical casts and by copying paintings in museums, could find heroes and gods in the crowds pouring out of his neighborhood movie theater.

From the eighteenth through the twentieth century American artists have subjugated themselves in rotation to the traditions of British portraiture, Düsseldorf genre painting, Barbizon landscapes, Italian sculpture, French and Dutch naturalism, Paris Impressionism and other modernist schools. At the end of World War II, American Abstract Expressionism and Action Painting at last broke the hold of European traditions. But this revolution did not remain in power very long. In the sixties traditionalism was extended in the form of color painting and various Minimalist and abstract tendencies. Monet, Cézanne, and Matisse were interpreted in such a manner as to make them forerunners and standard-setters of present-day American painting. One recalls the New York School exhibition of the late sixties at the Metropolitan Museum which proposed the thesis that all the modernist art movements of Europe had reached their apogee in the paintings and sculptures featured in New York. The ideal of individual freedom and self-development once again was conceived to be irrelevant to the formal evolution of art in America.

It needs to be recognized that the great bulk of creation in contemporary society is brought into being under various de-

grees of outside direction authorized by one tradition or another. The products of the so-called mass media, from TV plays and advertising commercials to fabric designs, follow prescriptions laid down in the past. In each genre certain formulas have been tested and proved effective in attracting and influencing audiences, and artists employed by the media are bidden to conform their creations to these recipes. In authoritarian societies, direction of the arts is political; in the democracies, the media strive to produce the maximum profit. In regard to artistic freedom, the difference between politically motivated art and economically motivated control is negligible. Indeed, leftist critics are prone to maintain that it is socially more progressive to manipulate people for political ends than to exploit their tastes in order to make money.

The basic distinction in regard to freedom between the arts in authoritarian countries and those in the democracies lies not in the character or objectives of their media, but in the fact that in free countries it is possible for artists to work outside the media and their aims and rules, and thus to create what they, the artists, not the media managers, choose; whereas in the Soviet Union and other culturally dictated nations all artifacts are produced under media conditions and are calculated to stimulate preconceived reflexes in mass audiences.

In the free countries (but not in modern dictatorships) there arises a conflict between elite and mass culture. "Elite" corresponds to freely created, "mass" to controlled—or, if one prefers, "mass" corresponds to socially designed and socially effective communication. Those who demand that art be useful, whether they represent media, patriotic groups, or militant minorities, are opposed to elite art. It is true that, statistically, elite art is of minor status, and has little effect on public opinion or the course of social change. In our time, the arts that keep free of the media system lack both extensive popular interest and strong immediate influence; they are free because society as a whole ignores them. Perhaps this is because of their disconnection from tradition, or because the traditions that once sustained them have ceased to exist or to

be honored. Poetry, painting, "serious" novels, plays, films and dance called experimental (that is, lacking a realistic expectation of financial success) are swamped in the public mind by their media equivalents and are thus absolved from giving an account of themselves. They are free in being disengaged. They exist, to use a familiar phrase, "for their own sake." To totalitarians and social progressives, such arts represent individualist self-indulgence, related to million-dollar yachts and fifty-dollar-a-bottle wines.

Social and cultural tradition has come to be represented by the media. It is they who identify themselves with the Fourth of July, the Statue of Liberty, the Bicentennial. As in Eliot's conception of poetry, each new movie and TV show is joined by formal links and intellectual assumptions to the entire body of motion pictures and television performances that have preceded it. It was no doubt Marshall MacLuhan's recognition of the overpowering intrusion into each creation of the medium as a whole that inspired his slogan "The medium is the message." Movies and TV dramas are also joined to the past of literature and the theater and are now considered in our universities in the light of these traditions under the general classification of narrative. A striking example of how motion pictures relate themselves to cultural traditions and become their embodiments in the experience of today is Stanley Kubrick's *Barry Lyndon*. The movie recapitulates Thackeray's early novel in terms of paintings, costumes, military science, gesture, music, and interior decoration of the period in a single cultural package available to everyone, a vivid "five-foot shelf" that dispenses with the need to read books or visit museums. It is difficult to recall any literary work of today that mirrors the past with more blank fidelity than this creation of Hollywood. In the great art of this century—*Ulysses, Joseph and his Brothers*—there is an irresistible impulse to parody the past and distort it by introducing modern equivalents. *Barry Lyndon* is old wine in new technological bottles, a fabrication that "quotes" the facts of an earlier period as they exist in recorded form.

In keeping with their traditionalism, the media limit themselves to what society is prepared to know and experience. The aim of the media is to convey, not experience, but what is expedient to stress as experience. Media creations permit themselves to be reshaped by the pressures of those social groups so long as these are sufficiently large and well-organized to allow them to claim to be representative bodies. Plots and images are changed to correspond to, or compromise with, articulated demands based on ideological religions and ethnic considerations. Clearance officers in the networks and production offices consider the age, sex, mores, and prejudices of their intended audiences. Media expertise in attracting and holding segments of the public, the repetitive formats in which the media incorporate premeasured quantities of time (on the air) and space (in print), are founded on analysis of results attained in the past. Novelty in the media, fresh apperceptions, extend only to details. The media world is a world of received ideas and accepted fictions. Perhaps in their sum, platitudes and fabrications do constitute reality of some kind.

Practiced under socially derived restraints, the media, like traditional art, are a culturally stabilizing factor, a shock-absorbing mechanism that shields the public from the impact of the information which the media convey. Images of massacre, disaster, and menace are brought into the living room without ruffling the mood set by entertainment and advertisements conceived in the same formats. The media induce mental uniformity that contributes to a sense of security, an effect also induced by art in the past. But the media cannot be considered as an agency of free expression.

### III

The communication of experience in its actual weight and density is left for the elite arts. Were it not for them, America would be immersed in an invented world, in its arbitrariness not too unlike that of traditionalist and authoritarian nations.

To the nonmedia artist, motivating an audience through ap-
pealing to a shared tradition is secondary to the realities of his
experience. Since every individual's experience contains ele-
ments which are unique, such an artist can be said to start
from scratch. He is aware of tradition, but has chosen to set
tradition aside in the interest of truth. Viewed in comparison
with the media, a work that touches on reality belongs to the
avant-garde, and every avant-garde work is a rebellion. Mal-
larmé described the modern poet as a "civilized primitive"
("civilizé édénique"), and primitivism, in the sense of per-
ceiving things without their garb of prescribed forms, is a re-
current motif in modern art. Of couse, no artist ever achieves
a completely clear slate, but the goal of eliminating clichés of
thought and response is continuously reiterated as a leit-
motif of modern art. "I want to paint like the first man" is
often heard among artists—whereas tradition requires exact-
ly the opposite: to learn all that has been accomplished, to
choose the best, and to paint like the *last* man, the heir of the
ages.

In America, to paint like the first man is a desire not re-
stricted to contemporaries. The phrase "first man" has about
it the tone of Walt Whitman's "red Adam," the aboriginal
human being, the Noble Savage. Since the beginning of the
Republic there has been a current in American art in addition
to that founded on the desire to acquire the skills and stan-
dards of the Old World, a current that would dispense with
those skills and standards and replace them with modes of
experience appropriate to experience in America.

In sum, American art has been divided between copying
and adapting European models, on the one hand, and spo-
radic efforts to break away from these models and derive sus-
tenance from the new, on the other. It is in these efforts that
freedom has found its voice in painting and sculpture. The
word "art" or "form" has been considered by these artists to
be synonymous with refinement and decorative disguise, in
short, with falsification. Reality and truth are preferred to
beauty. George Catlin, painter of Indians, was convinced that

the American prairies provided the best school for the American artist. Even such an accomplished American academician as Thomas Anshutz, successor to Thomas Eakins at the Pennsylvania Academy of Art, valued "fact" above style and believed that fact was to be achieved by intense looking at objects, not by imitating European masterpieces. It is not uncommon for American artists, no matter how highly trained, to attribute to themselves the simplicity and unknowingness of folk artists, to think of themselves as common people and strive to behave like mechanics or regular guys. The leading sculptor David Smith called his studio the Terminal Iron Works, as if it were a blacksmith shop; he drove a truck on his travels and affirmed that American art must be crude and unrefined. For him the American artist was naturally allied with Walt Whitman's "roughs and beards and space and ruggedness and nonchalance that the soul loves." Jackson Pollock's celebrated statement "when I am in my canvas I don't know what I'm doing" may be interpreted as an effort toward a consciously acquired naivety. American romanticism is less likely to take the form of complex fantasies than to consist of one-person realism. For Gertrude Stein, truth in art consisted in getting away from "things as everybody sees them."

The primitivism, real and assumed, of American artists has several drawbacks which must be weighed against its stimulation of energy and originality. As a mode of resistance to traditional attitudes, primitivism tends also to resist ideas, to promote anti-intellectualism and a mystique of aesthetic infallibility. The idea that Americans can produce art without assistance from the European past has fostered a kind of chauvinistic self-sufficiency, especially noticeable in the past fifteen years. Claims have been made that American art has absorbed the essence of the Continental avant-garde movements since Impressionism and has gone beyond them. Such an attitude may seem to free Americans to follow their own course. Actually, it is a form of coercion by contemporary form. It demands that art must begin with the here-and-now of American art and pursue the objectives implied by this art.

No room is left for the individual artist's own vision of art and life. For the old subservience to European traditions, it substitutes subservience to an American tradition, one, moreover, whose existence is dubious. Young artists are told that they need not look past their American predecessors—Pollock, Gorky, Newman, Smith, Hofmann, de Kooning—to the Europeans by whom these artists were inspired and whose work needs to be grasped in order to understand the Americans and their originality. The effect of this aesthetic knownothingism has been a growing shallowness, eccentricity, exhaustion. The absence of a tradition cannot itself be established as a tradition. No longer dependent on the European past, American art must avoid enslaving itself to a past of its own.

It was Whitman who most emphatically stated the proposition that starting from scratch in the New World did not entail rejecting the accomplishments of earlier generations. "America," he wrote in the ringing opening sentence of the 1855 Preface to *Leaves of Grass*, "does not repel the past or what it has produced under its forms or amid other politics or the idea of castes or the old religions." But though the past was not to be rejected or "repelled," it could no longer serve as a guide. Whitman was aware that as an American he had no continuing tradition able to sustain his poetry, that, as he put it, "I have all to make." One might say that for Whitman, as for Poe, the past consisted of a cultural rubble, among which magnificent treasures might be found.

> Not you alone proud truths of the World
> Nor you alone ye facts of modern science
> But myths and fables of old, Asia's, Africa's fables

Starting from scratch in the perspective set by Whitman means beginning from writings, paintings, and oral histories as one finds them and where one finds them. Tradition is replaced by a new universal eclecticism. Recall how the art of the past one hundred years has drawn on the forms of antiq-

uity, of Chinese art, of Japanese, pre-Columbian American, African. This borrowing from everywhere will continue.

An artist finds works of art in accordance with what he is. The same is true of the public. An immigrant to the United States in the 1890s does not encounter the Statue of Liberty in the same way that a New England art critic encounters it, that is, as a cultural artifact, an example of mediocre French academic art set in New York Harbor for political reasons. The immigrant encounters the statue as a torch of liberation and as a noble promise resounding across the seas. In his culture, the Statue of Liberty is both an image and an emblem by which his life has been transformed. It is thus a creation on a par with the greatest creations of man, a popular masterpiece rather than an art-historical one. "All the past we leave behind," sang Whitman in "Pioneers! O Pioneers!" contradicting what he said in his Preface. "We debouch upon a newer, mightier world."

The individual without a tradition, or as is common among Americans, with more than one tradition—traditions which are today multiplied by examples and reproductions of works belonging to all times and places—relates himself to the past by means of a one-person culture which he pieces together from the odds and ends that he accumulates as he lives and animates by his own undefined personality. To affirm the essence of his individual mixture of absorbed influences and primitive apperceptions is to realize freedom. The model for such an affirmation is the arts that have escaped conscription for economic or political ends. Whatever art may have been in the past, whatever functions it may have fulfilled for society and individuals in former ages, in our time art's deepest reason for being is as a vehicle for self-liberation. "The main thing is freedom," wrote Paul Klee, "a freedom which insists on its right to be just as inventive as nature in her grandeur is inventive." Freedom limited only by the nature of things is incompatible with tradition. Or it is compatible with the modernist tradition of shaking off inherited restraints.

## IV

The negations required by freedom are by no means easily attained—not in politics; not in art either. The old ideas hang on, the old moods, the old solutions. To liberate the eye, the hand, the mind from their habitual reflexes requires subtle techniques and heroic persistence. The advanced art of the past hundred years constitutes an encyclopedia of methods developed in order to attain self-liberation. One could write a history of art since Impressionism in terms of devices, theoretical and practical, employed by artists in circumventing the controls of external form and interior inhibition. Painting outdoors in the effort to render direct sensation of scene and atmosphere; application of color according to system rather than observation; derangement of the senses through displacement of metaphors; dislocation, distortion, and dismemberment of familiar shapes in order to evoke new feelings rather than satisfaction in things recognized; rearrangement of forms in arbitrary divisions of pictorial space, as in Cubism—all these are incidents in the liberation of art from traditional certainties and from the effects of rigidity of habit and belief on the human psyche.

The modernist tradition is the tradition of individualism, in the good sense as well as the bad. To be an artist, one is forced to choose—that is, to perform a free act. Freedom for art's sake accompanies art for freedom's sake. And the morality of freedom requires that the artist keep on choosing. To stop choosing is to cease being an artist and to become an imitator of one's own past. If one stopped being an artist one could relax and repeat oneself, like everyone else. But art is a profession that carries a pledge, the pledge of being free and activating freedoms.

For fifty years, de Kooning, for example, has demonstrated a continuous devotion to the principle of self-liberation as the moral imperative of painting in our time. The drawings and paintings of his latest phase are animated by a spontaneity that surpasses all his previous improvisations and refutes the

belief that age must result in rigidity. A comparable growth in freedom was visible in the compositions which Hans Hofmann produced well into his eighties. Picasso once said, "When I was a child I drew like Michelangelo; it took me years to learn to draw like a child."

Spontaneity, freshness can apparently be acquired through training. The transition from the rigors of Renaissance tradition to an art that starts from scratch is epitomized in Picasso's witticism. The ideal and the necessity of the human being today is the capacity to make discoveries within constantly changing phenomena both outside the observer and within, to contrive forms in the midst of confusion, to probe the world and his own consciousness for the raw materials of knowing. Our experience is, as Yeats expressed it, that of

Images that yet
Fresh images beget,
That dolphin-torn, that gong-tormented sea.

Within this sea change, there is no other place to start but from scratch, the unique reality that falls to each of us.

# 30

# Metaphysical Feelings
# in Modern Art

In general, art in our time is indifferent to religion or actively opposed to it. Exceptions exist, of course—for example, the biblical subjects of Chagall and Rouault, Manzu's sculptures of popes and cardinals. Yet at least on its surface modern art appears to be more closely allied with science and technology than with sacred images, ideas, or personages. One thinks of half a dozen recent art movements that have drawn concepts and techniques from the laboratory and the factory, or that have incorporated machine-made objects into paintings and sculptures. But not one prominent style of our time has been based on a religious cult or creed. In its identification with the dynamic world of speed, construction, rationality, power, art seems to have estranged itself from the older mysteries and the images and signs by which they are represented.

More important than the absorption by art of the phenomena of secular life is the adoption of the scientific outlook. A recurrent motive in art since Impressionism has been the principle of "de-mystification." Let things appear as they are rather than under the halo of religious, philosophical, na-

A talk delivered on May 17, 1975, at the Society for the Arts, Religion, and Contemporary Culture of New York. First published in *Critical Inquiry* 2 (Winter 1975):2.

tional, or ethical ideals. As if reversing the role assigned to it since its beginnings in the caves, art of the past one hundred years has undertaken to strip man, nature, and events of glorifying attributes. The heroes, banners, ceremonial vessels, deities, icons of all cultures and creeds have been reevaluated according to a single standard: the aesthetic—the category of experience that is indifferent to truth or "reality."

The aesthetic is present everywhere—in the street, in department stores, movie houses, mountainsides, as in the art gallery, the cathedral, the sacred grove. By universalizing the concept of the aesthetic, modern art has destroyed the barrier that once marked off Beauty and the Sublime as separate realms of being. In the eyes of modern art and modernist aesthetics, anything can legitimately appeal to taste. President Eisenhower, complaining about modern art, said that he had been brought up to believe that art was intended to carry one away from the dangers and unpleasantness of everyday life but that the new paintings (Abstract Expressionist) reminded him of traffic accidents. A recent statement by Francis Bacon, the celebrated British painter, also mentions traffic accidents. Bacon agrees with Ike that this type of event is not excluded by modern art. But Bacon finds traffic accidents to be a source of beauty. "If you see somebody lying on the pavement with the blood streaming from him," he explains in the catalogue of his exhibition at the Metropolitan Museum in spring 1975, "that is in itself—the color of the blood against the pavement—very invigorating . . . exhilarating. . . . In all the motor accidents I've seen, people strewn across the road, the first thing you think of is the strange beauty."

In our time, all things produced by man—from the krater of Euphronius or the Moses of Michelangelo to the stuffed goat in an assemblage and an arrangement of ten drums of fuel oil—are aesthetic in respect to their appearance and anthropological in respect to their meaning. This is the message that was conveyed by Duchamp when he exhibited in an art gallery a bottle rack and a snow shovel bought in a hardware store. In keeping with this message of the inevitability of aes-

thetic and sociohistorical interest, some artists of the 1960s went to the extreme of withholding from their work any reference not inherent in its material reality—the so-called Minimal art.

A similar process of depletion has been applied to the art of the past. To formalist art historians, whose influence is especially strong in modern-art museums, the importance of a work derives from the position it occupies in the evolution and diffusion of forms. Other meanings are discounted. Malraux has said that the museum has, by its very nature, "ruled out associations of sanctity."

Yet for all the modernist passion for denuding things of their mystery, art has been unable to relinquish its affinity with man's most mysterious power, and his most precious one: I mean, the power of creation. To this mystery, art—regardless of how it is defined or how removed it is from definition—is forever bound. And in our time, despite its awe of scientific method, the power of creation is as highly revered as in any of the ages of the past. Indeed, it is more revered, because in this epoch of crises the fate of individuals and of society itself is contingent, as perhaps never before, on inventive responses to unpredictable situations. In periods of stable governments, firmly held beliefs, traditional modes of behavior, men could find guidance in the wisdom of the past and in commonly accepted models. In our time, individuals are often compelled to set out on original paths, instructed only from within themselves. Or they must choose from among conflicting forces, perhaps with no more than the hope (to recall Laforgue) that their executioner will be of the highest order. How to be inspired with certainty—and to be filled with the certainty of inspiration—is the overwhelming problem of our revolutionary age. What state of mind will bring to individuals and groups the enlightenment they need in our constantly changing situations? In a period of crisis—and with us crises, private and public, come in an unending series—what can be more valuable than a trained gift for improvisation?

Sciences have been devised, and new ones keep emerging, to formulate techniques by which human capacities can be heightened—and thus to guarantee that extraordinary solutions will be forthcoming when the old ones cease to work. Psychoanalysis investigates the damming-up or release of energies by clusters of symbols. Revolutionary political parties divide on different conceptions of strategy for animating masses with perpetual fervor. Statistical experts endeavor to measure the rhythms of popular approval or rejection of official policies. The methodical stimulation of feeling, from the instigation of petty desires through advertising to the whipping up of fanaticism through political mass demonstrations, occupies the attention of our century with a dedication once given to the study of theology.

In the front rank of researchers into the mysteries of self-surpassing stands the artist—the professional of inspiration, who proves himself by material evidences of his capacity to see and create. His trade goes back to the oracles and soothsayers of ancient civilizations, yet society sees in him the figure of an avant-garde able to offer insights into truths so far inaccessible. No wonder interest in the artist has kept growing regardless of interest in what is communicated by art itself. For is he not the model of how individuals can train themselves to be more than themselves? Is not inspiration—that state of magically heightened capacity—with him a matter of everyday necessity, an ingredient of his job, perhaps, finally, even a routine? Speaking of his contemporaries, de Kooning concluded that they "do not want to conform. They want to be inspired."

One of the central documents of modern art is the letter which the poet Rimbaud wrote to his schoolteacher Izambard: in it, Rimbaud speaks of "working to make myself a seer." He has sensed, to use his phrase, that "I is another"—an insight common to religions, from the most primitive to the most philosophical. One is tempted to interpret modern art, taken in its entirety, as the practice of disciplines of self-inspiration, ranging from the rhythmic intoxications of jun-

gle-war preparations to the ego-effacing exercises of the neo-Plasticists.

I have been trying to indicate how art has become a many-sided adventure, or investigation, into the unknown, into mysteries thus far out of reach of the laboratory and perhaps destined to remain forever out of its reach. Intellectually, art in our time is oriented toward science and technology—as is almost every activity in modern society—and to the values of functionalism, rationality, and economy of means. On a less visible level, however, art has never ceased to expand its searches into those areas of experience formerly considered to be the province of religion and metaphysics. Perhaps it is another effect of crisis that each art today has sought a total conception of life. Kasimir Malevich, founder of Russian Suprematism, arrived at "the idea of art as an independent form of thought, a part of the human conceptual range on a level with religion and materialistic philosophy." Of course, his form of thought was crushed by that rival doctrinary power, Russian Communism.

The Surrealist movement in art and literature, expressly drawing on Rimbaud's formulations, strove to realize the role of the "seer," or oracle, in the menacing atmosphere of Europe between the two world wars. In his treatise "How to Force Inspiration" Max Ernst reached back to techniques of Poe, Baudelaire, and Rimbaud for inducing inspiration deliberately, a Promethean attempt to steal the fire of the gods. Consciously adhering to the formula "I is another," he devised methods of creation which, as he put it, "reduced to a minimum the active part of what until now has been called the 'author,'" so that the artist could "attend simply as a spectator the birth of his work." The aim of Surrealist automatism, and its experiments with chance and coincidence, was to instigate the operation of an intelligence beyond that of the individual mind. The artist's abnegation of his ego was in line with the conviction that of himself, without divine help, he could do nothing. It was the view of André Breton

that art based on chance "necessitates the unreserved acceptance of a more or less durable passivity."

Only if religious art is identified with the depiction of the sacred events of particular cults can modern painting and sculpture be deemed devoid of religious connotations. Yet figurative art, far from being the exclusive mode of religious expression, is actually banned in leading faiths, such as the Islamic and Judean. T. E. Hulme, an influential theoretician of the first quarter of this century, considered that religion belongs to a realm totally separated from the organic and the inorganic worlds, and that hence genuine religious art ought to be devoid of images of human beings and of nature. The crucifixions, flagellations, ascensions of Renaissance art, Hulme argued, confuse religion with humanism. "At the Renaissance," he wrote,

> there were many pictures with religious subjects, but no religious art in the proper sense of the word. All the emotions expressed are perfectly human ones. Those who choose to think that religious emotion is only the highest form of emotions that fall inside the humanist ideology may call this religious art, but they will be wrong. When the intensity of the religious attitude finds proper expression in art, then you get a very different result. Such expression springs not from a delight in life but from a feeling for certain absolute values, which are entirely independent of vital things. The disgust with the trivial and accidental characteristics of living shapes, the searching after an austerity, a monument of stability and permanence, a perfection and rigidity, which vital things can never have, leads to the use of forms which can almost be called *geometrical.*

The Constructivist movement in post–World War I Russia is the strongest originating influence in modern abstract art. The members of the group—Tatlin, Pevsner, Rodchenko, Lissitzky, to name but a few—were militantly committed to an art rationally conceived and with utilitarian aims. In the

period of postwar and postinsurrectionary reconstruction they sought to abolish the traditional distinction between fine and applied art—the Constructivist artist was prepared to give himself equally to designing buildings or overcoats, coffee cups, wall decorations, typography. Constructivist paintings and sculptures make use of geometrical forms: the square, the circle, the triangle, the cylinder. Constructivists are also inclined toward animated art: kinetic sculpture, operated by motor, gravity, wind, water. The geometrical shapes of Constructivism reiterate the decorative patterns of applied art, but they also echo the designs found in the most primitive and ancient ornamentation. These forms are also allied with those of machinery—and constructivism identified itself as a "machine aesthetic." To this day, art in the constructivist mode has continued to absorb new industrial devices and materials—for example, videotape, mylar, microphotography, the computer.

In the opinion of some Constructivists the real force of the movement lay not so much in its style, techniques, and materials as in its basic revision of the traditional conception of the artist. According to George Rickey's study entitled *Constructivism*, the new art demanded a "radical shift from ideas held for a thousand years." The aesthetic vocabulary of the square, circle, checkerboard, chevron implies an artist with a neutral, objective mind, whose feelings have been systematically effaced in his work. The elementary shapes of Constructivism and its impersonality constitute a single aesthetic principle.

From the beginnings of Constructivism, however, the self-effacement affirmed by it has been of distinctly opposite kinds: on one side, the utilitarian depersonalization of the factory hand, on the other, the metaphysical (or mystical) self-negation of the saint or seer. In Russia, eliminating the artist's ego coincided with art in the service of the masses (comparable to art designed for mass consumption in Madison Avenue and Hollywood studios). Negation of self was also a necessary condition for an art of essences or meta-

physical entities. The same abstract forms could represent either the anonymity of the conveyor belt or that of mystical revelation. For Kandinsky, for example, the triangle, says Rickey, had "its particular spiritual perfume." Said Malevich, creator of the black square on a black canvas and of a white square on a white one, "I felt only night within me, and it was then that I conceived the new art." This testimonial matches that of medieval saints. To Malevich, the "white field" represented the "void" beyond feeling, as did the White Whale of Melville. The logic of Malevich was directed not toward achieving a system of formal relations but to "advancing," as he put it, "into the 'desert' where nothing is real but feeling." Kandinsky said that "the impact of the acute angle of a triangle on a circle produces an effect no less powerful than the finger of God touching the finger of Adam in Michelangelo."

Constructivism, observed the sculptor Gabo, "has accepted the fact that what we perceive with our five senses is not the only aspect of life and nature to be sung about; that life and nature conceal an infinite variety of forces, depths, and aspects never seen and only faintly felt which have not less but more importance to be expressed, and to be made more concretely felt, through some kind of image communicable not only to our reason but to our immediate everyday perceptions and feelings of life and nature."

It is significant in regard to the nature of modern art that Constructivism, the most extreme and bellicose affirmation of aesthetic materialism and utilitarianism, has been accompanied, from the first, by its metaphysical shadow or double—a "religious"art seeking to pin down the absolute and the unknown in a universal vocabulary that preserves the essence of the old divine imagery (as in the Sistine Chapel detail of God and Adam) but liberated from exclusive associations with the beliefs and myths of Western culture.

It requires, of course, a profound mental revolution for art lovers to separate the notion of religious art from paintings of madonnas, crucifixions, and saints in the desert. This revolu-

tion has by no means taken place in contemporary writings on art, though it has had a widespread influence upon artists. This is another way of saying that the intellectual environment of art today is out of tune with its most significant paintings and sculptures. For the art of the twentieth century supports the contention of Hulme that experiences of the absolute and the transcendental achieve their essential expression in abstract art, whether based on the formal language of geometry or the symbolic vocabulary of primitive cosmology.

In postwar American painting, abstract and mythic art, and combinations of both, are the outstanding modes and have made American art of worldwide interest, since in all cultures today metaphysical moods persist, allied with creation but dissociated from traditional forms and creeds. A pantheistic enthusiasm is the substance of the paintings of Pollock and Hans Hofmann. Gorky, Newman, Gottlieb, Rothko draw on mythic sources and the spontaneous form making of the unconscious. A statement published in June 1943 by Rothko and Gottlieb, in the composition of which Newman collaborated, indicates the degree to which the New York artists' program overlaps religiometaphysical concerns. "To us," declares the statement, "art is an adventure into an unknown world," and it goes on to repudiate art that pursues merely aesthetic goals. Genuine art, it insists, has to deal with man's eternal condition. "It is a widely accepted notion among painters," it states, "that it does not matter what one paints as long as it is well painted. This," the statement continues, "is the essence of academism. There is no such thing as good painting about nothing. We assert that the subject is crucial, and only that subject matter is valid which is tragic and timeless. That is why we profess spiritual kinship with primitive and archaic art." In keeping with this pronouncement, Gottlieb began with prehistoric pictographs, and these led into the "cosmic" landscapes of his later years in which suns and moons of aboriginal art were converted into a private alphabet of signs. For his part, Rothko inclined toward atmospheric composi-

tions suggestive of sacred grottos or meditation cells, and his metaphysical ambition reached its zenith in the murals he executed for a chapel in Houston. De Kooning is as convinced as Rothko and Gottlieb that what counts is subject matter. His leaning is toward Renaissance rather than archaic or primitive art. He is in agreement with Hulme that Renaissance painting is humanistic in content, and he has expressed the opinion that oil paint was developed in order to depict flesh. De Kooning is neither religious nor mystical, in the sense of seeking to arrive at the sign of an absolute. Rather, he luxuriates in the multiplicity of real things and in his perceptions and memories of them and the associations they arouse. Yet he too is in quest of an illuminated state in which, during the course of painting, an ultimate reality reveals itself. He too, as he said, "wants to be inspired."

The imagery of Pollock, like that of Rothko, passed from primitive emblems and rituals—some with Mexican and American Indian derivations, others drawn from the unconscious through automatic drawing—to his famous abstract gesticulations with paint, dripped, poured, or flung on the canvas. For Pollock the key to creation was to enter into what he called "contact" with the painting he had begun, so that it would guide him as if it were an outside spiritual force. "I have no fears," he said, "about making changes, destroying the image, and so on, because the painting has a life of its own. I try to let it come through." Here, the artist conceives himself as a vehicle or medium of an entity beyond himself, a version of Rimbaud's "I is another."

Newman was the most explicit in associating art with the "sublime" and with "awe"—forms of experience that manifest themselves in all religions, hence transcend any particular one. For Newman, as for Hulme, total reality, such as subsists in the realm of the religious, can only manifest itself in the totally abstract, in which there is no trace or residue of the physical world—even Mondrian's rectangles were, in Newman's view, natural forms disguised as geometry.

The repeated all-black squares of Reinhardt's later years

come closest to resembling an ecclesiastical image. With his metaphysics of negation, Reinhardt sought to bring an asceticism into painting that would be equivalent to a vow of silence. An exhibition of his works, all black, all square, all the same size, produced the effect of a crypt. Art had been purged of the sensuality of color, of forms, of evocative line. It had become the witness of another self—one without attributes.

In its metaphysical sentiments and the magnitude of its conceptions, art in our time aspires to grandeur comparable to that of the great art of other ages. Yet whatever it succeeds in accomplishing, it must achieve under all-but-insurmountable handicaps. The struggle to make an absolute statement in an individually conceived vocabulary accounts for the profound tensions inherent in the best modern work—the anxiety of Cézanne, as Picasso called it, the "desperation" of de Kooning. In a memorable phrase, the British essayist, novelist, and painter Wyndham Lewis described the rituals and ideologies of modern art movements as "inferior religions." Self-invented and lacking the authority of tradition, they could not hope to match the systems of belief and practice upon which artists of earlier times built their creations. Thus modern art cannot avoid a species of flimsiness, the absence of that objective solidity that inheres in things seen in a single way by an entire culture over a long period of time. Modern art, as artists themselves have been the first to emphasize, is tentative and ephemeral—it lives in the expectation of being displaced. Its profoundest insights often convey the impression of eccentricity and self-indulgence and at times mental aberration.

Even modern works that reach the summit of public acceptance remain private, and, at best, they communicate only in part. It was the dream of Mondrian that his art could generate a communion that would make it comprehensible without the need for verbal explanations. "In the great epochs of style," he wrote, "the 'person' disappeared: the general thought of the age was the force that guided artistic ex-

pression. The same holds true today. More and more the work will speak for itself: each work of art becomes a personality instead of the artist. Each work of art becomes a different expression of the *one.*" But for paintings to convey their full meaning through direct sensation, a new phase in human relations would have to be reached. Mondrian's apprehension of a unitary "thought of the age" was a Utopian dream. Nor can art produce out of itself a social cohesion and a universally comprehensible set of symbols. This is another way of saying that art cannot assume the social role performed by religions in earlier cultures. Art cannot cure cultural chaos, no matter how effective it may be in giving body to the metaphysical absolutes of individuals. Today, art consists of one-person creeds, one-psyche cultures. Its direction is toward a society in which the experiences of each will be the ground of a unique, inimitable form—in short, a society in which everyone will be an artist. Art in our time can have no other social aim—an aim dreamed of by modernist poets, from Lautréamont to Whitman, Joyce, and the Surrealists, and in which is embodied the essence of the continuing revolt against domination by tradition.

In the meanwhile, it is the part of organized religions to conduct a holding operation for the spirit in order to guard individuals against annihilation by mass-mindedness. That conditioning for conformity threatens both religion and art in threatening the integrity of the individual is most clearly seen in the history of what has happened to all three in totalitarian countries. But let not Americans console themselves that speeches of politicians about individual freedom are sufficient to arrest these processes in the United States. To exist, individuality must be *acted.* Art, from which emerges style, is the training ground of individual doing. There are signs that some churches have begun to recognize that art, even of the most extreme sort, is their inevitable ally in the struggles of the spirit.

# 31
# Art Is a Special Way
# of Thinking

━━━━━━━━━

t is traditional for artists to be suspicious of ideas and how they might affect their work. Ideas in art give orders to the artist, they tell him what to do and how to do it. This is true even when the idea man is the artist himself. Under the authority of ideas art tends to turn into a craft following certain recipes. Creation, in contrast, implies the presence of an element that cannot be known in advance of the work itself.

Have ideas any function in art—beyond placing it at the mercy of nonartists? That is to say, have *words* any function, since it is verbal thinking that is at issue?

In our day, the connection between words and visual creations is stronger than ever before. So much art is being produced—and out of so many different sources. So much is being circulated, dug out of ruins and mounds, photographed, reproduced, exhibited, cataloged—people cannot simply look at them all: they must identify them, understand them. They know that art has a history and that a work must be *placed*—that is, related to the time and site of its origin and to other works in the same or comparable styles. They know that works of art have meaning, that they can be READ. Paint-

An address delivered at commencement exercises, Rhode Island School of Design, May 29, 1976.

ings and sculptures comment, for example, on the civiliza-
tions in which they were produced—they tell us about
Babylon, the Uganda, or the court of Louis XIV. Paintings can
also be read for psychological clues, as Freud explained in his
book on Leonardo. One might say that a painting these days
is more often dealt with as a document than as a painting. Yet
no matter what is said by the artist or anyone else, in making
the works the payoff comes in what the painter does when he
is alone in his studio manipulating material substances whose
outstanding characteristic is their silence.

"What use is my mind?" Degas is quoted as asking.
"Granted that it enables me to hail a bus and pay my fare. But
once I am inside my studio, what use is my mind? I have my
model, my pencil, my paper, my paints. My mind doesn't
interest me."

Paul Klee, one of the outstanding theoreticians of art in our
century, began a celebrated lecture on drawing by expressing
agreement with those who say, "Don't talk, painter, paint!"
Having presented this disclaimer, Klee embarked on a full-
scale exposition of his subject, complete with diagrams and
illustrations, like a phrenologist at a side show.

The notion that thought is an obstacle to doing extends far
beyond the borders of art. One thinks of Hamlet's "pale cast
of thought." Perhaps the most passionate expression of it is
the following: "When you start to think," said Phil Rizzuto to
Yogi Berra, Yankee catcher, "you hurt the whole team."

Among academics and humanists of conservative taste, ex-
cess of theory is taken to be one of the sins of modernism—
and the key to its weakness as art. Admirers of Renaissance
paintings are convinced that an artist is, and must be, a supe-
rior type of artisan—and that an artisan is one whose skill lies
in his hand, not his head. Leo Stein broke with Picasso, and
with his own sister, Gertrude, because in his opinion Cubism
was an exercise in mental ingenuity, hence at bottom shallow
and unimportant. More recently a journalistic comedian has
gained wide attention by attacking contemporary art as
"painted words," and predicting that by the end of our cen-

tury exhibitions will consist of quotations from critics accompanied by pictures illustrating their ideas.

Like other attacks on contemporary art as over-intellectual, the painted-word jokester rests, whether he knows it or not, on the old identification of the arts with the handicrafts, on the belief that painting and sculpture are skills intellectually on a par with those of a basket maker or ball player, in which analysis and reflection can have little part. Today, a further ground for uneasiness about thinking (ideas) in art has appeared. I refer to the challenge of Conceptualism, a form of art in which the object is eliminated in favor of diagrams, records, accounts, photographs of processes, events, things done or planned. Conceptualism is an extension of the kind of utilitarian thinking Degas had in mind when he said that his intellect enabled him to buy a bus ticket, but was not of much use in the studio. In our time, practical thinking has reached into art as an authoritative force in determining what is and is not worthy of being done.

Let us glance for a moment at the background of the attempt to dematerialize art and replace it with concepts. Here again we encounter the issue of the handicrafts. A major motive of art in this century—no doubt stimulated by advancing technology—has been to separate art from its age-old tie with the crafts. Only by gaining independence from outmoded forms of production could art recover the high place it once occupied in intellectual culture. For a time it was believed that this independence could be won by uniting art with technology on the basis of an equal partnership. Many still hold this view, though art-technology collaborations have usually failed, or been more useful to the engineers than to the artists.

A more recent notion—and a more extreme one—is that art can no longer survive as skill in making, but only through the Idea. Exhibiting factory-made products in art galleries more than half a century ago, Duchamp demonstrated that machines were capable of creating forms on a par with those of the sculptor, and that in regard to objects for use and deco-

ration, the handicrafts could now be dispensed with. Art no longer needed to be made. It could be found—provided the artist had the proper concept.

With Duchamp the concept was everything—the activity of the hand nothing. Indeed, he broke with painting in order to escape what he called "the servitude of the hand." The premises of Duchamp have been carried to their logical conclusion by Conceptualism. "There are already enough 'objects,'" a Conceptualist has written, "and there is no need to add to them." Conceptual art is at home in the head. With it, the rupture of art with the crafts has reached its culmination.

Duchamp was a great critic of the changed status of art introduced by making works for the open market—as opposed to the patron. His tough thinking raised vital questions that are still with us. His insights owe their depth precisely to the realism and practicality of his approach. But there was another side to Duchamp, as well as to the questions he raised. In his extreme stress on the conceptual in art, Duchamp discovered that concepts in art cannot escape contradicting themselves. Perhaps art itself is, in the industrial era, a contradiction. No matter how deeply dependent it becomes on rationalized systems and procedures, it cannot destroy its identification with individual practices and individual sentiments—and there, in turn, demand unique procedures in handling materials. Duchamp's criticism of the art object is interesting and important. But Duchamp's secrets—embodied in the juxtaposition of images and words in his creations—are more interesting and perhaps more important.

With the floods of troublesome verbiage by which art is contantly deluged, it is tempting to imagine painting as a silent physical activity, like the movements of a graceful animal or athlete. There is a sensual pleasure in drawing a contour. Paint appeals to several senses at once—not only to the eye but to smell and touch as well—and some of the exhilaration of painting, and of looking at paintings, is no doubt owing to these effects on the senses.

Here is a description of the state of mind of the ideal artist

at work: he experiences, says the author, the delight "intense, ecstatic, continuous and all-absorbing . . . of color concerned with rhythmic expression." In this state, what need is there for words?

The description I have quoted was in the report of a lady who was art supervisor of child day-care centers in Berkeley, California. Her "ecstatic, all-absorbed" artist was two years old. Her statement added the observation that "in this age group there is no apparent difference between the paintings of girls and those of boys." This is, obviously, as close to the angels as art can get.

Unfortunately, by the time the artists of the day-care centers have reached the age of three, the flow of ecstasy has become subject to increasing interruption. They find it difficult to dissociate art from a sense of purpose, in which their egos are involved. The three-year-old artist takes his product home to his mother in search of a critical reaction, that is to say, praise. Once the infantile paradise of continuous, all-absorbing ecstasy has been left behind, art becomes contaminated by thought, the thought of others and the self-consciousness of the artist. To get past thought requires a great deal of thinking.

Only through thinking can the artist apprehend the physiognomy of the times and the direction of the changes taking place in art itself. Without ideas there can be only repetition of things that have already been done and of notions that are already familiar. But the thinking of the artist cannot consist of the utilitarian generalizations of the man of affairs or the formulas of the scientist.

Concepts enlighten the artist as to his location in time, place, and culture. But whatever the concept, it is not sufficient. Concepts are abstract and tend to become more abstract—and remote from the condition of individuals and their experience of things and events.

Art is a mode of thinking from which the consciousness of self is inseparable. In it the body—its habits, its training, its correction of its habits—provides material to its thoughts

about the world. The body includes memory—both conscious remembering and revelations of the past that emerge in doing. This kind of thinking that reaches beyond the mind to the total individual is sometimes called imagination—the mental faculty, said Spinoza, by which things become real to us.

# Index